FROM ART NOUVEAU TO SURREALISM
BELGIAN MODERNITY IN THE MAKING

LEGENDA

LEGENDA, founded in 1995 by the European Humanities Research Centre of the University of Oxford, is now a joint imprint of the Modern Humanities Research Association and Maney Publishing. Titles range from medieval texts to contemporary cinema and form a widely comparative view of the modern humanities, including works on Arabic, Catalan, English, French, German, Greek, Italian, Portuguese, Russian, Spanish, and Yiddish literature. An Editorial Board of distinguished academic specialists works in collaboration with leading scholarly bodies such as the Society for French Studies and the British Comparative Literature Association.

MHRA

The Modern Humanities Research Association (MHRA) encourages and promotes advanced study and research in the field of the modern humanities, especially modern European languages and literature, including English, and also cinema. It also aims to break down the barriers between scholars working in different disciplines and to maintain the unity of humanistic scholarship in the face of increasing specialization. The Association fulfils this purpose primarily through the publication of journals, bibliographies, monographs and other aids to research.

MANEY
publishing

Maney Publishing is one of the few remaining independent British academic publishers. Founded in 1900 the company has offices both in the UK, in Leeds and London, and in North America, in Boston. Since 1945 Maney Publishing has worked closely with learned societies, their editors, authors, and members, in publishing academic books and journals to the highest traditional standards of materials and production.

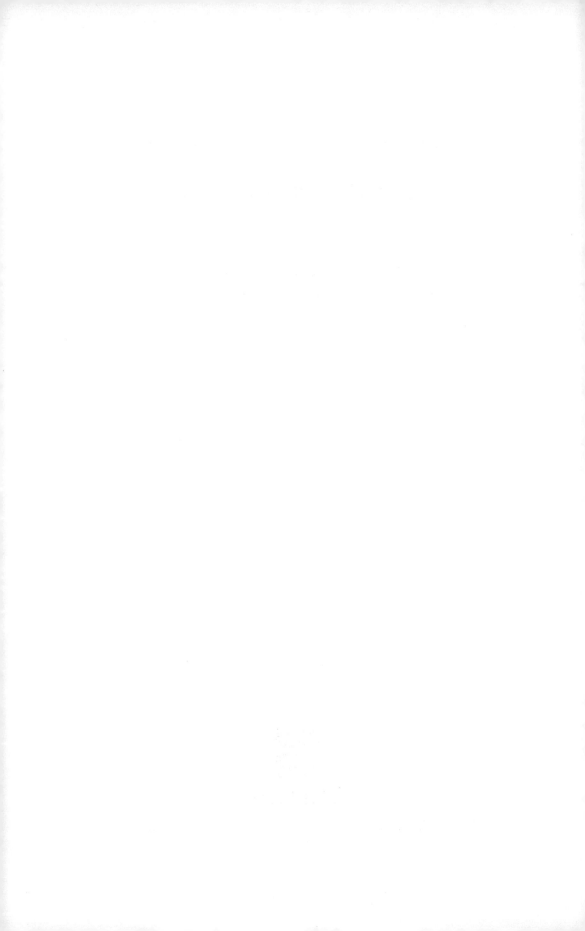

From Art Nouveau to Surrealism

Belgian Modernity in the Making

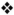

EDITED BY NATHALIE AUBERT,
PIERRE-PHILIPPE FRAITURE AND PATRICK McGUINNESS

Modern Humanities Research Association and Maney Publishing
2007

Published by the
Modern Humanities Research Association and Maney Publishing
1 Carlton House Terrace
London SW1Y 5DB
United Kingdom

LEGENDA is an imprint of the
Modern Humanities Research Association and Maney Publishing

Maney Publishing is the trading name of W. S. Maney & Son Ltd,
whose registered office is at Suite 1C, Joseph's Well, Hanover Walk, Leeds LS3 1AB

ISBN 978-1-904350-64-4

First published 2007

Printed in Great Britain

Cover: 875 Design

Copy-Editor: Cécile Dudouyt

CONTENTS

ACKNOWLEDGEMENTS

The editors wish to thank Oxford Brookes University, the Modern Languages Faculty of the University of Oxford and the British Academy for their financial help, and John McKeane and Victoria Clouston for their translations.

INTRODUCTION

Distance, Doubleness and Negation in the Belgian Avant-gardes

'Leur sens du relatif touche à l'absolu'
Louis Scutenaire, *Mes Inscriptions*

Reading the essays collected in this book, we are struck by the way a number of themes seem to recur, regardless of period (be it the 1890s, the 1920s or the 1940s), genre (poetry, prose, painting or music) or -ism (Symbolism, Surrealism or any of the other more perishable *ismes* the period threw up). These themes, broadly defined, are distance, doubleness and negation, and they appear in various guises and in different proportions throughout the essays that follow. Indeed, we might consider them to be a sort of Belgian trinity, awkward and intractable, but also enriching and full of unexpected possibilities.

Belgian literary and artistic movements have always explored, and often exploited, their differences from the major international groupings in whose orbits they grew and gained recognition. On the one hand, Belgian avant-garde culture is conscious of its need to harness itself to the big centres of activity, most often Paris. On the other hand, and usually in the same gesture, it demands that it be treated separately, to emphasize its distance from such centres, and its resistance to being co-opted into them. The avant-garde in Belgium seeks to transcend its own national context, all the while asserting how its *Belgianness* makes it unique, before in turn questioning the very notion of *Belgianness*. No sooner is a position taken (in relation to oneself and to others) than that position is undermined and exposed. Perhaps more than any European country, Belgium, which gave us Rodenbach, Magritte, Brel, Dotremont and countless other uncategorizable figures, is at home with its own ambiguities.

The Symbolists play a game of distance and proximity with their French counterparts, in part because they are engaged in the project of defining a Belgian literature, and in part because they recognise that their own art benefits from keeping their tensions unresolved. Belgian Symbolism produces disciples, but also prodigal sons — occasionally, these turn out to be one and the same. The Surrealists, less interested in the idea of a national literature but perhaps more concerned with autonomy, bring their own more negative dialectics to bear on their relationship with Breton and French Surrealism. Where the French Surrealists focus on revolt and revolution, the Belgians subvert and invert what is already there, whether in language, politics, art or public culture. Who could imagine Symbolism without the Belgians Maeterlinck, Rodenbach and Verhaeren, or Surrealism without

Magritte or Scutenaire or Nougé? Yet who could imagine a Belgian culture without Symbolism and Surrealism? Both movements find their centres in other people's margins, and from within those margins they follow their own unique and independent paths. With Dotremont and CoBrA, where this book ends, Belgian avant-gardists are looking elsewhere, to Amsterdam and Copenhagen rather than Paris, seeking to take their places on other artistic stages and open up new cultural dynamics.

Another characteristic of Belgian culture is its quest for self-definition, a resolution of its own doubleness that does not entail the erasure of that doubleness. Yet this quest is not accompanied by uncertainty or agonising discomfort: on the contrary, Belgian avant-gardes are unusually assertive, frequently (as in the case of the Symbolists) turning uncertainty into an aesthetic of uncertainty, doubt into an aesthetic of doubt, and promoting the cultural or psychologically debilitating into the artistically enabling. Some Belgian artists found their identity in the splicing of different cultures, in fusions and mergers of language, in hybrid sensibilities and traditions. Others preferred paradox and unresolved tensions, polarities and oppositions. Some simply sought the double negative as the only credible positive: in these cases, the only respectable definition is a definition that leaves things even more uncertain than before — an anti-definition. As Scutenaire wrote of 'Belgian' Surrealism: 'Il n'y a pas eu de surréalistes belges, pas plus qu'il n'y a des surréalistes chinois. Il y a eu des surréalistes en Belgique'.

Can we speak of a Belgian tradition? And if we can, does such a thing emerge from a book like this one? It is an appropriately ambiguous question. On the one hand there is certainly a tradition, if by tradition we mean a set of models and influences, and a notion of cultural succession. But it is fair to say that these come as much from outside Belgium (and we would have to agree, first, on which Belgium we were talking about) as from inside it. Centres of influence such as Paris or Berlin are not 'foreign' to Belgium in the way they might be, say, to each other, or to another European culture. Belgium already has them within itself, internalised. It already has the Nordic and the Latinate, the French and the Germanic, the Walloon and the Flemish. It is not just that duality is part of Belgian literature, but that what is external to itself is already partly within it, programmed into it, as it were. The Belgian artist, writer or musician, does not have to look to Paris in order to look outside himself. Turning away from Paris, or contesting and challenging its dominance, is, by the same token, a way of contesting and challenging part of oneself.

In the Belgian case, to belong to a 'tradition' means two things: to arrive weighted down with cultural baggage, but also to be able to start from scratch. Belgian artistic culture, at any rate its avant-garde culture, comes with a dual sense of, on the one hand, being oppressed by examples and models; and, on the other, of being free to begin again, or reject what one had begun with. Before Belgian culture has been able to say what it is, it has always had to articulate what it was not. This is an unusual if not unique state of affairs: a reliance on what might be called the negative way into oneself. Indeed, it has seemed at times that Belgian culture's positive definitions could only come from double negatives: not so much from what it is as what it is *doubly not*. To other traditions' obsessions with canons

and lineages, the Belgian case opposes mobile and shifting centres of influence and attraction; faced with the obsession with metropolitan culture, Belgian culture posits a defiant regionalism; instead of unified practices, it celebrates plurality and internal dissent. With the Belgian surrealists, forged in the fire of negativity, ambition is replaced with a sort of anti-ambition, clandestine action takes the place of literary fame, and subversion replaces revolution.

This book reveals and explores an artistic culture which produces, as a rule, the unclassifiable. This cultural tradition is made up of writers and artists apparently unrelated to any tradition, but who nonetheless *belong* together. It is, paradoxically, a tradition of one-offs: Maeterlinck, Ghelderode, Ensor, Nougé, Scutenaire...

Trying to define such a tradition was bound to cause problems. Literary critics like to be able to classify, but they are also fond of the unclassifiable, provided it is the right sort of unclassifiability. But the problem with the Belgian *inclassable* is that it calls into question the very notion of Belgian literature, Belgian art, or Belgian music. In short, it calls into question all the systems and markers with which we classify in the first place. It does so not because it questions the existence of literature, art and music *in* Belgium, but rather the national adjective of belonging that precedes them. The question has always existed, whether in the 1880s or in the 1940s, and, although no-one seems in any hurry to resolve it, it is as pressing in the realms of poetry, art and fiction as it is in theory. As Marc Quaghebeur wrote: 'la question majeure qui agita nos lettres depuis leur origine est celle de leur existence, de leur spécificité et de leur appellation'.[1] Are we dealing here with a culture defined by its constant production of definitions, rather than by any of the definitions it has produced?

As well as ruptures and disconnections, incommensurable chasms between languages, cultures and practices, there are continuities between Maeterlinck's 'dialogue du second degré', a sort of *détournement* of traditional theatrical language, and Nougé's *détournement* of set phrases and clichés, or between Khnopff's obsessions with doubles and reflections and Magritte's inversions and subversions of image and word. Even Ensor, an artist with no *appartenance* in his lifetime, connects up to Ghelderode and Crommelynck, but also, in very different ways, with Dotremont.

This book presents Belgian artistic culture from the 1890s to the 1940s. It does not deal solely with literary practices, but, in a way that mirrors the extensive collaborations between arts so characteristic of that period's cultural terrain, it also deals with music, painting and photography, as well as politics, culture and popular art forms.

In the first essay, Patrick McGuinness examines the theme of doubleness and reflection in Belgian Symbolism, connecting these to the double nature of Belgian culture, and further to the relationship of mirroring and doubling that characterises the ties between French and Belgian literary cultures. In his essay, Arnaud Rykner picks apart the generally vague notions of 'music' and 'musicality' in literary analysis, and examines the relationship between Maeterlinckian drama and the idea of music. He suggests ways in which the playwright's work, set to music by a number of composers, already approaches what Mallarmé called 'la

musique dans le sens propre', approaching the Symbolist dream of a language that is not, as Barthes says, *condemned* to meaning. Laurence Brogniez and Charlyne Audin also explore the notion of doubleness, in an essay that takes in literature, theatre, cultural criticism and art. For them, the enigmatic figure of the 'artiste double' is itself emblematically Belgian, and they trace the tradition from Ensor to Dotremont and Alechinsky. Ensor appears as the exemplary figure, an unclassifiable artist who bridges arts, cultures and also traditions — but who, in bridging them, also disrupts them. Pierre-Philippe Fraiture focuses on an underrepresented area: Belgian colonial fiction. In his essay 'Belgian 'negro' Fiction: Modernist Itinerary of a Didactic Genre', he argues that the colonial *terra incognita* was simultaneously explored and fantasised about, and shows the various ways in which colonial fiction was put to use in Belgian cultural politics.

Paul Aron, in a characteristically broad yet precise way, analyses the relations between artistic modernity and politics in the Belgian sphere, showing how the major currents of political radicalism and commitment affected the literary allegiances of the first half of the twentieth century. Here again, Belgium mirrors, yet also distorts and reconfigures, the period's dominant ideologies. A political dimension is also found in Thomas Amos's chapter on Jean Ray, exploring the relationship between political radicalism and the *fantastique*. Ray's *Contes du Whisky,* published in 1925, serve for Amos as a point of entry into the fraught cultural politics of the 1920s. Among the Belgian playwrights who appear to us as forerunners of modern avant-garde theatre, only Maeterlinck has been given his due. Pierre Piret makes a powerful case for seeing two Belgian playwrights, Fernand Crommelynck and Michel de Ghelderode, as precursors of some of the twentieth century's most radical theatre. In her essay on photography in Belgium, Danielle Leenaerts examines the ways in which, in Belgium, Pictorialism and the newer modes of expression remain in productive tension.

Benoît Denis, in 'Hergé-Simenon, Thirties', takes the cases of two of Belgium's most famous exports, and analyses the various ingredients that go into their making, finding unexpected resonances between the worlds of the two writers and their creations, Tintin and Maigret. Valérie Dufour, for her part, assesses the difficulties encountered by Belgian musicians to break from the shadow of César Franck and develop a specifically Belgian music. Dufour explores the tensions in the notion of a Belgian musical 'tradition', and asks if there existed a Belgian music the way there undoubtedly was a Belgian art or literature. Virginie Devillez, in 'The Avant-Garde on the Reworking of Tradition' sees the central fact of Belgian art in the interwar period as the oscillation between tradition and innovation. Devillez traces the relationships between these movements, exploring the extraordinary richness and diversity of the Belgian art scene, with Brussels and Antwerp serving as major centres for artists, galleries and reviews. In 'A Road Story of the Belgian Avant-Garde' An Paenhuysen follows the travels and exiles of Belgian artists and writers, and shows how their shifting topographies feed into their work. Focussing especially on Belgians in Venice, Paris and Berlin, Panhuysen examines the way in which travel itself affects the notion of home, and how departure modulates the idea of 'return'.

Bibiane Fréché's chapter, 'Surrealism in Belgium Between the Wars', provides a historical overview of Belgium's surrealist formations and their tensions, their distance from the Parisian scene, and their collaborative activities. She also explores how their clandestine and underground nature helps to make them both radical and invisible. Distance is also a theme in Nathalie Aubert's chapter, 'Twenty years on: Belgian and French Surrealists and "the" revolution'. Here, Aubert examines the differences between French and Belgian surrealists on the question of political engagement. Aubert takes us to the next phase in the story of the Belgian avant-garde, the period in which Christian Dotremont emerged to take the avant-garde energies into new, unpredictable and international directions. In the final chapter, Andrew Hussey takes the exemplary — because typically unrepresentative — figure of Louis Scutenaire, probing the connections between Scutenaire's self-effacing but nihilistic work and the early manifestations of Lettrism and, eventually, the Situationsim of Guy Debord.

No collective work such as this should tell a single story. There are no single stories to be told, least of all about what the contributors have chosen to explore. But such a book as this should bring out the common features that characterise even such a fraught and ambiguous terrain as the Belgian avant-gardes from the late nineteenth- to the mid-twentieth centuries. We began by suggesting that the 'Belgian Trinity' might be distance, doubleness and negation. Certainly these are, in some measure, to be found in all the essays collected here. But the idea of *détournement* is an equally fertile notion: Belgian artistic culture is turned towards and away from both itself and the outside world. Perhaps it is also *détourné* in the more subversive sense of inverting and subverting, turning things upside down and inside-out.

Note to the Introduction

1. Marc Quaghebeur, 'Balises pour l'histoire de nos lettres', in *Alphabet des lettres belges* (Brussels: Labor, 1998), p. 16.

PART I

Belgian Literature and the Symbolism of the Double

Patrick McGuinness

In his 'Study in French Poets', published in 1918 and collected in 1920 in the book *Instigations*, Ezra Pound described the Belgian Symbolist journal *La Wallonie* as constituting 'a history of Symbolisme' and a model for the sort of cosmopolitanism he himself sought to reproduce in the journal he had just started editing, *The Little Review*. Pound even sent a complimentary copy of *The Little Review* to Albert Mockel, the former editor of *La Wallonie*, in Liège. Mockel sent a gratifying reply, which Pound liked so much that he published it in full in his 'Study in French Poets'. It is interesting to consider Pound, a modernist trailblazer who had not been kind to Symbolism over the years (it smelled, as he put it, 'of talcum powder'), making contact with a critic and editor from the previous generation, not in Paris (the most obvious place to look) but in Liège, and not to commemorate a French magazine but a Belgian one. This will not have been an accident — Pound was well acquainted with Symbolism's magazine culture, and he was, more than any other modernist poet, aware of its hybrid and francophone nature. He had also studied the movement and its legacy in his earlier exploration of French poetry, 'The Approach to Paris' in 1912–13, where, despite a suspicion of Symbolism, he asserted that Verhaeren was 'the greatest living poet' writing in French. By 1918, Pound has relaxed his position somewhat, finding in *La Wallonie* a great deal to admire, not just in poetry but also in critical approach and cultural positioning. It is as if he wants to associate himself not only with this magazine, so redolent of the heroic period of Symbolism, but also with a French-speaking (as distinct from merely the French) avant-garde. *La Wallonie*'s title, so French and yet so un-French, is worth pausing over too: defiantly regional in appellation and yet perfectly international in scope, Mockel's magazine published, among others, Gide, Swinburne, Merrill, Mallarmé, Laforgue, Kahn, Huysmans, as well as the Belgian Symbolists themselves. *La Wallonie* perhaps exemplifies for Pound a literary moment and a literary location in which different artistic energies come together, in which the national and the international, the regional and the cosmopolitan, the local and the European, successfully coexist. Perhaps Pound imagined the American anglophone avant-garde of Modernism and the Belgian francophone avant-garde of Symbolism as corresponding, across decades, aesthetic differences and national boundaries. Certainly, Mockel's suggestive and gracious reply to Pound implies something like

this, as does Pound's decision to include Mockel's letter in his book:

> N'y a-t-il point là [in *La Wallonie*] quelques traits de ressemblance avec l'oeuvre que vous tentez aujourd'hui en Amérique, et, à trente années d'intervalle, une sorte de cousinage? [1]

Mockel's idea of *cousinage* — American/Belgian, Modernist/Symbolist, 1890s/1920s — will have struck a chord in Pound, whose ambitions for a Europe-based American avant-garde magazine took up a great deal of his time between the 1912 and the 1930s.

There is another highly suggestive Belgian moment in Pound's work, this time in *The Pisan Cantos*. In Canto 80, a canto replete with references to Mockel, *La Wallonie*, and Belgian figures such as Eugène Ysaye, Pound remembers the Lévy-Dhurmer portrait of Rodenbach. This famous image depicts Rodenbach in an open-necked shirt against a Brugian background, his shoulders seeming to blur into the canal behind him. Pound recalls it alongside a series of 'portraits in our time':

> and of portraits in our time Cocteau by Marie Laurencin
> and Whistler's Miss Alexander
> (and the three fat ladies by Sargent, adversely)
> and somebody's portrait of Rodenbach
> with a background
> as it might be L'Ile St Louis for serenity, under Abélard's bridges
> for those trees are Elysium
> for serenity
> under Abélard's bridges
> for those trees are serenity[2]

Does Pound mistake Lévy-Dhurmer's Bruges for Paris? It is possible, especially given that he cannot recall the painter's name. In a further twist, it appears that Lévy-Dhurmer had not in fact been to Bruges when he painted the picture, and instead used photographs, among them those included in the original edition of Rodenbach's novel. Pound's 'as it might be' is ambiguous too, mapping Bruges's bridges onto the bridges of Abelard, mapping an imagined Belgium onto a no less imagined France, and a late *dix-neuvième* atmosphere onto the medieval atmosphere of the doomed lovers' tale. Perhaps, in Pound's associative method, it is the idea of the bridge itself that becomes operative: a bridge between the two shores of past and present, life and death; between Pound's era and the *fin de siècle*; between Symbolism and Modernism, francophone and anglophone worlds. Pound sees himself as the connection-maker in a world of broken pieces, the shorer of fragments in a shattered Europe. *La Wallonie* had, in its way, been such a bridge, just as, more generally, Belgian Symbolism had — the exemplary bridging movement of the late nineteenth-century's avant-gardes. In a more minor way too, we may see Rodenbach himself as the bridging figure, interpreting Belgium for the French and France for the Belgians, imagining Bruges from the 'exile' of Paris, and viewing Paris through the lens of his 'petite patrie'.

Pound was clear about the centrality of Belgian literature to the European *fin de siècle* and to French Symbolism, and I have written elsewhere of the role Belgian writing played in Pound's enormous mosaic of reference.[3] He saw it as embedded

in the European tradition, but understood its specificity and uniqueness. 'French' Symbolism was perhaps the first literary movement consciously to declare and celebrate its francophone nature. France had always drawn writers from the French-speaking world, but Symbolism was more than just coincidentally francophone: it was *constituted* by its francophone composition.

The 'Manifeste du Symbolisme' was written by a Greek, Charles Moréas; one of the movement's most fertile critics, Teodor de Wyzewa, was a Pole who wrote on German, Russian and English literature, on music and on art; two of Mallarmé's most faithful disciples were Americans, Francis Vielé-Griffin and Stuart Merrill. But the most important contribution to the movement came from Belgian writers' lasting works across the genres. We know all this of course. Maeterlinck gave Symbolism a viable theatre, but took that theatre out of the realm of the mind and into dramatic practice without gambling away Symbolism's hard-won gains. Verhaeren gave Symbolism an epic vision and in so doing had laid the ground for the 'Unanimisme' and even the 'Futurisme' of later decades. In Verhaeren's poetry, Symbolism takes account of social and industrial progress and growth, but also of its casualties and devastations. His Belgium is a place at once over-imagined and true to its economic and social realities and its historical moment. Then there is Rodenbach, the poet of interiority, but also the novelist who, in *Bruges-la-Morte*, gave Symbolism its prose, suggestive and evanescent but not without a dose of traditional novelistic suspense and psychological drama. Albert Mockel himself became one of Symbolism's most penetrating critics, and no mean poet in his own right. Other Belgian Symbolists, such as Charles Van Lerberghe and Max Elskamp, while remaining within the genre of poetry, both produce unclassifiable *oeuvres* which, while markedly 'symboliste', nonetheless resemble nothing being produced on the French side.

Belgian Symbolism developed and grew from an already fertile context of francophone exchange and cultural interpenetration. When we recall Symbolism's historical and cultural situation — post-Commune, the threat from Germany, suspicion of German influence, etc — these were not times, in public and political life at least, propitious to such cosmopolitanism. Perhaps Belgian Symbolism's attraction was as a way of mediating between Frenchness and a certain degree of *Germanité*, a way of absorbing traits of German influence without having to go *via* Germany itself. As well as a place of internal difference, Belgium is a place of porous identity in which people, language and cultures overlap and intermingle. Porousness on the one hand, but also resistance: Charles de Coster situated Belgium neatly between two forces, playing both ends against the middle, when he described Flemish culture as 'l'antique élément germanique, digue puissante contre l'envahissement des tendances françaises'.[4] The discourse of cultural resistance to France is revealing here too: De Coster is the creator (at any rate, the modern reinventor) of Ulenspiegel, the mischief-making, unfixable trickster hero, the mercurial and roguish, genre- and border-transgressing individual in a uniform world of order and rationality. For these reasons, critics such as Patrick Laude and Marc Quaghebeur have seen Ulenspiegel as the emblematic figure of Belgian literature, a figure of betweenness, dodging categories, languages and cultures.[5] This bulwark

against Frenchness might also be seen as a kind of link between the two 'opposing' cultures — Belgium may be both a buffer and a bridge, and certainly in Symbolist discourse it serves as both. In conflict perhaps, the French and the Flemish sides, the Latin and the Germanic, are also mutually-stabilising tensions. They hold each other in place, with Belgian culture mediating and moving between them. Already in Romantic writers such as Gautier, Nerval and Hugo, Belgium is a Germanic, but not *German*, place. For the French Symbolists a generation later, the literary creation of a mystical, quasi-medieval and inscrutably inward Belgium has a similar function, an image focused more obviously on Flanders than on Wallonia. No French poets idealised Charleroi or Liège — cities which provided industrial workers for walk-on parts in Zola novels but no evocative figures for Symbolist poems. As location, the French-speaking south of Belgium is more suited to the Naturalist imagination, the Flemish-speaking north — with its convenient myths of nordicity — with the Symbolist. Even Namur, home to Rops, is passed over by a literary imagination hungry for Flemish *décor*.

It is ironic to note in this respect that those writers with the least success in France, and the least posthumous consideration even in Belgium, were the likes of Iwan Gilkin, Max Waller and Albert Giraud, poets who argued against the idea of *wallon* and *flamand* as viable literary or artistic sensibilities. It is precisely these poets, allied to *La Jeune Belgique*, who argued for the dissolution of national specificity in literature, with Giraud announcing that 'l'esprit flamand et l'esprit wallon [...] sont de petites verrues locales qu'il faut extirper au plus tôt'.[6] That word *locales* is crucial here. No French Symbolist poet would have sought inspiration from the local, but in Belgium however, words such as *localité, région, parois, terroir*, are not pejorative but positive and identity-defining. In many ways, French Symbolism is refinedly metropolitan, Belgian is proudly regional — something we will see reproduced in Surrealism some decades later. Moreover, French Symbolism does not object to the regionalism of Belgian literature — it encourages and responds sympathetically to it. Those Belgians the French are least interested in are the ones who want to be least specifically 'Belgian'. Connected with this is the fact that French Symbolism abolishes place while Belgian Symbolism restores it, suitably transfigured, estranged and re-imagined. 'Heureux les écrivains qui ont une province dans le cœur', wrote Rodenbach in *L'Elite* — an ironic statement given that he himself kept his province in his heart in the sense of not actually living there.[7] The Belgians, we could say, instil at the heart of French Symbolism a topography of otherness and alterity, while at the same time insisting on the concrete connections between place and people. The Belgium invented by the French — with a great deal of help from the Belgians themselves — is mysterious, not to say mystical, and even the Flemish mystics are revisited and re-used by the Symbolists. Its people are inward, intuitive, reflective; ancient in traditions and timeless in their customs. Belgium is also, in terms of its urban locations, imagined by the French as unchanged from the medieval and renaissance periods — in direct contrast to the constantly-changing urban realities of, say, Paris. Indeed Bruges ('la-Morte') may be read as a Symbolist anti-Paris, or even — in a world obsessed by doubles — the static double of vibrant, fast-moving French metropolis (the novel after all appeared in instalments in *Le Figaro*). Reading

the Symbolist versions of Belgium (Mallarmé's 'Remémoration d'amis Belges', Rodenbach's 'Agonies de Villes', or the innumerable 'ville morte' genre-poems of the period), one has trouble remembering that the country was in fact the second (after Britain) to undergo an industrial revolution.

Another distinctive aspect of Belgian Symbolism was its deeper and more overt engagement (relative to the French) with politics. Critics such as Jeannine Paque and Paul Aron have shown the extent to which Belgian writers were involved in the practical and often radical politics of their time. Paul Aron's definitive account of this question, *Les Ecrivains belges et le socialisme*, traces the particular forms political engagement took, and shows how, though French writers were 'political' in a broad sense and showed anarchist and socialist sympathies, these do not translate into the rarefied realm of literature, and often do not culminate in direct party membership and support. The Belgians for their part are more closely involved with the practical realm of politics.[8] It has been remarked in this context that Belgian Symbolists were readier to admit both the concrete world and social reality than their French counterparts, hence their tendency to incorporate regionalism, accents, or dialects into their work. There is also in Belgian writing a greater emphasis on the visual, based in the Flemish artistic tradition. For Verhaeren, the visual and plastic instincts of Flemish art were now finding expression in Belgium's francophone writing: 'La littérature belge est la résurrection de notre école plastique d'autrefois. Nous allons vers la France pour lui demander notre expression d'art, comme les peintres du XIIe siècle sont allés vers l'Italie'.[9] Verhaeren here is invoking a Germanic/Latinate symbiosis, not a conflict — the Franco-Flemish fusion of today's literature is an echo of the Italo-Flemish fusion of the seventeenth century. This hybrid art has a long and respectable pedigree, Verhaeren suggests: Belgian cultural doubleness is in fact continuity and not crisis.

In terms of literary schools, the antagonisms between Naturalism and Symbolism/ Decadence are not so pronounced in Belgium. Here too we may speak of a resolved duality, or a mutually-stabilising tension. One reason for this is the speed at which literary development took place in Belgium, and the way in which several decades of artistic change were compressed into a short and frenetically productive span of time. As Guy Michaud, Symbolism's most thorough historian, puts it:

> Brûlant les étapes, la littérature belge parcourut en moins de dix ans l'itinéraire entier du dix-neuvième siècle français: romantisme, pittoresque, réalisme, baudelairisme, verlainisme, toutes ces tendances se pressent, se bousculent, se confondent presque sans ordre.[10]

Michaud insists too much on the chaotic aspect of this development (and does not acknowledge the significant degrees of overlap between the different stages of the 'itinéraire'), but he is right to emphasise the rate of artistic change in Belgium. There were of course conflicts, such as those between *La Jeune Belgique*'s late-Parnassianism and the Symbolist tenor of *La Wallonie* (ironic, given *La Jeune Belgique*'s former radicalism and openness), but more typically there are many instances of crossover and comradeship between different temperaments and '-isms'. For Michel Otten, in his important essay 'L'Originalité du Symbolisme belge', this is one of Belgian's Symbolism's defining facets.[11] One signal example of this

is the 'Banquet Lemonnier', at which the arch-Symbolist (or, since it was 1883, probably 'décadent') Rodenbach presided. Rodenbach praised Lemonnier's status as 'Maréchal des lettres' and invoked a thread of martial imagery to describe Belgian writers' relations with their public and with the political and cultural conditions of their time. Such martial imagery ('troupes de conscrits', 'Veillée d'armes', etc) is always a staple of the literary avant-garde's self-envisioning. In this case the battle is not with other writers or even literary schools, but against a public and an establishment culture. Lemonnier was a novelist of a naturalist bent, writer of vigorous and realistic, though often poetic, prose — a Zola of the Belgian *terroir*, of the 'saveur flamande' (as he called it). Porous borders between literary schools may be a defining characteristic of the Belgians, though we need not push it too far: after all Mallarmé and Zola had cordial personal relations and admired each other's works — it is usually second- and third-order disciples who generate the literary skirmishes.

In a Symbolist movement already defined as hybrid in its *francophonie*, the Belgian case remains a special one. For obvious geographical, linguistic, cultural and political reasons, the Belgian contribution to Symbolism is unique, both because it brings new sensibilities to 'French' Symbolism and because, in a countervailing movement that is both its opposite and its continuation, it is a conduit through which French Symbolism brings something new to Belgian literary culture. French Symbolism helps Belgian Symbolism resolve its identity crisis, we could say, by helping it *assume* its identity crisis. It does so by enabling Belgian literature to define itself *through* and not *against* its hybrid nature and doubleness. As Verhaeren wrote, 'Tout chez nous est en contraste. Nous aimons les oppositions qui coexistent en nous.'[12] There cannot be many national literatures of this period seeking to define themselves through their very liminality, their very *either/or*-ness. On the contrary, most national literatures were being defined in terms of purity and essence. Many of the influential definitions of Belgian literature, however, such as those attempted by Camille Lemonnier and Edmond Picard, are dominated by images of duality, fusion, interpenetration.[13] The motifs of 'national' or 'racial' characteristics are still there of course (especially in Picard), but they are seen not as wholes but as halves, as opposites in need of fusion and not free-standing characteristics in themselves. This is of course equally artificial (and equally 'nationalistic'), but it is certainly distinctive. Picard's and Lemonnier's terms are telling too: their verbs stress mobility, change, category-subversion and genre-crossing, rather than solid, defined, bordered states. Belgian literature is aware of itself as a national literature made up of shifting regionalisms — *La Wallonie*, with its proudly *regionalist* title, ironically enough, helps make the international reputations of *Flemish* writers writing in French. Meanwhile 'le belge' as a language is a kind of double tongue, studded with mutual borrowings, Franco-Flemish neologisms, and mixes of high and low register. It is seen as free, vigorous, hardy and untamed (an analogy might be the fetishization of *argot* in France, which Marcel Schwob pointed out was as 'artificial' as the most recondite Symbolist language) and thus distinct from the rarefied language of 'French' Symbolism. All of this might be seen as a sort of antidote to Symbolism's quest for linguistic 'purity', and to a French language imagined in

A Rebours as 'faisandée'. There are frequent celebrations of the supposed 'freshness', 'artlessness' and 'ruggedness' of 'le belge' in the literary discourse of the time, often favourably compared with the supposed 'decadence', 'artifice' and 'exhaustion' of French. There even develops a species of counter-decadent discourse, in which 'le belge' is posited as a fresh and healthy alternative to the painted and sickly French language. Borrowing terms redolent of Baudelaire and Huysmans, but also of Zola and the Naturalists, Lemonnier writes:

> Contraste singulier avec l'arrogance de sa mère française! Sans détours, sans fard et sans roueries, bête comme une vierge des champs, combine sa rusticité, se fait mieux valoir par la comparaison des appas flétris de la vieille courtisane![14]

There are several discourses mingled here: that of make-up, drawing on ideas both of decadence and of falsehood; the startling mother/daughter image and the feminization of the language(s); the model of reverse degeneration, in which the new is healthier than the old; the images of innocence versus jadedness, virgin versus courtesan. Huysmans provides, in *A Rebours*, a linguistic model of 'Latin' degeneration; Lemonnier provides a counter-model of 'Latin' regeneration, that comes crossed with 'Germanic' vigour. No discourse on language in the late nineteenth-century is innocent of social, political or national implications, and the Belgian case in this respect is no different. What makes it distinct are the variations, inversions and reversals it creates within these set discourses. In that small paragraph of Lemonnier's are knotted some of the key notions of the period — degeneration, decadence, heredity — but given an unmistakably Belgian angle.

The problem with 'le belge', however, is that it remains largely an idea. Few of the canonical Belgian Symbolists — Maeterlinck, Rodenbach, Verhaeren — ever indulge in the hybrid language that is 'belge'. It remains a theoretical idiom, a linguistic correlative to a cultural and psychological hybridity, and not a serious practical resource. In this respect, Belgian Symbolists are selective about which rules to observe and which to break — the movement both undermines and asserts the unity of 'French' Symbolism. A critic looking for real neologisms, symbolo-macaronic and hybrid franco-fusions would do better to read Plowert's *Petit Glossaire des auteurs symbolistes et décadents*, where there are, incidentally, no Belgians represented.[15] Nonetheless, to Symbolism's constant discourse about verbal purity, Belgian literature adds a double: a (largely theoretical) counter-discourse of hybridity and even of deliberate impurity. Christian Berg sees in Rodenbach's novel a blurring of genres that is typical of the Belgian writer, testimony to 'des tentatives de toute une génération pour échapper aux clivages des différents genres qui se partageaient, à l'époque, le champ littéraire'.[16] In his excellent 'Lecture' in the Labor edition of *Bruges-la-Morte*, Berg reads the novel as what we might call a 'between-genre' masterpiece that 'tient le milieu entre le roman psychologique, la nouvelle fantastique et le poème en prose'.[17]

To the constant debates about 'genre', Belgian literature adds genre-transgressing works such as the novel-cum-prose-poem *Bruges-la-Morte*, in which the characters themselves seem drawn from a psychological drama but trapped inside the claustral stanzas of a poem. The novel's obsession with reflections might itself stand as a sort of narrative equivalent of rhyme in Symbolist poetry — reflections and rhymes are,

after all, visual and auditory 'doubles'. The whole of *Bruges-la-Morte* is a tessellation of doublings and pairings, reflections and inversions. The only element of the story that is unpaired is Viane himself, and when Rodenbach has him muse on his widowhood, it is to stress his 'impair' status: 'Veuf! Etre veuf! [...] Mot irrémédiable et bref, sans écho. Mot impair et qui désigne bien l'être dépareillé'. That word 'impair' reverberates in French prososdy too: the imparisyllabic line of the master of regretful decadence, Paul Verlaine, who in 'Art poétique', celebrates the beauty of the uneven, the odd and the asymmetrical: 'De la musique avant toute chose, / Et pour cela préfère l'Impair...'. That is Hugues Viane: a lost syllable in a world of rhyming, scanning pairs, a stray syllable in the prison of rhyme.

For many Belgian writers, Mallarmé's famous dictum about the 'double état de la parole' is not simply an abstract or theoretical notion, and it does not just apply to poetry. It touches on issues of community and *appartenance*, on psychological as well as cultural factors which will have been part of the lived experience not just of the literary class but of the ordinary Belgian. Valère Gille states the situation very simply: 'Ce qui a donné naissance à la croyance en l'âme belge, c'est, à mon avis, la littérature spéciale des écrivains de race flamande écrivant en français',[18] and the ambiguity in this statement is generally passed over in the rush to interpret it as a statement of faith in Belgian literature. But that word *croyance* seems to suggest that 'l'âme belge' may be a figment of the collective imagination, a cultural superstition perhaps, or something that exists only in the refined, distilled, sublimate of culture that is literature. Gille's statement is all too often read as an assertion of Belgianness; it may in fact be a questioning of it. A poet such as Elskamp, who disbelieves in 'le belge', nonetheless sees his own way of writing as marked by its Belgianness — but for him the Belgian duality is a kind of double void. In response to unfavourable reviews in France of *Salutations*, he wrote:

> Il faut croire que j'écris trop au Nord pour là-bas [...] je regrette amèrement de ne pas savoir le flamand; c'était la langue qu'il m'aurait fallu, puisque le 'belge' n'existe pas.[19]

This is an interesting statement: it implies a rejection of 'le belge' as an artificial medium (a mere 'croyance'), and lays claim to Flemish as the lost 'original' language, the 'ur-' language of a sensibility forced to express itself in French. More than any of the other Belgian Symbolists, Elskamp makes expressive use of Franco-Flemish fusions and neologisms in his poetry, and it is therefore ironic that he should so emphatically deny 'le belge' as a medium. Elskamp was attacked at home too, by Albert Giraud in *La Jeune Belgique*, for his 'pratique d'une langue adoptive',[20] that is to say, by that strand of Belgian literature most closely associated with 'l'art pour l'art' and most hostile to the 'verrues locales' of Belgium's two cultures. Yet Giraud is right, though not for the right reasons — Elskamp seems haunted by loss, triply exiled: from French, from Flemish, and even from the 'in-between' idiom of 'le belge'. His is not the 'both... and...' school of thought (Belgian literature is *both* French *and* Flemish) but what we could call the 'neither... nor...' school. This is not to say that Belgian writing is defined only by what it is not, but simply that negative definitions, involving cultural and linguistic loss or repression, play their part too. Often in Belgian francophone writing that 'lost' Flemish haunts the French, and

though many poets lay claim to this linguistic inner exile, many of them do so as a pose — crisis is always more interesting than comfort, duality more productive than unity. None of the Belgian Symbolists ever jeopardize their mastery of the French language, though all are willing to explore, in their own works, the implications of a certain (limited) degree of estrangement within French. Elskamp however seems sincere: French is 'foreign', 'le belge' is an invention, and Flemish is out of reach. He is, in this respect, multiply bereft, and cannot even take comfort from the paradoxical or dual nature of his own culture.

If Belgian French is haunted by the Flemish that lies behind or beneath it, it is also haunted by the incompatibility of the two languages. In a sense, Maeterlinck's attitude to language in theatre, his theories of 'dialogue du second degré', his use of silence and inarticulacy in drama, may be seen as a way of registering, at an aesthetic level, the cultural and psychological paradox of Belgian duality. In a revealing extract from his preface to his translation of Ruysbroeck, he writes:

> Cette traduction de Surius, d'une latinité belle et subtile, révèle scrupuleusement le sens de l'original; mais inquiète, allongée et affaiblie, elle est semblable à quelque image lointaine à travers des vitres impures lorsque l'on envisage les bizarres couleurs du primitif flamand.[21]

Here Maeterlinck is talking about the tension between the Latin translation and Flemish original, using his familiar metaphors of glass, of language as the revealer of forms but also the barrier to feeling and sensation. These are Maeterlinck's characteristic theatrical as well as poetic metaphors, from plays such as *Les Sept Princesses* to the poems of *Serres chaudes*. They define the dominant gesture of his work across genres, but it is their dramatic application that creates the radical novelty of his theatre. We might also consider in this context his extraordinary early notebook, *Le Cahier bleu*, in which 'latinity' is conveyed through negative images of glass and transparency — the 'génie français' is viewed as a false clarity alongside the inwardness and intuitiveness of its more 'opaque' opposite, *Germanité*. In a striking passage from the notebook, Maeterlinck writes:

> Chez les peuples de race latines, les mots débris de langues mortes et sans expressions directe, sont comme une ombre froide et éternelle entre les choses et l'âme [...] et même ceux qui ont tourné les mots, et ont vu leur signification de l'autre côté de la langue, ne peuvent cependant pas laver l'odeur de cadavre.[22]

The object of Maeterlinck's poetic and theatrical quest may be defined in that short phrase 'l'autre côté de la langue'. French, or the 'esprit latin', is the hothouse that confines expression and yet, in a series of images that owe a great deal to contemporary decadent imagery, they give expression to a strange and unhealthy surface glitter. For the Belgian Symbolists, as distinct from their French counterparts, there is no such thing as transparency because language itself — or rather, French — is the distorting glass. Mallarmé's or Régnier's glass and mirrors reflect; in Maeterlinck or Rodenbach they blur over, distort, entrap. An example of this is in *Serres chaudes*, where the poems are obsessed with glass and reflections, and with a kind of metapoetic self-reflexiveness. The poems of *Serres chaudes* represent a moment when Symbolism's theoretical metalanguage colonises the poem, creating a critical fusion between poetry and theory. In lines such as 'Et sous mon âme en

vos *analogies!*' and 'Végétations de *symboles*' (my italics),[23] the border between poetry and critical terminology is breached. The poem becomes a self-referential hall of mirrors in which the poetry and poetic theory become reflections of each other.

The second half of the nineteenth century is the epoch of the double, the dual self, and it is perhaps fitting that Belgian literary identity should embody one of the late nineteenth century's defining obsessions. From Stevenson's famous *Dr Jekyll and Mr Hyde* to the Hungarian Symbolist Endre Ady's powerful story, *Neighbours of the Night*,[24] a great deal of the literature, thought and art of the period dwells on the idea of the double self. More generally, however, Belgian Symbolism is able to present itself uniquely as doubleness *nationalised*, doubleness rendered culturally palpable. Within this national doubleness, its writers themselves become purveyors of a literature obsessed with doubleness and duality. Belgian Symbolism is a literature of reflections, reflecting the Germanic and the Latin, the Flemish and the French, the north and the south, to each other. The writers too become obsessed with reflections, doubles, tensed polarities and inversions. Maeterlinck's language/silence polarities in theatre, or his inner/outer tensions in *Serres chaudes* are examples; as are Rodenbach's poetic preoccupations with interiority and exteriority, with the dead woman and her double in *Bruges-la-Morte*, and the more overtly political and cultural tensions explored in *Le Carillonneur*. This novel shows the counter-world of symbolist/decadent interiority and nostalgia under persistent threat from the real, not just the abstract real but from economic reality, as Bruges becomes an ancient city facing modern choices — about commerce, culture and trade. The critical attention paid to *Bruges-la-Morte* tends to obscure the extent to which, in his other novels and short stories, Rodenbach engaged with a variety of issues, from economic and national questions to topical 'psychological' questions such as hypnotism and suggestion, mental illness and alienation. In his short story 'L'Ami des miroirs' in *Le Rouet des Brumes*, Rodenbach's poetic obsession with mirrors is used in an exploration of psychological breakdown. The story tells of a man whose fascination with mirrors begins innocently enough as a kind of manageable narcissism. The narrator begins the story with a statement about the connection between the poetic world, the world of images and metaphors, and the world of clinical madness. In doing so, he passes from one discourse to another:

> La folie, parfois, n'est que le paroxysme d'une sensation qui, d'abord, avait
> une apparence purement artistique et subtile.[26]

Rodenbach's prose and poetry evoke the still, reflective canals of the Flanders towns, river-cities face-to-face with themselves, just as Maeterlinck's poems contemplate their own metaphorical structures, and his early plays (*Intérieur*, *Les Sept Princesses*, etc) dwell on metatheatrical motifs. In Verhaeren such images can also be found, but cast in a sort of Symbolist-Baudelairean-gothic mode. In his great poem 'Les Usines', we find a tormented, hallucinatory vision that bears both contrast and comparison with that of Rodenbach:

> Se regardant avec leurs yeux cases de leurs fenêtres
> Et se mirant dans l'eau de poix et de salpêtre
> D'un canal droit marquant sa barre à l'infini,
> Face à face, le long des quais d'ombre et de nuit,

> Par à travers les faubourgs lourds
> Et la misère en pleurs de ces faubourgs,
> Ronflent terriblement usines et fabriques.[26]

Verhaeren's are polluted industrial waterways and not the pure mirror-like canals of Rodenbach's Bruges; they tell of — or 'reflect' — collective economic realities and not an individual's ivory-towered introspections. Yet the familiar tropes of mirroring and doubleness are used to equally powerful effect.

We may also see the specificity of Belgian Symbolism in its attitude to place, but place reimagined as a sort of evanescent duality. That experiment in finisecular psychogeography that is *Bruges-la-Morte* — fantasised but topologically exact, imagined but real — is produced by Rodenbach in Paris, from the imaginative distance of the French metropolis. It may be that Rodenbach's Bruges is an *other* to the bustling Paris, city of heraclitean flow, the inverted double of the Baudelairean city of dynamic movement. Bruges is a stagnant pool, its water stilled; a city that hesitates on the cusp of the 20th century — the *fin de siècle* cult of Bruges comes from an obsession with stilling Time in a period of speed and frenetic change. The novel's extraordinary popularity in Paris on its publication is surely due in part to this. To the prose of Rodenbach, we may add the extraordinary cityscapes of Fernand Khnopff, visual palindromes in which the dead cities of Flanders contemplate their own reflections in the water — doubleness closing over into a kind of epitaphic narcissism. *Le Carillonneur*, a less unified but more substantial novel than *Bruges-la-Morte*, has its own exploration of doubleness, dramatising tensions between the languages and cultures of Belgium, between past and future (as symbolised by the new, or rather 'restored', link to the sea), and explicitly touches on questions of nationalism and politics. In the concrete reality of the new 'Zeebrugge' we find also a crucial symbolism: the new port stands for openness and commerce, Bruges opening outwards once again; or it stands for the denaturing of place, the prostitution of identity and the drowning of a culture. Rarely have the literal and symbolic implications of ports, dichotomous and liminal spaces *par excellence*, been so seamlessly interwoven. Here again Rodenbach blurs the borders, as he had done in *Bruges-la-Morte*, where the perpetual question is raised of whether the book is 'about' Bruges or 'about' Hugues Viane: in *Le Carillonneur*, is the port a symbol made concrete or a concrete thing made symbolic?

In Rodenbach's prose, we could say that Belgium is made for export, like those luxury products one never sees in their country of origin. But it corresponds to the real place, is accurately described and contains, beneath the poetic veil, accurate assessments of the social, urbanistic and economic realities of the city. Rodenbach is well known for his theory that Belgium becomes more itself the further one gets from it:

> Paris donne du recul, crée la nostalgie [...] Or on peut dire de tout art qu'il provient d'une nostalgie, du désir de vaincre l'absence, de faire se survivre et se conserver pour soi, ce qui bientôt sera loin ou ne sera plus.[27]

The argument, in biographical terms, may be self-serving. In literary terms it is more interesting: Rodenbach's Belgian cities have the logic of death. Death is their reason for (poetically-speaking) existing. Exile from Belgium is the best position

from which to write about it — a culmination of the Belgian's internal exile is found in his literal exile. There is also a paradoxical relation with Lemonnier's belief that Belgian literature should be informed by the local: there is no more 'local' novel than *Bruges-la-Morte*, and yet Rodenbach's creation is less a concrete city than a sort of Symbolist sublimate of place. Belgium is most itself when one — or it — is not there. Mallarmé's poem 'Remémoration d'amis belges', for instance, imagines Flanders as an ideal Symbolist *polis*: situated on the border between presence and absence, reality and imagination, concreteness and immateriality. Rodenbach's Belgium needs to die as a place to be reborn as literature, or, to take it further: it needs to die as a Belgian location to be reborn as a French idea. The 'dentelle' is a key image in Rodenbach, as it is in critical responses to Rodenbach: the evanescent lace, half substance, half gap, is the perfect symbol of a place half-absent, half-present. With a poet like Mallarmé the 'dentelle' is connected to the 'écume', another semi-state in which the void and the solid come together to create a substance neither air nor water: emptiness coalescing for a moment into form, form composing itself around emptiness.

Where there is duality, there is also betweenness: if late nineteenth-century literature is obsessed by the double, it is also obsessed by the in-between. Belgium answers to the need for a double, but also to the need for the in-between, the liminal, the borderline. There are Van Lerberghe's 'entrevisions' and 'entredictions', Maeterlinck's 'dialogue du second degré' and its equivalent in a 'théâtre d'attente', in which waiting becomes theatre's 'in-between' time, and the underside of language, the half-formulated and semi-spoken becomes the focus of attention. There are borderline psychological states too, and the Belgians find themselves more drawn than their French contemporaries to the question of the 'inconscient' or the 'subconscient' (this is a pre-Freudian use of the terms, in which they are used interchangeably). Such areas of 'betweennness' may be found in Maeterlinck's prose work such as 'Confession d'artiste' and his early short stories,[28] or Rodenbach's short stories such as 'Suggestion' in *Le Rouet des Brumes*, in which the Symbolist keyword of 'suggestion' is shared with such 'occult' connotations as hypnotism and automatism. Then there are the liminal figures of Belgian Symbolism such as Verhaeren's 'fou', at once inside and outside the poem's drama, or Maeterlinck's blind characters in *Les Aveugles*. Perhaps these figures in Belgian Symbolism are the tragic descendants of the mischief-making outsider Ulenspiegel, so robustly imagined by Charles De Coster. For Patrick Laude, Ulenspiegel is the emblematic figure of Belgian literature: 'striv[ing] to situate itself within the unstable space of marginal creativity which is constantly skirting both subversion and integration'.[29] In Laude's nice phrase, Belgium itself is 'a permanent and ambiguous nexus of communication'.[30]

Related to this question of 'betweennness' is another consideration: the extent to which Belgians work in — and between — genres which the French leave free. French Symbolism makes unsatisfactory inroads into non-poetic domains: it wants theatre but cannot bring itself to theatre's level — perhaps a movement that does not believe in place finds it hard to work with the concrete requirement of theatrical space? It wants a prose, but is suspicious of narrative. It is as if French Symbolism had

genre-vacancies which needed filling, genres which might be deemed ancillary to Symbolism's essentially poetic tenor. The Belgians extend the Symbolist movement, conquering the other genres on its behalf, and often occupying them exclusively: Maeterlinck and (to a lesser extent) Rodenbach have few competitors in theatre and narrative prose. As Paul Aron puts it:

> Au lieu de concurrencer le symbolisme parisien sur son terrain, le mouvement belge va trouver un mode d'expression spécifique, qui lui permet de participer à l'école nouvelle tout en évitant de menacer les situations acquises. Il apparaît ainsi comme doublement novateur: par sa participation au symbolisme, et par son originalité au sein de ce courant. Cet aspect, rarement évoqué, de la stratégie d'émergence du symbolisme belge peut être défini comme un *dysfonctionnement générique*'. (my italics)[31]

Belgian literature's effect, if not its delegated mission, was to take Symbolism beyond the specialist area of poetry and into the genres which French Symbolism had coveted but never annexed. It stakes its claim to the marginal terrain, but in turn that marginal terrain, a reflection of Belgian culture's own porousness and liminality, stakes its claim on Belgian literature.

Belgian literature may be defined in terms of a search — what makes it clearly Belgian is perhaps its constant questioning about what makes it clearly Belgian. As Marc Quaghebeur wrote: 'la question majeure qui agita nos lettres depuis leur origines est celle de leur existence, de leur spécificité et de leur appellation'.[32] This is well put, and the three terms Quaghebeur lays out are crucial: existence (is there such a thing as Belgian literature?); specificity (if so, then on what grounds, and in what terms?); and 'appellation' (what to call it?). Here too we could invoke the image of the 'dentelle': presence and absence, form and void, substance and immateriality.

Belgian literature is defined, we could say following Quaghebeur, by the urgency of its quest for self-definition at a theoretical level, though there is no evidence that the authors themselves had any real agonies about how to write, what to write about, or what language to write in (Elskamp excepted perhaps). This may seem strange indeed — none of the major Belgian Symbolist writers register any sort of personal difficulty with their nationality. They do not suffer from it in the way, for example, Québecois writers have done. The vexed question of a national literature and the personal production of literature do not, it appears, impinge upon each other. On the contrary, it can be argued that definitional uncertainty at a national and cultural level provides rich material at the level of the individual writer and that the Belgian Symbolists were adept at exploring the permissions this uncertainty allowed them. The fact that the Belgian search for self-definition occurs predominantly on a theoretical plane perhaps also explains why Mockel, Verhaeren and Rodenbach are such fine and discriminating critics of literature, art and culture in their own right. Even Maeterlinck, whose *Cahier Bleu* is a coming to terms with a dual heritage, produces some startling insights into the hybrid *imaginaire* of the late 19th century Belgian writer. None of these writers can be charged with adapting their writing to a theoretical sense of what Belgian literature should be, much less to a national or national*ist* definition of 'Belgian' styles or subjects. The Belgians are able to engage in a national project without its affecting their own individual works.

The relationship between Belgian and French Symbolism cuts both ways: French Symbolism helps create Belgian literature, while the arrival of Belgian Symbolism helps to create a French Symbolist movement, to consolidate its gains across genres, and make it more internationally-known. It also gives French Symbolism depth, helps to make it less of a specialised attitude to poetry and more of an approach to language and imagination as a whole. This is in part because the Belgians experience as cultural and psychological conditions, and with a degree of literality and immediacy, many of the paradoxes about language and expression that the French understand only as theory. On the French stage moreover, Belgian culture is markedly itself. It does not need to go through the relentless soul-searching and self-defining that it goes through at home. It is solidly itself in direct proportion to its hybridity; that is to say, the things that, at home, make it unsure about what it is, outside its own frontiers make it unmistakeably and confidently unique. When the debate about one's painful doubleness is taken outside one's own realm and transferred to another cultural location, it becomes the central pillar in one's self-definition. Quaghebeur's three questions, when asked in Belgium, are part of a complex and assertive self-scrutiny. When asked in France, with a French audience as their super-addressee, they become key elements in an unmistakable literary identity.

In the end, Symbolism without a theatre or without a novel would still have been Symbolism, and so we can maintain that the movement would have existed whether or not the Belgians had lent themselves to it. In another respect, however, the contrary might also be true: Symbolism which remains *only* poetic cannot claim to be a literary movement in the broadest sense. At the risk of overstating the case, the Belgians turn 'French' Symbolism into an international movement, just as French Symbolism offers Belgian literature an international stage on which to express its *national* specificities, while eluding any of the constricting elements of a national literary project. It is a unique relationship. As well as being the *double* of French Symbolism — through the Latin/Germanic, French/Flemish, Paris/Bruges oppositions, to name just a few of the mesh of interconnecting dualities that link the two movements — Belgian Symbolism may also be defined as the Symbolism of the double: a double movement whose writers explore doubleness in subject, genre and language.

Notes to Chapter 1

1. Ezra Pound, *Instigations* (New York: Boni and Liveright, 1920), p. 89.
2. Ezra Pound, *The Cantos* (New York: New Directions, 1972), p. 512.
3. See 'From Mallarmé to Pound: the "Franco-Anglo-American Axis"', in Patrick McGuinness, ed. *Symbolism, Decadence and the fin-de-siècle: French and European Perspectives* (Exeter: University of Exeter Press, 2000).
4. Charles De Coster, quoted in Patrick Laude, 'Belgian Symbolism and Belgian Literary Identity', in McGuinness, ed. *Symbolism, Decadence and the fin-de-siècle*, p. 200.
5. See Laude op. cit. and Marc Quaghebeur, 'Balises pour l'histoire de nos lettres', in *Alphabet des lettres belges de langue françaises* (Brussels: Labor, 1982).
6. Albert Giraud, 'Le Mouvement Littéraire en Belgique', quoted in *Les Concepts nationaux de la littérature* II (Aachen: Alano Verlag, 1989), p. 14.

7. Georges Rodenbach, *L'Elite* (Paris: Fasquelle, 1899), p. 8.

8. See Paul Aron, *Les Ecrivains belges et le socialisme* (Brussels: Labor, 1985) and Jeannine Paque, *Le Symbolisme belge* (Brussels: Labor, 1989).

9. EmileVerhaeren, quoted in *Les Concepts nationaux de la littérature*, II, p. 79.

10. Guy Michaud, *Message poétique du Symbolisme* (Paris: Nizet, 1947), p. 238.

11. Michel Otten, 'Originalité du Symbolisme belge' in *Les Mouvements symbolistes en Belgique*, ed. by Anna Soncini Fratta (Bologna: CLUEB, 1990).

12. Verhaeren, quoted in *Les Concepts nationaux*, II, p. 79.

13. See especially Paul Aron's invaluable anthology of writings on Belgian culture, *La Belgique artistique et littéraire: Une anthologie de langue française 1848–1914* (Brussels: Editions Complexe, 1997).

14. Camille Lemonnier, *Nos Flamands* (Brussels: De Somer, 1869), p. 166.

15. 'Jacques Plowert', in *Petit Glossaire des auteurs décadents et symbolistes* (Paris: Vanier, 1888), new edn. (Exeter:University of Exeter Press, 1998).

16. Christian Berg, 'Lecture', in *Bruges-la-Morte* (Brussels: Labor, 1986), pp. 131–32.

17. Ibid., p. 112.

18. Valère Gille, 'Enquête sur la littérature nationale', *La Belgique artistique et littéraire*, 18, (1910), (p. 186).

19. Max Elskanp, letter to H Van de Velde, quoted in Jeannine Paque, *Le Symbolisme belge*, pp. 116–17.

20. Quoted in Jeannine Paque, p. 116.

21. Maeterlinck, *L'Ornement des noces spirituelles de Ruysbroeck* (Brussels: Lacomblez, 1891), p. xcviv.

22. Maeterlinck, *Le Cahier Bleu, Annales de la Fondation Maurice Maeterlinck*, 22 (1976), p. 139.

23. These lines are from the poems 'Serre chaude' and 'Feuillage du coeur', in *Serres chaudes*, first published in 1889.

24. Endre Ady, *Neighbours of the Night*, trans. by Judith Sollosy (Budapest: Corvina, 1994).

25. Rodenbach, *Le Rouet des Brumes* (Paris: Flammarion, 1929), p. 29.

26. Verhaeren, 'Les Usines', in *Les Villes tentaculaires*.

27. 'Paris et les petites patries', in Aron, ed. *La Belgique artistique et littéraire*, p. 86.

28. See the first chapter of Patrick McGuinness, *Maurice Maeterlinck and the Making of Modern Theatre* (Oxford: Oxford University Press, 2000).

29. Laude in McGuinness (ed.), *Symbolism, Decadence and the fin-de-siècle*, p. 199.

30. Ibid, p. 200

31. Paul Aron, 'Pour une description sociologique du symbolisme belge', in *Le Mouvement symboliste en Belgique*, p. 62.

32. Marc Quaghebeur, 'Balises pour l'histoire de nos lettres', in *Alphabet des lettres belges*, p. 16.

Maeterlinck and the Search for Music[1]

Arnaud Rykner

God I wish I had music but all I have is words.
SARAH KANE, *Crave*

La musique, ce serait ce pui lutte avec l'écriture.
ROLAND BARTHES, 'Rasch'

Whatever we do, whatever we read, whichever renowned musicologist writes a well-informed article, the musical fate of Maeterlinck's works remains largely incomprehensible, especially if we pay attention to their supposed 'musicality' (a hollow and one-size-fits-all concept if ever there was one).

Without disregarding the actual declarations of the poet and brazenly ignoring certain well-known biographical events, it is difficult to see where this musicality fits in. The dichotomy between the considerable number of musical adaptations Maeterlinck's works have undergone[2] and his own confessed, even treasured, deafness to any form of musical expression is confusing: 'Je n'entende rien, mais absolument rien à la musique'[3] is a recurrent credo of the writer which would almost justify, far beyond any other considerations, the clash with Debussy occasioned by the latter's *Pelléas*.

It is impossible, however, to not delve deeper into such a contradiction, whose very force speaks of its probable fecundity. Because Maeterlinck's work has nothing particularly 'musical'[4] about it, to adopt a common cliché which some apply to Baudelaire, some to Verlaine — who did encourage this... — some to Apollinaire or Eluard (and generally to any writer whose work can be reduced to a succession of phonemes and surface rhythms by an abdicated criticism), we must look elsewhere to see what links it to music. Stylistic or rhetorical procedures, more or less regular returns of sounds or pauses, echoes, redundancies, assonances have never on their own composed a score[5] — no more than an ekphrasis, even if successful, tells us anything about painting (an *ut musica poesis* not being much more useful than the classic and ambiguous *ut pictura poesis*). If Maeterlinck researched the domain of modern music, or perhaps of music pure and simple (what Mallarmé enigmatically names 'la musique dans le sens propre'[6]), it is because something was happening on the reverse side of his work, in the shadow of language, around the very foundations of the representation that the work sets up, a something that shares with music a similar approach to the Real. Without pretending to radically alter the research on the question, nor the aesthetic references which have already brought light onto it,

all we can do is to patiently try to reach that improbable place which is the origin if not of Maeterlinckian music, then at least of the musical space which his works do indeed explore.

It seems best to begin with the fundamental 'inexpressivity' of his work, in order to understand in what way it is linked with the living sources of an art whose character at once *insensate* and *sensitive* it shares.

On Symbolism as Inexpression

Doubtless all there is to be said about the symbol giving its name to symbolism has been said already. However, if we dare to come back to it once more, it is first of all in order to recall that this symbol is based not on a process of codification but rather on a fundamental blockage of interpretative mechanisms. What makes a symbol a symbol with Maeterlinck is what is withdrawn from comprehension and communication, an ungraspable reality that returns in language to stop the logical if not rational expansion of this language. What makes a symbol is whatever initially means *literally* nothing at all and by this is free from expression, based then not in a 'deliberate statement' but in an unconscious process which takes place 'without the poet's knowledge', if we are to use Maeterlinck's words, themselves taken from Jules Huret.[7] Symbolism, when conceived of in this way, is the art of happy and random meetings which short-circuit the normal chain of significations to create *another reality*, until that point a prisoner of ordered discourse (it can be seen how symbolism is the father of surrealism). In other words, the mutterings of Maleine or of Mélisande, far from tending to *express* the inexpressible, *brutally* throw it at the audience's feet; far from organising it by bending it to the laws of language, they become the *brute*, inexpressive trace of the inexpressible, since they are stripped of any unifying principle.[8] For him, and as far as theatre is concerned, dialogue is never able to modulate emotion by phrasing it correctly — or putting it into sentences. It always tends, on the contrary, to undo the mediations that one might think are consubstantial with language; it rips apart the tissue of the text and unveils what the text more usually conceals. In this way love is not declared, never expressed, or is so only at the last moment and almost in a hurry, otherwise running the risk of becoming fixed in an immobile, tomb-like position (as Sarraute was to say later in her own way[9]); it is literally poured out with Mélisande's hair, who herself is not, primarily, a metaphor, nor a simple metonymy of the gift of the self, but rather a concrete inscription of a body crossing the space of representation, even the space of words. Language's retreat, and its restraints which lead Maeterlinckian characters to speak sparingly and quietly, are countered by the expansion of what is based less on a given intelligible order than on the undecipherable enigma[10] of a presence:

> Je ne comprends pas non plus tout ce que je dis, voyez-vous... Je ne sais pas ce que je dis... Je ne sais pas ce que je sais... Je ne dis plus ce que je veux...[11]

This is why the Maeterlickian symbol is also the opposite of a transitive sign, not choosing a sense to deliver (and neither therefore an intelligent meaning) — which raises the danger of a study which could assign a particular sense to the numerous objects referenced by the representation. This symbol holds together the

multiplicity of the signifieds in simultaneity, signifieds which for this reason end up cancelling each other out with their way of setting out a unique form of the Real. The classical principle of non-contradiction is replaced by an art of non-resolution and of pressing opposite poles together, thus doing away with the pseudo-natural expressivity that we give to language. This is the first way in which the symbol arrives at this place of music which we mentioned as a beginning.

An Ineffable Word

It will therefore come as little surprise that Jankélévitch bases what seems to him a possible definition of music on Debussy, the Debussy of *Pelléas* of course (as Debussy himself took the principles of the work from Maeterlinck):

> Entre les sentiments contradictoires la musique n'est plus tenue d'opter, et elle compose avec eux, au mépris de l'alternative, un état d'âme unique, un état d'âme ambivalent et toujours indéfinissable. La musique est donc inexpressive non pas parce qu'elle n'exprime rien, mais parce qu'elle n'exprime pas tel ou tel paysage privilégié, tel ou tel décor à l'exclusion de tous les autres; la musique est inexpressive en ceci qu'elle implique d'innombrables possibilités d'interprétation, entre lesquelles elle nous laisse choisir. Ces possibles se compénètrent au lieu de s'entre empêcher comme s'entre empêchent, dans l'espace, les corps impénétrables localisés chacun en son lieu propre. Langage ineffablement général (si tant est que ce soit un 'langage'), la musique se prête docilement à d'innombrables associations.[12]

By indefinitely enlarging the space of language in the same way, by making fixed associations unstable via a vectorised use of words, Maeterlinck manages to reach this 'ineffably general language' that will be found in Proust in the form of the 'ineffable word', both contradictory and unthinkable, that is the 'petite phrase' of Vinteuil.[13] The music that is heard beneath the text of the characters is not made up of notes inscribed in the succession of phonemes, nor of the rhythms produced by their more or less regular return, but is rather language's very movement to rid itself of its structuring character, of its expressivity as of its discursivity. What is important, is to find once again in the word a state from before the word, without which it is not possible to understand modern literature and music's joint effort to abolish any mediation between the world and us (or at the very least to temper its parasitic effects). In a way, we could argue that Maeterlinck's theatre achieved a revolution that Schopenhauer had begun in the conception of art itself, and also particularly of music, a conception which Nietzsche picked up and developed. Jankélévitch's commentary on the analyses of the latter is most significant when seen in this way:

> Nietszche veut sans doute dire ceci: la musique est impropre au dialogue, lequel repose sur l'échange, l'analyse des idées, la collaboration amicale dans la mutualité et dans l'égalité; la musique admet non pas la communication discursive et réciproque du sens, mais la communion immédiate et ineffable.[14]

We can now see why, without being *a priori* musical in the sense traditionally given to the word, Maeterlinck's strategy meets that of music — and notably vocal music — on a profound level. 'Words in music are nothing more than a strange addition

of secondary value',[15] in the same way, the words uttered by characters seem secondary, characters, that is, who only signify, and only really speak to us, via their silence and their 'interior dialogue' which speaks 'in the pauses' and 'in the music of plastic movements'[16] as Meyerhold put it.

In a way, Maeterlinck accomplishes the unthinkable *tour de force* of making music without music, or more precisely of transforming language into music to the point of making music itself seem 'useless', to re-read Mallarmé's lines on *Pelléas*, this time in full:

> Silencieusement presque et abstraitement au point que dans cet art, où tout devient musique dans le sens propre, la partie d'un instrument même pensif, violon, nuirait, par inutilité[17].

Stripping dialogue, and more generally language, of its main way of functioning, rubbing it, so to speak, to the point of trauma in order to thin it down, Maeterlinck tends towards removing language's totalitarian temptation; in doing this, he manages to re-knot the thread which links language to silence and silence to music in the epiphany of a *voice*,[18] similar to that which, in the Russian bass part and according to Roland Barthes, 'directly carries the symbolic, above the intelligible and the expressive'.[19] That Barthes in turn comes back to the Maeterlinck/Debussy *Pelléas* is no more of a coincidence than the fact that Jankélévitch referred almost exclusively to the same work. It is just as symptomatic that Barthes, like Jankélévitch, never makes an explicit distinction between where the text ends and when the score begins. In this 'sung death' of Mélisande, which brings back the idea of 'grain', the effect of the Maeterlinckian text (if the expression can indeed still be applied to what precisely evades the order of the text) is no different to that of Debussy's music (if we can indeed limit what we are talking about to a question of notes). For it is at the join between the two, in this space of circulation that the work puts in place, that what we are interested in takes place:

> Quelles qu'aient été les intentions de Moussorgski, la mort de Boris est *expressive* [...]: c'est le triomphe du phéno-texte, l'étouffement de la signifiance sous le signifié d'âme. Mélisande, au contraire, ne meurt que *prosodiquement* [...]. Mélisande meurt *sans bruit*; entendons cette expression au sens cybernétique: rien ne vient troubler le signifiant, et donc rien n'oblige à la redondance; il y a production d'une langue-musique dont la fonction est d'empêcher le chanteur d'être expressif. Comme pour la basse russe, le symbolique (la mort) est immédiatement jeté (sans médiation) devant nous (ceci pour prévenir l'idée reçue selon laquelle ce qui n'est pas expressif ne peut être que froid, intellectuel; la mort de Mélisande 'émeut'; cela veut dire qu'elle bouge quelque chose dans la chaîne du signifiant)[20].

We can now see how the continuum that Barthes sketches here relates to the very foundations of the paradoxical relation which links Maeterlinck to music. It is because, as with music, his writing manages to escape the trap of expressivity, by re-establishing an immediate contact with the Real. It manages to make a veritable interface out of the screen of words.

Beyond the Signified

Let us come back to Schopenhauer's famous pages (which the Belgians and French were discovering in the years when Maeterlinck was writing his first texts), where the philosopher carefully separates music from the other arts:

> La musique n'est pas, comme tous les autres arts, une manifestation des idées ou degrés d'objectivation du vouloir, mais l'expression directe de la volonté elle-même. De là provient l'action immédiate exercée par elle sur la volonté, c'est-à-dire sur les sentiments, les passions et les émotions de l'auditeur, qu'elle n'a pas de peine à exalter ou transformer.[21]

Because it is the least conceptual of the arts, music gives itself as a model of unmediatedness capable of working towards the abandonment of the screen of sense. This is how music invites us to see symbolism as more than a critic of the symbol, indeed, as a real questioning of hermeneutics themselves. Symbolism — and Maeterlinck's work, of course, first in line — works, like music, to disrupt any pure and simple deciphering of the world, which presupposes an anterior encryption (done by what divine hand?). Jankélévitch analyses the process, whose delegitimization is his and our shared goal:

> Déchiffrer dans le sensible je ne sais quel message cryptique, ausculter dans et derrière le cantique quelque chose d'autre, percevoir dans les chants une allusion à autre chose, interpréter la chose entendue comme l'allégorie d'un sens inouï et secret, — ce sont là les traits permanents de toute herméneutique, et ils s'appliquent d'abord à l'interprétation du langage. [...] Mais la musique? directement et en elle-même, la musique ne signifie rien, donc elle signifie tout. On peut faire dire aux notes ce qu'on veut, leur prêter n'importe quels pouvoirs anagogiques: elles ne protesteront pas! [...] En fait, le préjugé métaphysique repose sur l'idée que la musique est un langage, une sorte de langue chiffrée dont les notes de la gamme sont l'alphabet. La musique dit en hiéroglyphes sonores ce que le logos, occulte ou non, dit avec des mots; la musique dit en chantant ce que le verbe dit en disant. Or, c'est toute la conception occidentale du 'développement', de la fugue et de la forme-sonate qui est influencée par les schèmes de la rhétorique.[22]

The paradoxical thing is that the Maeterlinckian word is no more a language than music is, in the sense we generally give to the word language. For him, rhetoric is burst asunder by the pressure of forces that are beyond it and that it can no longer pretend to be in control of,[23] just like the hermeneutics which only register what goes on at the surface of the text and are just a distraction for the intelligence. And if music is perhaps the most appropriate system for understanding Maeterlinckian writing, it is because music, by complementing the natural effects of language, tunes us into what is outside sense and outside the musical text with the disappearance of the referent — a disappearance which is an intrinsic part of music. In other words, Maeterlinck's work is not musical, but it can be listened to as music, with an ear which targets what, being beyond and outside of words, causes a crisis for the entire process of signification. In doing so, Maeterlinck's work resolutely steps over the line that Barthes himself seemed to think of as uncrossable:

Dans le texte articulé il y a toujours l'écran du signifié. [...] Par rapport à l'écrivain, le musicien est toujours fou (et l'écrivain, lui, ne peut jamais l'être, car il est condamné au sens).[24]

This madness of the sense-less is the same madness of the 'symbol', thrown into the heart of the work, a symbol in which the Real is treated in a brutal and incomprehensible way. It is the madness of music listened to with the eyes closed, as one *watches* a Maeterlinck play.

Notes to Chapter 2

1. A slightly different version of this text was published in *Textyles*: "Contre la musique — tout contre. Maeterlinck et la quête du hors-sens", *Textyles*, 26–27 (2005).

2. Jean Warmoes lists at least fifty-five musicians who have composed scores after Maeterlinck's texts in 'La bibliographie de Maurice Maeterlinck', *Annales de la Fondation Maurice Maeterlinck*, t. XVIII, (1972), p. 36–37.

3. In a letter of 14 May 1932 to Georges Astruc, kept in the Bibliothèque nationale de France. See also, amongst others, the interview that appeared in *Revue d'histoire et de critique musicale*, April 1902, 'A la veille de *Pelléas et Mélisande*' (Interview written by Louis Schneider), reprinted in Claude Debussy, *Monsieur Croche et autres écrits* (Paris: Gallimard, 1987). For example, p. 274: 'Maeterlinck was astonished that the subject matter could interest a musician. As he understands nothing about nothing — he says so himself — he had no desire to look at the score.'

4. No more, in any case, than that of Racine, for example, who did not become the object of such a clutter of musicians, either in his era or in ours.

5. What's more, to my knowledge, *Joyzelle*, Maeterlinck's play the most crammed full of these rhetorical/stylistic procedures (with its embarrassing false alexandrines) has never been set to music. A proof, perhaps, that music isn't where you might expect it to be.

6. *Crayonné au théâtre*, 'Planches et feuillets' (Paris: Gallimard, Bibliothèque de la Pléiade, 1945), p. 350. We are of course dealing with *Pelléas et Mélisande* which Lugné-Poe had recently put on in Paris.

7. Jule Huret, *Enquête sur l'évolution littéraire* (Paris: Librairie Charpentier, 1891), 2nd edn. (Paris: José Corti, 1999), p. 155.

8. On the concept of brutality and its interest for literary studies, see *Littérature et brutalité*, edited by Marie-Thérèse Mathet (Paris: L'Harmattan, collection 'Champs visuels', 2006).

9. 'Le mot amour' in *L'Usage de la parole* (Paris: Gallimard, 1980).

10. That is to say, an enigma not destined to be resolved. This is why it would be better to speak, as Jankélévitch does (see infra), of 'mystery', if this word were not itself full of vague connotations.

11. *Pelléas et Mélisande*, act V, in *Théâtre II* (Brussels: Lacomblez, 1902), p. 102, 2nd edn (Geneva: Slatkine reprints, 1979).

12. Vladimir Jankélévitch, *La Musique et l'Ineffable* (Paris: Le Seuil: 1983), p. 95.

13. Cf. 'Personne, à dire vrai, ne songeait à parler. La parole ineffable d'un seul absent, peut-être d'un mort (Swann ne savait pas si Vinteuil vivait encore) s'exhalant au-dessus des rites de ces officiants, suffisait à tenir en échec l'attention de trois cents personnes. ' Marcel Proust, *Du côté de chez Swann*, *Œuvres complètes* (Paris: Gallimard, 1987), I, pp. 346 –347. On this 'ineffable word' and the use of music in Balzac, Proust and Carson McCullers, I will allow myself to reference my work 'Du pan visuel au pan sonore: l'épreuve de la musique', in *Pans. Liberté de l'œuvre et résistance du texte* (Paris: Corti, 2004), chap. VI..

14. Jankélévitch, op.cit., p. 16.

15. Arthur Schopenhauer, *Le Monde comme volonté et comme représentation*, trans. A. Burdeau (Paris: Presses Universitaires de France, 1966), pp. 1189–1190.

16. Vsevolod Meyerhold, *Ecrits sur le théâtre* (Lausanne: La Cité / L'Age d'homme, 1973), I, p. 107.

17. Op. cit., p. 350.

18. The concept is today so much used — and therefore so confused — that we hardly dare to come

back to it. See, however, the important *Penser la voix,* G. Dessons, ed. (Poitiers: La Licorne, 1997) and specifically Henri Meschonnic's article, 'Le théâtre dans la voix', pp. 25–42. Picking apart the majority of contemporary discourses on the voice, Meschonnic pushes the barthesian approach to its limits. The latter will continue to be referenced, but Meschonnic's safe-guards regarding the confusion which generally reigns over the metaphorical use of the word must be borne in mind.

19. 'Le grain de la voix', in *Musique en jeu,* 9 (1972), also in *L'Obvie et l'Obtus* (Paris: Le Seuil, 1982), p. 242. *Œuvres complètes,* (Paris: Le Seuil, 2002), IV, p. 150.

20. Ibid. (pp. 242–43).

21. Schopenhauer, op. cit., p. 1189.

22. Jankélévitch, op. cit., pp. 18–20 and 25. See also this writer's work, in *Debussy et le mystère de l'instant* (Paris: Plon, 1976), pp. 15–17, on the difference between the 'secret' (which is deciphered) and the 'mystery' (which provides some resistance and is 'the music thing'...but also, we believe, that of a certain type of literature). Preferable to this last notion is that of 'incomprehensibility', summarized in *L'Incompréhensible. Littérature, réel, visuel,* ed. by M.-T. Mathet (Paris: L'Harmattan, 2003).

23. On this point, I shall allow myself to reference my contribution to the conference in Cerisy, *Présence/Absence de Maeterlinck,* proceedings published by M. Quaghebeur (Brussels: Labor, 2002), 'De la rhétorique à l'énigmatique', an article reprinted in *Pans. Liberté de l'œuvre et résistance du texte,* op. cit.

24. 'Rasch', in *Langue, discours, société. Pour Émile Benveniste* (Paris: Seuil, 1975). (Reprinted in *L'Obvie et l'Obtus* (Paris: Le Seuil, 1982), p. 273. *Œuvres complètes* (Paris: Le Seuil, 2002), IV, pp. 834–35.

CHAPTER 3

On the Art of Crossing Borders: The Double Artist in Belgium, between Myth and Reality

Laurence Brogniez and Charlyne Audin

Je n'aime pas ma main droite, celle qui écrit — en vieille contrariée qu'elle est — à la plume et tant moins bien que toujours mal. Je préfère 'the autre main', celle que les professeurs ont laissée intacte, qui de dextre à senestre dessine, peint et grave.

PIERRE ALECHINSKY, *Des deux mains*, 2004

The Image as International Language

The Avignon Festival of 2005, with Jan Fabre — a Flemish plastic artist and playwright — as the associated artist, invited by Hortense Archambault and Vincent Baudriller, provoked much comment. Among the most recurrent criticisms was that literary culture had been abandoned and that the 'theatre of the text' had taken a step backwards in the face of the increased resonance of the arts of the image which had little by little taken centre stage. It is no surprise that this sort of criticism was most particularly expressed in France, where, more than elsewhere, the theatre has always been linked more to words than to gesturality, anchoring itself in the text in order to become one of the pillars of national culture. According to Régis Debray, author of a leaflet entitled *Sur le pont d'Avignon*, 'the move from letters towards fine art is doubtless more resonant in France than elsewhere'.[1] The invectives against the 'great carnival of exploded theatre' are witness to a resistance — on the basis of identity — to this phenomenon of the undoing of boundaries and hierarchies between the arts which, as Nathalie Heinrich[2] has sharply analyzed, characterizes the current art scene, allowing (or even encouraging) the transgression of limits. In this way, the appearance of images, dance and music on the stage at Avignon has been interpreted by some as the menacing symptom of a renouncing of national traditions, founded on the text, in favour of an international language, both 'bastard' and hybrid. Jan Fabre, for whom images are a form of expression capable of crossing linguistic and cultural borders, appeared to certain French critics as a barbarian come from the North in order to turn Avignon into a Belgian village fête, a drunken dance, a 'theatre of the stomach'.[3]

Maurice Maeterlinck, another Flemish playwright (even if, in his time, Flemish identity was overshadowed by French), had to face these same objections over a century before, when the 'quarrel of cosmopolitanism' shook French intellectual circles in the 1890s, causing a confrontation between nationalists and cosmopolitans over the subject of foreign influences on the national tradition. Whilst the former, led by Charles Maurras, saw the menace of the 'European soul' replacing the French soul in the 'nordomania' that characterized symbolism, the latter, grouped around Maurice Barrès writing in *Le Figaro* in July 1892, took up a decision in favour of a modernity to be developed via the meeting of North and South, and for which Belgium appeared as a willing testing ground.[4]

The quarrel reached its climax around the staging of *Pelléas et Mélisande* in Paris in 1893, making Maeterlinck the target of a new wave of literary chauvinism and protectionism on the part of purist poets, like François Coppée, who willingly attributed the decadence of French literature to the nefarious influence of cosmopolitanism:

> Depuis de longues années déjà, nous suivons avec peine, chez quelques poètes, les ravages d'une sorte de maladie de nos rythmes et de notre langue, et, là encore, nous reconnaissons une influence étrangère. [...] Une brume germanique nous envahit et nous conquiert, et j'en suis désolé.[5]

This unheard relation to language and this theatre of few words was precisely what modernity's apostles liked in Maeterlinck and in a number of his compatriots. They confirmed the predominance of the gesture over the word, the 'décor' becoming a receptacle of feelings and of mysterious signs, the projection of the protagonists' state of mind, protagonists similar to those of the paintings of the primitives and the pre-Raphaelites.[6]

This pictorial sensitivity, this culture of images, this 'marvelous vocation'[7] of Belgian artists for the plastic arts have all been underlined by generations of critics and historiographers, both Belgian and foreign. They have become almost a sort of national 'label', a brand name which has allowed Belgian writers to sell themselves abroad and to create an identity in the eyes of an international audience. Even today, the Belgian author, even if he is living in Paris, can fall back on this tradition and on a link to the 'old Flemish painters.' In an interview accompanying the publication of a short story entitled *L'Entrée du Christ à Bruxelles* — the title being taken from a famous work by Ensor — the author Amélie Nothomb confirms that her interest in Flemish painting is her 'manière d'être belge'.[8] As for Patrick Roegiers, in a work published under the title *Mal du pays*, he has no hesitation in describing Jan Fabre as the 'l'héritier béni des maîtres peintres de la Flandre sauvage'.[9] By controversially stating that Ensor is 'le plus inventif et novateur écrivain moderne',[10] he is also claiming to share with his compatriots a 'langage propre au peintre amoureux des images'.[11]

In addition to writers' statements, the critical works on Belgian literature underlining this national affinity between painting and writing are not few in number, even if today this stereotype tends to be put back into perspective and 'un-naturalized' so that it can be analyzed as an identity construction which contributed to the growth of the 'petites mythologies belges'.[12] However, it is still clear that

painting played a key role in the emergence of Belgian literature, determining a particular way of relating to language as a specific representation of the writer as a 'painter who writes.' Painting leaves a thread throughout the history of Belgian literature, a thread that can be followed right up until the most recent productions, confirming a specificity which the writers still cultivate in different ways.

Painting, 'a language of its own'

In order to exist politically, a nation must also exist culturally. Accordingly, literature can appear as one of the factors that are able to back up the development of a young state, with the support of a cultural history charged with providing the nation with a glorious line of forefathers. In the case of Belgium, 'born' in 1830, the importance of defending and expanding a national literature capable of translating the aspirations of a people long shunned by history became clearly involved with a search for origins, with an exhumation of any predecessors and a re-editing of texts where a 'Belgian soul' might be exemplified, a soul suffocated by centuries of oppression and of foreign occupation.

According to Charles Potvin, one of the artisans of this literary nationalism, the country has the right to claim 'a full tradition of glory': the Belgian writer is unrecognizable as such without his 'escort of illustrious men'.[13] If literary precursors are lacking, then the great painters are easily assimilated to the 'illustrious men' capable of putting the wind into young Belgium's sails. If we wish to seize the essence of the national spirit, it is indeed necessary, according to authors such as Potvin, to come back to the glories of painting, unanimously recognized and admired. The idea of these painters having given voice to the distinctive characteristics that make up the nation's soul suggests itself, characteristics which also find an expression in the work of writers seeking to distinguish themselves from the French camp.

'C'est donc aux beaux-arts à faire apprécier notre esprit littéraire. [...] La gloire universelle de nos artistes peut et doit prêter son éclat au tableau de notre littérature' states Potvin, in 1870, in his work *Nos premiers siècles littéraires*.[14] This argument was extensively used in the 'old' histories of Belgian literature, the glory of Flemish art, highly respected, serving as a support to the definition of a literature lacking in federative characteristics. When inscribed in an historical perspective, the highlighting of the nation's gift for painting also acts in a linguistic perspective, explaining a problematic relationship to language. The Belgian writer, deprived of any language of his own capable of expressing his double culture, French and Flemish, is seen as one who deals with his awkwardness by turning towards the language of forms and colours.

Initially, Belgian literature limited itself to the fairly conventional exploration of the 'Flemish picturesque', which at the time was also being used in France in Romantic writing. The cult of the past, a return to origins and to the national 'classics', and 'nordomania' were the current themes in vogue in the whole of Europe, even if in Belgium this search for recognition, doubled by a claim to identity, took on a distinctly more systematic hue which was to deepen over the decades. Furthermore, the reference to Flemish painters was an important method

of legitimization. These artists were indeed well represented in French collections and benefited from a growing interest from collectors.[15] Not only did these works figure in public and private collections: they also occupied a place of choice in the imaginary museum of writers, such as Aloysius Bertrand, for example, who gave a part of his *Gaspard de la nuit* the title of 'Dutch school.' An extravagant imagery made of chiaroscuro effects, of descriptions of cabarets, of village fêtes and of buxom Flemish girls was gradually adopted, contributing to the perception of Belgium as picturesque and pictorial, generator of strong images which make a lasting impression on the mind.

In the 1850s, Belgian literature renewed this imagery, developing its re-appropriation of its heritage from a modernist standpoint. A form of realism in painting and in literature was developed in Belgium during this period, moving away from its French cousin by attempting to put forward a local and original version of the centuries-old tradition of the country reclaimed in the name of the 'old painters.' This assimilation between pictorial tradition and national identity owes much to a series of Belgian writers who were able to profit from the emergence of the realist current and write themselves into modernity, claiming a 'racial' originality, in the line of the great painters of the past.[16] By making realism, re-packaged and altered by the desire to be true to local colour, a vehicle of the search for identity, Camille Lemonnier was the main exponent, in his art writings as in his novels, of a national art founded, by tradition, 'sur une conception réaliste', sensitive to the 'expression de la nature' and of the 'observation immédiate de l'homme dans un milieu adéquat'.[17] This writer, who was to be acclaimed by the *Jeune Belgique* generation as the first national novelist, also took part, with art criticism, in this movement of solidarity which was created between militant painters and writers, a phenomenon which represents a determining and particular moment in Belgium's cultural history.[18]

For Lemonnier, art and race are inextricably linked. The Flemish myth that he develops, in Charles De Coster's footsteps, grows out of a national, even ethnic reading of painting. The writer bases his conception of national identity in this Flemish art, already explored by the very first Belgian writers and, in France, by Hippolyte Taine, in his lessons at the School of Fine Arts[19] — his conception being that a 'race' is conditioned by a particular physiology and psychology determined by both climate and home soil. With the support of the work of art critics and historians such as Eugène Fromentin and Théophile Thoré-Bürger, Flemish painting is assimilated to the Flemish 'race', and a country to the art associated with it.

With the coming of naturalism, these images are charged with new connotations and are used towards the aims of new ambitions, moving away from picturesque romanticism. In this way the 'heavy meats' of Flemish painting, rejected by the institutions, break out in the work of Zola or Huysmans, who was also the author of a collection of transpositions from art, *Le drageoir à épices*, where a Rubens *Kermesse* is in a prominent position. By favouring Flemish painting, the naturalists sought to give themselves a cultural alibi capable of justifying their own audaciousness and the freedom they demanded in their treatment of various subjects.

L'Artiste, a Belgian periodical created in 1875 by Victor Reding and taken over by Théo Hannon in 1877 (with a new slogan of 'Naturalism, Modernity'), published an article which contributed to the debate on naturalism, which was in full swing at that time: its author, Henry Céard, freely associated the independence of naturalist authors with the freedoms taken by the Flemish masters: 'Ce n'est pas par hasard ou fantaisie que, dans *L'Assommoir*, la noce de Coupeau fait halte devant la *Kermesse de Rubens*', he states in the edition of 14 October 1877. The Goncourt brothers had united a realist ambition to a defense of the Flemish masters as early as 1867 in *Manette Salomon*, their 'painters' novel', written in an 'artistic' language, at once refined and plastic. Huysmans was to follow the same route, pushing his Flemish and pictorial background to the fore, from the 'transpositions' of the *Drageoir à épices* to his novels, marking an evolution from strict naturalism to a 'spiritualist' naturalism, which like the first was pictorially inspired.

The fact that these writers were simultaneously practicing art criticism and fiction is doubtless not to be ignored: their novels contain many descriptive sections taking their source in a certain canvas, a certain analysis of painting. A new visual rhetoric is developed in these novels, as description of the painting itself makes way for description of a reality 'like a painting'; rather than a vestige of sensory experience. 'Over-referenced' landscapes are created, natural things 'framed' by pictorial references, whether implicit or explicit. This practice was to become systematic in Belgian writing and sought after to the point of appearing to be distinctive and original. The scenes of 'Belgian' life, which writers such as Lemonnier or later Eugène Demolder undertook the task of translating, were chosen like those featuring in famous Flemish paintings and particular scenes were sanctified to the point of almost becoming national myths.

With the acceleration that literary life in Belgium underwent in the last years of the century, Flemish painting continued to have a strong appeal in terms of identity, notably where the development of the 'nordic myth' was concerned, a myth propounded by numerous members of the naturalist movement, such as Maurice Maeterlinck, Émile Verhaeren or Charles Van Lerberghe.[20] However, it must be said that the use of the Flemish heritage at a certain point became over-use. Belgium, situated at Europe's cross-roads and therefore open to cosmopolitanism, opened itself up to other influences: English pre-Raphaelite painting, Japanese *objets d'art*, decorative art, etc. Paying homage to the master painters remained an obligatory rite of passage for the young writer: situating the initial direction of one's literary career under the sign of a famous painter was far from being an innocent choice for budding authors who wished to attract attention to a virtuoso writing — transposition from art — whilst at the same time underlining that they belonged to a prodigious 'race' of pictorial genii. In this light it becomes possible to analyze the transpositions of Bruegel's *Massacre des Innocents* produced by Maeterlinck and Demolder. These brief texts, the first works of both authors, first appeared in reviews (*La Pléiade* in Paris for Maeterlinck in 1886 and *La Société nouvelle* in Brussels for Demolder in 1889), and would be the object of multiple re-writings and re-workings in their successive editions, which is evidence of the interest the two writers retained in them.[21] We could also cite Verhaeren's *Les Flamandes* (1883),

a work with an emblematic title which openly declares itself heir to the pictorial tradition.

In terms of form, these transpositions adopt different shapes, moving from the form of a story to that of a poem or of a prose poem, then to that of a dialogue, as is the case in Demolder's play, *La Mort aux berceaux* (1899). This diversity is a recurrent feature of the particular relationship between Belgian literature and literary genres.

At the end of the century in Belgium, poetry had indeed reached the summit of the literary hierarchy, as was the case in France with the development of the Parnassian and Symbolist movements. Transposition 'à la Gautier' was a model that found numerous adherents in Belgium. However, it must be said that if the Parnassian mould was adopted for a time, notably in the heart of works by the poets of the *Jeune Belgique* group, the motifs used, coming from the 'realist' Flemish tradition, caused the creation of original formulae bearing the imprint of naturalism. A tension was created between form and content, between metrical and lexical choices. In this vein, Théo Hannon's (who was also a painter) and Georges Eekhoud's first verses provide interesting examples of transgression, 'contaminating' the poem by the use of a prosaic inspiration which is foreign to it.

It seems, however, that transposition is often a way of starting off, reserved to writers who want to try their hand. Many (like Maeterlinck or Verhaeren) freed themselves from the literal interpretation of Flemish painting in order to produce denser works that were richer in meaning. Others, like Demolder, did continue to plough this furrow their whole career long, at the risk of shutting themselves into a reductive regionalism and conventionally picturesque settings.

This literary production, originating in the proximity with painting, led to the emergence, in Belgium, of a particular representation of the writer: the 'writer-painter', an ideal construction whose fame has definitively spread beyond Belgium's borders, creating expected horizons that every Belgian writer is expected to define himself against in order to gain the favour of the critics, both Belgian and foreign, in addition to public recognition.

If the label of 'painter' is applied metaphorically to many of the above writers, this does not reduce its instructiveness when thinking in terms of the relationship with language that Otto Hauser, a German critic, has aptly highlighted in his introduction to his anthology of Belgian French-language poets. He compares the situation of the Belgian Flemish poet who expresses himself in French with that of the painter-poet Dante-Gabriel Rossetti, an Italian born in Britain but immersed in the culture of his parents.

By insisting on the paramount importance of English art on Belgian works of the last quarter of the 19th century, Hauser goes as far as attributing the 'renaissance' of Belgian literature to the discovery of the pre-Raphaelites who struck a resonant note in the minds of these writers who were also the heirs of a 'race of painters',[22] thus forming a good illustration of *ut pictura poesis*:

> Die belgischen Poeten sehen die Welt mit den Augen der kongenialen Maler an, so daß die Grenzen von Dichtkunst und Malerei ineinander verschwimmen. Verlangte Rossetti, daß jedes Bild ein gemaltes Gedicht sei, so kann man von

ihnen sagen, daß sie Gemälde in Versen schreiben [...] Vielleicht besteht überhaupt die hohe Selbständigkeit der Belgier darin, daß sie ihr germanisches Empfinden in einer romanischen Sprache ausdrücken, wodurch ihre Gedichte den gallisch-französischen gegenüber origineller erscheinen, als sie vielleicht in einer germanischen Sprache wären. Dasselbe kann man an Rossettis, des Angloitalieners, berühmter Sonnettenfolge *The House of Life* beobachten.[23]

[The Belgian poets see the world through the eyes of congenial painters, such that the boundaries between lyrical poetry and painting become blurred. Just as Rossetti demanded that every picture should be a poem in paint, so one can say that these poets write portraits in verse form. Perhaps the high level of independence shown by the Belgians is *per se* due to the fact that they express their Germanic sensibilities through a Romance language; this has the effect that their poems seem to stand out from those Gallic-Francophones, appearing more original than they would have been in a Germanic language. The same can be found in a work by the Anglo-Italian Rossetti, specifically the famous cycle of sonnets *The House of Life*.][24]

The phenomenon of linguistic insecurity,[25] brought about by the lack of legitimacy linked to the peripheral position of Belgium's French-speaking community, can certainly help us understand the pictorial tropism of Belgian literature. The absence of any national language would indeed have an influence on the standpoints adopted by the main French-speaking authors, who, from 1830 to 1920, sought to find a solution that was distinct from the Parisian norm.[26] In order to compensate for the inhibitions caused by linguistic insecurity and to emancipate themselves from the nearby French model, many writers adopted a form of writing with an 'exotic' allure, which was manifested as distortions in the language, deviations from the norm. Belgian writing's tendency to turn towards the baroque took various forms: the presence of many archaisms and belgisms in Charles De Coster, a multitude of neologisms in Emile Verhaeren or a proliferation of euphemisms in Camille Lemonnier; so many traits converge to define what has been called the 'carnivalesque style' (or, more offensively, the 'macaque flamboyant') — these characteristics seem to invoke the infamous 'style artiste' developed by Huysmans and the Goncourt brothers in the context of a closer contact with painting. This propensity to play freely with language (and in this way subvert the dominant literary genres) also seems to come from the not too far removed art scene. Refusing to be servile to France, Belgian writers undertook the task of forging an individual way of writing, a form of 'over-writing', adding a pictorial dimension to the literary world, injecting new colour and new forms into the normal French language.

The lines separating disciplines were particularly porous in Belgium during the 19th century. This situation can be explained not merely by the small size of the country — which favours close relations, for example with all the artists of a certain milieu knowing each other, living side by side, and being friends — but most of all, via the existence of a largely non-institutionalized cultural life (different reviews, newspapers, groups and societies) where literary and artistic practices could freely combine. In this particular cultural configuration it is therefore not rare to see 'couples' forming, as much in terms of creativity itself, with the painter illustrating the work of a writer friend (De Coster-Rops, Lemonnier-

Claus, Verhaeren-Van Rysselberghe). In terms of relationships, not just friendships but even family links were sometimes established between the two worlds (the writer Eugène Demolder married the daughter of the painter Félicien Rops; the artist William Degouve de Nuncques married Juliette Massin, the sister-in-law of the poet Emile Verhaeren).

At the turn of the century, the exhibition entitled 'Salon of the writer-painters or the Violins of Ingres' (Brussels, 1908) — in which painters invited writers to take up the brush, reserving for themselves the right to comment on the 'works' of those who usually criticized their work — appeared to be the emblematic event of a new relation between literature and painting in Belgium. More than a simple meeting of genres, this event — where the writer was converted into a painter and vice-versa — prefigures the shading of the boundaries between the two practices, as well as the move towards multi-disciplinarity, a tendency which would become more accentuated as the first half of the 20th century unfolded.

Towards a new language: from Ensor to Alechinsky

In order to discover what is hidden by the persistent reputation which endows what is called 'Belgian literature' with various pictorial epithets, it can be interesting in some cases to ask ourselves to what degree the emergence of a Belgian literary modernity could have been influenced by double practice.

During the last decade of the 20th century, a process of making the pictorial field autonomous had begun, a process that worked towards the aim of emancipating art from realism's mimetic demands. A greater emphasis on the valorization of pure plasticity began to be seen at this time, relegating the intellectuality of words to a secondary role. In this context, the increased interest that a good number of artists[27] — and particularly the Symbolists — showed towards literature deserves our special attention. Strictly linked to words by the inclusion of literary symbols and allegories, the symbolist painters are also involved with them due to their propensity to take up the pen.[28] In this way the dedications and titles of works by Fernand Khnopff threaten to become prose poems; Jean Delville, following the rosicrucian model, added manifestoes and poems to his ambitious realist programme; Félicien Rops, for his part, demonstrated such a high quality of writing in his correspondence that Degas said: 'celui-là écrit encore mieux qu'il ne grave; [...] Si l'on publie un jour sa correspondance, je m' inscris pour mille exemplaires de propagande'.[29]

But, following the decadent sophistications of the end of the 19th century, the age of suspicion into which the superiority of words would gradually enter, created, at the start of the new century, a new tension between painting and literature, which paved the way for multi-disciplinarity and mixed practices to appear. James Ensor (1860–1949) was a syncretic figure, a 'painter-writer' who moved from the palette to the study without ever losing his sense of colour, and in this way kept out of the reach of intellectual contamination. For him, the coming together of the two practices, pictorial and literary, seems to create a language cleansed 'des lavasses impures revomies par les veaux vautrés de la littérature'.[30] By their virulent tonality, their syntactical overspill and their lexical audaciousness marbled with

foreign words, Ensor's *Ecrits* seem both to put the French language in trouble and to vitalize it.

The coming together of Max Elskamp's (1862–1931) writing and plastic art is emblematic of the climate of general suspicion in relation to the erudite words worshipped by decadent aesthetics, even if at first glance this coming together appears to be an attack on the linguistic insecurity of the poet from Anvers, worried about writing 'too much from the North.' The unsophisticated simplicity of the xylographic ornamental decoration of *Enluminures* is part of a double movement of formal balancing-out and of spiritual asceticism, wherein the vagrancies of language manage to anchor themselves in the material.[31] This antagonism between writing and painting was achieved by the author of *Dolorine et les ombres* (1911), Jean de Boschère (1878–1953) who, following his encounter with the English 'Imagists' began to dream of a language without words, of a 'pure saying' that could only be rendered by the actions of the artist.[32]

The tension between words and images existing at the beginning of the 20th century became even more radical in the aftermath of the First World War. The unspeakable and the violence of the unconscious were at the centre of a veritable struggle between word and image. The creative doubling performed by Henri Michaux (1899–1984) directly opposed poetry and painting in a war-like dynamic. Driven by the desire to seize the avant-garde of thought, Michaux constantly pushes the boundaries of poetic creativity to the point of finally turning to images, via the practice of calligraphy, in his eyes the only practice capable of abstracting writing from its rational anchorage. The progressive purification a drawing reduced to a single line, in the work of this artist appears to be the fruit of the need for the act of writing to be renewed.

After Michaux, other double artists, such as Christian Dotremont (1922–1979) and Pierre Alechinsky (1927-), would explore calligraphy in order to try and respond to the perceived necessity of abolishing the borders between the visible and the readable. Dotremont's logogrammes, poem-pictures or the great arabesques traced in China ink, shared the textual space, inviting us to approach the relation between text and image in a new dialectical perspective, one of circulation between visual and textual signifiers.[33] An initiate of Japanese calligraphy, Alechinsky discovered in the manipulation of the brush the same physical gesture that is used to set out writing. From this moment on, script would constantly be suggested as part of his pictorial oeuvre, as one of the meta discourses questioning the genesis and the development of the images.

From one century to the next, the shadow of Ensor and of his double practice continually hovered above the history of Belgian literature: 'il manie drôlement la plume, ce peintre qui possède un français bien à lui' states Pierre Alechinsky in his self-portrait entitled *Des deux mains*[34] (one holding the pen, the other the brush), recognizing in hindsight Cobra's debt to his precursor, whom the avant-gardes too hastily lumped together with the nebulous 'fin de siècle' and its altered artifices.

Doubtless, Ensor incarnated, in an emblematic way, this figure of the 'painter who writes' which continued, beyond the 19th century, to act as a pole of attraction

and of identification for the 'breakaway' Belgian artists in search of a new language. This was a language which, as Patrick Roegiers[35] underlines, was perhaps in Ensor's case elaborated in a double 'decentering': that of the painter in relation to writing, but also an 'Anglo-Belgian', language, distinct from French. This pushed the language onto its last defenses and brought about the transgression of the borders between visible and readable, between the art of words and the art of images.

Notes to Chapter 3

1. Régis Debray, *Sur le pont d'Avignon* (Paris: Flammarion, 2005), p. 88.
2. Nathalie Heinich, *Le Triple Jeu de l'art contemporain* (Paris: Les Éditions de Minuit, 1998).
3. Régis Debray, op.cit., p.88.
4. On this subject, see Paul Delsemme, *Teodor de Wyzewa et le cosmopolitisme littéraire en France à l'époque du symbolisme* (Brussels: Presses universitaires de Bruxelles, 1967) and Gisèle Ollinger-Zinque, 'La Belgique au tournant du siècle: Un nationalisme très international' in *Paradis perdus. L'Europe symboliste, 8 juin-15 octobre 1995* (Montréal/Paris: Musée des Beaux-Arts de Montréal/Flammarion, 1995), pp. 264–273.
5. François Coppée, quoted by Iwan Gilkin, 'Pelléas et Mélisande à Paris', in *La Jeune Belgique*, June 1893, p. 230.
6. Albert Mockel, *Conférence sur Maurice Maeterlinck: la jeunesse de Maurice Maeterlinck et la poésie du mystère*, Institut des Hautes Études, Bruxelles, 17 décembre 1937, (Brussels: Archives et Musée de la Littérature, Fonds Mockel).
7. Camille Lemonnier, *L'École belge de peinture 1830–1905* [1906] (Brussels: Labor, 1991), p. 106.
8. Amélie Nothomb, 'Les nouvelles de l'été. L'Entrée du Christ à Bruxelles', *Elle*, 5 July 2004, p. 57.
9. Patrick Roegiers, *Le Mal du pays. Autobiographie de la Belgique* (Paris: Le Seuil, 2003), p. 149.
10. Ibid. p.536.
11. James Ensor, quoted by Patrick Roegiers, ibid., p. 533.
12. See also Paul Aron, 'Quelques propositions pour mieux comprendre les rencontres entre peintres et écrivains en Belgique francophone', *Écriture*, 36, (1990), pp. 82–91; 'Un pays de peintres', in *La Belgique artistique et littéraire. Une anthologie de langue française 1848–1914*. Texts presented by Paul Aron (Brussels: Éditions Complexe, 1997), pp. 125–257; Véronique Jago-Antoine, 'Littérature et arts plastiques' in *Littératures belges de langue française. Histoire et perspectives (1830–2000)* ed. by Christian Berg and Pierre Halen (Brussels: Le Cri Édition, 2000), pp. 627–650; Laurence Brogniez and Véronique Jago-Antoine (ed.), *Textyles*, n° 1–718, 'La Peinture (d)écrite', 2000. See also Jean-Marie Klinkenberg, *Petites Mythologies belge* (Brussels: Éditions Labor/Éditions Espace de libertés, 2003).
13. Charles Potvin, *Cinquante ans de liberté, Tome IV, Histoire des lettres en Belgique* (Brussels: Weissenbruch, 1882), p. 8. On the same subject, see also *Textyles'* special issue on 'La Belgique d'avant la Belgique', 28, (2005).
14. Charles Potvin, *Nos premiers siècles littéraires: Choix de conférences données à l'hôtel de ville de Bruxelles dans les années 1865–1868* (Brussels: Lacroix, Verboeckhoven et cie, 1870), p. 27.
15. See Jean-Pierre Guillerm, *Les Peintures invisibles: L'héritage pictural et les textes en France et en Angleterre, 1870–1914* (Lille: Presses universitaires de Lille, 1982).
16. Camille Lemonnier, *Gustave Courbet et son œuvre* (Paris: Lemerre, 1878), p. 31.
17. Camille Lemonnier, *L'École belge de peinture 1830–1905* (Brussels: Labor, 'Espace Nord', 1991), p. 75. On Lemonnier as an art critic see Paul Aron, 'Camille Lemonnier: critique d'art et stratégie littéraire', *Revue de l'Université de Bruxelles*, 4–5, *Le naturalisme et les lettres françaises de Belgique*, (1984), pp. 119–128; Paul Gorceix, 'Camille Lemonnier ou l'identité picturale belge', *Bulletin de l'Académie royale de langue et de littérature françaises*, t. LXXII, n° 1–2, (1994), pp. 269–281; Laurence Brogniez, '1869, Camille Lemonnier publie *Nos Flamands*' in *Histoire de la littérature belge (1830–2000)*, ed. by Jean-Pierre Bertrand, Michel Biron, Benoît Denis and Rainier Grutman (Paris: Fayard, 2003), pp. 117–126.

18. See Paul Aron, 'Les revues littéraires, média privilégié de l'identité culturelle?', in *L'Identité de la Belgique et de la Suisse francophones*, textes réunis par Paul Gorceix (Paris: Champion, 1997); 'Revues artistiques et littéraires', *La Belgique artistique et littéraire: Une anthologie de langue française 1848–1914, op. cit.*, pp. 5095–63; 'La Belgique francophone, carrefour du cosmopolitisme européen', *La Belle Époque des revues 1880–1914*, sous la dir. de Jacqueline Pluet-Despatin, Michel Leymarie, Jean-Yves Mollier (Paris: Éditions de l'IMEC, 2002), pp. 325–334.

19. Hippolyte Taine, *Philosophie de l'art dans les Pays-Bas*. Leçons professées à l'école des Beaux-Arts, Paris (Paris: Germer Baillière, 1869).

20. See Jean-Marie Klinkenberg, 'La Génération de 1880 et la Flandre', in *Les Avant-Gardes littéraires en Belgique* (Brussels: Labor, 'Archives du futur', 1991), pp. 101–110.

21. See Laurence Brogniez, 'La transposition d'art en Belgique: le *Massacre des Innocents* vu par Maurice Maeterlinck et Eugène Demolder', *Écrire la peinture entre XVIII^e et XIX^e siècles*, Pascale Auraix-Jonchière (éd.) Presses Universitaires Blaise Pascal, 'Révolutions et Romantismes', (2003), pp. 143–162.

22. See Claudette Sarlet, *Les Écrivains d'art en Belgique, 1860–1914* (Brussels: Labor, 'Espace Nord', 1992).

23. Otto Hauser, *Die Belgische Lyrik von 1880–1900. Eine Studie und Übersetzungen* (Großenhain: Baumert & Ronge, 1902), pp. 9–10.

24. Translated by James Hodkinson.

25. See Benoît Denis and Jean-Marie Klinkenberg, *La Littérature belge. Précis d'histoire sociale* (Brussels: Labor, 'Espace Nord', 2005), pp. 58–61.

26. This particular era corresponds to what Denis and Klinkenberg call the 'centrifugal' phase, which corresponds in Belgian literary history to the desire to create a specifically Belgian centre.

27. There is currently a database dedicated to the written works of 19th C Belgian painters that is being elaborated at the Facultés Universitaires Notre-Dame de la Paix in Namur.

28. See Dario Gamboni, *Le Plume et le Pinceau: Odilon Redon et la littérature* (Paris: Les Éditions de Minuit, 1989) and Peter Cooke, *Gustave Moreau et les arts jumeaux. Peinture et littérature au dix-neuvième siècle*, (Berne: Peter Lang, 2003).

29. Extract of a letter from Degas to Manet quoted in Boyer d'Agen & De Roig, *Rops...Iana.* (Paris: Pellet, 1924), p. 5.

30. James Ensor, 'Discours de Monsieur le baron James Ensor', *Mes Écrits ou les suffisances matamoresques* (Brussels: Labor, 'Espace Nord', 1999), p. 76.

31. See Denis Laoureux, 'Dans le grenier de la poésie: Max Elskamp et l'image. L'écrivain-plasticien belge, une figure (a)typique?', Christian Berg and Jean-Pierre Bertrand, (ed.), 'Max Elskamp/Charles Van Lerberghe', *Textyles*, 22 (2003), pp. 49–60.

32. See Christian Berg, *Jean de Boschère ou le mouvement de l'attente* (Brussels: Palais des Académies, 1978).

33. See Nathalie Aubert, 'Les logogrammes de Christian Dotremont' *French Studies*, 1 (2006), pp. 49–62.

34. Pierre Alechinsky, *Des deux mains* (Paris: Mercure de France, 2004), pp. 47–48.

35. Patrick Roegiers, op. cit., p. 536.

Belgian 'Negro' Fiction:
Modernist Itinerary of a Didactic Genre

Pierre-Philippe Fraiture

Colonial literature, although the phrase is not without its ambiguities and inner contradictions with regards to the imperial project, was an off-shoot of cultural anthropology. In the case of Belgium, one can indeed observe that africanism operated both as a legitimising force and as an agent that, in one way or another, authorized fictional discourses about the Congo. This, however, does not mean that Belgian africanism and colonial literature were separate entities or autonomous *fields* as defined by Bourdieu in *Les Règles de l'art*.[1] When Leopold II (1865–1908), the second king of the Belgians, decided to take effective steps to undertake his colonial venture, Central Africa was still a relatively unknown geographical area, this 'blank space' or 'white patch for a boy to dream gloriously over' that Marlow famously alludes to in *Heart of Darkness*.[2] Although it became one of the most enduring stereotypes about the Congo, this 'blank space' allows us to consider the representation of the Belgian colony both as a scientific and an imaginary process. The *terra incognita* was simultaneously explored and 'dreamed over' and in the initial stage of the conquest it generated a host of hybrid accounts that were to lay the foundations on which Belgian africanism and colonial fictions would be later erected. Georg Schweinfurth's *Im Herzen von Afrika* (1874)[3] or Henry Morton Stanley's *The Congo and the Founding of its Free State* (1885)[4] were widely read and were, as a consequence, translated in several European languages. Their appeal lies in the fact that they combined narrative qualities — and a clear journalistic *penchant* in Stanley's case — with factual richness and novelty. Naturalistic details about African fauna and flora, local customs and rites or somatic features of indigenous populations were the necessary and effective ingredients of this new genre. In their blurring of the divide between science and imagination, these books met a double objective: they were providing adventure novels with a new territory but also opening up areas that had hitherto remained largely unexplored by the scientific community (geologists, geographers, zoologists or ethnographers). These exploratory narratives paved therefore the way to a deeper and more systematic approach to Central Africa as an object of scientific investigation and, in the last decade of the 19th century, africanism slowly became a recognized discipline.

Ethnography and Modernity

It is worth noting that from the very outset, science and progress had been profusely evoked to promote Leopold's colonial project in Central Africa. His 1876 Brussels-held Conférence internationale de géographie intended to assess the existing knowledge on the region and identify the possible benefits, scientific but also commercial, to be reaped from the enterprise. Geography was therefore the obvious vehicle to bridge the gap between science and trade in order to map out the Congo, delineate its rivers, chart its relief and quantify its potential in raw materials and labour force. Alphonse-Jules Wauters, a cartographer but also a noted art critic, became the key-agent of what was then regarded as a much-needed exercise. As a convinced free-marketeer, he embraced Leopold's project wholeheartedly.[5] In 1884, he founded *Le Mouvement géographique*, a weekly publication which aimed to provide its readership with news about the progress and successes of Belgian capitalism abroad in an attempt to help '[...] le pays à sortir pacifiquement de ses étroites frontières' and more specifically to 'faire connaître les progrès de l'œuvre africaine du roi, les travaux et les entreprises des Belges au Congo'.[6] The magazine was the unofficial voice of Leopold's propaganda until Wauters distanced himself from the king in 1891 when the latter, in an act of blatant contravention with the spirit of the Treaty of Berlin (1884–85), decided unilaterally to turn the trades of ivory and rubber into state monopolies.

Wauters remained, however, a strong advocate of the colonial project in spite of the very critical stance that he adopted towards the king.[7] In 1895, he published the first comprehensive bibliography on the colony[8] and, four years later, he provided in his *L'État Indépendant du Congo*[9] a critical commentary of this bibliographical material. In this book, Wauters based his reflections on accounts — or primary sources — by explorers, travellers, scientists or missionaries in order to produce a didactic and user-friendly survey of the knowledge available about the Congo at a time, as he remarked in his preface, when the Belgian Government had decided '[...] de mettre au programme de l'enseignement moyen la géographie du Congo [...]'.[10] This 'livre synthétique',[11] as the author put it, is also about knowledge *from* the Congo (as opposed to European knowledge *on* this part of the world). Wauters shared with *all* his contemporaries an evolutionary conception of human civilizations and held therefore the common view that humanity was made up of superior and inferior races. One needs to point out, however, that he also praised, albeit condescendingly, Congolese material culture and crafts: although the natives '[...] vivent encore à l'état barbare',[12] they display in the '[...] industries manuelles [...] une habileté et un savoir-faire extraordinaires'.[13] This ambivalence is to be observed in most accounts about the colony from the turn of the century until independence.

The Colonial Exhibition of 1897 in Tervuren bore witness to a similar *Zeitgeist* in that it manifested the same ambiguity. The event was first and foremost a tribute to Leopold's achievements in the newly-founded Congo Free State but, at the same time and, it must be said, somewhat peripherally, it was also a discrete acknowledgment of the Congolese skilfulness and inventiveness. The general public

discovered — the event attracted 1.2 million visitors — that the colony was more than an inexhaustible repository of raw materials and manpower. The exhibition was traditionally laid out and followed a pattern that had been used in previous world fairs in London (1851), Paris (1855) or Antwerp (1885 and 1894).[14] Several sections dealt with commerce, natural sciences, ethnography whilst the so-called *Salon d'Honneur* was exclusively devoted to art and craft, two domains that the *fin de siècle* aesthetic revolution had brought together. Ivory was the centre of much attention as this material had enabled artists to revisit chryselephantine sculpture, a genre that had been developed in Ancient Greece. Théodore Masui, the curator and the editor of the exhibition catalogue,[15] noted that this renewal was '[...] définitivement [...] parmi les grands événements artistiques de notre époque'.[16] This emphasis on chryselephantine sculpture partly needs to be read against the background of the prevailing ethnocentrism. Ivory, in this context, appears as a means to an end, as a material symbolising the colonial situation since it enabled artists to convert a purely local product to the Western canon and, thereby, to bypass local tradition. This explanation, however, cannot on its own translate the complexity of a situation which depended on a combination of forces and factors. This exhibition took also into account the aesthetic input *from* the Congo. Masui's understanding of the phrase 'mise en œuvre artistique des produits du Congo'[17] was therefore not as straightforward as it might seem. In a commentary on pieces of furniture designed and exhibited by Belgian *art nouveau* figures such as Paul Hankar, Victor Horta, Gustave Serrurier-Bovy and Henry Van De Velde, Masui pointed out that the furniture designers' *tour de force* resided in the fact that they had incorporated into '[...] des meubles d'art de toute beauté [...] soit des tissus congolais, soit des ivoires, montrant ainsi le parti que l'on peut tirer aussi bien de la matière première que *des œuvres mêmes des artisans noirs*'.[18]

The success of the exhibition was such that it was decided that Tervuren would become the home of a permanent 'Musée du Congo' which eventually became 'Musée du Congo belge' in 1910. In the meantime, steps were taken to archive all the available data and artefacts from the Congo. Cyrille Van Overbergh, a politician and essayist, co-founded in 1905 the Bureau International d'Ethnographie (B.I.E.), an organization based in Tervuren, aiming at standardising and disseminating ethnographic research worldwide; two years later he created the so-called 'collection de Monographies ethnographiques'. In his many prefaces, Van Overbergh appeared as an unambiguously convinced promoter of the colonial project. These prefaces, which I shall here treat as one single text, also show that colonial discourse adopted, already before the First World War, a line of argument that would remain practically unchanged until the demise of the Belgian empire. On the subject of the Congolese Van Overbergh argued that '[c]es grands enfants [...]' would be totally unable to climb '[...] d'un bond tous les degrés qui [les] séparent des hauteurs où brillent les institutions compliquées et délicates de la race blanche'.[19] The key-point here was the purported backwardness of the colonized population which, according to *all* commentators, was such that it could only legitimize a permanent colonial occupation as it was thought that centuries would be needed to achieve the cultural elevation of the locals. In 1956, only four years before decolonization, Antoine

Van Bilsen's tame *Un Plan de trente ans pour l'émancipation de l'Afrique belge*[20] was significantly deemed audacious and far too premature.

With this new series, Van Overbergh aimed to constitute, on the basis of an ethnographic questionnaire designed by Joseph Halkin, a professor of geography at the University of Liège, a practical, and again, user-friendly database. This catalogue would, in his own very confident and enthusiastic opinion, cover all aspects of indigenous customs and everyday practices. All volumes — 14 of them until 1914 — covered a different ethnic group and were compiled by authors with solid africanist credentials, that is to say missionaries such as the R.P. Colle[21] and colonial functionaries such as Commandant Charles Delhaise[22] or even the very controversial Fernand Gaud.[23] Each monograph answered 202 questions which were grouped under seven rubrics, or as Van Overbergh put it, seven 'phénomènes sociaux essentiels'[24] such as 'la vie matérielle' (questions 10–65), 'la vie familiale' (65–100) or 'les caractères anthropologiques' (187–202). The novelty of this approach lay in the fact that the series was one of the feeding channels of the ethnographic archive of the B.I.E. which was organized along the same rubrics. Each volume acted therefore as a type of interface between the users and the database. Although the Halkin questionnaire was in many respects a prescriptive and arbitrary tool, it also pleasantly disrupted the traditional divide between the author and the readers (or users) inasmuch as the author could not be regarded, in the system that Van Overbergh had conceived, as the exclusive owner of the information. The archive (and as a consequence the volumes of his series) was in Van Overbergh's words 'perfectible', constantly under review and this open-endedness relied on the users' vigilance: '[l]a moindre lacune constatée par le lecteur peut être signalée au personnel du Bureau qui s'empresse d'y remédier'[25] and, in this manner '[...] tout lecteur ou consultant peut devenir un collaborateur occasionnel de l'Œuvre'.[26] Practically this flexibility was facilitated by the fact that the books, as the Halkin questionnaire, were made up of 'fiches détachables'[27] that could easily be amended or, if need be, replaced.

The methods of data collection were also conducive to a reassessment of the concept of authorship. Ethnographic authors were indeed largely dependent on their informers or questionnaire respondents. These *mono*graphs produced consequently a multiplicity of voices and were the site of sometimes contradictory or discordant perspectives. Van Overbergh held the view that this inherent contradiction was the key-component of a scientific project which had envisaged 'la possibilité de réaliser le Musée sociologique intégral'.[28] This venture relied on the contribution of authors — e.g. Colle, Delhaise or Gaud — but ultimately their personal input was curtailed by the intrinsically non-authorial methodology in which they operated (the 202 questions). The monographs, and the wider project in which they belonged, i.e. the B.E.I., were above all manifestations of a collective effort to accumulate, in a comparative perspective, readily usable knowledge about colonisable populations and their social environment. Van Overbergh mentioned indeed '[...] l'indispensable nécessité pour tous ceux qui, par profession ou autrement, s'occupent de l'amélioration des noirs, d'étudier d'abord à fond leurs coutumes et leur mentalité'.[29] The constitution of this database was therefore

guided by a set of very pragmatic objectives. Van Overbergh paid tribute to the first wave of explorers and their accounts on Central Africa but he was also aware that their many prejudices were invariably born out of ignorance. The Tervuren-held B.E.I bibliography was in his eyes very important but he called it, however, 'la partie morte' of a system the relevance of which for the colonial project depended above all on the availability of 'la partie vivante', i.e. '[...] le résultat des enquêtes orales et écrites, poursuivies à travers l'Afrique et en Europe, auprès des explorateurs et des missionnaires les plus compétents'.[30] This notion of competency is crucial and in the context of anthropology and Belgian africanism it undoubtedly signals the advent of a new practice. Until the beginning of the 20th century, anthropology remained a speculative discipline characterized by a hierarchical divide between scientific experts based in the metropolis and ethnographers in the colonies. The preserve of interpretation rested with the former category, the so-called 'armchair anthropologists' who were, as with Wauters, Halkin and Van Overbergh, established figures of the scientific institution, whereas ethnographers, in a state of institutional and geographical disconnectedness, continued to be regarded as mere collectors of (arte)facts. The competency to which Van Overbergh was referring mirrors the rise of the 'man on the spot', to use a phrase first coined by James Frazer. The 'enquêtes orales et écrites' gave them a voice that they had been hitherto denied. This shift is of the utmost importance in that it produced a more dynamic, less dualistic vision of colonial culture which cannot be reduced to a set of fixed dichotomies (metropolis vs. colony, same vs. other). The emergence of the 'man on the spot' marked the beginning of modern ethnography, a discipline which was to be closely associated with cultural anthropology. In this new context, ethnographers, be they missionaries (such as R.P. Colle), colonial administrators (as with Charles Delhaise), or, as we shall see, members of the indigenous populations became the interpreters of social facts that they had directly observed (collected) and in which they had sometimes participated. Participant observation introduced a notion of proximity which was completely absent from old-style anthropology, a science that had internalized in its practices the necessary remoteness between interpreters and the exotic objects under investigation. When Marc Augé contends that 'l'anthropologie a toujours été une anthropologie de l'ici et du maintenant',[31] he implicitly admits that the demise of the 'armchair anthropologist' was its defining moment.

Van Overbergh's bibliographical project participated in the development of this 'anthropologie du proche'.[32] This new emphasis on the 'men on the spot' and their sometimes discordant perspectives not only eroded the traditional concept of omniscient and all coherent authorship but also the very idea of absolute colonial authority. In this new dynamics all informants were the *co-lectors*, in the sense of co-interpreters and co-readers, of the social phenomena under scrutiny. Local informers took also part in this co-reading. In one of his prefaces, Van Overbergh mentioned the active intervention of the native Tisambi.[33] He praised Joseph Halkin, the author of the monograph on the Ababua, for ensuring '[...] la collaboration de ce nègre'. He also remarked that this '[...] premier essai de ce genre [...] a ouvert une voie féconde'.[34] The inclusion of Tisambi's views on the Ababua faith and religious system was, according to Van Overbergh, the sign of

ethnographic dynamism and evidence of the discipline's openness and ability to review its postulates. In his evolutionist demonstration, Van Overbergh opposed the past to the present and endeavoured to prove that Tisambi's intervention manifested the radical methodological progress of contemporary africanism: '[...] voyez comme cet indigène met de précision dans l'état et la mentalité de ses concitoyens' and, on this premise, he proceeded to compare Tisambi to an allegedly less convincing ethnographic figure: 'M. Tilkens, ancien chef de poste de Libokwa [...] qui faisait partie de ces premiers explorateurs qui, campés dans le pays, ne parvenaient pas à se rendre compte de ce qui se passait à l'intérieur des têtes [...]'. The latter declared categorically that the 'Ababua n'a pas d'idées religieuses [...] ne croit pas à un Dieu unique, ni à plusieurs dieux'[35] whereas Tisambi expounded the subtleties of their spiritual practices and the very monotheist nature of their faith. Van Overbergh concluded that '[...] pour qui est familiarisé avec les systèmes idiologiques [sic] d'Afrique, les quelques déclarations de Tisambi jettent des éclairs brillants sur la mentalité religieuse des Ababua'.[36] In this demonstration, Tisambi's intimate knowledge of indigenous culture is used as an argument to validate the ethnographic authenticity of Van Overbergh's scientific project.

Ethnography and fiction

In the first decade of the 20th century, the novel became also the site of a reflection on the significance of *authentically* local knowledge as the necessary vector to activate and legitimize the renewal of literary exoticism. Exotic writing reached in this period its golden age. Rudyard Kipling received the Nobel Prize for literature in 1907, and, in France, Claude Farrère and the Leblond brothers were awarded the Goncourt prize (respectively in 1905 and 1909) for novels which represented critically the French colonial expansion.[37] Kipling and the Leblond brothers were a new breed of writers; they were of European descent but had been brought up overseas and they had consequently acquired a more thorough knowledge of their native lands and developed more nuanced perspectives on the empire. They knew local languages and had therefore direct access to indigenous cultures. It was thought that they would be able to represent the empire — i.e. the natives and their 'mentality' — more authoritatively and intuitively than any other European writers before. Their views and overall posture were regarded as trustworthy and authentic as Tisambi's in the field of africanist ethnography. Anthropologists had opted for an 'anthropologie du proche' and, at the same time, critics and novelists such as the Leblond brothers or Pierre Mille were demanding what one might call — although the expression was never used — *exotisme du proche*. The Leblond brothers celebrated Victor Segalen's *Les Immémoriaux*[38] as a perfect example of this new poetics.[39] Segalen's novel had overall very few readers at the time of its publication but met indeed with some success in colonial circles. The book possessed admittedly all the necessary attributes of the nascent indigenous realism. Although Segalen was not a native of Tahiti, this erudite narration, and its detailed account of Maori culture and worldview, gave, somehow, the illusion of an authentically reconstructed indigenous gaze.

The quest for indigenous or native realism would dominate not only colonial fiction but also — more understandably — the emerging Francophone literatures until the end of the 1950s. In this literary process, René Maran's *Batouala: Véritable roman nègre*,[40] the 1921 surprising Goncourt prize winner, played an important role, not only in France but also in Belgium. This novel embraced, it would seem, the ethnographic and documentary posture that had prevailed in *Les Immémoriaux*. Maran, as with Segalen before, was the observer of social phenomena that he had thoroughly and deliberately researched during the many years he lived and worked as French colonial administrator in Central Africa (Oubangui-Chari). This concerted ethnographic exploration served, however, a literary project and sought to represent what had hitherto been largely neglected by fiction (and anthropology), that is to say the effects of the omniscient observer on the natives and their environment. Batouala's monologues on white people's strangeness[41] are the translation of this truly modernist revolution that Segalen had expounded in his *Essai sur l'exotisme*.[42] In an oft-quoted passage he had indeed declared his intention to '[...] prendre le *contre-pied* de ceux-là dont je me défends',[43] i.e. Loti, Saint-Pol Roux and Claudel:

> Ils ont dit ce qu'ils ont vu, ce qu'ils ont senti en présence des choses et des gens inattendus dont ils allaient chercher le choc. Ont-ils révélé ce que ces choses et ces gens pensaient en eux-mêmes et d'eux? Car il y a peut-être, du voyageur au spectacle, un autre choc en retour dont vibre ce qu'il voit. [...] Tout cela, réaction non plus du milieu sur les voyageurs, mais des voyageurs sur le milieu vivant, j'ai tenté de l'exprimer pour la race maorie.[44]

Batouala, the main protagonist, expresses, on behalf of the Banda ethnic group, this 'autre choc en retour'. As in *Les Immémoriaux*, the novel results as a linguistically hybrid attempt to transplant native syntax and idioms literally into French. This *collage* revealed the fragility of a project which had defined itself along the paradoxical line of a monolingual universalism. Maran's linguistic posture questioned the uniqueness and homogeneity of the French language and, therefore, the very authority of the colonial rule, as Sartre would later describe it in 'Orphée noir'.[45] Despite this provocative stance and the violent reactions that it triggered off in French colonial circles,[46] the book was well received in Belgium. Until the beginning of the 1920s, Belgian colonial expansionism had inspired many writers with or without direct experience of the colony. Overall, this literary corpus produced very few credible indigenous characters.[47] The bulk of these fictions focussed on European protagonists and their attempt to convert the new territory to Western practices. In this context, local characters played, in most cases, a subservient and ancillary role and appeared, with very few exceptions, as a mass of anonymous, interchangeable and silent individuals. These narratives did not disappear in the interwar period but their frequency subsided with the advent of a new ideological climate towards the Congolese population. As in France, the war and its utter *savageness* had somewhat weakened Europe's claims to absolute superiority as a cultural model. Colonial officials and decision makers had internalized the lessons of pre-war anthropology and avant-garde. Since *Les Demoiselles d'Avignon* (1907), the Sub-Saharan aesthetic sense had gained in status and infiltrated the Western canon. Oral tradition was no longer synonymous with cultural backwardness and Maurice Delafosse's much-

acclaimed *Haut-Sénégal-Niger* (1912)[48] had proved that oral sources constituted a reliable material to establish the historical trajectories of peoples which had often been regarded as a-historical. By the same token, it was now also accepted that the Congolese operated in highly ritualistic societies.

In Belgian colonial circles, it was felt that these new positions needed to feature in works of fiction. Gaston-Denys Périer, a fierce advocate of *Batouala* in Belgium, launched a campaign in favour of a new genre that would take into account, and even celebrate, the cultural input of the 'negro race'. Périer, who started his career as an art and literary critique in the post symbolist journal *Le Thyrse* (1899–1940), was also in charge of cultural affairs at the Belgian *ministère* des colonies. Périer was an eclectic figure who militated for an aesthetic *rapprochement* between Belgium and the Congo. Congolese art was, in his eyes, more than the expression of an atavistic or traditional call. He contented that it also belonged to the present and that music, sculpture and painting were 'arts vivants', a notion which was then synonymous with 'contemporain' or 'avant-gardiste'.[49] He felt that Congolese art needed to come out of the primitivist ghetto in which it had been confined for too long. As early as the beginning of the 1930s, he complained that museum and exhibition curators — in Tervuren[50] and elsewhere[51] — would routinely refuse to show, in the name of authenticity, objects or paintings unless they possessed clearly identifiable primitive features. For Périer, this attitude amounted to '[...] condamner deux fois l'Art d'une humanité non consultée, d'abord en lui ravissant ses souvenirs, ses classiques, puis en décourageant les réalisations actuelles'.[52] He worked for the recognition of living local artists who were, according to him, all too often omitted at the expense of what he named 'l'anonymat communautaire'.[53] The exhibition that he organized in 1929 at the Palais des Beaux Arts of Brussels on the Congolese painter Lubaki intended to promote this post-traditional vision of Sub-Saharan art. Périer noted that '[c]omme le gothique [...] l'art noir ancien reste anonyme et difficile à expliquer dans ses conceptions formelles' and he insisted that it was therefore essential 'pour éclairer le problème' to gather '[...] informations sur un peintre vivant, sur sa manière de vivre et de travailler [...]'. He demanded more '[...] enquêtes directes auprès des artisans et des artistes congolais' but admitted that these investigations were difficult to carry out because they '[...] exigent une connaissance approfondie des langues parlées par les intéressés'.[54]

Périer was also the most prolific colonial literary critic of the interwar period. His *Petite Histoire des lettres coloniales de Belgique*[55] is the only available pre-independence critical account on Belgian colonial fiction. Périer's erudite analysis provided a chronological overview of all fictional writings about the Congo from the Renaissance to the present day. In this study he identified a gradual shift or evolution from exotic to colonial literature, the latter allegedly providing a more accomplished and truthful representation of the Congo: '[...] Le genre tend à plus de vérité [...] et vise à pénétrer plus objectivement l'âme d'une humanité nouvelle. Il n'y a pas de romanesque colonial sans un fond de vrai'.[56] This conception of the genre reiterated, in a very similar fashion, the poetic objectives that the Leblond brothers or Pierre Mille had voiced already before the First World War. Genuine colonial literature needed to be written by 'men on the spot', be they white people

or members of the indigenous community and, in this respect, it is important to underline Périer's key role in creating after the Second World War literary prizes for local writers. Direct experience of the Congo on the part of the novelist/observer — his use of the phrase 'enquête directe' owes a great deal to the new anthropological paradigm mentioned above — is therefore the major practical method used to gain access to Congolese mentality and worldview. In another piece published earlier, Périer had ascribed to this *exotisme du proche* the need to convince '[...] ses lecteurs de la formation d'une conscience belgo-congolaise'.[57] This idea of a Belgo-Congolese commonality or reciprocal understanding — the word *compréhension* was often used in commentaries on colonialism — was also developed before the First World War as a tool to convert the locals to civilization and Christian ideals. It was argued that some local customs and practices were potential 'pierres d'attente de la foi (ou de la civilisation)', and were therefore deemed sound enough — that is to say close enough to Western codes of values — to be used as cornerstones on which future African societies would be adapted (rather than completely rebuilt). Already in 1913, Périer remarked that '[i]l ne faut point, sous couleur de civilisation, vouloir remplacer ce qui existe, le détruire, le mépriser: il importe bien plus de le comprendre'.[58] The ultimate function of colonial literature was in Périer's eyes indeed one of *compréhension* of the Congolese *other* but he wanted also the genre to reflect the human transformations brought about by colonialism. Colonial fiction, he contended, '[...] s'annexe [...] une vraie nature de laquelle dépendent des humains de races diverses, parmi lesquelles la blanche elle-même se transforme. Des situations complexes naissent de contacts nouveaux'.[59]

A comprehensive overview of the Belgian colonial corpus would reveal the main tendencies identified by Périer: the genre effectively explored, sometimes in great detail, Congolese mentality and the effects of colonialism on blacks and whites. What such a survey would show, however, is that these human transformations were ultimately all represented in the name of a very limited set of ideas about interracial contacts. *Amedra*,[60] the 1926 novel by the Belgian female novelist Milou Delhaise Arnould on which I shall now focus to highlight some of these ideas, was in many respects the embodiment of the poetic renewal that Périer had been advocating since the early 1920s. In his preface to the novel, the critic declared that 'le "roman nègre", genre que devait presque inaugurer "Batouala", ne se rencontrait pas sur le rayon belge des bibliothèques [...]'[61] before the publication of *Amedra*, significantly subtitled *Roman de mœurs nègres du Congo belge*. This first Belgian 'negro novel' was awarded in 1926 the 'prix triennial de littérature coloniale' by *La Renaissance d'Occident*, a Brussels-based literary journal and cenacle co-founded by Périer in 1920. In their opening manifesto, the co-signatories of *La Renaissance d'Occident* announced that it was their intention, at a time which coincided with the emergence of 'une nouvelle pensée' and the development of 'nouvelles formes', to '[...] montrer ce qui fleurit dans le jardin du nouvel Occident'.[62] The journal, which was defined as a 'revue anthologique',[63] published texts by French-speaking writers, be they Belgian or French: Fernand Severin, Marie Gevers, Franz Hellens, Max Elskamp, Claude Farrère, Francis James, Georges Duhamel, Jean Cocteau or René Maran. The co-signatories' ambition to '[...] encourager tous les mouvements

nouveaux'[64] extended also to colonial fiction. The journal organized in 1920 a survey and it was established by the respondents that Belgian colonialism had failed to inspire any literary works of genuine quality. *Amedra*'s publication and official accolade were therefore meant to mark the passage to a new era. The novel resulted, according to Périer, from a more humane attitude *vis-à-vis* the Congolese population and needed to be understood in the context of changing colonial and ethnographic practices:

> Sans doute, pouvait-on prévoir, depuis quelques années, que l'homme noir de notre domaine africain prendrait une place plus grande dans les ouvrages romanesques de chez nous. Les tendances humanitaires de notre politique indigène, le souci de pénétrer l'âme congolaise, les recherches de plus en plus attentives en vue de connaître la société noire, les études patientes sur son organisation, ses idiomes, ses arts et métiers, le rôle de plus en plus marquant accordé à l'élément humain dans l'œuvre colonisatrice ne pouvaient laisser indifférents les écrivains coloniaux. Nécessairement la littérature consacrée à l'exotisme s'orientait vers les Nègres.[65]

Milou Delhaise Arnould had all the africanist credentials required and Périer, in his preface, was keen to portray her as a woman 'on the spot': her '[...] longue expérience africaine' had enabled her to collect '[...] de précises informations sur les êtres, les objets, l'atmosphère nègre' and to develop '[...] une vision directe et un jugement formé sur place, dont on aura déjà apprécié l'acuité au long des notations, des articles variés qu'elle a fait paraître [...].[66] Périer was therefore able to claim on her behalf the same authority as that of Maran, whose celebrated but also notorious *véritable roman nègre* had been much debated in colonial spheres. In her 'Note de l'auteur',[67] Delhaise Arnould, as Maran and his challengers (André Demaison, Jean & Jérôme Tharaud or Gaston Joseph), drew her readers' attention to the (purported) absolute truthfulness of her account: 'La vérité a été respectée dans ses moindres détails et les coutumes de ces intéressants indigènes, originaires de l'Uele, ont été scrupuleusement décrites, avec un souci constant de ne rien inventer'.[68]

Amedra, the main protagonist of this narrative, is a hero in the most conventional sense of the word: she is graceful, intelligent and beautiful and her persona is used as a yardstick against which all other characters are measured, judged and often disqualified by the narrator. As the chief's daughter, Amedra is also the most attractive match of the village but, independent as she is, she rejects all marriage proposals. One day, however, she fortuitously encounters Esiague in the forest. Esiague is a handsome young man from a neighbouring village and the attraction between the two young adults is such that they fall in love instantly with one another and declare solemnly their desire to spend the rest of their lives together. This ambition will, however, not materialize. Asimangue, Amedra's father is blackmailed into promising her daughter to a polygamist, the powerful chief Egboto. Amedra has to accept but, secretly, plans to escape with her lover. In the meantime, however, her plans are discovered by Nodo, one of the men whom she has previously rejected. Driven by jealousy and a cruel sense of revenge, Nodo kills Esiague. The story reaches its tragic *dénouement* and Amedra is left with no alternative but to take her life.

As in *Batouala*, the love story — and the different strategies used by the male characters to conquer the key female protagonist — is a narrative vehicle that helps to explore indigenous customs and shed some light on local daily practices. *Amedra* would seem to belong to the same ethnographic modernity as *Batouala*. In his famous preface, Maran announced that the novel was constructed as a succession of 'eaux-fortes',[69] that is to say a series of snapshots that would inform the readers on the major features of the Banda society. Maran was therefore anticipating by a few years the investigating system that was to be developed by Marcel Mauss from 1926 onwards and, subsequently, applied by one of his most successful students, Marcel Griaule, in his work on the Dogons. The main concept of this system is that of 'total social fact', or the belief, as James Clifford noted, '[...] that the totality of society is implicit in its parts [...]'.[70] Mauss was convinced that a representative sample of significant social facts would have the capacity of grasping '[...] synthetically an over determined cultural reality'.[71] A similar 'synecdochic ethnography'[72] would appear to be loosely at work in *Amedra*. The author also provides her readers with cultural facts on the Bapopoïe and their hunting or eating habits, religious beliefs, sexual mores, marital practices, methods of governance, architectural preferences and festivals. When aggregated, all this information also conveys a synthetic picture of what is otherwise an 'over determined' social or cultural 'reality'. This said, one needs, however, to add that of all the social or cultural facts selected by the author some have a much greater prominence than others. *Amedra* can be in many respects regarded as an ethnographic study but it is also, and perhaps above all, a narrative in which a new interracial (or societal) model is postulated. In her introductory 'Note de l'auteur', Delhaise Arnould observed that the novel '[...] se déroule longtemps avant l'arrivée des Européens dans le pays des Bapopoïe' and she further remarked that '[a]ucun indigène, à cette époque ne soupçonnait l'existence d'êtres humains d'une autre couleur et les mœurs de la tribu étaient exemptes de toute importation étrangère'.[73] This pre-colonial setting does not, paradoxically, weaken the case for a new societal model. In her demonstration, the author chose to favour the Bapopoïe marital practices over other social facts. This choice enabled her to pit traditional Africa against a new Africa that Amedra symbolizes.

Traditional Africa appears in this novel as an 'over determined reality'. The main thrust of its representation relies on a set of formulaically distributed signs and on the stereotypical assumption of some pre-colonial savageness. The prevailing sexual politics in Amedra's native village encapsulates the cultural dilemma she is facing. As a woman, Amedra is forced to comply with tradition and, given its restrictions with regards to female freewill in marital matters, her options are extremely limited. She can either accept to be seduced by Nodo, her co-villager or marry Egboto, the powerful chief. Nodo is the archetypal lecherous and bloodthirsty savage: 'C'est Nodo [...] séducteur de femmes. Sa stature imposante, ses traits réguliers dégagent un surcroît de force mâle, d'énergie brutale et malsaine. [...] Il a plusieurs assassinats sur la conscience, mais on se tait ... on a peur ...'.[74] Egboto, for his part, is also the stereotypical negro despot: 'Vautré au fond du tipoï, sur une peau de léopard [...]',[75] he is portrayed as an incompetent and debauched chief: '[...] il cuve une ivresse alcoolique [and] a perdu tout prestige. De sa bouche épaisse et baveuse, sortent des

paroles inintelligibles; une sueur mal odorante ruisselle sur sa peau ridée [...]'.[76] Egboto is also a polygamist. As a bearer of change, Amedra cannot possibly associate herself with an Africa that the narrator keeps disqualifying. In what is presented as an essentially backward and lawless *milieu*, she stands out and this difference is also physical. She projects herself along conventionally accepted aesthetic criteria: 'Le corps fardé d'un grain fin de poudre de nkula [...]. La figure, polie légèrement d'huile pure aromatisée, est encadrée de longs cheveux roulés en cordelettes, partagés aux deux côtés du front orné du tatouage de la tribu'.[77] This tribal compliance does not, however, prevent her from creating her own aesthetics: 'La coquette jeune fille a quelque peu *enfreint* la coutume de sa race: de longs cils épais frangent ses yeux très doux, tandis que toutes les Bapopoïes ont les paupières *sauvagement* épilées'.[78] She applies the same strategy to her sentimental life and it is highly significant that her first encounter with Esiague, her lover, takes place in a hostile forest where she feels increasingly disorientated: '[...] des fougères arborescentes, une végétation [...] aux formes multiples, étranges, aux coloris les plus invraisemblables, s'entassent, s'étouffent mutuellement. [...] Une odeur de moisi, des bouffées de vapeur malsaines [...] flottent dans l'air qui circule mal'.[79] In this deleteriously luxuriant setting, Esiague appears as an agent of change: Amedra's fears subside because his presence coincides with a potentially new cultural stage. Esiague is also a pre-colonial Congolese but he is not a local; he is, conveniently it must be said, from outside, from another tribe. It is probable that the author — she was after all a noted ethnographer — knew that in Bantou myths significant cultural changes were often symbolically brought about by external agents, by foreign princes who would fall in love with indigenous princesses, marry them, seize power and introduce new cultural practices, as the Belgian structuralist Luc de Heusch has abundantly shown in his anthropological studies on Central Africa.[80] This process is uncannily reminiscent of the civilising mission as it was conceived by the Belgians. Esiague and Amedra, the ideal couple imagined by the author, advocate — as *all* Belgian colonial officials or missionaries — a selective reform of traditional culture. Their failure is a stark reminder of the tasks ahead: polygamy needs to be kept in check, law and order enforced and the forest — so rich but at the same time so uncontrollable — must be converted into a readily exploitable domain.

All Belgian 'negro novels' written until the Congolese independence follow the same thematic pattern. The conversion of the locals is represented as a positive, albeit painful process initiated by some enlightened messiah-like figures such as Amedra. These agents are often female characters.[81] In the history of contacts between Belgians and Congolese, women played a comparatively minor role. As an essentially male enterprise — it slowly changed after the First World War — Belgian colonization brought above all men from both sides into contact. Somehow, it was felt that European modernity had bypassed women, particularly in rural areas. They were regarded ambiguously as the victims of a male-dominated tradition, and, at the same time, as the paradoxical guarantors of this very tradition. It was thought that their conversion or emancipation would produce a much more radical transformation of traditional culture and pave the way to a more acceptable compromise between Bantou customs and European modernity.

Although narratives such as *Amedra* participated in what I have named here *exotisme du proche*, it can be argued, by way of conclusion, that they were also part of a didactic mission. These books were supposed to be read by the metropolitan public in order to combat prevailing stereotypes about the colony. Périer remarked that '[...] Madame Delhaise démontre une fois de plus que le noir comprend aussi l'amour, en dehors du désir brutalement charnel'.[82] At a time which coincided with the first systematic transcription of Congolese oral literature, notably by Olivier de Bouveignes, and the publication of the first oral narrative directly written by a Congolese — *L'Éléphant qui marche sur des œufs* by Thadée Badibanga[83] — colonial critics such as Périer relied on canonical, that is to say *universal* references to legitimize the fragile status of the 'negro' genre: 'L'histoire d'Amedra et de son amant [...] rappelle, par endroits, "Roméo et Juliette"'.[84] If literature is a vehicle for (self)-knowledge, 'negro' novels and colonial fiction as a whole addressed a very specific type of knowledge. This over-specificity was held in suspicion in literary circles. In historical studies on Belgian literature published in the inter-war period,[85] this specialized corpus was mainly ignored. This oversight results from the overall mediocre quality of colonial fictions, the inevitable sense of guilt that they provoked in Belgian readers but also from the latter's tendency — and the same attitude helps us to understand the ghettoization of 'Negro-African' literature — to regard literature as an exclusively Western mode of expression. Ultimately, however, colonial fiction — be it 'negro' or not — was above all seen as a recruiting tool and directed, as a consequence, towards the existing (or future) colonial personnel. 'Il faut convenir', as Périer argued already before the First World War,

> que les récits de Léopold Courouble, les notes de voyage d'Edmond Picard ou de James Van Drunen, ont fait autant pour la connaissance des pays d'outre-mer que les meilleurs manuels de géographie. Ils ont éveillé notre admiration, assigné un but à ces vagues nostalgies dont s'émeut souvent la jeunesse [...]'.[86]

Colonial 'negro' novels and the emerging Francophone literatures resulted from the same epistemological rupture but their route diverged in the 1930s. The former focussed on the exploration of a purported authenticity that would, it was hoped, create harmonious relations in the colonies; the latter, on the other hand, broke away from this cataloguing of local rites and from what Sartre referred to as 'l'épanouissement d'instincts ataviques'.[87] Henceforth, Francophone authors such as Aimé Césaire, Ahmadou Kourouma or Patrick Chamoiseau would operate in the very language in which they had been colonized, a poetic revolution at the crossroads between surrealism and magic realism.

Notes to Chapter 4

1. Pierre Bourdieu, *Les Règles de l'art. Genèse et structure du champ littéraire* (Paris: Éditions du Seuil, 1992).
2. Joseph Conrad, *Heart of Darkness* (Harmondsworth: Penguin Books, 1995), with an introduction by Robert Hampson, p. 22.
3. Georg Schweinfurth, *Im Herzen von Afrika: Reisen und Entdeckungen im zentralen Äquatorial-Afrika während der Jahre 1868–1871. Ein Beitrag zur Entdeckungsgeschichte von Afrika* (Leipzig: F.A. Brockhaus, 1874).

4. Henry Morton Stanley, *The Congo and the Founding of its Free State. A Story of Work and Exploration*, 2 vols. (London: Sampson, Low, Marston, Searle & Rivington; New York: Harper & Brothers, 1885).

5. On this important (but somewhat neglected) figure of Belgian modernism at the turn of the century, see Marie-Christine Brugaillère, 'Un journal au service d'une conquête: *Le Mouvement géographique* (1884–1908)', in *Images de l'Afrique et du Congo/Zaïre dans les lettres belges de langue française et alentour*, ed. by Pierre Halen & János Riesz (Brussels: Textyles-éditions, 1993), pp. 23–35. See also the first chapter of my forthcoming monograph: *La Mesure de l'autre. Afrique subsaharienne et prose ethnographique de Belgique et de France (1918–1940)*, 'Bibliothèque de Littérature Générale et Comparée' (Paris: Honoré champion, 2007).

6. *Le Mouvement géographique* (9 March 1890), quoted by Brugaillère, 'Un journal au service d'une conquête', p. 25.

7. In his *Histoire politique du Congo belge* (Brussels: Pierre Van Fleteren, 1911).

8. Alphonse-Jules Wauters, *Bibliographie du Congo 1880–1895. Catalogue méthodique de 3.800 ouvrages, brochures, notices et cartes relatifs à l'histoire, à la géographie et à la colonisation du Congo* (Brussels: Administration du Mouvement Géographique, 1895).

9. Alphonse-Jules Wauters, *L'État Indépendant du Congo* (Brussels: Librairie Falk Fils, 1899).

10. Wauters, *L'État Indépendant du Congo*, p. ix.

11. Wauters, *L'État Indépendant du Congo*, p. viii.

12. Wauters, *L'État Indépendant du Congo*, p. 321.

13. Wauters, *L'État Indépendant du Congo* p. 322.

14. See Dirk Thys Van Den Audenaerde, 'Le Musée Royal de l'Afrique centrale à Tervuren. Aperçu historique', in *Africa Museum Tervuren 1898–1998*, ed. by Dirk Thys Van Den Audenaerde & Sony Van Hoecke (Brussels: Musée Royal de l'Afrique centrale, 1998), pp. 13–22.

15. *Guide de la section de l'État Indépendant du Congo à l'exposition de Bruxelles-Tervueren en 1897* ed. by Charles Liebrechts and Théodore Masui, illustrations by Amédée Lynen (Brussels: Imprimerie Veuve Monnom, 1897).

16. Liebrechts and Masui (eds), *Guide de la section de l'État Indépendant*, p. 11.

17. Liebrechts and Masui (eds), *Guide de la section de l'État Indépendant*, p. 9.

18. Liebrechts and Masui (eds), *Guide de la section de l'État Indépendant*, p. 9. My emphasis.

19. Van Overbergh, 'Préface', in R.P. Colle, *Les Baluba (Congo belge)*, Collection de Monographies ethnographiques, X (Brussels: Albert Dewit Éditeur & Institut International de Bibliographie, 1913), p. xii.

20. Antoine Van Bilsen, *Un Plan de trente ans pour l'émancipation de l'Afrique belge* (Brussels: L'Action Sociale Catholique, 1956).

21. R.P. Colle, *Les Baluba (Congo belge)*.

22. Charles Delhaise, *Les Warega (Congo belge)*, Collection de Monographies ethnographiques, V (Brussels: Albert Dewit Éditeur & Institut International de Bibliographie, 1909), 'Préface' by Cyrille Van Overbergh.

23. *Les Mandja (Congo français)*, Collection de Monographies ethnographiques, VIII (Brussels: Albert Dewit Éditeur & Institut International de Bibliographie, 1911), with the collaboration of Cyrille Van Overbergh.

24. Van Overbergh, 'Préface. L'Œuvre ethnographique à l'Exposition internationale et Universelle de Bruxelles', in Joseph Vanden Plas, *Les Kuku (Possessions anglo-égyptiennes)*, Collection de Monographies ethnographiques, VI (Brussels: Albert Dewit Éditeur & Institut International de Bibliographie, 1910), pp. v–xxxviii (p. xv).

25. Van Overbergh, 'Préface. L'Œuvre ethnographique à l'Exposition internationale', in Vanden Plas, *Les Kuku*, p. xi.

26. Ibid.

27. Cyrille Van Overbergh, *Les Bangala (État Ind. du Congo)*, Collection de Monographies ethnographiques, I (Brussels: Albert Dewit Éditeur & Institut International de Bibliographie, 1907), with the collaboration of Edouard De Jonghe, p. x.

28. Van Overbergh, 'Préface. L'Œuvre ethnographique à l'Exposition internationale', in Vanden Plas, *Les Kuku*, p. xxv.

29. In 'Préface' of R.P. Colle, *Les Baluba (Congo belge)*, p. xlvii.

30. 'Introduction' to Fernand Gaud, *Les Mandja*, p.ix.

31. *Non-Lieux. Introduction à une anthropologie de la surmodernité*, 'La Librairie du XX^e Siècle' (Paris: Seuil, 1992), p.16.

32. Ibid., p.15.

33. 'Introduction', in Joseph Halkin, *Les Ababua (Congo belge)*, Collection de Monographies ethnographiques, VII (Brussels: Albert Dewit Éditeur & Institut International de Bibliographie, 1911), with the collaboration of Ernest Viaene, pp.v–xv.

34. 'Introduction', in Joseph Halkin, *Les Ababua*, p.xiii.

35. 'Introduction', in *Les Ababua*, p.xiii.

36. 'Introduction', in *Les Ababua*, p.xiv.

37. On the Leblond brothers' colonial writing and literary prizes, see Dodille, Norbert, 'Goncourt colonial: Marius-Ary Leblond', in *Prix Goncourt, 1903–2003: essais critiques*, ed. by Katherine Ashley (Oxford; Bern: Peter Lang, 2004), pp.59–75.

38. Victor Segalen, *Les Immémoriaux* (Paris: Mercure de France, 1907).

39. See *L'Idéal du XIX^e siècle* (Paris: F. Alcan, 1909), p.302.

40. René Maran, *Batouala: Véritable roman nègre* (Paris: Albin Michel, 1921).

41. In Chapter II of the 2^nd edition (1938), pp.37–40.

42. Segalen, *Essai sur l'exotisme, une esthétique du divers* (Paris: Fata Morgana, 1978).

43. Segalen, *Essai sur l'exotisme*, p.17. In italic in the original.

44. Ibid., pp.17–18.

45. In Léopold Sédar Senghor, *Anthologie de la nouvelle poésie nègre et malgache de langue française* (Paris: PUF, 1948), pp.ix — xliv.

46. For an analysis of these reactions, see my article: '*Batouala*: véritable roman d'un faux ethnographe?', *Francofonía*, 14 (2005), pp.23–37.

47. I gave a critical overview of this corpus in: *Le Congo belge et son récit francophone à la veille des indépendances. Sous l'empire du royaume*, collection 'Critiques Littéraires' (Paris: L'Harmattan, 2003). See also: *Papier blanc, encre noire. Cent ans de culture francophone en Afrique centrale (Zaïre, Rwanda et Burundi)*, ed. by Marc Quaghebeur, Emile Van Balberghe et al., 2 vols (Brussels: Labor, 1992).

48. *Haut-Sénégal-Niger: le pays, les peuples, les langues, l'histoire, les civilisations*, 2 vols (Paris: Maisonneuve & Larose, 1912).

49. Pierre Halen, 'Les douze travaux du congophile: Gaston-Denys Périer et la promotion de l'africanisme en Belgique', in *Textyle*, 17–18 (2000), 139–50 (p.143).

50. On this type of censorship imposed in Tervueren, see Jean-Luc Vellut, 'Ressources scientifiques, culturelles et humaines de l'africanisme en Belgique. Perspectives sur un patrimoine d'outre-mer et sa mise en valeur', *Cahiers africains*, 9–10–11 (1994), *Belgique/Zaïre. Une histoire en quête d'avenir*, sous la direction de Gauthier de Villers, 115–44 (p.131).

51. See Elena Ricci: 'Quelques remarques sur la 1ère Exposition d'art colonial de Rome en 1931: le pavillon belge', *Congo-Meuse. L'Œil de l'autre. Colloques de Kinshasa et de Bruxelles*, 2/3 (1998/9), 185–201 (p.196).

52. 'Art vivant des noirs du Congo belge', in *Artes Africanae*, 3–4 (1936), 3–13. (p.3).

53. Périer, 'Art vivant des noirs', p.4.

54. 'Art vivant des noirs', p.4.

55. Gaston-Denys Périer, *Petite Histoire des lettres coloniales de Belgique* (Brussels: Office de Publicité, 1942).

56. Périer, *Petite Histoire*, p.16.

57. Perier, *Panorama littéraire de la colonisation belge. La littérature coloniale belge* (Brussels: Albert Dewit, 1930), illustrated by Djilatendo, p.18.

58. Gaston-Denys Périer, 'Le Rôle de la littérature coloniale' (Brussels: Imprimerie Gaston Bonnet, 1913), p.2.

59. Périer, *Petite Histoire*, pp.46–47.

60. Milou Delhaise Arnould, *Amedra. Roman de mœurs nègres du Congo belge* (Brussels: Éditions de la Renaissance d'Occident, 1926), preface by Gaston-Denys Périer.

61. 'Préface', p.9.

62. Maurice Gauchez & Léon Bocquet (and 13 other signatories including G.-D. Périer), 'Manifeste', in *La Renaissance d'Occident*, 1 (January 1920), 3–5 (3).

63. Maurice Gauchez & Léon Bocquet, 'Manifeste', p. 3.

64. 'Manifeste', p. 5.

65. Périer, 'Préface' of Milou Delhaise Arnould's *Amedra*, pp. 7–8.

66. Perier, 'Préface' of *Amedra*, p. 10.

67. Delhaise Arnould, 'Note de l'auteur', in *Amedra*.

68. Delhaise Arnould, 'Note de l'auteur'.

69. René Maran, *Batouala. Véritable roman nègre* (Paris: Albin Michel, 1921). Edition used here: 1938 (p. 9).

70. *The Predicament of Culture. Twentieth-Century Ethnography, Literature and Art* (Cambridge & London: Harvard University Press, 1988), p. 64.

71. Clifford, *The Predicament*, p. 64.

72. Clifford, *The Predicament*, p. 64.

73. Delhaise Arnould, 'Note de l'auteur', in *Amedra*.

74. *Amedra*, p. 16.

75. *Amedra*, p. 57.

76. *Amedra*, pp. 62–63.

77. *Amedra*, p. 17.

78. *Amedra*, p. 18. My emphasis.

79. *Amedra*, pp. 26–27.

80. On the Kuba, Luba and Lunda myths, See Luc de Heusch, *Le Roi ivre ou l'origine de l'État* (Paris: Gallimard, 1972).

81. See Henri Drum, *Luéji ya kondé* (Brussels: Éditions de Belgique, 1932), Chantal Roy, *Thubi, fille noire* (Brussels: Buelens, 1943) or Joseph Esser, *Matuli, fille d'Afrique* (Paris; Brussels: Elsevier, 1960).

82. Périer, 'Préface' of *Amedra*, p. 11.

83. Thadée Badibanga, *L'Éléphant qui marche sur des œufs* (Brussels: L'Églantine, 1931), preface by Gaston-Denys Périer et Georges Dulonge, illustrations by Djilatendo.

84. Périer, 'Préface' of *Amedra*, p. 10.

85. See Maurice Gauchez, *Histoire des lettres françaises de Belgique des origines à nos jours* (Brussels: Éditions de la Renaissance d'Occident, 1922) and Georges Doutrepont, *Histoire illustrée de la littérature française en Belgique. Précis méthodique* (Brussels: Didier, 1939).

86. *Le rôle de la littérature coloniale* (Brussels: Imprimerie Gaston Bonnet, 1914), p. 1.

87. Jean-Paul Sartre, 'Orphée Noir', in Léopold Sédar Senghor, *Anthologie de la nouvelle poésie nègre et malgache de langue française*, avant-propos de Ch.-André (Paris: PUF, 1948), p. xliii.

PART II

CHAPTER 5

Modernity and Politics

Paul Aron

The most characteristic trait of the European 'avant-garde' movements of the first half of the 20th century resides in the link they established between formal revolution and political revolution. On the one hand, this is an old link. From Romanticism on, the boldest movements in art had often shown their sympathy with those who wished to change the social order. But this link changed in nature when the political parties, and notably the parties of the left and the extreme left, were reorganized from the 20th century. Indeed, they developed a very strong form of membership, which has sometimes been compared with that which unites the followers of a religion or sect, and they also put in place highly hierarchical and structured organizations which have been at one and the same time the terms of their efficiency and have provided the means of controlling their members. Overall, this tendency is not to be found in the traditional parties of the centre and the right, although the network formed by the numerous associations of the Catholic world has produced a comparable effect; at the extreme right of the political spectrum, other parties also developed a strong relationship with their members. These characteristics often placed artists in an ambivalent situation: they felt themselves torn between two belonging logics, the Art or the Party, and were obliged to choose between the two.

Seen from the beginning of the 21st century, these debates may seem archaic. Nonetheless, we must remember the role played by politics as such in the 'short 20th century' (Eric J. Hobsbawm). In Western Europe, indeed, the legacy of the French Revolution ensured for two centuries — till 1989 to be exact, year of the fall of the so-called Communist regime — the belief that politics was the most powerful vehicle of change in the lives of men in society. This is why artistic movements, which answered to the same requirement, could not help but come into contact with it.

French-speaking Belgium is no exception to this general rule. Although no cross-study of all artistic and political fields has ever been dedicated to this question, we can sketch out here a few of their points of contact. However, it is important to keep in mind the characteristic features of local political culture. Indeed, in this small country, organized around a State with little autonomy, three large 'families' govern a large part of social life. Liberals, Catholics and Socialists, divided moreover according to their linguistic affiliation (French-speaking or Dutch-speaking), share between themselves not only most of the available political representation, but

also most of the power in community life, trades union, insurance and therefore in the cultural sphere. The country is steeped in a sort of discreet politicization, a marking up of social life, which does not necessarily correspond to conscious or voluntary commitment. So, for example, a young Belgian born in a Socialist hospital, who goes to a state school, is dependent on Socialist insurance and receives his unemployment benefit from a Socialist trades union, can live this situation with no inference as to his political convictions. This local reality makes it impossible to trace the link between artists and politics only in the movements which demand of their members a strong and committed support. On the contrary, it is better to show that all artistic experiences of *les années folles* in Belgium were rooted in or linked to socio-political networks. The panorama which follows is therefore an outline of the political sociology of Belgian modernity between the wars.

A Socialist Tradition

The Socialist world is the first, as such, to have established links with the artistic avant-garde. These links go back to the last decade of the 19th century. Founded in 1885, the *Parti ouvrier belge* (POB) (Belgian Workers' Party) rapidly succeeded in embodying the 'social question' in the large towns and industrial centres of the country. It built its development on the organization of cooperatives and trades unions, but also, and most of all, on the demand for the right to universal suffrage. This gave concrete form, on the political level, to the hope of the working masses of attaining a better life. The general strikes which followed gave a measure of the power of the party. It was also shown in its capacity to absorb a certain number of young liberal intellectuals, who, for ideological as well as career-related reasons, decided to join. They gave the party the parliamentary executives it needed. The President, Émile Vandervelde, who led the party until the end of the '30s, came from this group. His first wife, Lalla Vandervelde, threw herself into the organization of a 'Section d'art' where artists they liked and spent time with could be both associated with the activities of the POB which in turn partly benefited from their fame. The artists invited to join the 'Section d'art' were those who also spent time with the 'Cercle des XX' and 'la Libre Esthétique'. They constituted, or at least wanted to constitute, a real avant-garde, united by the desire to renew artistic forms. The idea of commitment, in the modern sense of the word, was alien to them. Nor had they, for the most part, given allegiance to the Party, which in fact only got collective membership from local sections, and not from individuals. Moreover their presence at the section's tribune was significant, and it was effectively seen as a guarantee granted to the party's activities. For their part, the artists had the feeling that in this way they had a new line of communication with the 'peuple'. The symbol of all these links was inscribed in stone and iron. Indeed they met in the 'Salle blanche' of the Maison du peuple built by the architect Victor Horta. To decorate the venue, the painter Seurat had been commissioned to do a great canvas. Entitled *Au temps d'harmonie* (*In harmonious times*), the canvas never got to Belgium. It was replaced by a large head of Christ by Antoine Wiertz, which seemed to prophesy the 'new alliance' between artists and the proletariat.[1]

At the same time, the Socialist leaders were the first party heads to define a 'line' in the cultural field. Jules Destrée and Émile Vandervelde thus specified what expectations the Party could legitimately have with regard to artists. But they also underlined their respect for artistic freedom of choice, and their concern not to legislate in this area.

Little by little the Section d'Art weakened its position in the years leading up to the Great War. This said, it remained sufficiently present in the minds of the Socialist leaders to justify its rapid restoration after the Armistice in 1918. The young generation which took on its legacy was, however, able to abandon the symbolist aesthetic dear to their predecessors in order to direct Socialist choices in matters of Art towards a truly innovative trend. From then on, the POB could accommodate and supervise in Belgium the large movement which, coming out of Russian constructivism and taken on by the Bauhaus, renewed the need for refined and functional shapes, combined with a highly structured social project. This represented, as Eric J Hobsbawm recalled, one of the two great innovations of the International avant-garde, the other being Dadaism and Surrealism.[2]

This trend gave rise to the ambition to revamp all artistic *genres*. The review which embodied this in Belgium was called, significantly, *7 Arts* (1922–1929). This weekly journal was founded by Pierre and Victor Bourgeois, Pierre-Louis Flouquet, Karel Maes and Georges Monier (replaced in November 1926 by Paul Werrie).

The Bourgeois brothers' group managed to hold onto a large amount of initiative at a political level, notably by founding the F.A.B.E.R. (Faisceau amical Belgique Russie) which organized cultural contacts with the USSR, and therefore with one of the most advanced cinematographic productions, while at the same time taking up the field of poetry, with the creation of the *Journal des poètes* in 1931, jointly managed by Pierre Bourgeois and Pierre-Louis Flouquet. The latter was a close friend of Victor Bourgeois (who built him a house); he then collaborated with Van de Velde on the review *Bâtir*. *7 Arts* published numerous cinematographical columns signed by Léon Chenoy, Paul Werrie and Charles Dekeukeleire. They emphasized the importance of the 7th Art (cinema) as the area of the 'fusion des arts', which thus took over the place Wagner had assigned to opera.

It was also the Bourgeois who revived activity in the Section d'Art in 1924. The poet Pierre Bourgeois and his brother Victor, the architect, fought for a modern, social and functional art. Under the aegis of Van de Velde, they adopted a programme which admirably summed up the title of an article written by Victor and published in *L'Avenir social* on 31 December 1925: 'Le Beau par l'utile'. The Bourgeois brothers certainly had erratic success. Their main interest was architecture. The garden-city *La Cité moderne* (1922) made Victor Bourgeois' reputation. It was a project integrating urbanization, gardens (Louis Van der Swaelmen), and innovative architecture applied to social housing. In 1926 the École de la Cambre was created by the Socialist Minister Camille Huysmans for his friend Henry Van de Velde. Clearly under the influence of the POB, the new establishment adopted the options of Le Corbusier, but also those of the Bauhaus.

For a party which was gaining power at municipal and provincial levels, the need for social housing and the necessity of thinking in terms of hygienic and

PART II

CHAPTER 5

Modernity and Politics

Paul Aron

The most characteristic trait of the European 'avant-garde' movements of the first half of the 20th century resides in the link they established between formal revolution and political revolution. On the one hand, this is an old link. From Romanticism on, the boldest movements in art had often shown their sympathy with those who wished to change the social order. But this link changed in nature when the political parties, and notably the parties of the left and the extreme left, were reorganized from the 20th century. Indeed, they developed a very strong form of membership, which has sometimes been compared with that which unites the followers of a religion or sect, and they also put in place highly hierarchical and structured organizations which have been at one and the same time the terms of their efficiency and have provided the means of controlling their members. Overall, this tendency is not to be found in the traditional parties of the centre and the right, although the network formed by the numerous associations of the Catholic world has produced a comparable effect; at the extreme right of the political spectrum, other parties also developed a strong relationship with their members. These characteristics often placed artists in an ambivalent situation: they felt themselves torn between two belonging logics, the Art or the Party, and were obliged to choose between the two.

Seen from the beginning of the 21st century, these debates may seem archaic. Nonetheless, we must remember the role played by politics as such in the 'short 20th century' (Eric J. Hobsbawm). In Western Europe, indeed, the legacy of the French Revolution ensured for two centuries — till 1989 to be exact, year of the fall of the so-called Communist regime — the belief that politics was the most powerful vehicle of change in the lives of men in society. This is why artistic movements, which answered to the same requirement, could not help but come into contact with it.

French-speaking Belgium is no exception to this general rule. Although no cross-study of all artistic and political fields has ever been dedicated to this question, we can sketch out here a few of their points of contact. However, it is important to keep in mind the characteristic features of local political culture. Indeed, in this small country, organized around a State with little autonomy, three large 'families' govern a large part of social life. Liberals, Catholics and Socialists, divided moreover according to their linguistic affiliation (French-speaking or Dutch-speaking), share between themselves not only most of the available political representation, but

also most of the power in community life, trades union, insurance and therefore in the cultural sphere. The country is steeped in a sort of discreet politicization, a marking up of social life, which does not necessarily correspond to conscious or voluntary commitment. So, for example, a young Belgian born in a Socialist hospital, who goes to a state school, is dependent on Socialist insurance and receives his unemployment benefit from a Socialist trades union, can live this situation with no inference as to his political convictions. This local reality makes it impossible to trace the link between artists and politics only in the movements which demand of their members a strong and committed support. On the contrary, it is better to show that all artistic experiences of *les années folles* in Belgium were rooted in or linked to socio-political networks. The panorama which follows is therefore an outline of the political sociology of Belgian modernity between the wars.

A Socialist Tradition

The Socialist world is the first, as such, to have established links with the artistic avant-garde. These links go back to the last decade of the 19th century. Founded in 1885, the *Parti ouvrier belge* (POB) (Belgian Workers' Party) rapidly succeeded in embodying the 'social question' in the large towns and industrial centres of the country. It built its development on the organization of cooperatives and trades unions, but also, and most of all, on the demand for the right to universal suffrage. This gave concrete form, on the political level, to the hope of the working masses of attaining a better life. The general strikes which followed gave a measure of the power of the party. It was also shown in its capacity to absorb a certain number of young liberal intellectuals, who, for ideological as well as career-related reasons, decided to join. They gave the party the parliamentary executives it needed. The President, Émile Vandervelde, who led the party until the end of the '30s, came from this group. His first wife, Lalla Vandervelde, threw herself into the organization of a 'Section d'art' where artists they liked and spent time with could be both associated with the activities of the POB which in turn partly benefited from their fame. The artists invited to join the 'Section d'art' were those who also spent time with the 'Cercle des XX' and 'la Libre Esthétique'. They constituted, or at least wanted to constitute, a real avant-garde, united by the desire to renew artistic forms. The idea of commitment, in the modern sense of the word, was alien to them. Nor had they, for the most part, given allegiance to the Party, which in fact only got collective membership from local sections, and not from individuals. Moreover their presence at the section's tribune was significant, and it was effectively seen as a guarantee granted to the party's activities. For their part, the artists had the feeling that in this way they had a new line of communication with the 'peuple'. The symbol of all these links was inscribed in stone and iron. Indeed they met in the 'Salle blanche' of the Maison du peuple built by the architect Victor Horta. To decorate the venue, the painter Seurat had been commissioned to do a great canvas. Entitled *Au temps d'harmonie* (*In harmonious times*), the canvas never got to Belgium. It was replaced by a large head of Christ by Antoine Wiertz, which seemed to prophesy the 'new alliance' between artists and the proletariat.[1]

At the same time, the Socialist leaders were the first party heads to define a 'line' in the cultural field. Jules Destrée and Émile Vandervelde thus specified what expectations the Party could legitimately have with regard to artists. But they also underlined their respect for artistic freedom of choice, and their concern not to legislate in this area.

Little by little the Section d'Art weakened its position in the years leading up to the Great War. This said, it remained sufficiently present in the minds of the Socialist leaders to justify its rapid restoration after the Armistice in 1918. The young generation which took on its legacy was, however, able to abandon the symbolist aesthetic dear to their predecessors in order to direct Socialist choices in matters of Art towards a truly innovative trend. From then on, the POB could accommodate and supervise in Belgium the large movement which, coming out of Russian constructivism and taken on by the Bauhaus, renewed the need for refined and functional shapes, combined with a highly structured social project. This represented, as Eric J Hobsbawm recalled, one of the two great innovations of the International avant-garde, the other being Dadaism and Surrealism.[2]

This trend gave rise to the ambition to revamp all artistic *genres*. The review which embodied this in Belgium was called, significantly, *7 Arts* (1922–1929). This weekly journal was founded by Pierre and Victor Bourgeois, Pierre-Louis Flouquet, Karel Maes and Georges Monier (replaced in November 1926 by Paul Werrie).

The Bourgeois brothers' group managed to hold onto a large amount of initiative at a political level, notably by founding the F.A.B.E.R. (Faisceau amical Belgique Russie) which organized cultural contacts with the USSR, and therefore with one of the most advanced cinematographic productions, while at the same time taking up the field of poetry, with the creation of the *Journal des poètes* in 1931, jointly managed by Pierre Bourgeois and Pierre-Louis Flouquet. The latter was a close friend of Victor Bourgeois (who built him a house); he then collaborated with Van de Velde on the review *Bâtir*. *7 Arts* published numerous cinematographical columns signed by Léon Chenoy, Paul Werrie and Charles Dekeukeleire. They emphasized the importance of the 7th Art (cinema) as the area of the 'fusion des arts', which thus took over the place Wagner had assigned to opera.

It was also the Bourgeois who revived activity in the Section d'Art in 1924. The poet Pierre Bourgeois and his brother Victor, the architect, fought for a modern, social and functional art. Under the aegis of Van de Velde, they adopted a programme which admirably summed up the title of an article written by Victor and published in *L'Avenir social* on 31 December 1925: 'Le Beau par l'utile'. The Bourgeois brothers certainly had erratic success. Their main interest was architecture. The garden-city *La Cité moderne* (1922) made Victor Bourgeois' reputation. It was a project integrating urbanization, gardens (Louis Van der Swaelmen), and innovative architecture applied to social housing. In 1926 the École de la Cambre was created by the Socialist Minister Camille Huysmans for his friend Henry Van de Velde. Clearly under the influence of the POB, the new establishment adopted the options of Le Corbusier, but also those of the Bauhaus.

For a party which was gaining power at municipal and provincial levels, the need for social housing and the necessity of thinking in terms of hygienic and

functional urbanization constituted two essential concerns. But La Cambre did not limit its programme to the art of building. It was the field of an innovative educational adventure, the intellectual coherence of which was supposed to reflect the harmonious integration of the Fine Arts and Architecture with the art of living. For Van de Velde, however, aesthetics took precedence over politics. His ambition was to cure the world of ugliness by Reason and Beauty.[3]

It was also thanks to their intimate knowledge of the Germanic world that in the thirties Herman Teirlinck and Henry Van de Velde turned the La Cambre school into an important place in the history of experimental theatre. The small room of the *Institut Supérieur des Arts Décoratifs*, although minuscule, was used for testing the play of light, dappling set and actors in a totally new effect of homogenization of space. In 1935, Van de Velde invented a curtain composed of three fragments of a circle which allowed the scene to be hidden and unveiled by means of a diaphragm. Thus he made a particular point in the space appear instead of opening the scene in the median way by the red curtain. Teirlinck worked with his pupils in this little theatre putting on plays by Pirandello, Claudel (*L'Orestie*), O'Neill or plays of his own. He would present some of his productions to a larger public, at the Palais des Beaux Arts, in the palace at Laeken or at the Brussels Conservatory.

Accompanied by her husband, the painter Marcel-Louis Baugniet, the dancer Akarova collaborated with the playwright Herman Teirlinck and painters Floris Jespers and Anto Carte; she also lived in the studio built for her by La Cambre Professor Jean-Jules Eggerickx in 1937. Her shows, inspired by Satie, Debussy or Bela Bartok, in costumes of geometrical inspiration designed by Baugniet, her choreography integrated in Teirlinck's courses, her personal interpretation of the contemporary dance motifs inspired by Laban were like so many poetic representations of the modern movement in Belgium. Her spectacle based on Honneger's *Pacific 2.3.1.* was put on in 1934 at the Maison du Peuple in Brussels, during a demonstration in honour of the militant Italian anti-fascist Matteoti. Akarova danced in a simple black leotard, in front of a red set decorated with sickle and hammer. One only has to follow the activities of Akarova and those round her from day to day to see to what extent the Socialist world had succeeded in carving out a remarkable place for itself in the modern aesthetic trends in Belgium.[4]

The aesthetic modernist choices of the Socialist world were brought to a wider public by means of the weekly *A/Z*, richly illustrated with photographs, and very open to the international style.

The Socialist world exercised a great attraction over artists from very different backgrounds. In the field of the plastic arts, the Cubist and Expressionist movements thus made contact one after the other with Flemish Extremism and the 'parti ouvrier'.

Flemish Activism — nationalist movement in favour of the independence of Flanders — was linked to the artistic movements of the avant-garde. It brought about the action of the *Doe Stil Woort* circle from 1917, with the blessing of the *Raad van Vlanderen* (Council of Flanders) founded under the German Occupation. After the war, Activism tried to maintain its position, againt the official 'Belgianising'

trend. In Antwerp in particular, it found an intermediary in young bilingual artists. Paul Van Ostajien, Oscar and Floris Jespers, Michel Seuphor, Roger Avermaete tried to rally the Expressionist painters Constant Permeke, Gustaaf Van de Woestijne or Gust de Smet to a programme of artistic revival in the fields of painting or sculpture. This movement failed. Some of its members were going along with the pacifist obedience of the avant-garde — this was so with Roger Avermaete and his review *Lumière* — before distancing themselves from concrete political action. Others rallied round, if briefly, the network of international avant-garde members, such as those round Lassok Kassak's Hungarian review *Ma*. This was the case with *Het Overzicht* founded in 1921 by Michel Seuphor and Geert Pijnenburg, who were joined shortly afterwards by Jozef Peeters. Literary in orientation to begin with, the review then turned to the support of abstraction in painting, linking up notably with what Mondrian was doing in Holland and Malévitch in Russia. But a great number of these artists then came together round Paul-Gustave Van Hecke and his friend André De Ridder and the reviews *Het Rode Seil* (The Red Veil), then *Sélections* and *Variéties*. De Ridder, professor of Economic Sciences, was a militant Socialist. He was Chief Editor of the daily Socialist paper *Vooruit* in the thirties. It was not just by chance that this paper published propaganda caricatures and drawings signed by the big names of Flemish Expressionism (notably Gustave de Smet and Van de Woestijne).

The Catholic World

In general, the Catholic world was certainly the least well disposed towards artists. Not only because, from the artists' point of view, it embodied traditional values, but also because of the age-old mistrust of the Church towards the secular arts. The Church supported the applied and decorative arts, in particular in their craft components, but it rarely collaborate with the avant-garde. In Flanders, the religious painting of Albert Servaes and a few Expressionist painters was able to effectively link faith with art. Some interesting commissions were given to architects, interior designers and stained glass artists. Thus the Église de Forest (Brussels) provided the opportunity to realize a bold programme of reinforced concrete constructions; certain parts of the Basilique de Koekelberg, too, were characterized by the use of shapes and materials currently in fashion.[5] But this was mostly about the diffusion of formulae and not the participation of the Catholic world in the places and networks of their invention.

In the field of the theatre, however, it was quite different. During the Great War, Oscar De Gruyter's *Frontoneel* (Theatre of the Front) had put on shows aimed at the new audience which was made up of illiterate soldiers. In 1919, this producer founded the *Vlaamsche Volkstooneel* (VVT), a professional troop which was bolder and more demanding than many official theatres. Five years later, when the Dutch producer Johan de Meester succeeded him, the practice of itinerant theatre, capable of going to seek out its audience beyond the areas usually visited by traditional companies, was widely established. De Meester added to this new practice dramatic art inspired by the research of Meyerhold and the German Expressionist theatre.

The ideological message of Flemish nationalism, founded on Christian identity, thus overcame obstacles thrown up by traditional culture: it was in touch with the dynamic of a movement capable of being immediately understood by everyone.

The texts favoured by the VVT were inspired by the mystery plays of the Middle Ages or were put out to contemporary authors. Michel de Ghelderode acquired from this context a training in scenography at the highest level and also an enthusiastic public. By making use of the actor's body in a collective rhythmic production, and working boldly with masks and light, De Meester put on exceptional shows. He kept certain music-hall traditions with the aim of holding the attention of his audience, alternating surprise effects with moments of intense emotion. Camille Poupeye has described meticulously the sets of Anton Van de Velde's *Tijl* and Vondel's *Lucifer*, two of the major successes of the VVT and its set designer René Moulaert, who left for Paris in 1927 after working with Jules Delacre at the Théatre du Marais and putting together numerous sets for the Vlaamsche Volkstoneel. He worked with the Théatre Populaire de Paris, and with various productions on the edge of the Communist world. In this way Moulaert spent time with the French leftwing, in particular Henri Barbusse; he was also in touch with Meyerhold and was to use the experience gained into the Flemish Catholic demonstrations in support of the great celebrations organized by the Communists during the Front Populaire. The activities of the VVT were followed passionately and without sectarianism by *7 Arts*. By using the collective dynamism induced by the national movement in Flanders, he managed to invent new forms uniting the working-class basis with plastic creation. This success, borne out by abundant illustration, stands out in the country's theatrical history.[6] For obvious reasons, there is no francophone equivalent, with the exception of political theatre.

Art in the Service of Political Combat

The time between the wars was the era of mass demonstrations. Most of the political organizations claiming working class legitimacy organized big demonstrations and impressive parades. These were staged in such a way as to give maximum visual effect, as much to the spectators as to the 'actors' themselves. This 'théâtralisation de la politique', which the German philosopher Walter Benjamin had already picked up on in his time, and which had given way to the invention of countless propaganda techniques, led a number of designers to join forces directly with the political demonstrations.

By its use of spoken chorus and the techniques of *'agit-prop'*, the Proletarian Theatre of Communist Obedience prefigured the means put into action by the POB for the campaigns in favour of the Plan du Travail. In addition, when it distanced itself from the PCB by integrating the young Socialists into its troop, the Théâtre prolétarien became the théâtre du Peuple, and then, so as not to take the name of the existing theatre at Bussang in the Vosges, the théâtre de l'Équipe. Its 'Front populaire' spirit was to mark the start of the itinerant theatre with its wide social diffusion which Jacques Huisman claimed to follow when he founded the Théâtre national after the Second World War.

In the thirties, under the influence of the Soviet and German experiments, the practice of the spoken chorus became a matter of Socialist concern. Charles Plisnier (1896–1952), former militant Communist, close friend of Albert Ayguesparse and the organizers of the Proletarian Theatre, joined the Belgian Labour Party in 1933. In March 1935, he proposed the setting up of a technical commission alongside the propaganda committee for the Plan. This commission would have the task of establishing a 'plan d'ensemble de la propagande par la poésie, la musique, la plastique, le film, la radio, l'édition'. To this end he wrote an exploratory report, which remained unpublished. In it he theorized on the role of the spoken chorus as an instrument of emotional conviction:

> Si le chœur ne sert qu'à attirer le public par l'élément nouveau qu'il présente, s'il n'est qu'un divertissement, un ornement, il manque son but profond. Il doit nécessairement l'intéresser, mais il n'atteint pleinement son but que lorsqu'à l'aide de ses moyens plastiques et sonores, il place réellement les auditeurs dans cet état de disponibilité sentimentale, d'exaltation, à travers quoi les mots d'ordre prendront une valeur mystique. [...] Il faut que, sortant d'une salle où s'est donné un spectacle de chœur parlé, les spectateurs non socialistes, se sentent et au-delà de leur raison, entraînés dans le mouvement de la pensée et de l'action socialistes.[7]

In the brochure for the *Théâtre Rouge* (1935) bringing together works proposed by Arthur Haulot and Louise Larballette with propaganda groups for the Plan du Travail, a radiophonic spoken chorus of Plisnier's gives an idea of some of the techniques designed to create this mystical exaltation.

Other presenters in the theatrical world took part in similar enterprises. In 1925, Albert Lepage had mounted *Sketch 1925*, put on at the Maison du Peuple, then *Jour de la Jeunesse* with the help of the Young Socialist Guards.

On 1 May 1932, Henri de Man introduced his mass game *Wir*, a vast allegory of the working-class impetus towards Socialism. As a new dominant personality of the POB, de Man returned to Belgium to write the Plan du Travail, adopted in 1933 at the Christmas Congress. In this way the Party entered the 20th century propaganda world by adopting the research of its future president on the psychology of the masses. De Man got in touch with important young Socialists, already used to these methods: from Flanders, Maurits Naessens, from the Walloon area, Arthur Haulot. On 4 November 1934, Haulot, who had originally been a member of youth movements within the Party, united the groups of Walloon choral speakers in a new Fédération du Théâtre Rouge which was joined in the first instance by 9 different troops. A Writers' Confederation was also created to assemble as many texts as possible. Franz Dewandelaer was in charge of this project; in this context, he contacted the Front Littéraire de Gauche in order to publish, in March 1935, *Chœurs parlés* with texts by Léon Degand, Sadi de Gorter, Pierre Bourgeois, Albert Ayguesparse, Dewandelaer, Haulot, ... and Charles Plisnier who wrote *Le Christ chez les chômeurs*, with a Christ rising up against the apathy of the victims of the crisis. Once the Party came to power in 1935, de Man lost interest in this method; however some good initiatives were still to come to light in Belgium to support, amongst others, Republican Spain. Herman Closson was the author of a 'scenic *montage*' entitled *Espagne 36* — the text of which has never been found — but which was a direct

part of the propaganda in support of the Spanish Republic. This theatralization touched upon all aspects of public life. The funeral of the Socialist leader Émile Vandervelde was celebrated in this way in 1938 with a great parade, which was filmed for propaganda use by the film-maker Henri Storck (*Le Patron est mort*).

The Catholic Party, for its part, was also to take up the spoken chorus, but it multiplied the numbers of militants involved by several hundred. Having learnt the techniques of the spoken chorus at its annual congresses, the Christian Labour Youth of Canon Cardijn staged an event for its jubilee congress on 25 August 1935. *Nieuwe Jeugd*, written by the Rev. Father Bauweraerts, was translated into French by Émile Schwartz, thus making it a bilingual performance. But most of all, it was remembered for its impressive number of singers: 1,560 members of the C.L.Y. spread across the lawn at the Heysel stadium, directed by Lode Geysen, former stage manager of the Vlaamsche Volkstoneel. For logistical reasons, there was even a huge rehearsal of the spoken chorus on 10 July 1935 on Catholic Radio. On 25 August, the directives were followed to the letter: the uniform worn, the performance of the group, songs and music, strict alignment of the groups. The success of the Congress meant that other demonstrations of the same type were set up and the Catholic hierarchy, won over, organized a vast theatrical game at the Heysel stadium for the VIth Congress of Mechelen (13 September 1936). *Credo* was written by the Rev. Father Boon, translated by Schwartz and directed by Geysen; the whole character of the production was made by the participation of the composer Arthur Meulemans. From the moment of this new success, the Catholic Party was to abandon the spoken chorus in favour of this new form of collective activity, a cross between 'jeux mariaux' and 'festspielen'.

Since the spoken chorus, like singing, was also regarded as a recreational activity suited to youth movements, it is no surprise to see it put to use by Flemish nationalism, particularly by the Jongdinaso, an organization for young militants from Verdinaso. Short pieces of spoken chorus were published in the Jongdinaso review: *Trommelaars*, under the pseudonyms of Daglielo, De Jonge Vlag and Koen, chanting about their love of the country and pride in serving it. A few bolder publications were to appear with *Een Vlag waait open...*, by Wies Moens (1933) and later, *Laat ze niet rotten o Vlaanderland!*, by Cyril Verschaeve with a tribute to the Yzer pilgrimage.

The paradox of political commitment

While it is possible to document the existence of strong links between the worlds of politics and art, it must nonetheless be remarked that these links remain essentially due to circumstances or individual initiatives and are seldom if ever brought about by large political organizations. The only avant-garde literary group which clearly stood by its political convictions was the Surrealist group. However even this example shows just how much these convictions were open to ambiguity.

Paul Nougé, whose strong personality left its mark on all the trends in Belgium sympathetic to Surrealism, was amongst the first members of the founding group of the IIIrd International in Belgium in 1919. But, from the creation of the Communist

Party in 1921 — a merger imposed by Moscow on the two small groups claiming their links to the Extreme Left — Nougé began to distance himself from political militancy.[8] Nevertheless, he maintained links with the Secours rouge international until 1927, a humanitarian organization which was also responsible for the political open-mindedness of the International. At the time of the war in Spain and the attempt to bring about a Popular Front in Belgium, Nougé contributed to the paper *Combat*, which embodied this spirit of union. After the war he again joined a Brussels cell of the Communist Party with which he threw in his lot 'sans réserve'; at this time he wrote some film columns for the *Drapeau rouge*. He moved away at the beginning of the 1950s, but not to join any other political group.

His friends had similar itineraries. Scutenaire proclaims Stalinism at several points in his *Inscriptions*, even if his status as a civil servant might have dissuaded him from joining the Communist Party. As for René Magritte, the account of the painter Wilchar recorded by André Blavier suggests that he was made a member of the Party three times, in 1932, 1936 and 1945.[9] The Hainault Surrealists went still further in that direction. The painter Louis Van de Spiegele was a member of the Central Committee after the war, and Achille Chavée, party member since his time in the International Brigades, remained equally faithful to Stalin and to André Breton up till the time of his death.

These ideological choices are very different from those of the French Surrealists who all, at various moments, had to orientate themselves either with respect to the Party 'line' or remain faithful to the artistic-political choices of Breton. The Belgian Communist Party, for its part, sometimes showed a certain sympathy for working-class literature, but on the whole its leaders preferred to focus on the passing-on of cultural heritage, which, in fact, was not very different from the position of the Socialists. Therefore the only avant-garde group obviously committed did not find encouragement within the Party. The latter preferred not to take sides in debates where the aesthetic ins and outs were beyond its leaders.

From this point of view, the history of the aesthetic avant-garde is strangely reminiscent of that of more traditional trends. Its skirmishes with politics was inevitable, in a country where the social organization as a whole bore the mark of religious and political networks and pillars. However, since this mark is both diffuse, ubiquitous and discreet, it is there as evidence rather than a field of significant personal commitment. Politics is everywhere, which is to say at the end of it all, nowhere. It saturates public space and merges with it. The encounter of avant-garde artistic forms with political radicalism will not leave the banks of a short-lived Utopia in Belgium any more than anywhere else, but for different reasons.

Notes to Chapter 5

1. See Paul Aron, *Les Ecrivains belges et le socialisme (1880 — 1913): L'expérience de l'art social, d'Edmond Picard à Émile Verhaieren* (Brussels: Labor, 1985); re-edition: 1997.
2. Eric J. Hobsbawm, *Age of Extremes: the Short Twentieth Century 1914–1991* (London: Abacus, 1995), p. 179.
3. See Jacques Aron, *La Cambre et l'architecture* (Liège: Mardaga, 1982).
4. See *Akarova: spectacle et avant-garde 1920–1950: entertainment and the avant-garde*, ed. by Anne Van Loo (Brussels: Archives d'architecture moderne, 1988).

5. See Jos Vandenbreeden & France Vanlaethem, *Art deco et modernisme en Belgique: architecture de l'Entre-deux-guerres*, photographs by Christine Bastin & Jacques Evrard (Brussels: Editions Racine, 1996).

6. See the contribution by Fabrice Van de Kerkhove, in *Akarova: spectacle et avant-garde*, ed. by Anne Van Loo.

7. Quoted from *Charles Plisnier, entre l'Evangile et la Révolution*, ed. by Paul Aron (Brussels: Labor, 1988), p. 87.

8. Geneviève Michel, 'Paul Nougé: la réécriture comme éthique de l'écriture' (unpublished doctoral thesis, Universitat Autònoma de Barcelona, 2006).

9. René Magritte, *Écrits complets*, edited and annotated by André Blavier (Paris: Flammarion, 1979).

CHAPTER 6

Representation and Subjectivity:
Belgian Playwrights and Modernity

Pierre Piret

Theatre is one of the genres in which Belgian writers excelled between the wars. It enabled them to reach, in France as in Belgium, both public success and symbolic recognition: Francis de Croisset, who often wrote his plays together with Robert de Flers, continued to be successful in boulevard theatres; Paul Demasy was welcomed at the *Comédie Française*, and at Gaston Baty's and Lugné-Poe's theatres, the latter also showing — after Maeterlinck — Soumagne and Crommelynck, whilst a play by Louis Fallens was put on by Copeau; plays by Herman Closson, Albert Lepage and Ghelderode were staged at the Laboratoire Art et Action; etc. With hindsight, this contribution to theatre retains its importance given the innovative character of some of the works, which continue to stand out in the history of French language theatre. This is the case for those of Fernand Crommelynck and Michel de Ghelderode, who dared, like Maeterlinck before them, to invent new pathways heralding what was to become known as the 'new theatre.' In this way, a continuous line can be traced between three generations (1890s, between the wars and post-war), a line which has been recognized by several authors and critics: Crommelynck and Ghelderode both cited Maeterlinck as their inspiration; Jean Genet, an admiring spectator at several performances of *Fastes d'enfer*, declared: 'Il y a tout là, tout ce qu'on fera '; and today we see with ever greater clarity how much Beckett, Sarraute or Duras have in common with Maeterlinck.

In the first analysis, all these works — however singular and different they may be — equally reject a model of theatre which was judged obsolete, a model particularly well established in France for historical reasons I will not go into here. This model is that of the 'pièce bien faite' (Scribe), that is the highly polished play, closed on itself, and for this reason perfectly readable, transparent: maintaining clear boundaries between illusion and reality, between genres, between tones, exhibiting defined signification, producing masterful effects by using a conventional rhetoric, this theatre of triumphant rationality comforts the spectator in his position of exteriority, voyeurism and absolute certainty. Such a model thus simultaneously confirms a playwright's ideal and a given conception of the links between language, representation and subjectivity. This conception, now so obviously dated, underwent a major crisis from the end of the 19th century onwards, a crisis observed from close quarters by the invention of psychoanalysis, for example, and

that, later, of Saussurian linguistics. This crisis did not fail to affect theatre itself, as far as it affected this outdated *episteme*, a phenomenon which drove the playwrights of modernity to invent new forms.

Histories of French theatre generally consider, and not wrongly, that this invention was the product of what is called 'nouveau théâtre '. But it seems that the ground had been prepared by a certain number of playwrights, including Maeterlinck, Crommelynck and Ghelderode. The period between the wars in particular was certainly from this point of view a laboratory of modernity, in Belgium as in France. At this time, a series of playwrights, in no unitary way, produced plays that broke with the most fundamental constraints of the genre. But the apparent disparity of this theatrical production masks a coherence that was at the very least relative: all these *œuvres* are marked by the heightened and painful perception of a radical alienation — an alienation that was not existential (Sartrean), but structural, in the sense that it grew out of man's subjugation to the signifier (to language as structure). This perception is not merely thematic; it is also seen on the dramaturgic level, as the works of Fernand Crommelynck and Michel de Ghelderode show in their different ways.

Fernand Crommelynck or Disenchanted Representation

In December 1920, Fernand Crommelynck (1886–1970) was almost totally unknown in Paris and the staging of *Le Cocu magnifique* by Lugné-Poe was a revelation: as soon as the play was shown, people spoke of it as a masterpiece; it had a remarkable reception in France and abroad. The play was notably shown in Moscow, in 1922, by Meyerhold, who used a 'révolutionnaire' *mise en scène* which has remained famous.[1] This success however was not without certain misunderstandings, since, as the critical discourse shows, it only came about as the result of reductive interpretations.[2] This penchant towards interpretation is explained by the feeling of malaise produced by all Crommelynck's plays (one might say *inquiétante familiarité*): on one hand, the audience is able to see the patent references (*Le Cocu magnifique* revisits *Othello*, *Tripes d'or* reworks *L'Avare*); whilst on the other, Crommelynck does not seem to respect the models that he invokes from the moment that his characters begin behaving in an incoherent, even clearly absurd way (the jealous man ends up giving his wife to the whole village; the miser ends up eating his gold!). In an attempt to re-establish this apparently lost coherence, critics have described Crommelynck as a playwright of excesses, or of crises. Contrary to this theory, which Crommelynck's work resists, I wish to show that his work consists not in pushing the big traditional themes to their breaking point, but rather in denaturing them — precisely because he re-works them according to a new conception of the relation between language, representation and subjectivity.

In the way it is treated in *Le Cocu magnifique*, the fable of the jealous man (Bruno) is strictly associated with the story of his gaze. In this vein we can say that Stella, the object of his love and of his suspicions, plays no role whatsoever in the birth and development of his jealousy: she is the object of an enigmatic love, whose jealous gaze falls on her without ever being able to free itself of gnawing doubt.

The path Bruno follows is characterized first of all by the particular dramaturgic logic it obeys. Crommelynck himself underlined this fact, comparing his character to Othello: Bruno's jealousy does not obey the law of causality. In *Othello*, if Emilia states that jealousy 'tis a monster begot upon itself, born on itself', it is because she does not know that Iago, her husband, is the cause of his mistress's unhappiness; the spectator witnesses this terrible machination and knows how the Moor's jealousy has been conceived and nurtured. In *Le Cocu magnifique* on the other hand, the only reason given as the source of such jealousy (Pétrus's gaze, in which Bruno thinks he sees a flame burning) is removed by Bruno himself (after slapping Pétrus, he asks him to forgive this gesture and pretends to be cured), but for all this the doubt is no less present. The brutal release of jealousy precipitates Bruno, in an instant and irredeemably, from heaven to hell. The temporal structure of *Le Cocu magnifique* (and of all Crommelynck's plays) thus follows what we could call a logic of the *fall*. The first act is played out in total happiness, until, suddenly, the enchantment is broken, with no possible remedy. To alleviate the doubt that gnaws at him, Bruno shuts his wife away (act II), then gives her over to the entire village (not being able to be certain of her fidelity, he decides to be certain of her infidelity, act III), but in vain: how can he be sure that she is really cheating on him, that is with the other one, the only one who counts?

This brutal reversal takes place during a famous scene, the breast scene: overly happy during the celebration of Pétrus's return, (Stella's cousin and her childhood friend), Bruno makes his *belle* dance in front of him and manages to expose her 'petit sein sans péché ': 'Pétrus évidemment regarde. Et les yeux de Bruno ne quittent plus le visage impassible de son cousin. Et tout à coup, sans raison apparente, il envoie à Pétrus un soufflet formidable'.[3]

In the history of representations of jealousy, this scene is singular in two aspects: not only, as we have seen, the absence of causality, which makes this outburst of jealousy so sudden and enigmatic, but also the determining role given to the gaze of the other. When the problem arises, Stella is, so to speak, *hors du coup*. Whereas the ordinary jealous man suspects his wife first and foremost, here, Stella's own desire is only taken into account as a second thought: her potential duplicity is only secondary to that of Pétrus. But, as Bruno confesses, it is in his own gaze that everything takes place: 'Oui, je suis malade. Je n'ai plus le même œil' (p.48). In this way jealousy is explicitly presented as an illness consisting in a transformation of the eye: Bruno has lost what Merleau-Ponty described as 'foi perceptive';[4] Stella being shut out from now on, she is nothing more than a multitude of enigmatic signs — and irredeemably so. Bruno's jealousy does not stem simply from doubt, which could no doubt be assuaged; it is a more radical experience, that of the impossibility of knowing (if Stella is loyal to him just as if she is disloyal!).

In this way, his outbreak of jealousy leads to a more fundamental transformation, which touches on the *scopic field*: this transformation works less at the heart of the relation between Bruno and Stella than in the relation between the gaze of Bruno and that of Pétrus. From this point of view, Bruno's unexpected turn-around fits into a logical schema which is perfectly positioned and the play then takes on a certain coherence. One can indeed only be struck by Bruno's *hospitality*, from the

beginning of the play, even before Pétrus's arrival, to the gaze of the other. Having recently returned from town, he starts working, having a statement to write for the *bourgmestre*,[5] as well as a description of his property for the Count of Morten, who 'vend ses terres et son château' (p. 35). This is a truly admirable scene: Bruno simultaneously dictates the two texts to Estrugo, his scribe, and punctuates his words with allusions to the beauty of Stella, multiplying the potential confusion and ambiguity. When the *bourgmestre* arrives, Stella leaves to get Pétrus's room ready; as soon as she has left, Bruno starts to worry whether the *bourgmestre* is able to perceive the perfection that Stella incarnates in his own eyes:

> BRUNO, *au bourgmestre, s'exaltant*:
> > N'est-elle pas la plus gracieuse et la plus légère?
> > Elle marcherait sur l'eau sans mouiller ses souliers!
> LE BOURGMESTRE, *avec un gros rire incrédule*:
> > Oh! oh! non!...
> BRUNO, *étonné*:
> > Vous ne croyez pas? (p. 36)

The *bourgmestre*'s incredulity, which the reader explains as his incapacity to grasp the poetic subtleties (metaphorical and analogical) that pepper Bruno's speech, seems to sadden the latter and reduce his desire to persuade his interlocutor, as if his own desire depended on that of the other. He immediately calls Stella on a false pretext, to the point of lying to her, in order that the *bourgmestre* can admire her legs 'd'un élan incomparable' (p.38). This last affirmation signals Bruno's defeat: engaged in an infinite hyperbolic movement, he never manages to *spiritually* identify with anyone *in* the gaze he brings to bear on Stella. This incapacity is felt all the more painfully since, in his profession as a writer, Bruno is constantly staging the world through the biased eyes of language. Bruno is presented as the guardian of the power of words: he can say anything, describe anything — with the exception of Stella, whom he discovers to be ineffable. The description of the property that he had just started must become 'un véritable paysage' (p.35); as for the statement, it makes the *bourgmestre*, brimming with joy, say: 'Ah! Ah! je les vois, mes bougres! Je les vois à deux, à minuit, dans la forêt. Quelle besogne ils feront!' (p. 40). Bruno, just by speaking, is capable of making one see; however he responds, signalling at the same time the nature of his desire and what is missing for his love to be fully realized: 'Si tu pouvais voir Stella, à minuit! (p. 40)'. Throughout the first act, Bruno thus transforms the other into a double. In order to sustain his own desire, he forces someone else to imitate his own gaze. In the scene we have just analysed, the double does not live up to his role: the *bourgmestre* does not understand any part of Bruno's amorous discourse. When Pétrus arrives, however, the childhood friend, the intimate friend, a witness all the more loyal and sensitive because he has travelled the world... Initially, Pétrus's arrival leads this sentiment of *jouissance* that Bruno feels to its crisis point, when Stella is set up as a spectacle: Pétrus is the *double idéal*, to whom Bruno abdicates his desire and his gaze:

> BRUNO, *ému*:
> > [...] Je suis heureux. Te voici parmi nous. As-tu reconnu le village?
> *Estrugo sort.*

PÉTRUS:

> Il m'a paru plus petit, tassé, mais familier, humble et gai. Le chemin
> creux ne m'a pas effrayé comme autrefois.

BRUNO, *sans élever la voix*:

> Et Stella, tu vas la voir! Elle apprête ta chambre à côté de la nôtre.
> Tu la verras! Tu es ému! Moi, je tremble à ta place; c'est comme
> si j'allais la retrouver (p. 42).

In the same way that he has just re-discovered the village, Pétrus will see Stella again, with a totally new gaze; Bruno, jubilant, explicitly identifies with his perception; he asks him to wait, as if to further increase his own excitement. He starts showing her off with his words, punctuating his speech with the words 'Tu la venas'. When Stella arrives, he shows her Pétrus's eyes, which have seen the world. Then he adopts the latter's point of view, looks at her as a sailor might, appropriating his gaze in order to rediscover Stella: 'Pétrus, n'est-ce pas une merveilleuse ballerine? Sa marche est une respiration tranquille! Elle laisse un sillage lumineux après elle. Elle se balance comme une bouée sur le flot! Ah! Pétrus!...' (p. 44). The marine metaphors he uses to describe Stella are the concrete sign of this process of doubling and superimposition of gazes. Bruno gets a thrill out of seeing Stella through the eyes of his childhood friend, this alter ego, his perfect double, with whom he identifies more and more distinctly, until the reversal is suddenly produced: Bruno had thought that he could completely appropriate Pétrus's gaze; instead he discovers its radical alterity, its inaccessible part. An unbridgeable gap therefore develops, which kicks back, so to say, onto the loved object: Bruno discovers that Pétrus is seeing something in Stella which he himself does not have access to.

The brutal transformation of the relationship between Bruno and Stella can in this sense be understood as the effect of the representation's disenchantment. A breach, which will be impossible to fill, suddenly opens in the ideal and enchanted representation that Bruno had of Stella when he discovers Stella's absolute otherness. She had been transparent, completely visible, but this enchantment is torn to shreds when Bruno discovers that the Other who had supported his desire in truth grows out of his own gaze. Bruno perceives at this moment, simultaneously, his own division — between what he sees and what the other sees (the *lost object*, of which he is deprived) — and Stella's absolute duplicity, an enigma at the heart of the visible. From this point on, the only thing that counts is what he does not see, the rest being nothing but appearances. Until the end of the play, Bruno will keep coming up against the radicalism of this law which is suddenly revealed to him and the power of which he seeks to evade by any means. His attitude, the decisions that he takes — perfectly absurd in psychological terms, since the choice of infidelity is not linked to just any old resignation — are the expression of a unique and unfailing wish: to do away with the enigma of the visible. Two stages, dialectically linked, can be distinguished. First, Bruno attempts, by shutting Stella away and by masking her, to remove her from the gaze of the third party and therefore to overcome the enigma that surrounds her. The failure of this first solution leads him to put the reverse strategy into operation: inviting the other by showing Stella off, in the hope of capturing the gaze and in this way capturing the *lost object*, which is to say the invisible object.

In *Le Cocu magnifique* as in his other plays, Crommelynck asks fundamental questions about the relation of the human subject to language, which leads him to denature the traditional themes that he revisits. Notably he subverts the fundamental theatrical paradigm of being and appearing, and demonstrates the omnipotence of the symbolic law. Jealousy, for example, is no longer envisaged according to a dialectics of trickery which preserves the truth of the loved being (even if this being is masked). Instead, jealousy confronts the subject with a multitude of unverifiable signs.[6] This fundamental principle is not merely thematized in his *œuvre*, it also determines the dramaturgy. First, the construction of the action obeys a paradoxical logic, admirably resumed by the question that Bruno addresses to Stella: 'Dis-moi quelque chose que tu ne puisses me dire' (p. 49). By his very question, and the 'double contrainte' that it introduces, Bruno blocks the action's movement and prevents any dénouement from taking place (which corroborates the fact that the play is ending). Secondly, space systematically seems to double as soon as the one thing that counts escapes representation. Thirdly, the system of characters is structured around a point of incommunicability that is confirmed more and more: Bruno shuts himself into a universe without foundations or points of reference, and cuts himself off from the other characters, with whom no dialogue is possible any longer. Finally, spectators see themselves caught up in this vertiginous arrangement, as soon as nothing allows them to recognize Stella's 'truth' and they find themselves confronted with the enigma of the visible. This is where the double effort produced by the play comes from, the spectators being led to laugh about Bruno's absurd behaviour, but also to feel his absolute alienation and the tragic impossibility of knowing what sort of person it will produce.

Thanks to these aspects, Crommelynck's *œuvre* establishes a dialogue with contemporary research in theatre, despite its classical appearance.

Michel de Ghelderode or the Tyranny of Language

Michel de Ghelderode (1898–1962) was internationally recognized only after the Second World War, although his *œuvre* was almost entirely conceived between the wars. In this period, contrary to what he attempted to pretend later, his work as a writer rested on a considerable knowledge of the ins and outs, the means and the specifics of the theatre of his time. He notably took part in the adventure of the *Vlaamsche Volkstooneel* (popular Flemish theatre), which, under the guidance of the excellent director Johan de Meester, was able to achieve one of the great theatrical ambitions of the 20th century: to put on shows that were both popular and avant-garde. Ghelderode had the chance to take part as a playwright in what he termed this 'généreuse aventure': in this way he was to write from a position of direct contact with the stage, to try his new techniques out in a concrete way and to appropriate a language specific to the art of theatre. All this went on in an extremely stimulating context, Johan de Meester stamping a clearly modernist direction on his troupe, notably inspired by Russian constructivism and German expressionism.[7] It was in this context that Ghelderode wrote *Pantagleize*, which was first performed on 22 April 1930.

As its title clearly states, *Pantagleize* is a play centred on one character, a character defined, in the first analysis, by the original gaze with which he looks on the world, and on human society in particular. He is innocence incarnate, which unmasks, by its astonishment alone, all those who take part in the vast role play of society, in particular those who govern it (or pretend to do so). But if Pantagleize plays a structuring role in the play, it is perhaps more because he is constructed as an anti-character, whose innermost (and absurd) thoughts no-one will ever know. The presentation of the character in such a prominent position is instructive in this sense. We witness the staging of a body and the progressive construction of a totally objectivized character: Pantagleize is first perceived as two feet who 'entendent' and 'frémissent', then as a snoring sound, a man who 'parle en rêve', and finally as a body which 'se dresse, d'un bond, hors de sa caisse', which irons its costume — a clown's costume: 'Robe de chambre à ramages, pantalon trop court, chandail blanc et bleu de marin'[8] — and starts talking about different things. This initial *mise en scène* of the theatrical body unveils the constitutive principle of the character which will prevail throughout the whole play.

We learn elsewhere, during the first scene, that he is at a cross-roads in his life: Pantagleize is forty years old and feels that he has achieved nothing; having long believed that he would have 'un destin, un beau destin', here he is 'arrivé à l'âge où l'on glisse dans la catégorie des ratés' (pp. 17–18). One hope lives on, however, since his horoscope, predicted by the professor Estampah-Fakir, turns this normal day into an extraordinary one: 'Toi qui restas sans destin, le tien commencera inopinément quand tu atteindras la quarantième année. Ainsi disent tes astres' (p. 18). This prediction allows a typical scenario to be identified straight away: the search for identity. And Pantagleize — who is also a bastard (p. 42) — indeed sets off in search of himself. But this mission involves a paradoxical dimension in as far as its object and destination remain unknown and out of reach. Hence Pantagleize's passivity, as he is condemned to wait until his destiny fulfils itself, in order to discover it and learn, at the same time, who he is.

Now, this destiny is revealed to him in the form of a lure: Pantagleize awakes and pronounces words that couldn't be more conventional — 'Quelle belle journée' —, but it so happens that these words had been chosen by conspirators to trigger the revolution. He therefore sees himself pushed forward as emblem and leader of the revolution without knowing it, and the whole play unfolds, from this moment on, to the tune of misunderstandings, Pantagleize being incapable to interpret the situation correctly. This is why his progress seems controlled only by the law of chance and does not reflect any interior evolution, any personal progression. This does not mean that it is disjointed or incoherent; on the contrary, everything lines up perfectly, in an almost mechanical way, because Pantagleize, who has opened up his mind thanks to the initial prediction, and is thus ready to do anything to fulful his destiny, espouses the revolutionary cause. In this way, the two distinct movements that make up the play converge and we can now precisely set out Pantagleize's position in the action, which is exterior to him and in which he can participate, but without ever mastering it, without ever getting ahead of it: overall, in contrast with traditional heroes, Pantagleize does not act, but reacts. Out of this, grows the play's particular

temporality, driven by a law that is not the one, totally rational, of the project: when this law prevails, when the desire or wish of the characters present is set out, the action moves towards the future and becomes predictable, even for the spectators. But Pantagleize obeys a different principle, that of immediate concatenation: whatever happens (and anything can happen, nothing should surprise us) is determined by what has just happened, one surprise leads to another, one incident to another, the action remaining confined to a pure present, its coherence only appearing (if it does appear) later on. By defining his play as 'vaudeville attristant', Ghelderode himself underlined its particular character. Indeed, if there is a genre which leaves room for this logic of immediate concatenation, which multiplies coincidences and surprise effects, which shuts the character into the pure present, it would be vaudeville. And it is true that *Pantagleize* recalls, by its very rhythm, the perfect mechanics and the sometimes vertiginous speed of certain Feydeau plays. It also recalls, in a completely different register, some of Charlie Chaplin films, in particular *Modern Times* (1935), a film also characterized by the speed of the action (in tune with that of modern life) and by the concatenation of incidents. Like Pantagleize, Chaplin is caught up — literally — in the chain, in the mechanism of events and he sees himself placed, without wishing it, at the head of a social movement.

Amongst all Ghelderode's texts, *Pantagleize* is doubtless one of the most ambiguous. From the moment of its creation, it has also provoked violent and sometimes contradictory reactions. This ambiguity comes from the joint effect of two factors of indeterminacy which we have already highlighted: the character's construction and his position in the action. On the one hand, Pantagleize is shown to us from a strictly objective point of view: he is first of all a body (of the theatre: a clown) and not a recognizable discourse; he does not exist, as a character, in the form of a coherent psychological entity, existing prior to the play and out of which the spectators could interpret his present actions and attitudes. Pantagleize says so himself: when the play begins, he is nothing. On the other hand, as the play is governed by a double movement, Pantagleize takes on the role of a tight-rope walker, being neither clearly involved in the action, nor clearly outside of it. We can tell that he is not in charge of it: if he triggers the revolution, this does not mean that he leads it at any time (he is some way removed from being a heroic figure). However, he does take part in it, confusing it with his own destiny, and thus believing that he is playing an essential role: he is not simply like Candide, a victim of events. In this way, the Pantagleize character is not prepared for any of the outcomes expected: having no past, he is also, not without a project, but the carrier of an empty project, content-less, open to all possibilities.

Ghelderode himself theorized the radical indeterminacy which characterizes Pantagleize: 'Comme dans certaines peintures de Picasso, qui tiennent en leur découpage, j'ai pris une tête, des bras, des jambes... Du tout, j'ai fait un homme ...'[9]

This cubist definition is confirmed by the very name of Pantagleize ('all is clay') and by the retrospective way he looks at his journey: 'Mettez dans un sac une phrase stupide, une éclipse, une femme, un trésor, secouez le tout et il en sort mon destin' (p.121). We are of course reminded of Tzara's formula for obtaining a dada poem. Ghelderode shows in this way the principle for making a character: amalgamation.

And we can indeed see that Pantagleize does not make any claim to a particular discourse — he is a philosopher, and of course he writes, but without subscribing to the ideas that his texts articulate and which he does not even want to sign with his name: he is a ghost writer, after all (p.15) — but all of which he absorbs, indiscriminately. In the same way, he seems to have no existence of his own, only defining himself in the eyes of the other. His very imbecility is only a projection, an interpretation:

> Peut-être. C'est moi l'imbécile, un imbécile parmi les autres. Du moins je me donne cette apparence. Cependant, j'avoue ignorer ce que je suis. [...] Je suis l'imbécile, parfaitement. Celui qu'il vous plaît de voir en moi (pp. 36–37).

Pantagleize's ultimate indeterminacy, which makes him an anti-character similar to those of the new theatre, can be interpreted as the direct consequence of Ghelderode's specific re-appropriation of an old metaphor which has inspired the entire Western world: *theatrum mundi*. This metaphorical motif, which for Ghelderode is equivalent to a vision of the world, is omnipresent in his work, where every social relation is assimilated to a role play — the question always being to know who pulls the strings. Thus, in Pantagleize, the characters are explicitly identified with music hall actors (p.79), even with puppets, for example in the 'ubuesque' scene where the new ministers are killed off in turn (pp.87–88). 'Rêvé-je ou ne rêvé-je pas? Néant, qu'as-tu fait de ces marionnettes?', Pantagleize asks himself at this point, and this reaction perfectly illustrates the renewal of the metaphor because, traditionally, the theatre of the world is shown to a privileged spectator: God. Whether he is close by, almost made visible by his actions, or far away, unrecognizable, God in either case always remains present, a distributor of roles or, at the least, the one who understands the true sense in the immense masquerade we fall into; the social role-play has the immediate goal of the truth promised in the afterlife. In this way death often has, in Calderon or in Shakespeare, a revelatory value. But if Pantagleize's life is a dream, if the social agitation that surrounds him seems completely illusory, the entirety of this small theatre seems to be placed under the sign of nothingness. No transcendental guarantee comes along to counterbalance the reign of appearances, and this is why it is vain to look for any sort of truth about the character under its multiple masks: Pantagleize will never reach the revelation of his destiny, not even in death, which is wilfully absurd.

In this degraded vision of the baroque *theatrum mundi,* the character is in fact nothing more than a pure effect of language: this movement is given to a number of Ghelderode's plays, in which we deal with signifiers that have ended up here as if by chance and on which the character bases his existence. It is this tyranny of language which saturates the subject, enclosing it into the circle of random representations, ultimately denounced by Ghelderode's theatre, according to a perspective which is the complete opposite of Crommelynck's. The work of the latter is underpinned by the impossibility, for the subject of the enunciation, to identify with the subject of what is stated: the subject's being is always outside the representation, stolen by the hidden other, as Bruno puts it — this is why the movement of Crommelynck's plays always tends, asymptomatically, towards a point that will never be reached. With Ghelderode, on the contrary, the subject gets lost in what is stated, in the

signifiers projected onto him, not as a way of meeting his particular destiny, but as an alienating and brutal fatality — which, through his grinding and sometimes even destructive theatre, Ghelderode has incessantly attacked.

The two most significant Belgian playwrights of the interwar period therefore explored the vast issue of the relation between language, subjectivity and representation but they did it in different, even opposite ways. If this problematic is thematized in their works, it is even more prominent on the level of enunciation, in the dramaturgic innovations it leads them to, and through these, in turn, their plays announce the inventions of the 'new theatre'. In their own way, Crommelynck and Ghelderode therefore dedicated themselves, like other major contemporary playwrights, to understanding the considerable mutation that took place during the course of the 20th century; this mutation relates to the function of the sign in subjective and social life. This mutation, that the human sciences have analysed along the lines of rationality, was probed by these playwrights and this led them to transform theatre itself, or at least the theatrical model their predecessors had left to them.

Notes to Chapter 6

1. Cf. Alma H. Law, '*Le Cocu magnifique* de Crommelynck. Mise en scène de Meyerhold', in *Les Voies de la création théâtral (Mises en scène des années 20 et 30)*, (Paris: CNRS, 1979), VII, pp. 14–43.

2. Cf. Pierre Piret, '30 avril 1925. Première à Paris de *Tripes d'or*, de Fernand Crommelynck, dans une mise en scène de Louis Jouvet. Le théâtre à l'ère de la reproductibilité technique', in *Une histoire de la littérature belge francophone (1830–2000)*, ed. by Jean-Pierre Bertrand, Michel Biron, Benoît Denis and Rainier Grutman (Paris: Fayard, 2003), pp. 325–35.

3. Fernand Crommelynck, *Le Cocu magnifique* (Brussels: Labor, 1987), p. 45. All references are to this edition.

4. Maurice Merleau-Ponty, *Le Visible et l'Invisible* suivi de *notes de travail*, ed. by Claude Lefort, accompanied by a fore- and afterword (Paris: Gallimard, 1979), p. 17.

5. Belgian equivalent of the French 'maire'.

6. To explore this further, see, Pierre Piret, *Fernand Crommelynck. Une dramaturgie de l'inauthentique*, (Brussels: Labor, 1999), p. 357.

7. Cf. Roland Beyen, *Michel de Ghelderode ou la hantise du masque. Essai de biographie critique* (Brussels: Académie Royale de Langue et de Littérature Françaises, 1980).

8. Michel De Ghelderode, *Pantagleize* (Brussels: Labor, 1998), pp. 11–13. All references are to this edition.

9. Cited by Roland Beyen in his article: 'Un auteur et un personnage: Ghelderode et Pantagleize', in *Études de littérature française de Belgique offertes à Joseph Hanse pour son 75ᵉ anniversaire* (Brussels: Jacques Antoine, 1978), p. 288.

CHAPTER 7

A Sulphurous Time:
Les contes du whisky by Jean Ray,
a Translation of 'les Années Folles'

Thomas Amos

Nachwandlern gleich, gejagt
Vom Entsetzen der Träume[1]

GEORG HEYM

'Un cop ouvrait la porte criant: Time! Time!'[2]

Viewed from a distance, the twenties — that laboratory where so many Fausts, Frankensteins and Prosperos set to work — are revealed as the most fascinating, fruitful and decisive period of the *Interbellum*, if not the century. In breath-taking alternation, this dynamite-decade seems to anticipate in acceleration all the splendours and all the miseries of the years to come. Europe, shattered by the war, would never again see such a wide diversity of slightly ephemeral artistic movements: Dada having faded away and Expressionism gone out of fashion, there followed Surrealism, *Neue Sachlichkeit*, *de Stijl*, and the literature of Art-Deco and the *jazz-age*. At the same time, other types of 'avant-garde' and, in the truest and most deep-rooted sense of the word, fascisms, grew and became ready for the *Machtergreifung*. Strange epoch-making times! Anything seemed possible, and sometimes events of the most opposing nature coincided grotesquely, giving expression in this way to an almost cynical aberration, but which was only logical in a world out of kilter: the same year, 1924, saw the publication of the first *Manifeste du surréalisme* and Hitler's release from prison.

Such was the situation in Europe, when, in 1925, the *Contes du whisky* were published in Brussels, a collection of 27 texts whose author was a certain Jean Ray, real name Raymondus Joannes Maria de Kremer, from Ghent. The huge effect of this first work — *Le Figaro* hailed Ray as 'the Belgian Edgar Poe',[3] and other writers were quick to imitate his style — resulted from the fact that his contemporaries found their bearings in it and noted that its study of circumstances was accurate and to the point. The *Contes du whisky* do not in any way betray the spirit of the time in which they were written, and this becomes all the more obvious when one considers that Ray, in the next stage of his career, abandons the contemporary

period; *Le grand Nocturne, La ruelle ténébreuse* and *Le psautier de Mayence* and the novella *Malpertius* (1942–43) owe their trenchant strength above all to the fact that they are set in an artificial stylized world which lacks any connection with its surroundings.

The first of Ray's works is not, as general opinion would have it, the nucleus from which everything else stems, but a beginner's field of activity producing sometimes successful and, here and there, sometimes outstanding results. What is more interesting are the influences he came under before finding his original style. Ray, perfectly bilingual, who wrote, most unusually for a Belgian author, in French and Dutch, made the most of the exceptional position of his country bordering the neighbouring literatures of France, England, Germany and Holland, and did not spurn the idea of taking them as models. The *Contes du whisky* would have been inconceivable without the rise of other artistic trends of the time in Europe. Ray tried the avant-gardes, toning down his caustic approach and trying to reach a wider public; he was familiar with the European narrative tradition, so much so that he was able to make liberal use of it. For instance the topics are always used somewhat knowingly, as if Ray himself was surprised by his own ability to introduce them in a new context. But this extremely clever game with established narrative is perhaps just the most sophisticated artifice that experimental literature could invent. The attraction of the collection stems from the fascinating tension between traditional components and dominant innovation; not to mention moments where modernity sets a trap for the reader. Also, one would not agree that Ray was a traditionalist or conservative writer, a verdict given again by Marc Quaghebeur who seems to echo the old resentments against all apparently working-class literature. For Quaghebeur, Ray ranks among those authors who 'évitent la modernité et connaissent le succès'.[4]

The *Contes du whisky*, product of one of the two or three decisive interchanges of the 20th century, claim, no more no less, to be the balance sheet and soundings of the narrative and its possibilities and invite the reader, for ever and aye, to participate, to launch himself body and soul into the mad turmoil of the twenties, the true beginning of the century.

'Une formidable pêche aux fantômes et aux cauchemars'[5]

Typical of the twenties, the *Contes du whisky* take their inspiration from the principle of collage or combination, and, initially, one can only make out a jumbled collection. But this combination of the most incongruous elements seems less spectacular as soon as one realizes that, in the realm of the fantastic, pioneer collections such as Hoffmann's *Die Serapionsbrüder* (1819–21), *Tales of the Grotesque and Arabesque* (1840) or Gustav Meyrink's *Des deutschen Spießers Wunderhorn* (1908) are distinguishable by their multiplicity and reflect the entire literature of their time. An overall view of the *Contes du whisky* will throw into relief the main characteristics of the collection and its particular nature.

The Form of the Narrative is of its Time

Since the novella, that great society lady of the past century, did not survive the caesura of the First World War and died after a brilliant swan song with a deeply meaningful title, Thomas Mann's *Der Tod in Venedig* (1913), Ray, together with many other European authors, found themselves confronted by the necessity to find a narrative form appropriate to the age.

The solution is to shorten the text. In the *Contes du whisky*, a majority of the texts are made up of between roughly 550 and 1600 words; the exceptions being the opening story *Irish whisky* (about 3000 words) and *A minuit* (about 350 words). By making this decision as to the story or, more generally, the short text, Ray returns to the output of authors at the end of the century and the century before. Influenced by Poe's famous postulate in *The Philosophy of Compostion* (1846), he asks of the story, as of all literary works, not to go beyond a certain length so that the reader might read the texts at one go ('there is a distinct limit, as regards length, to all works of literary art — the limit of a single sitting'[6]), otherwise the effect is in danger of being weakened. But let us leave aside the theoretical approach. Ray, who had been working in journalism since 1919, immediately understood that a short narrative is better suited to a public and a situation which have changed. A quite clear conclusion to which American authors had already come a century earlier: the *Contes du whisky* were written for the hard-pressed reader of magazines and newspapers, where Ray actually published them initially (*L'ami du livre, Journal de Gand, Ciné*). This kind of literature, obviously orientated towards the public and the market, was quick to arouse the suspicion of being trivial, superficial, in short 'louche'. Another writer-journalist, the Italian Dino Buzzati, also had to do battle with this prejudice.

In order to take stock of the innovation from the formal point of view, let us start with what Ray put aside. *Irish whisky*, the longest text, shows all the signs particular to the novella: the action of narrative-outline, the small number of characters, the turning point required by Schlegel/Tieck, the conflict directed resolutely towards the end, the 'unheard event' ('unerhörte Begebenheit'), indispensable for Goethe, the strict structure with compressed exposition, a sudden change of fortune or situation, and attenuation. But it is easy to see that Ray only pretends to re-install the novella; in reality, he destroys, with a certain amount of pleasure, the body of the text, cutting it as if with a scalpel: the narrator stops incessantly, incidentally, to drink whisky, thus blocking the flow of words, creating passages of unequal length. The text really seems reduced to its components. This process, which Ray employs throughout the narratives in his collection *Le grand nocturne*, is similar to the putting together of a film, in particular that of *Das Cabinett des Dr. Caligari* (Robert Wiene, 1919). In a film, the scenes are separated from one another in an exceptional way: the camera's eye closes and opens at the end of each scene so that the spectator feels alternatively asleep and awake. An amusing idea for a horror film, *Caligari* counterfeits a state of sleep, the *rapid eye movement* (sic), the dream phase.

Despite the fact that all the texts in the *Contes du whisky* have no problem in fulfilling Poe's fundamental formal criterion as regards length, we hesitate to

apply the term *short story* or *récit court* to all the texts in the collection. Put forward by Washington Irving in *The Sketchbook* (1820) and supported in 1842 by Poe in his critique of Hawthorn's *Twice-Told Tales* (1837), the American *short story* never once betrays its origins, the novella, the most important narrative form of the XIXth century, so that it might even be considered as a compressed novella. As a consequence, the old primacy of the epic genre, the primacy of the narration of an event, is never lost in a *short story*. On the contrary, from the beginning of the last century, the narrative, or rather, the short text, tends to hold back, interrupt and omit the action. Increasingly the *plot*, which is, in the classical sense, laid out with care,[7] loses so much of its importance that, after 1945, the *récit court* is often restricted to a snapshot, whose fragmentary nature serves to create a temporary reality.

The *Contes du whisky* mark a turning point. Most of the texts relate an action, even if Ray already begins to give less importance to the action. Some examples will show that Ray is gradually distancing himself from it as the decisive element of the narrative: at the beginning of *Une main*, he sketches out 'the story of the kite'[8] before stopping short ('ce récit sera pour une autre fois'[9]); *Le nom du bateau* and *Petite femme au parfum de verveine* finish with prose poems; *Minuit vingt* consists of just a dialogue or rather a film scenario in the reader's head. Finally, *La dernière gorgée*, a scene on its own, with nothing before an open end, brings about the total break and, with no conventional action, attaches much more importance to the characters. This is how Ray anticipates the dissolution of the narrative in favour of a more or less completed part-text.

Given that their short compressed form characterizes the collection, the diversity of texts in the *Contes du whisky* appears thinner on the formal side; it is necessary to study the contents of the texts to see the particular element of each one.

Fantastic & Co.

The fantastic element characterizes many of the texts in the *Contes du whisky*. According to Tzvetan Todorov (*Introduction à la littérature fantastique*, 1970), a fictional text recounting an apparently supernatural event belongs to the fantastic genre if it fulfils two criteria.[10] Firstly: the text presents the reader with two possibilities, the acceptance of the supernatural or restriction to known natural laws. The fantastic is characterized by 'the hesitation'[11] of the reader, born in a moment of 'uncertainty'.[12] A decision in favour of one of the two possibilities will bring the reader on the one hand to the marvellous[13] (e.g. the fairy tale), on the other to the weird;[14] the fantastic stands on a line separating these neighbouring categories. Secondly, the reader, by staying with the literal sense, rejects a poetic or allegorical interpretation.[15]

If we apply this diagram, thirteen of the narratives in the collection belong to the fantastic. But what does the fantastic of the *Contes du whisky* resemble? The thematic of the fantastic is dominated by animal metamorphosis (spider, *Irish whisky*; salmon, *Le saumon de Poppelreiter* and *Entre deux verres*; *Le singe*) and by the object with supernatural power (a ring, *Josuah Güllic, prêteur sur gages*); a Hindu statuette (*Le singe*); a clock, (*Minuit vingt*; *Le tableau*). Apart from that, Ray uses monsters (*Dans les*

marais du Fenn; *La bête blanche*), an animated hand (*La dette de Gumpelmeyer*), a female vampire (*Le gardien du cimetière*), a curious being, half-woman, half-seal (*Entre deux verres*) and a ghost (*Irish whisky*). Ray introduces no haunted house or room — he gives an entirely original turn to this in his novel *Malpertuis* — and allows the only ghost just a brief appearance, but his narratives, extremely well constructed, follow the traditional 19th century canon of the fantastic and hardly take the informed reader by surprise.

One exception stands out, *Les étranges études du Dr Paukenschläger*. Here, Ray dares to advance into a new territory, that of *cosmic horror*, introduced into 20th century fantastic literature by the American H. P. Lovecraft and continued by his disciples, and which totally changed the genre. Lovecraft starts from the supposition that very ancient divinities, horrible creatures, threatened the world, coming either from the universe or from the depths of the ocean. After the publication of *The Call of Cthulhu*, he starts to invent a whole paramythological system. The other source influencing Ray, the works of Einstein, very popular at the beginning of the twenties, introduce the idea of a fourth dimension of time, and, by means of a process of popularization, space; all sorts of beings could make their entry by means of this latest door.[16]

A foretaste of *cosmic horror* is given by the beginning of *Une main*, a short independent text about a kite which is flown, equipped with microphones, to gather the sounds of the sky during a night storm which makes 'un cri, une plainte, quelque chose pas tout à fait de ce monde-ci'.[17] More tragic, is Paukenschläger's experience, a definitive initiation into the terrors from beyond the sky and beyond time.[18] The *mad scientist* and his unwilling *famulus* manage to make contact with the world of the fourth dimension thanks to a strange contraption, and both end up becoming the victims of unnatural entities ('figures de cauchemar entremêlées à des formes sphériques et coniques').[19] For the first time, Ray sketches out a place which is important to his later narratives, an intercalary world, neighbouring on our own and peopled by curious beings, threatening and dangerous. Note that this parallel world is (again) seeking support from science fiction: 'une dizaine de grosses sphères, bulles bizarres, bondissent sur le marais, et les mêmes fumées tourbillonnantes les remplissent'.[20]

From the other side of the fantastic, the weird largely escapes an exact definition. Todorov asks of a 'weird' text that, without the supernatural making its appearance, it should provoke in the reader an effect similar to that of the fantastic, that is to say a feeling of disorientation.[21] With *La nuit de Camberwell*, Ray satisfies these requirements brilliantly by creating a little work of art disguised as a news item. The man he knocks down in the middle of the night is not a burglar, but the actual owner of the house, and the narrator has got the wrong address. A London filled with fog, the loneliness of the people who live there, the deceptive charm of the home, the struggle in the shadows — the whole atmosphere is heavy with hostility and menace, recalling the inexorable world of Kafka where the absurd reigns. This is why one can claim with all justice that, if a narrative can make a resident of the metropolis shudder, it is *La nuit de Camberwell*.

The narratives where a revelation ends up destroying the fantastic are more numerous; according to Todorov, it has to do with the 'weird-fantastic'.[22] In

L'observatoire abandonné, classic version of the supernatural explained, the 'Dead Horse' which haunts a lonely landscape of the Pyrenees turns out to be the invention of smugglers to keep importunate visitors at bay; another time, the horrifying transformations of a would-be magician are the result of faulty glass (*La fenêtre aux monstres*). Or, another example: the ghost is only the narrator's friend come with the firm intention of stealing a bottle of whisky from him (*A minuit*).[23] In *La vengeance*, the protagonist kills his father and hides him under the floor; the knocking he soon hears does not come from the dead man, but from the rats which are going to devour the assassin.[24] Thanks to this ending, as also in *A minuit* and *La fenêtre aux monstres,* Ray escapes the danger of deceiving the reader by a prosaic explanation of the supernatural.

The marvellous is slightly neglected in the *Contes du whisky*, with only one text which confirms the supernatural in its ending. As the last sentence of the *Gardien du cimetière* establishes immutably the existence of the female vampire, the narrative, fantastic up to that point, turns into the marvellous; Todorov would talk about the 'fantastique-merveilleux'.[25] Despite its apparently definitive title, a problematic case seems to be *Un conte de fées à Whitechapel*: a street girl, Priscilla Malverton, victim of a cruel joke set up by two rich dandies, is saved by an archangel and marries one of the millionaires. Setting aside the fact that the appearance of God himself and the Virgin are atypical in fairy stories and that divine intervention is not necessarily the supernatural one might have expected, it remains unlikely that there will be a marvelous deliverance. For the instance where the reader believes in it, a legend is offered — the conversion of a prostitute. *Un conte de fées à Whitechapel* is appreciated for its true worth, if we consider that the public, demanding its right both to dream and escape, loves the most unlikely strokes of luck, particularly the turnaround of a happy ending. A tendency to sentimentalism, to kitsch, is perceptibly added in Ray's texts:[26] art touches up reality. Consistent with one of the characteristics of the literature and film of the twenties,[27] a new narrative form is born which is nothing more than an adaptation of the traditional fairy tale. The modern variant — Ray claims explicitly to follow a tale from the *Mille et une nuits*[28] — retains both the characters and of course the cheerful function, but, instead of dwelling on the supernatural, prefers to set an unbelievable and improbable event in an everyday setting and 'un temps proche, tout proche de nous.'[29] *La fortune d'Herbert* gives a typical example: the desperate protagonist, both unlucky *and* unemployed, throws himself out of the window, remains safe and sound, but, on reaching the ground, kills a millionaire; the nephew of Croesus who was in fact just going to be disinherited, generously recompenses Herbert — and considers the whole thing 'très vraisemblable'.[30]

The cynical (and necessary, it seems) counterpart to this unblemished world is, in the *Contes du whisky*, the cruel tale. According to Villiers (*Contes cruels*, 1883 and *Nouveaux contes cruels*, 1888), this term, hailed by turn–of–the–century authors who curtailed their novellas of this type, was coined to describe a narrative where cruelty, be it psychic or physical, is central, cultivated and celebrated. But in spite of the fact that vengeance and cruel punishment — favourite themes of the sub-genre — are used on several occasions in the *Contes du whisky*, genuine examples are rare.

Sometimes, Ray takes great pleasure in not fulfilling the reader's expectations; thus *Un conte de fées à Whitechapel* begins as a cruel tale of the first order — two men want to give Priscilla a day of great luxury so that afterwards she will feel her poverty all the more —, and turns into an edifying legend. *La bonne action* both makes fun of the cruel tale and relies on it: when a heartless multi-millionaire wants to achieve great things, he causes the death of a solicitor. *Herr Hubich dans la nuit* picks up on another workable theme, unrequited love:[31] a good provincial German falls in love with a French singer and, to give real proof of his love, commits suicide but the woman leaves the small town before the death is discovered...

It seems significant that the cruel tales of the collection do without loud or shocking actions.[32] Whereas a horror story in the true sense is lacking — compared to Lovecraft's *horror* stories, *Les étranges études du Dr. Paukenschläger* only constitutes an attenuated form[33] —, several narratives contain horrifying scenes or details. Ray wants to inspire disgust in the reader, for instance by the representation of monsters: 'une énorme main brune terminée par des griffes horribles. La matière en était gélatineuse et peu consistante; elle se décomposa, au bout de quelques minutes, en un liquide rose et gluant, d'une odeur insupportable'[34] (*Dans les marais du Fenn*) or 'un cadavre flasque, mou, glaireux, d'une consistance douteuse'[35] (*La bête blanche*). Ray's monsters obviously come from the fair; however, exactly the same beings — amorphous, fetid, disgusting — fill Lovecraft's works and share the notion of monster right to the present day. The female vampire's death in *Le gardien du cimetière* is reminiscent of the excessive (and almost comic) violence of Punch and Judy, where fear becomes a game: 'avec un grand hocquet, qui éclaboussa les murs de sang noir, la vampire [...] s'écroula sur le sol'.[36] To sum up, Ray does not recoil before the horrific or rather 'the sight of horror',[37] but his description has a reserved, minimalist style, very different from the overloaded writing, *camp ante litteram*, of Lovecraft. At the same time, the use of strong colours (e.g. 'immenses yeux nyctalopes de flamme verte',[38] (*La bête blanche*) show up the passages where something awful or shocking happens in the course of the narrative; it is the transposition of film method into another medium, as silent films used colour in some parts of the black and white images.

Even if the grotesque is defined quite simply as the combination of opposite elements — beautiful and ugly, comic and dreadful — it runs right through the *Contes du whisky* and, together with the fantastic, leaves its mark on the collection. Looking at it more closely, the three areas targeted by the grotesque — according to Wofgang Kayser, who was the first to treat the grotesque as an aesthetic category[39] — are dealt with by Ray.

For Kayser, the process of creation of the grotesque results from the psychic condition of the artist; let us add to this rather imprecise criterion, that of course the author is not autonomous, but submerged in a world, a time, and a society. Undeniably, the disposition or predilection for the grotesque is missing in classical times, which were stable and peaceful, while times of crisis, determined by disturbances and the fall of an old order, propagate it.[40] This therefore explains the numerous appearances, especially in Germany, of the grotesque narrative from the beginning of the century up to the twenties; Nazism, with its rejection

of any practice of anti-realist style, loathed the grotesque, which it considered to be one of the principal elements of 'Entartete Kunst', or 'degenerate art'. There is an immanent subversive force in the grotesque. Its aim is to evoke contradictory feelings in the reader/spectator: Christoph Martin Wieland talks about 'Gelächter, Ekel und Erstaunen'[41] (laughter, disgust, amazement: *Unterredungen mit dem Pfarrer von ★★★*, 1775). Moreover, ambivalent perception links the grotesque to the fantastic (the weird or the marvellous) in such a way that the two frequently back each other up: hence the grotesque characters in the tales of Hoffmann, Armin and Gautier. Ray concedes this predominant role to the grotesque because the reader has to experience the same fluctuation of feelings as people of the time — the Interbellum, a historical period destined to come about without making a success of it — enthralls at every step with flagrant antagonism. If a higher being watched over Europe in 1920, it was surely the terrible sneering demon of the grotesque.[42]

Having looked at the so-called psychological category and that which concerns the aesthetic effect, we should now characterize the grotesque by its subjects. If the grotesque corresponds to an effort to conjure up and evoke the demoniacal in the world, Wofang Kyser's hypothesis,[43] it is important that it makes its appearance as the gargoyles do on the façades of Gothic cathedrals. The following themes, which abound in the grotesque throughout time, are discernible in the *Contes du whisky*: madness (of the narrator, on which both *Le saumon de Poppelreiter* and *La fenêtre aux Monstres* open); the monkey as human caricature (*Le singe*); the deformed monster (Gilchrist, half-man, half-spider swallows a fly in *Irish whisky*[44]) and the repugnant monster with a tender heart (*La bête blanche*[45]); the malignancy of objects demonstrated by the pursuit of a chopped hand (*La dette de Gumpelmeyer*[46]); the two-handed duel 'Ce fut une lutte grotesque, insensée' (*Josuah Güllick, prêteur sur gages*).[47]

Ray varies and modernizes the story of Beauty and the Beast twice over,[48] as tragic farce (*Herr Hubich dans la nuit*) and — by alluding to the initial text, Mme Leprince de Beaumont's fairy tale, which appeared in 1757 — as a touching story: with an air from *Madama Butterfly*, a singer stops two bad youths from attacking rich clients in a bar (*Petite femme aimée au parfum de verveine...*[49]).

Sometimes even the form of presentation reflects and imitates the tortured state which the grotesque constitutes. *Le nom du bateau* is divided into two antithetical halves; Ray begins with the bad jokes of four drunken crooks going down a canal in a barge stolen from a Jew; the inscription on the prow, *La Sion retrouvée*, once revealed, leads onto the turning point: faced with the synonym of much longed-for paradise, but a paradise out of reach for them, these unfeeling men fall into sentimental reverie. Behind these opposites, can be discerned the well-known theory developed by Victor Hugo who defends the mixture of the grotesque with the sublime (*Préface de Cromwell*, 1827); Ray goes as far as to bring together in his characters not only the two manifestations of the grotesque proposed by Victor Hugo (the deformed/horrible and the comic/buffoon[50]), but also the sublime or at least the parodied sublime of sentimentalism.

In Detail: Boat and Metamorphosis

In spite of everything, the *Contes du whisky* show a certain unity by the use of a leitmotiv, for example, whisky, the city of London, fog, in short, an England in the style of Edgar Wallace. We meet, too, stereotype characters (rich, poor, lawless; the two philosophical vagrants Bobby Moos and Hildersheim run through the collection[51]); the bar in the *Site enchanteur*, transfigured place and luminous haven, makes several appearances.[52] This creates a homogenous atmosphere and background and, for the reader, makes for easier access to the collection which is presented as a closed world. It remains for these elements to carry out a more or less decorative function like the scenery and accessories on stage, their value more symbolic than substantial, remaining quite visible all the time. Ray's art, which consists of amalgamating tradition and modernity, is best expressed in his treatment of the symbol of the boat and the theme of metamorphosis.

Hear the Sailors' Cries

The boat, omnipresent in Ray's work as a symbol or rather a striking image,[53] also surfaces time and again in the *Contes du whisky*. From the beginning of the collection, *Irish whisky* takes pleasure in destroying the dreamy romantic view that the public still held of the sea at the time of the Atlantic liners: in order to pocket the amount insured, Gilchrist, the rapacious shopkeeper, plays his part in the death of the crew and sinks a cargo ship, the name of which, *Waverley*, deliberately goes back to a novel of Walter Scott's, published in 1814, at the height of English romanticism. Even the spirit of adventure, Ray suggests, does not escape human greed.

The boat plays a more important role in the triad of stories about the sea spread about here and there, a sort of sub-section, in the *Contes du whisky*. *Le nom du bateau* and *Entre deux verres* have substantially the same *plot*: some layabouts want to use a boat to find happiness but fail miserably; in a transparent allusion, Ray evokes the boats used for madmen in the Middle Ages, which were sent aimlessly down the rivers and whose crew of exiles was just a perpetual provocation to the ecclesiastical and secular authorities.

The short series of sea stories in the collection ends with a bang and by making a final point. *La dernière gorgée*, discussion between two sailors in a boat at the moment of shipwreck, seems, at first glance, a re-make of the prologue-scene of *The Tempest* (1611), the last of Shakespeare's plays. But behind this superficial similarity are hidden fundamental differences.

With the sailing boat, Ray claims to follow a long and rich tradition: from antiquity, raising sail (*vela dare*) was used as a metaphor for making verse.[54] Ray has recourse to this easily understood imagery, but in such a way that the few nautical terms he uses ('les amarres se sont rompues',[55] 'Le mât est parti... Le roof'[56]) turns the imagery on its head. Given that it is indispensable to any avant-garde movement to reject fiercely whatever it aims to outstrip, Ray literally sinks bad poetics by dismantling the boat, slowly and with relish, until nothing is left of it.[57] The *Contes du whisky* are born out of this creative void. The same poetic

(and artistic) renewal, otherwise called *Modernity*, is introduced in the penultimate verse of *Bateau ivre* (1871) when, after a great surge of words and images, Rimbaud falls into a minimalism full of almost indecipherable signs and once again based on a boat of very different nature: 'Si je désire une eau d'Europe, c'est la flache / Noire et froide où vers le crépuscule embaumé / Un enfant accroupi, plein de tristesse, lâche / Un bateau frêle comme un papillon de mai'.[58] Was Ray thinking of these lines? In the cave where the siren-seal swims, drawing in the sailors, there is a 'un trou rempli d'eau noire'.[59] (*Entre deux verres*)...

In Germany, among the admirers, and sometimes the imitators of this supreme poem appear the Expressionist generation and the young Bertolt Brecht. *Die Hauspostille* (1927), which reads in places like a verse transcription of the *Contes du whisky*, pays homage to Rimbaud several times. Besides the *Ballade auf vielen Schiffen* or the *Ballade von den Seeräubern*, it is the song *Das Schiff* which comes closest to the French model. However, it is significant that Brecht — who was soon to turn to Marxism — is already doubtful about the form (and Bourgeois art) so that his rotting boat changes, as a culmination, into an amorphous, monstrous thing: 'Eine Insel? Ein verkommnes Floβ? / Etwas fuhr, schimmernd von Möwenkoten/ Voll von Alge, Wasser, Mond und Totem / Stumm und dick auf den erbleichten Himmel los'.[60]

The complex symbol of the boat has another no less important meaning which refers to the political dimension of the *Contes du whisky*. The allegorical representation of the State as a ship on a stormy sea appears time and again in Greek and Roman authors, but it is Horace who caused it to become wide-spread with a well-known ode (I, 14). This poem is almost certainly the common point of departure for both Shakespeare and Ray, as these two borrow essential elements from it: the nautical terminology, the seriously damaged boat, the desperate situation with no hope of divine assistance.[61] Going beyond the warning of civil war hidden in Horace's allegory, they expose their boats to a storm, anr make them sink to indicate and illustrate existing crises: the loss of the feudal society and the beginning of colonialism, the end of the First World War. Georg Heym's story *Das Schiff* (posthumously entitled *Der Dieb*, 1913) builds a terrifying plot round this allegory which in the meantime has become topical: on a boat in the South Pacific, the mysterious apparition of a woman in black causes the deaths of all the sailors in succession, and is then revealed as the personification of the plague. Certain indications, especially the international nature of the crew and the striking final image, confirm the allegorical character of the text and turn it into a prophetic presentiment of the war. The boats evoked by Heym and Ray are called *Europe* and represent the continent before and after the war.

The other part of the image, the 'Sturm', the fantastic storm ('Quelle tempête, boy! Je n'en vis jamais de pareille!'[62]) which is rife in Ray's work, comes, if we acknowledge his gift for this, straight from German expressionism. After Herwarth Walden launched his weekly magazine, *Der Sturm*, in 1910, the term meant a force which, like a natural phenomenon, shakes or even destroys the era of the Kaiser; it is one of the great simple words idolized by expressionism.[63] A few years later, the German poet Jakob van Hoddis (1887–1942) wrote in his well-known poem

Weltende (1918), a perfect summary of the situation after the war, including ironic nuances in these lines: 'Der Sturm ist da, die wilden Meere hupfen / an Land, um dicke Dämme zu zerdrücken'.[64]

Ray differs from Shakespeare as to the nature of the storm. In Shakespeare, however powerful, the storm is theatrical, brought about by the magician Prospero, as shows the concise stage directions ('a tempestuous noise of thunder and lightning'.[65] Ray, on the other hand, sketches out an almost apocalyptic setting by plunging everything into darkness ('Il fait noir, noir'[66]) with the sea portrayed as 'une ligne blanche au milieu du ciel.'[67] Following a practice typical of Ray, the images are not described, as if in the shadows: they come together and run like a film in the reader's head. By contrast with the travellers described by Baudelaire, who announce quite nonchalantly 'Enfer ou Ciel, qu'importe?' (*Le voyage*), Ray's characters foresee that their situation anticipates the fate which awaits them — nothingness. The exclamation 'Quelle horreur!'[68] sums up an atmosphere completely without hope.

The prologue-scene of *The Tempest* brings face to face two opposing social groups, kings and their courtiers on one side, sailors on the other. Under the cover of an apparent fairy story, the conflict of a political drama unfolds. Ray is far from following in Shakespeare's ambitious steps. The semi-philosophical semi-political statements on forms of government, power and the abuse of power, crime and punishment developed in the course of *The Tempest*, are, by Ray, reduced to very concrete wishes: his spokesmen, poor wretches, simply dream of what they do not have, that, is affection, love, prosperity. Ray sets realistic description against the debates of the Shakesperian play; as it happens, he rejects every explicitly political statement. The critic recognizes more and more in Shakespeare's later works, in particular *The Tempest*, the forerunners of the epic theatre of Bertolt Brecht,[69] the dialogical presentation and sometimes nihilistic humour of *La dernière gorgée* anticipates the theatre of the absurd, the grave-diggers of *Hamlet* are set in modern times where their laughter sticks in their throats.

In Motion: Metamorphosis and its Forms

No term other than metamorphosis — in German: (*Ver-*)*Wandlung* — corresponds better with the eventful and transitory decade of the twenties. Familiar with the inherent symbolic range, Ray picks up the theme in almost every story in the *Contes du whisky*. The boldest metamorphosis being the most startling, Ray changes men into animals. He uses the device purposely, since a character commonly associated with an animal has a fairly obvious connection with it; thus a cruel grasping shopkeeper becomes a spider (*Irish whisky*[70]), an ignorant collector transforms into a primate (*Le singe*). Both times, the metamorphosis serves as punishment for misdeeds and is accomplished by degrees, slowly and painfully. The reader is reminded of La Fontaine's saying 'Je me sers d'Animaux pour instruire les Hommes'[71] and can see that the didactic message of the allegory, present without necessarily being interpreted, and the fantastic tale, are brought together to best advantage. Very definitely influenced by fable and caricature, myths and fairy tales,

these metamorphoses hardly make any impression on a world which, but for the fantastic element, functions exactly like the real thing.

A more fascinating metamorphosis takes place in *Le saumon de Poppelreiter*, in which a certain Mr. Pilgrim, a respectable Bourgeois, is able to change himself at will into a salmon. Ray rejects any explanation or objective foundation for this remarkable gift and finally extends it to others: Poppelreiter, Pilgrim's assassin, shut up in a psychiatric hospital, takes the warders for fish: 'Qui en esturgeon, qui en carpe-miroir, qui en petit poisson rouge.'[72] The absurd and light-hearted nature of these metamorphoses and their proximity to Surrealism are so obvious that, with reference to the beginnings of another artistic movement of the time, one might talk about a surrealist fantastic. The restraint with which Ray approaches this singular subject finds its equivalent in Surrealist painting, that of Dalí or Magritte[73] or, previously, in Kafka's stories. Contrary to what happens in *Die Verwandlung* (1915), where order is restored after Gregor's death, which comes as a comfort to his family, Ray enjoys shaking the belief placed in so-called reality beyond the reading. The unformulated morality, here and in most of the texts in the collection, is to lose reason: those who take part are quickly relegated to the mad-house, a place which, according to *Das Cabinett des Dr. Caligari*, reflects in miniature the situation of a world let loose. The psychiatrists Caligari and Mabuse (*Dr. Mabuse der Spieler*, Fritz Lang 1922) seem to be there to cure a sick society: a seductive thesis, and Siegfried Kracauer regards this type of person as the strong man, sought by a large part of the German population after 1918.[74]

A similar fate, internment in a psychiatric hospital, finally awaits the narrator in *La fenêtre aux monstres* who, fascinated and repulsed, observes the 'diaboliques métamorphoses'[75] of his neighbour: 'Une fois, ses mains se séparaient du corps et semblaient vouloir s'agripper dans le vide; une autre fois, son corps se scindait au milieu; une autre fois encore, tout son être n'était plus qu'une boule de chair et de vêtements d'où grouillaient des mains longues et décharnées'.[76] In a real kaleidoscope of fear, Ray links metamorphosis to metamorphosis, image to image with no other aim than to frighten or, sometimes, to create the grotesque ('Et cette tête suspendue en l'air, me disait bonjour...'[77]). The swift succession of these images, on a window-pane, set in its frame, imitates the sequences of a film, and the whole performance, preceded by the raising of a curtain,[78] is like a film show. More so, certain topics and their use — the little town caught in an eternal Biedermeier, the leaning architecture of the buildings ('Les fenêtres et les corniches, les moellons s'enchevêtraient en d'impossibles courbes.'[79]), the long (Chinese) shadows, the demoniac character of the neighbour Haans, his expressive gestures — come from the silent films of the twenties, for example *Caligari*, *Nosferatu* (Friedrich Murnau, 1921) or *Dr. Mabuse der Spieler*. Ray's story, the title of which, *La fenêtre aux monstres*, paraphrases in poetic terms the earliest cinema, is a film study in this sub-style called, in France, *caligarisme*, and provides the literary equivalent of a trend found in cinema[80] — fantastic expressionism or the expressionist fantastic.

But when German expressionism swooped on the term 'metamorphosis', its defenders remembered their innovative and revolutionary leanings and took on only the total transformations planned for the State, society and the individual.

A literature with such didactic aims likes to draw in parallel two psychic stages, two degrees of existence, including the accentuation of change and its motivations, in order to illustrate its message by a case example.

The *Contes du whisky* takes radical psychic metamorphosis as a theme time and again. Usually it fails: Gilchrist — set up as a counterpoint to the famous Scrooge, the skinflint who is transformed into an altruist in Dickens' *A Christmas Carol* (1843)[81] — remains incorrigible and is punished (*Irish whisky*); Güllick (*Josuah Güllick prêteur sur gages*) and Gryde the moneylender (*Le tableau*) do not seize the chance to overcome their hardness of heart and they, too, die of it. Ray's hatred falls on the rich; his stereotypes of the enemy are moneylenders ('Dieu punisse les usuriers!'[82]) who take advantage of destitution. The opposition of rich and poor maintained throughout the collection recalls the clear world of the fairy-tale — and is appropriate to the hard reality of post-war Belgium, where the economic crisis was to last until 1925. But at bottom, this Manichaeism is not really enough, as Ray limits himself to representing the state of things without offering a solution. *Une main* relates a successful metamorphosis which leads to a gesture of solidarity: the narrator offers the hand which appears at the window one night, holding a knife ('Cette main tremble de froid, de faim, de douleur'[83]), a glass of whisky, then shakes it for a long time. In honeyed tones which even so let the expressionist pathos come through, Ray upholds the demands made by man on man, but, at the end of it all, he is just writing a poem in apolitical prose. These hand-shakes take place, slightly modified, in *Metropolis* (1925/26, Fritz Lang) in which the final scene shows the symbolical coming together of the industrial (in the allegorical language of the film: the brain) and the team leader (the hand), approved by Maria, half-saint, half-revolutionary (the heart). Siegfried Kracauer reflects back onto the dubious nature of this way of talking, which forces nothing, and moreover bears a resemblance to Nazi speech.[84]

The one time a man fundamentally mends his ways comes in *La dette de Gumpelmeyer*. Throwing out a beggar, the jeweler Gumpelmeyer inadvertently tears off the man's hand with the steel shutter of his shop-window; after this incident, a strange disease, like leprosy, afflicts the shopkeeper's own hand, and his decline begins, until he is living like a pariah. Only when he mutilates himself and loses his infected hand, does he pay 'sa dette devant Dieu et devant les hommes.'[85] The Christian morality stands out clearly: whoever violates the commandment of love thy neighbour, will be punished (by divine justice); only penitence can ward off the worst.

If we compare Ray's texts with Ernst Toller's typically expressionist drama *Die Wandlung* (1919), we notice the same generally idealistic tone — much more emphatic in Toller, while much more moderate in Ray. Setting out his own biography, Toller recounts the tale of a metamorphosis, named in the sub-title 'Das Ringen eines Menschen', one man's hard struggle: full of enthusiasm, a young bourgeois goes into the army as a volunteer and, as a result of his experience of war, becomes a pacifist and a revolutionary. From then on, Toller and Friedrich, his protagonist, are fired by the wish to bring their message to the world. The poem at the beginning sets out the duty of the poet on his path to a new humanity: 'Den Weg! / Den Weg! — / Du Dichter weise.'[86]

Toller believes firmly in the goodness of man and the possibility of positive change in him; a moving vision including a social utopia concludes his play, expressed by the protagonist: 'Geht hin zu den Reichen und zeigt ihnen ihr Herz, das ein Schutthaufen ward. Doch seid gütig zu ihnen, denn auch sie sind Arme, Verirrte!'[87] Like the whole of Toller's play, these words encapsulate the atmosphere which, after the war and the fall of the Kaiserreich, were to rouse German writers and encourage them to involve themselves in current affairs during the Weimar Republic in a way they had never done before.

Ray, on the other hand, seems to be resigned: *La dette de Gumpelmeyer* does not compensate for the despairing pessimism of the other stories, for example *La dernière gorgée*. The metamorphosis of the jeweler happens in too forced and painful a way to be more than a feeble ray of light in the dark and, at times, nihilistic world of the collection. There remains the slightly hesitant attempt on Ray's part to use the fantastic to touch on the social question, which implies two crucial dangers — as demonstrated by Ray's great role model, Charles Dickens: the story is at risk of falling unexpectedly either into allegory, or a certain sentimentalism. Unlike Dickens,[88] Ray escapes the allegorical temptation, but the bland tone, no doubt appreciated by the reader of the time, is rather irksome to us.

The *Contes du whisky* are among the rare cases where literature of the fantastic — to which we were used to attributing quite conservative, not to say reactionary, tendencies — takes a progressive direction and criticizes society, although the outcome, a kind of Christianity of the heart, remains unclear. In the panoramic view of the twenties given by the *Contes du whisky*, Ray has no intention of swapping the magic wand (Caligari's cane, that of the omnipotent stage producer) for the school-master's index finger; he is soon to abandon that way, chosen without conviction, for an explicitly political literature. Ray's commitment from then on, above all in the works published during the Occupation,[89] consists of challenging so-called reality by recounting unheard-of and disturbing stories, full of frightening images. Can there be a more subversive literature than this?

Notes to Chapter 7

1. 'Like sleepwalkers, chased by the fear of dreams'; Georg Heym, *Dichtungen und Schriften*, ed. Karl Ludwig Schneider, 3 vols (Hamburg & München: Ellermann, 1964), I, p. 320.
2. Line of the sonnet 'London News' by Jean Ray, quoted by Jean-Baptiste Baronian & Françoise Levie, *Jean Ray: L'archange fantastique* (Paris: Librairie des Champs-Élysées, 1981), p. 162.
3. François Truchaud & Jacques Van Herp, *Jean Ray* (Paris: Editions de l'Herne, 1980), p. 106.
4. Marc Quaghebeur, *Balises pour l'histoire des Lettres belges de langue française* (Brussels: Labor, 1998), p. 240; see also pp. 240–49.
5. Jean Ray, *Contes du whisky* (Verviers: Gérard, 1965), p. 71.
6. Edgar Allan Poe, *The Complete Works of Edgar Allan Poe*, ed. by James A. Harrison, 17 vols (New York: AMS Press, 1965), XIV, *Essays and Miscellanies*, p. 196.
7. The thriller is influenced by this propensity: *The Big Sleep* (London: Hamish Hamilton, 1939) gives the account of a murder left unexplain by Chandler .
8. Ray, *Contes*, p. 123.
9. *Contes*, p. 124.
10. Tzvetan Todorov, *Introduction à la littérature fantastique* (Paris: Seuil, 1970), p. 37 sq.
11. Todorov, *Introduction*, p. 29.

12. *Introduction*, p. 29.

13. *Introduction*, p. 29.

14. *Introduction*, p. 29.

15. *Introduction*, pp. 63–79.

16. Ray tackles these theories in a few words in his narrative, in *Contes*, p. 166.

17. *Contes*, p. 123 sq. There are some similarities with *The Statement of Randolph Carter* (written by Lovecraft in 1919 and published in May 1920 in *The Vagrant*) but Lovecraft's story, unlike Ray's, still belongs to the *gothic horror* genre.

18. Lovecraft uses an almost identical framework in his narratives. It is possible that the American author was familiar with *Les contes du whisky*.

19. Ray, *Contes*, p. 217.

20. *Contes*, p. 216. See Marc Vuijsteke, 'Les univers intercalaires de Jean Ray', in François Truchaud & Jacques Van Herp, *Jean Ray*, pp. 234–47.

21. Todorov, *Introduction*, p. 51 sq.

22. *Introduction*, p. 49 sq.

23. The plot of *A minuit* — the protagonist, faced with a supernatural being, repents of his life — is, quite remarkably, identical to that of the lyric drama *Der Tor und der Tod* (1900) by Hugo von Hofmannsthal to the point of allowing us to call it a distorted style form.

24. The narrative mixes Poe's *The Tell-Tale Heart* (1843) with the end of *Ambrosio or The Monk* (1796) by Matthew Lewis, the most successful 'Gothic' novel of the 18th century; the theme of parricide, the *Vatermord*, is present throughout expressionism (let us cite for example Arnolt Bronnen's drama *Vatermord* (1920).

25. Todorov, *Introduction*, p. 57 sq. Ray certainly knew Gautier's *La Morte amoureuse* (1836), the example cited by Todorov to illustrate the 'fantastique-merveilleux' ('Introduction', p. 57 sq.).

26. Cf. the scene in the sky, in Ray, *Contes*, p. 47.

27. Even a 'serious' author like Heinrich Mann cannot forego it. Cf. the novels *Mutter Marie* (1927) and *Die große Sache* (1930). Carl Mayer plugs *Der letzte Mann* (1924), film about the gradual slide of a hotel porter, with a fabulous ending: having been present at the death of an American millionaire, the social outcast becomes heir to an immense fortune. See Siegfried Kracauer, *From Caligari to Hitler: A psychological history of the German film* (Princeton: Princeton University Press, 1947), p. 100 sq.

28. Ray, *Contes*, p. 37 sq.

29. *Contes*, p. 48.

30. *Contes*, p. 52.

31. The most interesting elements of this tale are without doubt the intertextual references to Apollinaire's cycle of poems *Les Rhénanes* (*Alcools*, 1913) and Heinrich Mann's novel *Professor Unrat* (1905). Is Ray commenting on the Franco-German relations of the time? Rather, he is writing a mocking story around one of Victor Hugo's sayings: 'France and Germany are essentially Europe. Germany is its heart; France is its head'.

32. Ray seems to take as model a narrative of Villers, 'La torture par l'espérance', in *Nouveaux contes cruels* in which the Inquisition lures the prisoner into believing that he will be released.

33. However, we find in it this passage concerning a vagrant, another victim of the fourth dimension: 'l'homme n'avait pas de figure! [...] il n'y avait plus qu'une section vette, rouge, bouillonnante de sang, comme si un invisible couperet s'était abaissé sur le front du malheureux', Ray, *Contes*, p. 214 sq.

34. Ray, *Contes*, p. 60.

35. *Contes*, p. 163.

36. *Contes*, p. 183.

37. *Contes*, p. 26.

38. *Contes*, p. 159.

39. Wolfgang Kayser, *Das Groteske in Malerei und Dichtung* (Hamburg: Rowohlt, 1960), passim, especially pp. 133–42.

40. For Kayser, grotesque figures protest again all rationalism and systems of thought, *Das Groteske*, p. 140.

41. Christoph Martin Wieland, *Sämtliche Werke*, 39 vols, (Hamburg: Hamburger Stiftung zur Förderung von Wissenschaft und Kultur,1984), X, p. 517.

42. Edgar Poe refers to this demon in *The Angel of the Odd* (1844).

43. Kayser, *Das Groteske*, p. 139.

44. Ray, *Contes*, p. 24 sq.

45. *Contes*, p. 164 sq.

46. *Contes*, p.223 sq.

47. *Contes*, p. 100.

48. Hugo is wrong to say that 'l'Antiquité n'aurait jamais fait *La Belle et la Bête*' ('Préface de Cromwell' (Paris: Librairie Larousse, 1972), p. 53. An example demonstrating the opposite: Vulcain, ugly and lame, and his wife Venus. But Antiquity was not as fascinated by the grotesque and the grotesque combination as French Romanticism, for example.

49. With this story, Ray pays homage to Puccini, who died in Brussels in 1924.

50. Hugo, 'Préface de Cromwell', p. 45.

51. The two layabouts are found mostly in the texts with a philosophical undercurrent ('A minuit', 'Le Nom du bateau', 'Petite femme au parfum de verveine', 'La dernière gorgée').

52. 'La Nuit de Camberwell', 'Petite femme au parfum de verveine', 'Mon ami le mort'.

53. We limit ourselves to giving one brilliant example (which shows, yet again, the eminent influence of film on Ray); in 'Le Fantôme dans la cale' (from the collection *Le grand nocturne*), Ray takes pleasure in transforming the dark hold of a cargo ship into a cinema where a horror film is being shown for a drunk tramp.

54. For the history of this metaphor, cf. Ernst Robert Curtuis, *Europäischer Literatur und lateinisches Mittelalter* (Bern & München: Francke, 1973), pp. 138–41.

55. Ray, *Contes*, p. 127.

56. Ibid., p.131. With this specialist terminology (and semblance of reality), Ray gives an idea of the first scene of *The Tempest*.

57. As in Shakespeare: 'A brave vessel [...] / Dash'd all to pieces', I, 2, *The Tempest*, ed. by Frank Kermode (Walton-on-Thames Surrey: Nelson, 1998), I., 3. p. 9 sq.

58. Arthur Rimbaud, *Œuvres* (Paris: Garnier, 1960), p. 131.

59. Ray, *Conte*, p. 87.

60. 'An isle? A rotting raft? / Something sails, bright with seagulls' droppings / Full of seaweed, water, moon and dead things / Silent and huge towards a pale sky' (my translation); Bertolt Brecht, *Gesammelte Gedichte*, 4 vols (Frankfurt am Main: Suhrkamp, 1978), I, p. 181. Brecht seems to allow himself here a little slightly coarse bit of fun. Is he thinking of the English noun for 'Möwe'? It is 'sea-gull', the French homophone of which ('cigale') takes one back, in this context, to La Fontaine's fable. The 'Möwenkoten', the seagulls' droppings, would therefore be those of the poets...

61. Torn sails are considered the worst destruction; Horace addresses the boat: 'Non sunt integra lintea' (Q. Horatius Flaccus, *Oden und Epoden* (Berlin: Widmannsche Verlagsbuchhandlung 1958), p. 73.

62. Ray, *Contes*, p. 101.

63. Cf. the article by Franz Werfel, 'Substantiv und Verbum', *Die Aktion*, 1–2 (1917), columns 4–8.

64. 'Here is the storm, the wild seas leap / To the land to crush the sturdy dykes' (my translation); Kurt Pinthus, *Menschheitsdämmerung* (Hamburg: Rowohlt, 1959), p. 39. The collection begins with *Weltende*.

65. Shakespeare, *Tempest*, p. 3.

66. Ray, *Contes*, p. 128.

67. *Contes*, p. 127.

68. *Contes*, p. 127.

69. Thomas Metscher, 'Shakespeares Spätstücke als episches Theater betrachtet', in *Shakespeare Jahrbuch (Ost)*, 115 (1979), pp. 35–50.

70. Hanns Heinz Ewers, *Die Spinne* (*Die Besessenen*, 1909), a spider-woman forces a young man to hang himself at the crossing. Ray holds his German colleague in great estimation (cf. his account of the collection *Das Grauen*, published in 1908, Truchaud & Van Herp, *Jean Ray*, p. 392 sq.

71. This line can be found in the dedication to the *Fables* (Paris: Flammarion, 1966), p. 49.

72. Ray, *Contes*, p. 82.

73. A good example, in *L'Invention collective* (1934), René Magritte paints a creature half-woman, half-fish in the process of transformation. *La Présence d'esprit* (1906) places the well-known man with a bowler hat (a sort of *alter ego* to Magritte), dressed in black, between a gigantic falcon and a fish. We imagine that Magritte, great connoisseur of (popular) literature, read Ray's work. *La présence d'esprit* and *Le Maître d'école* (1954; a mysterious man, probably the devil, is called in that way in 'Le Psautier de Mayence'), the man in the bowler again, was to be influenced by Ray's texts.

74. Cf. the chapter 'Procession of Tyrants', in S. Kracauer, *Von Caligari*, pp. 77–88.

75. Ray, *Contes*, p.142.

76. *Contes*, p.144.

77. *Contes*, p.143.

78. *Contes*, p.142.

79. *Contes*, p.145.

80. Gustave Meyrink showed the way with his novels *Der Golem* (1915) which generated several cinematic adaptations) and *Walpurgisnacht* (1917).

81. Ray explicitly mentions Dickens' story, in *Contes*, p. 8 sq.

82. Ray, *Contes*, p. 91.

83. *Contes*, p. 125.

84. Kracauer, *Von Caligari*, p. 163 sq. and p. 287.

85. Ray, *Contes*, p. 229.

86. 'The way! / The way! / You [show it], wise Poet' (my translation) Ernst Toller, *Gesammelte Werke*, 5 vols (München: Hanser, 1978), II, p. 9.

87. Toller, *Werke*, p. 61; 'Go to the rich and show them their hearts, which have become a heap of rubble. But be good to them, for they too are wretched and lost' (my translation).

88. *A Christmas Carol* is obviously very close to a fairy story, and it seems that Dickens swings away from the fantastic on purpose.

89. It is of course possible to read in *Malpertuis* (1943) the coded situation of Belgium during the occupation; however, that would be just one way of reading a complex novel which crosses at will very different temporal levels.

Belgian Photography between the Two World Wars, or the Hesitations between Late Pictorialism and the New Vision

Danielle Leenaerts

Modernist photography in Belgium was born on the still warm ashes of a major movement in the history of photography: Pictorialism. Considered as the first manifestation of an autonomous photographic aesthetic, Pictorialism had developed internationally at the end of the 1880s, before being progressively replaced by new tendencies in the 1910s. In this context, the Belgian particularity lies in the fact that this transition, far from being a rupture, was rather tenuous. For the most part, the promoters of the pictorialist aesthetic remained faithful to it, updating it by associating it to contemporary motifs.

The renewal of photographic expression in the movement of the avant-gardes during the first quarter of the 20th century, which the Hungarian Moholy-Nagy named the 'New Vision', thus found in Belgium a deferred echo. As Pool Andries, curator of the Museum voor Fotografie in Antwerp emphasizes, we cannot speak in Belgium of a breaking point between late Pictorialism, inherited from the end of the 19th century, and a modernist track emerging suddenly after World War I: 'On a plutôt le sentiment que le bien-fondé du pictorialisme n'a jamais été véritablement remis en question, en particulier chez les amateurs. C'est en douceur que le renouveau allait s'installer', and the writer identifies the other characteristic of this renewal:

> C'est uniquement par le verbe — donc sans trop de conséquences malgré l'expression de points de vue parfois très radicaux — que s'affrontaient les tenants de la modernité et ceux de la tradition au sein des clubs d'amateurs. A peine évoquait-on une révolution esthétique. La tendance existante allait peu à peu assimiler et intégrer les éléments novateurs'.[1]

We will verify that those elements would especially appear in the work of professional photographers who were active in the fields of advertising, industrial photography or reportage. Besides, we must underline that the latter was definitively recognized between the two world wars, offering the authors a new form of visual discourse. In the field of amateur photography, the modernist and conservative poles confront each other through published articles, particularly in the pages of the Bulletin of the *Association Belge de Photographie* (A.B.P.).

In order to highlight these distinctions, we will take into consideration the works of photographers who may be considered the most representative of this debate, of these hesitations between the two rival photographic aesthetics. On one hand, there are Jozef Emiel Borrenbergen and Léonard Misonne, as heirs to Pictorialism, and on the other hand Willy Kessels, promoter of the renewal of photographic vocabulary. The work of Germaine Van Parys provides, as far as it is concerned, an illustration of the developments of photoreportage between the two world wars, of which Van Parys appears as a major figure. But, before studying these works, it is necessary to come back to what 'Pictorialism' signifies, to understand why it remained anchored in Belgium for such a long period of time.

The Origins of a Lasting Heritage: Specificities of Pictorialism in Belgium

While the pioneers of photography essentially practiced it as a commercial activity, we observe the progressive rise of new practitioners, who differ from earlier photographers by their claimed status of 'amateur'. Coming from the aristocracy or middle-classes, they associated the nobility of their art with their financial disinterestedness and the independence of their creative choices. Alongside professional photographers, many of them took part in the creation of the *Association belge de Photographie* (A.B.P.) in 1874. Its 143 founding members united in a common willingness to federate the photographic sphere by giving it a structure and to animate it by stimulating emulation. In order to do so, the Association endowed itself with two major tools: the publication of a monthly bulletin and the organization of exhibitions and competitions.

Given the subdivision of the Association into local branches, its Bulletin provided a common platform. Beyond reviews of assemblies or exhibitions, one can find presentations of processes and technical inventions, as well as criticism, some of them taken from foreign publications and translated into French. Reproductions of photographic work also guaranteed dissemination among the readers.

At the end of the 1880s, we see in several countries that the yearning for recognition of their art encouraged some photographers to create a secession, to distinguish themselves from photographic associations that were not specifically dedicated to art. This movement gave rise in 1886 to the London Camera Club, to the Wiener Camera Club in 1887, and the following year to the Photo-Club de Paris, emancipated from the *Société française de photographie*. In London, the Linked Ring Brotherhood was founded in 1891, separate from the Royal Photographic Society. This dissidence emanated from educated amateurs, recruited among the bourgeoisie, practising photography as dilettanti, thanks to their social rank. These photographic circles or clubs aimed at a more restrictive access, compared to the societies from which they distinguished themselves. In this context, the specificity of the A.B.P. is not to have been the object of secession by its art photographers, but to have adopted the artistic claims and orientations of Pictorialism.

It is exactly in the same integrative mode that the A.B.P. proceeded towards modernist tendencies, some forty years later, making them cohabit with the formal traditions that Pictorialism had established. Judging as fundamental the subjective expression of the artist, this movement had developed a series of means to serve this

subjectivity as well as possible. 'Artists' lenses' were used to take photographs in order to obtain optical effects. The prints, usually made through hand or craft processes, consisted in interpretations of the basic negative. Photographers aimed at giving the photographic image the materiality that was thought to be the strict preserve of painting, by taking advantage of grainy or rough papers and pigment processes, like charcoal, bichromated gum or fatty ink. The lack of ornamentation required by these printing techniques gave photographers the same artistic licence as engravers in that they were able to highlight or tone down aspects of the images. Doing so, he could give it the quality of an original work that enabled it to rise to the level of art.

Rather than imitating painting, the issue was to compete with it in order to gain similar recognition.[2] This required abandoning photography's focus on imitation and reproduction. In a willingness to distinguish themselves from mainstream photography and to return to the traditional genres of painting, Pictorialists gave preference to portraits and landscapes. In the name of timelessness and traditional values, these genres tended to banish contemporary subjects.

The A.B.P. fully adhered to the aesthetic opinions defended by Pictorialism and gave concrete expression of this as early as 1892, by organizing an exhibition of British art photography, gathering both the pioneers and current British members of this movement. International art photography salons followed this landmark event.[3] From 1892 onwards, annual exhibitions of the A.B.P. were organized by the local sections of the Association.

If the success gained by the Association grew continuously until 1901, when it reached 751 members, it then declined until its practical (if not legal) dissolution in 1940. During this period of time, it nevertheless remained the federating instrument of Belgian photography, at a time when it was diversifying, geographically as well as aesthetically. It is these new orientations which we shall discuss here, beginning with the tendency to associate the Pictorialist heritage and an opening to modernity. This tendency can be illustrated by the respective work of Jozef Emiel Borrenbergen and Léonard Misonne.

Jozef Emiel Borrenbergen (1884–1966), Léonard Misonne (1870–1943): Two Representatives of Late Pictorialism

The works of Jozef Emiel Borrenbergen and Léonard Misonne exemplify well, each in their own way, the persistent references to Pictorialism in Belgian photography between the two world wars. Although belatedly, the former ended up integrating the modernist direction that he associated with a romantic vision, whilst the latter was to expose his conservatism resolutely, even when opening up to contemporary subjects.

In line with the *modus operandi* established by Pictorialism, it was as an amateur that Borrenbergen[4] practiced photography, while he was administrative director of a cereals business at the port of Antwerp. In 1909, he became a member of the amateur circle *Iris*, created in Antwerp the previous year, before taking charge of its presidency, between 1912 and 1939. From 1921, he also became an active member of the Antwerp section of the A.B.P. Alongside this intense activity, he

was also between 1924 and 1939 a critic in the pages of the self-published *Fotokunst* review as well as in the Bulletin of the A.B.P. Moreover, Borrenbergen organized competitions, exhibitions and conferences, thereby demonstrating the essential role he played in the photographic domain.

In one of his articles published in the Bulletin of the A.B.P., Borrenbergen evaluated the designation 'amateur', not only as a sign of distinction claimed in the 19th century by pictorialists, but also as a mark of their disinterestedness and therefore of their independence as artists. His intervention followed Alexander Keighley's article, published in the previous issue. He defended the etymological meaning of the term 'amateur', in opposition to its pejorative meaning. Following Keighley, he maintains that the recognition of the amateur comes to distinguish between the independence of the artist and the subservience of the professional photographer:

> Dans la plupart des arts anciens, c'est le professionnel qui a toujours indiqué la voie, laissant l'amateur bien en arrière; en photographie, au contraire, les progrès d'ordre pictural sont dus presque exclusivement à l'amateur. Le professionnel est d'ailleurs obligé d'accorder toute son attention au côté commercial, de se plier aux exigences du public.[5]

By the same token, Borrenbergen pays homage to the role amateurs played in defending and promoting artistic photography:

> Ce sont des amateurs qui ont trouvé la voie qui a conduit la photographie artistique à la hauteur à laquelle elle est parvenue; ce sont des amateurs qui ont inventé et appliqué la plupart des procédés permettant un contrôle personnel sur les épreuves; ce sont encore les amateurs qui ont montré aux professionnels la route à suivre pour améliorer leurs productions et les revêtir d'un cachet artistique'.[6]

Nevertheless, time had come for these amateurs, he insisted, to call themselves 'artists'. Indeed, this is probably one of the main issues of photography between the two world wars, in which Borrenbergen played an active part.

At first his work remained rooted in a tradition of pictorial inspiration, through the pastoral nature of his themes, principally rural landscapes and scenes from the Flemish countryside. Aiming at timelessness, the photographer kept contemporary motifs at a distance. In terms of rendering, this distance meant that sharpness was rejected in favour of a more diffuse effect, recalling the art of drawing. In a lecture given to the Antwerp section of the A.B.P., Borrenbergen stated that

> Si le but (du photographe) consiste à produire une photographie artistique, il faut rejeter l'idée d'une netteté absolue de façon à conserver la perspective aérienne; s'occuper ensuite particulièrement de la composition du motif principal, des lignes, des formes, de la pondération des masses, etc. Le développement lent de l'image permettra un contrôle sur l'harmonie de l'ensemble.[7]

Consequently, Borrenbergen would privilege the use of bromoil printing, a process that associates the use of fatty inks with gelatine-bromide.

This characteristic withdrawal from the Pictorialist aesthetic, in terms of subject matter as well as rendering, progressively gives way to the new motifs that emerged

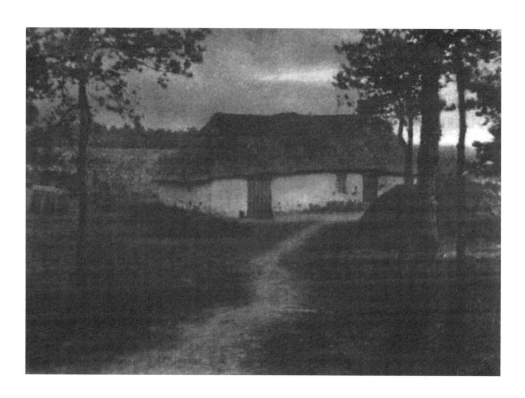

FIG. 1 (above).
Josef Emiel Borrenbergen,
Bij valavond, Wechelderzande,
1920, Antwerp, Museum voor
Fotografie

FIG. 2 (left).
Josef Emiel Borrenbergen,
Rolbasculebrug, ca. 1925–1930,
Antwerp, Museum voor
Fotografie

in Belgian amateur photography in the 1930s, almost ten years later than other European countries. Thus, in Borrenbergen's work, a series of resolutely modern elements, which were found in the contemporary environment such as the port of Antwerp, began to appear. Its industrial activity suddenly invades this *oeuvre*, so far hermetic to external signs of contemporary times.

This 'modernisation' squares with a more fragmentary approach to the subject. It tends to centre more closely and give preference to details rather than to the overview. Borrenbergen therefore began to integrate one of the distinctive signs of the New Vision: the fragment, sometimes accompanied with an overbalancing when taking the photograph, by the means of high or low angle shots. By this simple gesture of cutting, of fragmenting, he invites the spectator to look differently at the world around him.

This fragmentary vision was analysed by Maurice Piérard, a member of the Charleroi section of the A.B.P., in an issue of its Bulletin. He described it as a generalizing tendency in photography, legitimately corresponding to the specificities of the photographic camera:

> La photographie qui s'est complue pendant de longues années dans la représentation des 'ensembles', s'achemine à l'heure actuelle vers la reproduction de détails ou, pour être plus exact, des 'fragments'. D'aucuns critiquent cette tendance et vont jusqu'à la qualifier de puérile. Cependant, l'évolution de la photographie est légitime, tant au point de vue technique qu'artistique.[8]

We find expressed here one of the major principles of artistic modernity, i.e. taking into account the specificities of each creative medium, indeed even their thematic specialisation. Now, it was precisely these specificities that Pictorialists refused to explore, in favour of manipulations that expressed the artist's interpretation of his subject. If this gesture had not yet disappeared from Borrenbergen's work, it was by this time well moderated by the fragmentary vision, as set out by Piérard, and introduced in the photographer's work by the presence of subjects drawn from his most concrete environment.

We will show that this modernisation, a consequence of the integration of new motifs, can also be identified in the work of another major photographer of the period: Léonard Misonne. But unlike Borrenbergen, the confrontation with motifs found in the everyday contemporary world did not lead Misonne to modernise the plastic rendering of the image.

Born in 1870 in the Charleroi area, where he remained throughout his life, Misonne, a mining engineer, was forced by his asthma to give up all professional activity. Living on a pension, leading a life he himself deemed dull and bourgeois, according to René Debanterlé,[9] Misonne devoted all his time to his passion: photography. Despite his affiliation to the Brussels section of the A.B.P. as early as 1897, it is away from the photographic milieu that he developed an *oeuvre* that rapidly gained him an important reputation, making him one of the leading photographers of his era. This is not the only paradox that Misonne would cultivate. Anchored in the purest respect for the pictorialist aesthetics, his work was supplemented by numerous texts, published in specialized periodicals on which we will focus to highlight some of their contradictions. Beyond those, the many

exhibitions in which he took part ensured his work international influence. Let us mention, among others, his participation to the London photographic salon of 1910, a personal exhibition at the New York Camera Club in 1922, or another personal show presented in 1937 at the Musées royaux d'Art et d'Histoire in Brussels. The popularity of his work among his contemporaries was attributed by Marcel Vanderkindere to 'son adoption [...] des principes qui ont résisté à l'épreuve du temps dans le domaine de la peinture.'[10] A judgement shared by René Debanterlé, some seventy years later: 'Tout son art ne fait que conforter la certitude du "bon goût" et les solides valeurs de la peinture académique.'[11] It is these principles which we shall now examine.

The first is the search for timelessness, drawn from pastoral scenes. Devoted almost uniquely to the genre of the landscape, Misonne calls back to nature, in a region where machines are predominant. As he lived in the area of Charleroi, he explored the surroundings of the industrial zones, in search for parts of landscape left untouched, in order to assert the preponderance of nature over human constructs. Moreover, life in the countryside is always depicted only under its poetic aspects. The figure of the countrywoman, usually accompanied by children, appears as central. Rather than being depicted in her labour, she is often represented in a moment of suspension of action, at rest or engaged in conversation. The effect Misonne aims at, as we can understand it, is that of the painting, the 'picturesque' rather than a documentary of rural life. Let us note the fact that this attachment to nature, apart from a few exceptions, remains the artist's credo. As he stated in the *American Annual of Photography* in 1935: in this century of the machine, it was more than ever a duty to photograph nature.

The poeticizing of the real is also expressed through artistic effects created during the printing process. After using the charcoal technique, Misonne worked, between 1915 and 1935, with the Rawlins process, based on the use of fatty inks. He improved it by associating it with bromide, perfecting what he would call the 'mediobromide' process. The characteristic softness of his works essentially comes from these effects of veiling or screening, generated by these techniques. A *sfumato* covering the landscape dissolves the outlines of his motifs, surrounding them with an atmosphere often tinged with melancholy. As Misonne himself confessed, the photographer is less concerned with reality than with its surface, its 'dressing'.

The primal status of the print is nevertheless counterbalanced by the particular attention paid by Misonne to light, to the extent that he regards the taking of the photograph as essential to his art. If we find here another paradox, consisting in estimating the primacy of the taking of photographs and at the same time of their printing, it is because Misonne defines the taking of pictures as simply the observation of atmosphere and light. In 1935, he wrote in the preface to his Viennese exhibition catalogue:

> Si on me demandait de résumer en quelques lignes ce que m'a appris une carrière photographique longue déjà de plus de quarante ans, je dirais: 'Observez la lumière, vous ne la connaissez pas; vous ne la soupçonnez pas! Vous photographiez les choses pour ce qu'elles sont, alors que vous devriez le faire pour ce qu'elles paraissent, c'est-à-dire pour ce qu'en font la lumière,

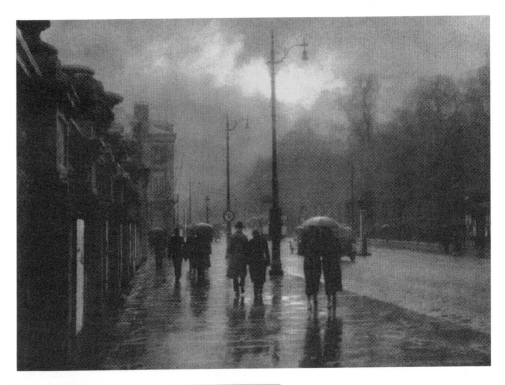

FIG. 3 (above).
Léonard Misonne, *Il pleut*, 1935,
Coll. Famille Misonne

FIG. 4 (left).
Léonard Misonne, *Sur la porte*, 1934,
Charleroi, Musée de la Photographie

l'atmosphère. La lumière fait resplendir toute chose; elle transfigure les sujets les plus humbles, les plus vulgaires. Le sujet n'est rien, la lumière est tout!'[12]

If there is a relative openness to modernist ideas in Misonne's work, it is maybe in this single theoretical aspect. Because his photographs reveal that this light, understood as atmospheric rendering, continues to work as a screen keeping reality at a distance. This is why, even when he sometimes took urban views, or more rarely factory surroundings, he would never do so for the subject itself, but more as a pretext for luminous compositions.

This is what differentiates Misonne from Borrenbergen, and even more from modernist photographers who dared to represent subjects taken from the everyday reality of the world around them. This confrontation mainly came from professional photographers, who did not hesitate to develop a personal *œuvre* nourished by this experience, willing to look at the world from a different perspective. Among them we shall focus on Willy Kessels, an emblematic personality of the New Vision in Belgium.

Willy Kessels (1898–1974): (Re-)Discovering Photography

The new generation following Borrenbergen and Misonne introduced Belgium into the modernist movement which had stimulated photography in several western countries since the 1920s. However belatedly, it assimilated the various tendencies of this photographic renewal, oscillating between New Objectivity, Constructivism and the documentary.

Willy Kessels, a leading figure of modernist photography in Belgium, was introduced into the avant-gardes of the 1920s via other artistic practices. After unfinished studies in architecture, he worked as a draughtsman in several architectural firms in Flanders and in Brussels. He was a decorator but also a sculptor, which led him to take part in international salons devoted to modern sculpture. In 1925, his participation in the International Exhibition of Decorative Arts in Paris put him in contact with the aesthetic of 'Plastique pure', to which he subscribed. As the life and soul of the artistic club *Primavera*, he invited painters such as Victor Bourgeois or Marcel-Louis Baugniet, with whom he exhibited in 1926.

It was through the avant-garde publication *7 Arts* that Kessels discovered contemporary developments in photography, through the works of Man Ray, Moholy-Nagy or Renger-Patzsch, among others. In 1929, his meeting with the professional photographer Albert Malevez was a decisive moment. The two men decided to found *Publicité Par Photo*, a structure under which they signed their collaborative work in advertising. The same year, Kessels set up his own business, as a professional photographer. His various financial backers were recruited from the building industry as well as from the pharmaceutical industry and public institutions.[13]

In 1930, Albert Guislain asked Kessels to illustrate his book *Découverte de Bruxelles*. Published by the socialist publishing house L'Églantier, this book introduced Willy Kessels to the general public. The resolutely modernist vision Kessels unfolds in this publication, transforming urban landscapes by his uncommon view angles and

the novelty of his photomontages and collages, established his reputation as a leading figure of avant-garde photography.

Aside from these commissioned works, Kessels continued with his own creations, leading him to experiment with the possibilities offered by the photographic medium. For instance, apart from his advertising or reportage photographs, he created an ensemble of nude studies, in which he explored variations of lighting, contrasts and framing. In his darkroom, he eagerly experimented with solarization and photogram.[14] Kessels proved the extent to which he had integrated the specific parameters of photographic technique, fully exploited or rediscovered by modern photographers. Indeed, during the 1920s, one could have observed the generalization of inclined view angles, narrow, deliberately fragmented framings. Manipulations of the photographic print, dear to the Pictorialists, had been replaced by experiment in the darkroom, aiming at, in Moholy-Nagy's terms, productive — and no more reproductive — ends. Henceforth, the ambition of contemporary photography was to go back to photography's laws, cleared of references to the pictorial model, in order to explore its own territories.

The aesthetic quality and formal innovations Kessels had proved capable of, gained him the opportunity to present examples of his work at the International Exhibition of Photography, presented in the Palais des Beaux-Arts in Brussels, in 1932 and 1933. For its first edition, a Kessels image figured on the catalogue cover. The following year, as one of the main Belgian members of the show, one of his photomontages featured on the exhibition billboard. Inspired by the manifesto-exhibition *Film und Foto*, organized in Stuttgart in 1929, these two Brussels events gathered the most famous representatives of the new photographic trends. Thus Willy Kessels exhibited his work next to that of Man Ray, Germaine Krull, André Kertész and Albert Renger-Patzsch.

Within a few years, Kessels' photographic career underwent a prodigious development. In 1933, another experience put him in touch with the world of documentary cinema, as he shared with Sascha Stone the responsibility for stills photography during the filming of *Misère au Borinage*, directed by Henry Storck and Joris Ivens. Contributing to its general recognition, the photographer's participation in this committed film tended to make Kessels appear as a man of progressive ideas and work. His interest in social matters had first come to light at the beginning of the 1930s, in a report on unemployment published in the socialist illustrated weekly paper *AZ*, as well as in his pictures of the *Théâtre prolétarien*.

So how could we not interpret Kessel's membership of the extreme-right Flemish party Verdinaso, around the mid 1930s, as a reversal? When he had placed his talents as a portrait photographer at the service of such personalities as the painter Paul Delvaux, whose paintings he had reproduced, his pictures would now relay the power of the president of the Verdinaso party, Joris Van Severen, whom he portrayed several times from 1935 onwards.

Kessels's activity in the party eventually ended in his arrest and then deportation by state security. Released two years later, and returning to Belgium, Kessels did not hesitate to portray the main leaders of the Collaboration. After the war, Kessels was sentenced to ten years detention for his collaboration with enemy propaganda. On appeal, this sentence was reduced to four years of detention.

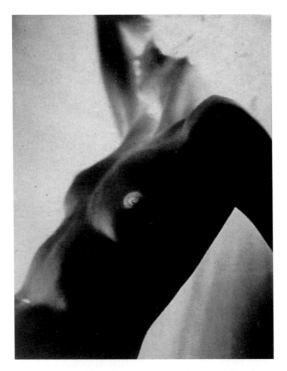

Fig. 5 (upper). Willy Kessels, *Etude de nu*, 1931, Willy Kessels Estate
Fig. 6 (lower). Willy Kessels, *Photogramme*, 1934, Willy Kessels Estate

If we can consider Willy Kessels as a pioneering figure of creative photography in Belgium, we cannot keep secret this dark side of his past.[15] That side of the man and his work seems even more enigmatic when compared to his documentary commitment in *Misère au Borinage*. As a key performer in the renewal of photographic vocabulary between the two world wars, Kessels had nonetheless not neglected the documentary path, binding both the creative and informative dimensions that photography can equally convey.

The introduction of art photography in the modern art chorus is made obvious in Willy Kessels' *oeuvre*. Rooted in professional practice, it definitively broke with the withdrawal of the amateur as a criterion for artistic distinction. At the same time, this integration of photography as modern art among other means of expression made henceforth obsolete the eternal debate around the question 'la photographie est-elle un art?'.

However, this essential step for the history of art photography should not mask the importance acquired by photographic reportage between the two world wars. Indeed, documentary photography gained a major position at this time, reflected by its massive presence in the illustrated press. In this context, the photographer's creative power gives precedence to his role as an eye witness, as a historian of his own era. In this field, the photographer Germaine Van Parys clearly stands out.

Germaine Van Parys (1893–1983): Testifying through Photography

It is rare to find women mentioned in the history of photography before the 1920s, in Belgium as well as elsewhere in the world. Photojournalism, fully mature by then, would not only gain them access to a profession and a source of income, but also to the recognition of their contribution to the photographic creation of their time. Germaine Krull, Lee Miller or Berenice Abbott, to name but a few, bear witness to this evolution.

In the early days of the feminizing of photography, Germaine Van Parys played a key role in Belgium, being the first woman to work as a photoreporter. While she stayed faithful to this photographic genre throughout her career, her output, covering approximately fifty years, has now become a monument in the history of Belgian photography.

On behalf of several newspapers and magazines, such as *Le Soir, Le Soir illustré* or *La Meuse*, she related the news of the country in photographs, illustrating the small as the great historical events, beginning with King Albert I's ceremonial entry into Brussels in 1918. Her financial backers can also be found abroad, as she worked as a correspondent for the French magazine *L'Illustration*. She was also a war correspondent in 1940 as well as during the Liberation.

This activity as a photoreporter offered great opportunities within the day-to-day life of Brussels, Van Parys' native city and place of residence.[16] Inside this vast photographic archive, we can mention this view of the Fish Market, bearing witness to the survival of markets in the centre of Brussels, due to the presence of inner-city waterways, which were soon to disappear for ever. It is as much a place as an activity that Germaine Van Parys chooses to describe here, by rendering the

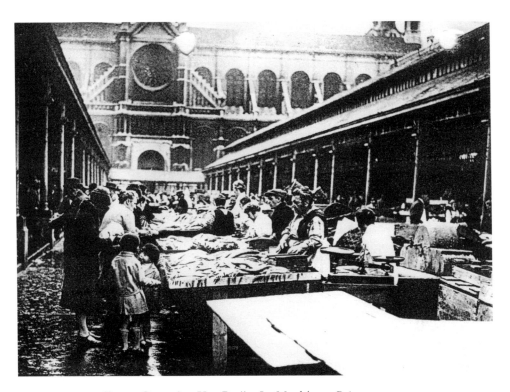

FIG. 7. Germaine Van Parijs, *Le Marché aux Poissons*, 1930,
Charleroi, Musée de la Photographie

geometric structure of the market stretching from the Saint Catherine church, contrasting with the disordered presence of the stalls, the sellers and the customers. Opposed to the photographer's subjective recording that we encounter in the works of the photographers discussed above, Van Parys' presence seems literally to disappear behind her camera, as none of the persons featured in the picture seem to pay her any attention. The act of recording is indeed the photoreporter's first mission, the testimony prevailing over expressiveness.

Between the two world wars, photography constituted a landscape of multiple layers, in which different practices cohabited. As the golden age of photoreportage that would extend somewhat to the 1950s, this period also witnessed emerging trends aimed at the renewal of photography in its particular relationship to reality. Sidelined by Pictorialism, this latter trend became (again) a major preoccupation for modernist photographers, who intended to look at reality — as well as at their creative medium — in a different way. In Belgium, the appearance of this movement was clearly moderated by the persistence of a late Pictorialism that remained durably popular with the public as well as with photographers themselves. This status was to be decisively supplanted by photographic modernity, opening to what would be known after World War II as 'creative photography'.

Notes to Chapter 8

1. Pool Andries, 'Entre tradition et modernité. La photographie dans l'entre-deux-guerres', in *Pour une histoire de la photographie en Belgique*, ed. by Georges Vercheval (Charleroi: Musée de la Photographie, 1993), pp. 89–90. All other translations from non-English sources quoted in this article are the author's own.
2. The means mentioned here to reach this goal, while characteristic of Pictorialism, should not mask the diversity of visions that nourished this movement. At its very heart, some photographers would oppose sharpness in favour of blur, or would rebel against what they regarded as anti-photographic or excessive retouching.
3. These *Salons* are organized by the A.B.P. in Brussels in 1896, 1898, 1902 and 1908, and during international exhibitions in Liege and Ghent in 1905 and 1913 respectively.
4. Borrenbergen's work was exhibited in a retrospective marking the centenary of his birth. See the following catalogue: Pool Andries, *Jozef Emiel Borrenbergen, 1884–1966* (Antwerp: Museum voor Fotografie, 1984).
5. Alexander Keighley, 'Pour avoir droit au beau titre d'amateur', *Bulletin de l'Association belge de Photographie*, vol. 46, 4 (1924), p. 177.
6. Emiel Borrenbergen, 'Evolution de l'art en photographie', *Bulletin de l'Association belge de Photographie*, vol. 47, 1 (1925), p. 6.
7. This lecture was transcribed in the following article: Emiel Borrenbergen, 'La composition dans le paysage. Conférence faite par M. E. Borrenbergen à la Section d'Anvers', *Bulletin de l'Association belge de Photographie*, vol. 49, 3 (1927), p. 46.
8. Maurice Piérard, 'Ensemble ou fragments', *Bulletin de l'Association belge de Photographie*, vol. 55, 8 (1933), p. 122.
9. See René Debanterlé, 'Notes sur l'esthétique de Léonard Misonne', in *Léonard Misonne. En passant...*, (Charleroi: Musée de la Photographie, 2004), p. 101.
10. Marcel Vanderkindere, 'L'œuvre de Léonard Misonne à Londres', *Bulletin de l'Association Belge de Photographie*, vol. 35, 10 (1912), p. 389.
11. Debanterlé, 'Notes sur l'esthétique de Léonard Misonne', p. 127.
12. *Léonard Misonne* (Vienna: Die Galerie, 1935).
13. Linked by his training to the architectural milieu, Kessels also developed a whole set of his photographic activities around the art of building. Close to Henry Van De Velde, he became

his appointed photographer. This aspect of his photographic work found a precious support in the specialised publication *Bâtir.*

14. Solarization is a process which consists of submitting a sensitised surface to a momentary exposure during its development. A photogram is an image obtained without the intervention of the camera, by exposing to light objects placed on a sensitised surface. If the origins of these processes date back to the 19th century, their re-evaluation for creative purposes is due to the work of photographers between the two world wars.

15. This aspect was the focus of the following exhibition, organized by Piet Coessens in Brussels at the Palais des Beaux-Ars in 1997: *Amnésie. Responsabilité et collaboration. Willy Kessels, photographe.*

16. These photographs have been exhibited and partially presented in the following catalogue: Eugénie De Keyser, *Pas perdus dans Bruxelles. Photographies du début du siècle. Germaine Van Parys* (Brussels: Monique Adam, 1979).

CHAPTER 9

Hergé-Simenon, Thirties

Benoît Denis

Let us imagine for a moment that the Ministry of Culture of Belgium's 'Communauté française' took on an employee whose job it was to promote francophone Belgian literature abroad. If this employee understood the task correctly, we can be sure that he would quickly learn to highlight the time between the wars. This period saw the almost simultaneous births of the two characters francophone Belgium has given to worldwide popular culture: Tintin, whose first adventure was published on the 10 January 1929 in *Le Petit Vingtième*, youth supplement of the Brussels newspaper *Le Vingtième Siècle*; and Commissioner Maigret, whose first investigation, *Pietr-le-Letton*, was published in July 1930 in the French weekly *Ric et Rac*. The cartoon and the crime novel, Tintin and Maigret, Hergé and Simenon: comparing them seems only natural, it makes sense — it is no coincidence that Pierre Assouline, who is particularly adept at selecting personalities whose biographies make enthralling reading, has written a large work on each of them.[1]

Georges Rémi (the true name of 'R.G.', who became Hergé) and Georges Simenon have more than a first name in common: born in 1907 and 1903 respectively, they belonged to the same generation, came from the same social background, received the same kind of education and professional training, and their trajectories as creators followed remarkably similar lines. Let us add that in nearly half a century of activity, both produced an *œuvre* that is widely agreed to be profoundly cohesive in its themes and methods, and which is therefore easily identified by a 'style': in Hergé's case, this means the 'solid line', an aesthetic concept in both drawing and narrative that can be defined as a realist stylization of the world, favouring readability and the search for the most economic combination of text and image.[2] As for Simenon, despite his work being divided into 'hard' or 'destiny' novels, not based on crime, and the Maigret series, its unity is to be found in what criticism, from the start, recognized as a particular 'atmosphere', which tends to underline in his work the coming together of readily identifiable themes and an approach to style which is remarkably stable: a short narration, based on a single dramatic event (generally a violent death), and almost always taking place in a third-person narration narrowly focussed on the main character; very simple language, voluntarily unliterary and almost elliptic due to the economy of its means. In both cases, from this marked stylistic unification come very similar methods of reading, dominated by principles of recognition and repetition: generally one reads a 'Simenon' without worrying too much about the particular title, the author's 200

novels appear to a degree interchangeable and all equally suited to satisfying the expectations of the loyal reader; as for Hergé, his *oeuvre* comprises only 23 books, but was reworked after the Second World War in order to smooth over the differences between the books and to do away with the chronological order, allowing each one to be read independently, but within familiar, recognizable parameters.

Finally, an unusual occurrence for widely-read literature: these two *œuvres* have had long-term success, having been constantly republished since the beginning, so that all the titles are still available; what's more, they are available in many different languages, which seems to show that the francophone cultural imprint is not seen as an obstacle to international success. When these two phenomena are put together, impressive cumulative sales figures are produced in both cases; they are still growing today, thanks to an extremely professional and active management of the rights of the two *œuvres*, wherein the slice relevant to film and television adaptations is considerable.[3] Paradoxically, this openly declared commercial ambition does not obstruct relative institutionalization: Hergé is seen as a master — even as the founding father — of the Franco-Belgian cartoon strip, whilst Simenon, who is meant to have invented a crime novel *à la française*, recently received the honour of being included in the 'Bibliothèque de la Pléiade', without provoking any real complaints from literary circles.

Such success has everything possible to tempt our Ministry employee — this is the last time he will appear —, since the two authors would allow him to demonstrate the 'diversity' of French culture in Belgium, composed as it is of micro-identities all preoccupied by their local problems.[4] One of them — Hergé — is from Brussels and a large section of the town's folklore is present in the adventures of Tintin as well as in the spin-off series *Quick et Flupke*;[5] more generally, Tintin today is a highly-resonant figure for the 'belgicain' or 'unitarist' imagination, to the point where the little reporter would seem to incarnate the ideal values of a reconciled Belgium: seriousness and willpower, a sense of duty and courage, modesty and a love of order, tolerance and refusal of conflict, desire to defend just causes over that for power, inclination to using brains rather than brawn. The other, Simenon, is from Liège — he wrote the town's greatest novel in *Pedigree* —, and is therefore a Walloon; boastful and sentimental, a moaner and a generous man; he likes honest folks, distrusts the powerful, hates the rich; his career in France represents a francophilia common in Liège, where Paris is often preferred to Brussels.[6] In short, a whole raft of stereotypes is now projected onto these authors and onto their characters, a phenomenon which in itself would be worthy of a study.

However, when trying to conceive what these *œuvres* represented at the time of publication, a notably different picture appears, less smooth but more instructive with regard to the social, ideological and cultural conditions which made their publication possible. This article intends once more to explore the thirties in an attempt to grasp what the double invention of Tintin and Maigret could have represented.

Genre Literature: Trainings and Dispositions

Hergé and Simenon were born in the first decade of the 20th century, shortly before the war and occupation that they experienced as children and adolescents. Both came from the same lower middle class, popular and urban. Their family structures are remarkably similar: a father in employment (in a sweet factory for Hergé, with an insurance broker for Simenon), a mother at home with fragile health, a younger brother. In both cases, the family was catholic and bi-cultural, with a Walloon, French-speaking father and a Flemish mother, with Dutch-speaking origins.

As for their education, we can say that Hergé and Simenon represent in their class the first generation to have had long secondary educations — neither, however, was able to continue onto higher education. They received, in catholic institutions, the typical education given to future employees and lowly civil servants: this was what was then called in Belgium the 'modern' humanities or, in the case of Simenon, the 'classic' humanities (graeco-latin), although the latter did not complete his secondary education.[7] This also means that, for each writer, producing on the cultural level was a sort of refusal of the social logic in which they lived. Nothing in the family models available nor in the education given enabled them to take this kind of professional choice. In both cases, we are dealing with true self-taught writers, for whom the status of creator was achieved after a struggle, despite much resistance — this will lead the two authors to look on their journeys, citing hard work, willpower and tenacity as the factors behind their success.

At this point it is possible to note a neat change of emphasis between the cultural baggage the two authors had acquired, and the area of production in which they excelled.[8] What was produced was an artisan's ethos, leading the authors to heavily invest in genres with questionable legitimacy, exactly where competition from those possessing a strong socio-cultural baggage is weaker. Unlike the aristocratic or upper middle class authors who wrote popular novels in the 19th century (Sue, Ponson du Terrail, etc.), Hergé and Simenon do not undervalue what they practice, indeed they tend to demand that it be high quality, and that it be respected. Finally, the opposition between literary value and economic potential does not seem to be present in their conception of their practice. This allows them to live (extremely) relatively serenely as para-literary authors and to unashamedly present the commercial success of their work as a measure of its value.

However, this established status in the profession came about only gradually, after the authors had passed through, in both cases fairly slowly, the world of the press. From the age of 16, and after having tried several small jobs unsuccessfully (baker's apprentice, library assistant), Georges Simenon was taken on as a low-ranking journalist by the *Gazette de Liège*, a conservative catholic paper directed by the lawyer Joseph Demarteau; as for Hergé, after finishing school he took a job at *Le Vingtième Siècle*, an ultra-conservative daily of the catholic press, whose director, abbot Norbert Wallez, was known to sympathize with Mussolini; Hergé was soon to be put in charge of the youth supplement, *Le Petit Vingtième*, where he would create Tintin. This time spent in journalism, for Simenon and for Hergé,

was the decisive factor in their training, closely controlled by Demarteau and Wallez, who acted as true mentors, paving the way for the young writers to climb the social ladder. We might also add that at least until the Second World War, both benefited from the support of networks within these circles.

This moment was decisive in Hergé and Simenon's training for more than one reason. First from an ideological point of view, there can be no doubt that at their papers both authors were part of an ultra-conservative environment, characterized by anti-communism, anti-liberalism (and therefore anti-Americanism) and anti-Semitism. We also know that the young Sim (one of Simenon's pseudonyms at the *Gazette de Liège*) prepared at the request of his boss a series of virulent articles entitled 'Le Péril juif', directly parodying the *Protocols of the Wise Men of Zion*. What's more, just by reading his short opinionated columns, it is possible to see attacks against freemasons, the 'reds', or political figures he accused of corruption or incompetence, coming back again and again.[9] The ideological background was therefore established, and it was to reappear, in mediated and transformed guises, in the official corpus of novels: indeed, Jewish characters are not rare and are always described with the features that the anti-Semitic lobby ascribed to them;[10] this characterization is turned around in the novels by a sympathetic eye that sees in the suffering of the 'damned race' the stamp of a misery and desolation relevant to the human condition — this posture does not suppress stigmatization but transforms its significance. More generally, Commissioner Maigret has a tendency, in his investigations, to bring the blame onto the ruling bourgeois classes and political figures; Maigret also implies that the latter's class egoism is responsible for the malfunctioning of a social order based on natural hierarchies, as well as the duties that these hierarchies ascribe to each group. In Hergé's case, the facts are even clearer, since the same ideological core is at work in the first four albums, whose subject matter was largely prompted by Norbert Wallez: anti-communism (*Tintin au pays des Soviets*, 1929),[11] colonialism (*Tintin au Congo*, 1930), anti-Americanism (*Tintin en Amérique*, 1931) and anti-freemasonry, via the representation of a secret society with criminal aims (*Les Cigares du Pharaon*, 1932); in addition to the many badly intentioned characters with foreign characteristics (for example the recurring baddie named Rastapopoulos), the first part of Hergé's work is not free of anti-Semitic moments (particularly *L'Étoile mystérieuse*, 1941), which were painstakingly removed from post-war editions.

In addition to this very specific ideological background, that the authors would later attempt to attenuate, the stamp of Catholicism also plays a determining role, even if it does not appear to do so (with the exception of the very first Tintin albums in the original version). In Hergé's case, we are aware of how the values that Tintin incarnates are inspired by the catholic boy scout movement that the author was so interested in; more generally, one of the reasons behind the success of the adventures of Tintin is Hergé's ability to integrate the catholic moral code in a dynamic and fun narrative structure: Tintin's world is founded on a strong binary structure, immediately recognisable (goodies and baddies), on a total ban on the representation of sexuality and even of love, to which the healthy camaraderie of an almost totally male environment is preferred, and on euphemistic representation

of violence. With Simenon, the catholic influences are much more subtle, even if it is possible to maintain — which, to our knowledge, has never been done — that the simenonien sense of the 'tragic' and the structure of his 'crisis'[12] novels do not totally ignore the forms of the catholic novel of the first half of the 20th century; in what is fundamentally an effect, any non-crime based novel by Simenon will be based on the same schema: a lowly character finds himself taken away from his routine universe by a tragic event (most often a violent death), starting him off on a long descent that will carry him to the extremes of depravity, in social and especially moral terms. Having arrived at this dead end, stripped of his illusions and certainties but feeling himself 'called' by destiny, the character at this point rediscovers, in his own depravity and at the end of what recalls a Calvary trail, a sort of redemption, lacking in transcendence but corresponding to the structure of recuperation of a typically Christian failure.[13]

We ought to insist most of all on the fact that this religious belonging is not unconnected to success in the domain of genre literature (cartoon strip, crime thriller, etc.): this belonging indeed corresponds to a 'sectorization' of the public which is perfectly compatible with the religious press's desire to rigidly pigeon-hole its readers by providing them with purpose-built cultural products. This state of affairs is readily observed in its entirety in the case of Hergé, who wrote for the young, on whom the catholic press was also focusing; but it is also a factor in Simenon, whose success lies for a large part in his very precise knowledge of what his readers expected: the formula of a short book, readable in one go on a single evening, the construction of a simple and linear plot, the author's constant desire to produce books both affordable and materially more distinguished than the usual pulp fiction, all of this suggests that Simenon had a clear idea of who he was writing for.

Let us go even further. Commercial success also owed much to the way in which the catholic cultural world organized itself to fulfil its mission of ideological pigeon-holing: indeed, it was supported by a network of close links between the press, publishers and the different educational structures through which cultural products were filtered (youth movements, teaching establishments, etc.). In this alone, the use of profitable, sophisticated commercial practices that para-literature allows to be developed, is not at all opposed to the purely spiritual objectives of these businesses; on the other hand, the commercial saturation of the youth or best-seller market is also justified in terms of gaining an ideological influence. From this results Simenon's and Hergé's capacity to seize good opportunities and flair for commercial 'coups'. The case of the latter is exemplary, typical of an ideal. In the beginning, Tintin's first adventure was only destined to be published in a newspaper; it was its unexpected success that led Norbert Wallez to contact the catholic publisher Casterman, who controlled a sizeable production capacity, in order to publish *Tintin au pays des Soviets* as an album, starting off the form that would give the series its long life. Much more, from the time of Tintin's first successes, Hergé created an 'advertising office', which would market the image of his hero, prefiguring with this the trade in spin-off products that we know today. In the same way, in order to maintain readers' interest between two adventures,

Le Petit Vingtième at the start of the 30s organized 'Tintin's homecomings' at the station in Brussels which attracted crowds of young readers. By going up to Paris and signing with editors neutral in terms of Catholicism, Simenon would seem to refute the theory we have just set out, but he retained the same reflexes throughout the thirties, notably via a pronounced sense of commercial marketing and of the media coup: he launched himself in Paris by proposing to write a novel in three days, enclosed in a glass cage placed in the middle of a shopping centre (the project never took place, but did attract a lot of attention); similarily, he was to launch the Maigret series with a 'bal anthropomorphique' that attracted Paris high society. More generally, he was to be particularly active in the exploitation of his own *œuvre*, being himself in charge of all the questions pertaining to the different forms of publication of his novels, to their translation or to their film adaptation: ideally, for Simenon, each novel should have a prepublication in the press, before appearing as a volume and, if possible, also being adapted for the cinema. Even more telling is the fact that the author showed a real editorial creativity all through his career: in the 30s, he was the first in France to publish novels whose covers bore a photograph as illustration; during the same years, he sought to create a kind of picture novel which prefigures the post-war photo-novel.[14]

Finally, it can be argued that the success of Hergé and Simenon speaks volumes about the peripheral role of Francophone Belgium in relation to the French centre. This situation produced a symbolic belittling which in turn led to the development, by the Belgian authors, of subversive strategies that aimed to avoid direct confrontation with their French colleagues in the sectors where such competition is usually most pronounced. The result was an insistence on the genres and forms habitually neglected by the Parisian centre and on which the Belgian mind could work with greater freedom. This led Belgian authors to concentrate on cultural 'niches' that had been left unexplored. The development of the francophone cartoon strip, for which Brussels remained the most important city until the end of the 1960s, is a perfect illustration of this, Hergé of course playing a driving role in this process. Simenon would appear to be the exception to the rule. The choice of the crime novel, the most legitimate of the para-literary genres, gave him a logical disposition towards making his career in Paris. The fact however remains that he was to continue to adopt 'peripheral' attitudes: once he had established himself, he was forever going away from Paris, moving first to the provinces, then to the USA and finally to Switzerland, as if he only felt at ease with some distance between him and the centre, a distance that was also symbolized by his refusal to associate with the literary crowd and by his marked preference for media or film circles, less obsessed by distinctions and critical subtleties.

In this way, we can see how the paths of Hergé and Simenon developed at the beginning of the thirties: a neat detachment between their cultural groundings and the genres they practiced, led them to explore seriously and instinctively the so-called lesser genres; a peripheral status that predisposed them to avoid direct confrontation with French writers, in sectors that would surely lead to their rejection by the latter; a training in the conservative catholic world, which resulted in an unmistakable ideological saturation, as well as in the adoption

of moral and aesthetic codes ideally suited to structuring the works of these autodidacts, and fitted into an efficient distribution network, perfectly set up for the sort of works that had been chosen.

Thirties: the Inventory of the World

Hergé and Simenon did not undergo these initial stages of their trajectories passively, but played a dynamic role in them instead. Their craftsman's ethos indeed led them to adopt extremely individualist attitudes, which was notably manifested as a wish for autonomy clearly displayed in relation to the conditions of production of their *œuvre*. In both cases, conditions of such independence were not wholly achieved until the end of the 1940s: having moved to the United States where he was reorganising the administration of his *œuvre* according to Anglo-Saxon practices, Simenon left Gallimard and moved to the young editor Sven Nielsen, of Presses de la Cité, with whom he was to sign an editorial partnership agreement that gave him complete control of the managing of his *œuvre*; as for Hergé, the creation of the *Tintin* weekly with Raymond Leblanc in 1946 and the establishment of the 'Hergé Studio' in 1950, after the American model of comic production workshops, allowed him to control all aspects of the making of Tintin's adventures.

During the 1930s, this wish for independence was already present. After the first four albums, strongly influenced by the 'ideological' guidance of Norbert Wallez, Hergé was able to build on his success and choose singlehandedly the framework and the subject matter for the new adventures of Tintin, just as he tried to move away from previous ideological dogmatism to widen the range of his sources of information.[15] For Simenon, the rupture was to come in two stages: in 1922, he left Liège to move to Paris, which also meant freeing himself from the tutelage of Joseph Demarteau; in 1930, he drew up a contract for the edition of the Maigret series with Fayard, that he signed with his own name, thus abandoning the practice of producing bread and butter work under pseudonyms, from which he had profited since 1924.[16] The result was that, contrary to popular belief, the work of these two authors underwent an important and accelerated evolution during this period. Between 1931 and 1934, Simenon published the first nineteen Maigrets; bolstered by this success, and contrary to the wishes of his editor, he abandoned the character that had given him his break in order to write non-crime novels with Fayard in the 'Nouvelle collection de Georges Simenon'; this series paved the way for his move to Gallimard, in 1934, from whom Simenon expected a complete recognition: during this period, he began writing more ambitious and longer novels, introducing several main characters, haunted by the author's fondness for a 'romanesque' depiction of society, even for the novel as chronicle *à la* Roger Martin du Gard, an ambition that *Pedigree*, written during the Occupation, ought to have realized.[17] We can therefore say that in the thirties, Simenon was engaged in a gradual journey towards a novelistic form that was very different from that he had initially practised, but from which he expected recognition and which gives his works from this time a much more varied, heterogeneous character than is generally believed. In Hergé's case, one has to go back to the original versions

of the albums to see what progress had been made, from a graphic perspective as well as in terms of the narrative codes: the stories were more likely and coherent, as well as denser; Tintin's erratic pilgrimages, punctuated by poorly explained twists and turns, made way for a unity in both framing and intrigue. Most critics agree that Tintin's fifth adventure, *Le Lotus bleu* (1934), was the decisive moment when Hergé's creation found both its equilibrium and a real sense of direction.

One of the ways in which such rapid evolution by the authors was manifested, together with the wish for independence that we have described, is — perhaps paradoxically — to be found in the realist ambition that drove them. Indeed everything took place as if the task of saying the world as it is could, in the para-literary forms practiced, be assimilated to a form of seriousness which had the potential to endow their work with a legitimacy which it had initially lacked. Hergé and Simenon's creations work around the objectives of making the cartoon strip a way of exploring the world, no longer merely a childish diversion, and of reclaiming simenonian narrative from the 'fait divers' in order to apply it to all existences and times.[18] Overall, in the thirties, both were involved in writing the *inventory of the world*, which would make it necessary to rework the way in which the ideological bedrock (from which these authors started) had been represented.

The adventures of Tintin are good examples of this point of view: after the first albums, which we can label ideologically-driven and which saw the little reporter going through Soviet Russia, the Belgian colony of the Congo, the US and the British colonies of Egypt and India, Tintin was to explore the world's hotspots: China under attack from Japanese imperialism (*Le Lotus bleu*, 1934), the oil war known as the Gran Chaco between Bolivia and Paraguay between 1931 and 1935[19] (*L'Oreille cassée*, 1935); the conflict in the Balkans between Syldavia and Borduria and the nationalist *coup d'état* against the Syldavian monarch (*Le Sceptre d'Ottokar*, 1938), the oil question in the Middle East and the Zionist project in Palestine (the first, incomplete version of *Tintin au Pays de l'or noir*, 1939). This series of adventures strikingly sets out the contours of a truly geopolitical world, built out of their respective points of tension: Latin America, the Far-East, the Arab world, the Balkans. Tintin's role was to defuse the building crisis, and to reveal the occult forces at work and the interests they serve silently: the imperial ambitions of a powerful neighbour, the control of oil resources, the shady roles of arms merchants or international criminal organizations, are the true leitmotif of the series.

The political vision that emerges is one haunted by an obsession with masks, simulations and falsities:[20] in this way, lies and plotting make up the norm of political action, which is in addition controlled from on high by the unscrupulous rich. Tintin fights against this world order, not in the name of a different political vision, but in that of essentially moral values (just and unjust, good and evil). In this dichotomous world, where the first target is power built on money (capitalism often being, via an instructive leap in reasoning, compared to mafia behaviour), the hero's cause seems to merge with that of defending the weak and oppressed: the unfair fate met by American Indians or the tribes of the Amazon, the Japanese sacking of millennia-old Chinese culture, the plot led against a monarch both peace-loving

and considerate towards his people (*Le Sceptre d'Ottokar*), all these cases provoke moral indignation or compassion. If we look closer, it is however always a political order, whose legitimacy stems from being anchored in tradition or in the rights of the first peoples, which must be defended against the dispersive forces of the modern world, which is read as being at one with technology, the reign of money and desire for power.

What is most striking is that this anguished vision of the world grows from an *absent centre*, never spoken of nor really described. It is perhaps banal, but still necessary, to say that Tintin is, literally, a person without origins, without name or family, and with no apparent allegiances.[21] His work as a journalist, that we never see him practice, of course gives him a reason to travel, but we hardly ever see the place where Tintin lives between two adventures: this place can be seen as a sort of no-man's land, of which the existence depends both on the obvious and on the unrepresentable: the world Tintin comes from, like Hergé, is that of francophone Belgium, catholic and conservative, and it seems unlikely that such a starting point could be dramatized without seeing its intangibility immediately challenged. Because of this, the projecting nature of the adventures becomes clearer: the tensions that Tintin succeeds in resolving all around the globe are precisely the same tensions that structure his own universe: the menace that a small country feels from a powerful and aggressive neighbour (Belgium and Germany?); the internal, absurd divisions which undermine the unity of small countries (the conflict between Flemish and French-speakers in Belgium?); the dissolution of traditional forms of authority in the face of an emerging moral influence exerted by private interest (international finance and politicians against the legitimate political order that the Monarchy represents?), all of this applies both to the outside world and to Belgium, at least in the way Hergé could have grasped them in the milieu in which he was brought up. The clearest album from this point of view is doubtless *Le Sceptre d'Ottokar*, where Syldavia evokes a euphemized image of Belgium: a small, peaceful and neutral Monarchy, the country is coveted by its neighbour who, to achieve its goals, provokes nationalist agitation; most critics have also noted that the palace of Muskar XII strangely resembles that of Laeken and that the sovereign himself has features (including a taste for sports cars) which at the time were associated with King Léopold III.

When seen in this light, Tintin's adventures no longer result from the 'ideological certainty', as did the first albums; the inventory of the world that they carry out from an absent centre tends rather to signal, in an anguished way or a euphemized form of moral indignation, the retreat of the values and principles on which rested the order which Tintin had previously been charged with defending. This, however, does not exclude the possibility that, in the case of historical crisis, the initial ideological complex might resurface. *L'Etoile mystérieuse*, which appeared from 1941 onwards, can be read as a direct response to the cataclysm of the War: the adventure opens with the menace of an apocalypse, due to the approach of a gigantic meteorite; when this meteorite has crashed into the arctic ocean, two rival expeditions are launched to recuperate the extra-terrestrial object and study its properties: one is led by an Anglo-American coalition led by an unscrupulous

Jewish banker from New York (named Blumenstein), whilst the other, in which Tintin is involved, groups together learned 'Europeans', i.e. Germans, Spanish, Portuguese, Swedish, Swiss and Belgians...

It might appear that, in the thirties, the universe of Simenon's novels is far removed from the one just described: the place he prefers, and with which he will be strongly identified, are the French provinces, little towns both stifling and mediocre, where nothing happens, and everything is a burden, starting with a rigorous and alienating level of social control, and from which the characters only succeed in extracting themselves at the cost of often unnecessary conflicts.[22] This, however, would be to forget that between 1932 and 1935, Simenon too was to compile an 'inventory of the world', putting himself in the shoes of a top-level correspondent travelling all over the globe: he was to visit the Nordic countries, Africa (Egypt, Sudan, the Belgian Congo, French equatorial Africa), central and Eastern Europe (including the Germany that had recently elected Hitler Chancellor), Turkey, the USSR, before doing a round-the-world trip 'in 155 days.' These voyages produced two types of work from Simenon, at once distinct and simultaneous: on one hand, the writing of reportages, which didn't have anything of the rigour his model, Albert Londres, aspired to; on the other hand, the composition of novels directly inspired by these voyages and using the same anecdotal material as the reportages. These two registers of writing are interesting as far as they treat the same data in very different ways.

These reportages take on a clearly ideological dimension. Their major theme is that of the 'decline' of (Latin) civilization in the context of the simultaneous rise of communism and the Anglo-American world and against the backdrop of the unstoppable collapse of colonialism. Thus *Peuples qui ont faim* concludes on the question 'Croyez-vous la civilisation latime en péril?'[23] In the same way, in *Histoires du monde malade*, the author lets an American speak: 'L'Europe est fichue. La France n'existe plus. Les Latins ont donné tout ce qu'ils avaient à donner et sont dégonflés comme des baudruches...'[24]

In the same way, the theme of Western decline, extremely common at the time, is constantly suggested as the voyage's horizon, Simenon abstaining from adopting any particular position in order to play only on the dramatic charge inherent in the question. It remains the case that his work fits into what Marc Angenot has called a 'vision crépusculaire':[25] the correspondent seems obsessed with hunting down, wherever they may be, signs of the ineluctable decomposition of Western society and values; the latter are in any case not defined except by negation, in a form generally anguished or polemical: the threat of seeing the individual squeezed out by the collective, repugnance towards all the phenomena of standardization and delimitation of social life, fear of seeing machinery and rational organization take the place of human action, etc. According to this viewpoint, a group of features would characterize this crepuscular representation of the world, as developed by Simenon in his reports.

The first characteristic is, as with Hergé, the obsession with falsity, which the traveller will encounter everywhere: the trickery of colonial propaganda, the dissimulation and mystification of official Soviet communiqués, American falsification of the idea of liberty with the aim of justifying the principle of the

survival of the fittest. The correspondent is confronted with all these mendacious signs and evolves accordingly at the centre of an inverted world where words pronounce the opposite of what they mean: the civilizing work of the West in Africa is in reality a slow disintegration of the white man; classless society is only realized by general famine; the freedom of a few Americans, only exists thanks to the subjugation of the majority.

The other point to be made is that of a generalized massification visible in the USA[26] and the USSR.[27] It produces a disdain for the individual and for human life, which struggles to define itself faced with the ideological ghost of 'death en masse', at work in each of the places visited. Such is the case in the USA or the USSR, who in this way rediscover the obscure fatality that has always held sway in Africa: 'Ils sont des millions comme ça dans l'Afrique sans bornes qui vivent parce qu'ils sont nés et qui ne sont pas encore morts, sans jamais avoir eu l'idée de se demander s'ils sont heureux'.[28]

From this point on it seems that, for Simenon, societies as advanced as the USA or the USSR were experiencing, via the influence of the multitude, a regression analogous with what the traveller witnessed in Africa. In this way Americans sacrificed themselves on the altar of progress with an 'ingénuité d'enfants',[29] recalling the childlike innocence of the black man. What is even more striking is that the famine that ravaged Odessa brought on a return to primitivism which showed itself in the practice of cannibalism, in which Simenon always had an obsessive interest.

Simenon's discourse, haunted by this apocalyptic vision, tends to join together what he regards as the two sides of the evolutionary chain: the primitivism of Africa has an implacable 'rigueur mathématique', just as the extreme machinist rationalism of the USSR ends up with the return of the most archaic instincts (cannibalism). It is as if the state of nature which characterizes reality in Africa and the technological perfection proper to developed societies such as the USA and the USSR finally found themselves in some sort of equivalence; the result is a suspension of moral laws, of values and meaning, the negation of the very idea of civilization. In this fact, Simenon observes the uninterrupted victory of anti-humanist ways, at once primitive and technological: this victory leads to the destruction of the individual in favour of the masses and contempt for human life, readily observable in the cold, rational massacres which the correspondent thinks he sees everywhere and whose ultimate form is the ghost of cannibalism.

Faced with this apocalypse, the correspondent can only find one fixed point, France and French traditions: thus the piece *Peuples qui ont faim* finishes with a section entitled 'Nous avons mis deux mille ans à composer nos paysages'[30] where the 'vieille sagesse' of a people that has been 'longtemps, très longtemps [...] civilisé'[31] is invoked. Once more, we come across the dominating theme of Simenon's novels of that period: the life of the provinces, its tranquil certainties and its resistance to change.

Now, the question at hand is how can this paradoxical valorization of French provinciality in the articles and the deprecatory treatment it receives in the novels of the same period be reconciled? It is none other than the novels taken from the

voyages that provide a starting point to answer this question. These novels indeed almost always use the same plot: an everyman from the provinces, of humble origins, takes on the adventure of a new life by leaving his hometown for an exotic elsewhere (colonies, islands, countries in Latin America, etc.) where he hopes to succeed and lift himself out of his initial mediocrity; each time, this life change is deceptive: the protagonist soon looses his illusions and engages on a track of disintegration which leads to a sort of loss of the self and of its reference points, to the point where the only way out available is death, madness, or even a return to a form of savagery that Simenon calls 'se déciviliser'.[32]

Such a solution remains problematic in all respects, and this is its interest: it shows the inhabitable side of the world whose inventory Simenon resolved to write in the thirties. Conversely to Hergé, who constructed Tintin's world outwards from an absent centre and who developed his character in a tense space between morals and politics, Simenon described a universe stretched between the poles of provincial banality and an exotic elsewhere, both equally deceptive; the ideological dynamic at work with Simenon no longer grows out of morals or politics, but out of a social problematic. The typical Simenon character is indeed a modest petit bourgeois, often young: prevented from fulfilling his ambitions via social climbing, he rages at not being able to escape his situation, whose mediocrity is experienced as a fatality; filled with resentment, he does, however, find a paradoxical grandeur in his desire to attempt — at least once, and even if he knows his attempt to be destined to fail — to move away from his first existence, rooted in provinciality, at once detestable and however the only stable point of reference in a world where all fixity is quickly dissolving. The world, mediated in the reportages through images of crisis and decline, is therefore the geographical projection of the social tensions of which Simenon became the interpreter.

The Post-War Revisions

It is perhaps worth noting that the imagery today associated with the *œuvres* of Hergé and Simenon is not that which we have just described. The fact is that a significant break occurred in the work of both authors, which was to deeply transform the themes dating from the thirties. This break was of course the Second World War, in all respects a caesura in the paths followed by Hergé and Simenon. We know that neither would come out of the war years with his reputation untouched. Along with a section of the staff of the *Vingtième Siècle*, during the Occupation, Hergé worked for the *Soir* 'volé', a paper placed under the control of German censorship and run by protagonists of the collaboration; after the Liberation, Hergé was harassed and temporarily prevented from publishing, before the proceedings against him were dropped; he was then able to continue his activities at the heart of *Tintin* weekly, but was to remain deeply marked by the suspicion he had been subjected to. As for Simenon, he lived out the Occupation in retirement in the Vendée, managing to maintain his lifestyle by giving over the cinema rights to a part of his work to Continental, the German film company registered in France; it is mainly for this reason that the *Comité d'épuration des gens de lettres* opened an

investigation into his activities (which was closed in 1949 with an acquittal): this encouraged Simenon's decision to leave France for North America. These two episodes place our two authors in what we might call the 'grey zone' of intellectual collaboration, where relations of friendly proximity with open collaborators are balanced against the need to continue publishing for financial reasons; in any case they were to feel the consequences: beyond the bitterness of being stigmatized, Hergé and Simenon took a greater distrust towards politics and sought to remove all possible ways to read their works in a specific historical or ideological way.

This operation was made easier by another factor: the occupation was, for Hergé as for Simenon, the moment of a return to the private sphere. From 1940, Simenon in fact was beginning an autobiographical text which, after being reworked, was to become the 'autobiographical novel'[33] *Pedigree*. This text is at once a culmination and a failure. First conceived of as an account for the benefit of his son Marc, then redirected to become a vast novelistic description speaking of 'l'épopée des petites gens' and inspired from a singular fate, the project was interrupted after the first three parts, covering the childhood and adolescence of Roger Mamelin, the novel's alter ego for Simenon. The guarded appreciation of Gide and Gaston Gallimard was largely behind this interruption, which saw Simenon renouncing his ambitions to write a chronicle-novel and to return to his 'fundamentals': the almost faultless alternation of 'Maigret novels' and of 'hard novels' ('romans durs'), a formula he then stuck to until the end of his career. Overall then, in the aftermath of the War Simenon re-adopted the novel formula with which he had begun his official career with Fayard, his time with Gallimard came to be seen as a secondary episode.

What's more, at the very same moment when he was finishing the third part of *Pedigree*, Simenon wrote an article for the *Confluences* review in which he indirectly theorized his failure: 'Le Roman de l'homme',[34] in a few pages, he rejected the temptation of the *roman-chronique* preferring to it what he called the 'roman-crise', 'plus proche de la tragédie, de Shakespeare, par exemple, ramassant, à la faveur d'une crise aiguë, un monde pantelant autour de quelques individus poussés au paroxysme'.[35] This, despite being schematic, was an accurate definition of Simenon's formula for novels, as we are able to identify it today. It therefore seems that it was via the writing of *Pedigree* that Simenon came back, almost in retreat, to recognising and fulfilling his style, to the point of giving it a definition he was to stick to both in terms of facts and of general discourse.

In this sense *Pedigree* is a culmination, all the more so because this autobiographical text condenses, in a form almost resembling a matrix, all the main thematics of Simenon's *œuvre*, past and future. The author's *liégoise* childhood and adolescence became the background for the entire *œuvre*, the keys for reading which allow his obsessive themes and grand symbolic configurations to be identified: the revolt of the young Simenon/Mamelin, brow-beaten by his lowly status, becomes that of all the young male characters enraged by the mediocrity of their existence; Liège suddenly appears as the model of all provincial towns featuring in the work; the defining characteristics of the paternal and maternal figures are distributed amongst the novels' secondary characters; etc. The return to private life does not therefore remained constrained to the single autobiographical project of *Pedigree*: it is to be

found in the reversed perspective of the *œuvre*, which no longer attempts to be writing the inventory of the world, recounting all lives in all places, but which, from this point on, was to link all the particular destinies written about to the same personal matrix, obsessively questioned in Simenon's whole novelistic *œuvre*.

This also means that the possibility of a socio-historical reading, like that we suggested earlier, is rejected. Indeed the author changed projects from writing 'l'épopée des petites gens' to 'à la recherche de l'homme nu', a search whose terms he used to cast a different light on his entire *œuvre*:

> Or, si j'ai toujours rêvé d'écrire un roman-chronique — et si tous les critiques m'y poussent — je ne m'y sens pas à l'aise. J'éprouve inconsciemment le besoin de ramasser, de concentrer, de pousser tout de suite mon ou mes personnages au paroxysme. Peut-être par faiblesse? Peut-être aussi parce que le roman-chronique est fatalement un roman d'époque, un roman de 'mœurs', et que cela ne m'intéresse pas, que je ne cherche, au fond, que l'homme tout nu (...).[36]

The reader will perhaps have noticed how, in Simenon's binary typology, the chronicle-novel is associated with an engagement with social and historical questions (the *roman de mœurs* and the novel of its times), whilst the crisis-novel is associated with a different type of novelistic project, which took the place of the previous one, itself characteristic of the thirties. From the mid-point of the following decade, 'l'homme nu' was indeed imposed as a leitmotif in Simenon's discourse on his *œuvre*. His writing focused on the knowledge of man *en soi*, and how he appears when he has been stripped of all racial, social, cultural and intellectual mediations behind which the human condition is ordinarily hidden away. Removing itself from history as from sociality, Simenon's way of writing novels was no longer concerned with the outside world and was seen by the author as a stripped-down representation of man, who was reduced to a few general characteristics guaranteeing his universality. This simenonian 'humanism' is in this way the product of post-war revisions: an abstract and universalizing psychology took the place of the grand ideological configurations of the thirties, a psychology largely founded on Adlerian psychiatry and psychology, to which Simenon was to refer constantly from the fifties onwards.

Even though it adopted different forms, an analogous process of return to the private is readily observable with Hergé. It was indeed during the War that Tintin's universe was progressively peopled with recurrent characters who would eventually make up the little reporter's 'family': the Dupont, Captain Haddock, Professor Tournesol, Castafiore, etc., all these characters were to enter into the series and stay there for good. What's more, at the end of the double adventure of *Le Secret de la Licorne* (1942) and *Le Trésor de Rackham le Rouge* (1943), the pseudo-family comes to possess the château of Moulinsart, which then became the nerve centre of Tintin's adventures. From the moment when the French-style château begins to be used, the reporter's adventures take on a different hue: Tintin and his chums no longer set off under the sign of a sort of sacrosanct vocation, but because the defence of the Moulinsart clan's interests dictate that they do; be it because the château is invaded by 'outsiders' (the Arab prince Abdallah and his retinue, the frightful petit-bourgeois Lampion and his cluttering family) or because Tournesol disappears, each

time Tintin and Haddock set out in order to protect the territory and restore the basic group to its full complement. From this point on, everything is as if Tintin only leaves on a new adventure in order to return to a better life.

For this reason, the appearance of Tintin's world changes: we witness an increasingly insistent return of the same characters and of the same imaginary countries. The latter cease to refer to a real country and become autonomous representations internal to the *œuvre*, with interchangeable meanings: the fascist neighbour takes on the face of communist totalitarianism at the same time as some of the protagonists surviving in South America (nazi criminals or Soviet military attachés?). Increasingly self-referential, the little reporter's world shrinks like a *peau de chagrin* to a summary view of world politics over which the hero incessantly goes, the history of the countries visited being confused with that of his adventures. The last big mission of discovery will, significantly, be the trip to the moon, demarcating the extreme of an exploration which can now go no further.

This substantial change in Tintin's universe must of course be traced back to the move to Moulinsart. Indeed it seems that the château, along with the group it shelters, takes on the role of defining this fictitious geography, in a very specific way. Moulinsart, in its peaceful rural setting, figures in a sense the opposite of adventure and seems dedicated to tranquil, sedentary life; it is like a shelter from the world, in some way protected against the troubles that shake the globe. It observes in an essentially passive way history in the making: history comes towards it rather than the other way around, either in the form of news which the media continually projects into it (Tintin in fact is less a reporter than a reader of the paper and a radio listener, later a viewer of television), or in the form of attacks or intrusions which compromise the integrity of the basic group. If Tintin and his group react to events, it is therefore in a second moment, under the constraint of necessity. Far from being a centre, Moulinsart is rather a peripheral space and the passive point of convergence of all the tensions that surround it. This is to say that the post-war Tintin is less a protagonist of the fictitious stories than a secondary participant, sent off to the four corners of his hand-drawn maps by a undefined mixture of altruism and absolute necessity. In as much as it is a base camp from which Tintin's team operates, Moulinsart seems to be a place strangely removed from the theatre of History (which is perhaps still a representation of Belgium, as the post-war period leads one to think of the country).

Tintin's quest changes direction from this moment: the globe-trotter who drew up an inventory of the world's anguish has left the scene, a phenomenon yet more accentuated by the reworking, both narrative and graphic, which Hergé undertook during the war years, of the first albums, which had the effect of accentuating the uniformity of the work and the feeling that Tintin's universe was from now on completely autonomous. The reporter is no longer really interested in politics, which has become nothing more than an anecdote or an appearance, destined to allow the humanist and universalizing values of the post-war Tintin to be expressed: the defence of the rights of man and the rejection of any kind of totalitarianism; proportionate faith in science; spiritual — even mystical — searching, visible in Hergé's interest in Eastern religions, in Jungian psychoanalysis

or in parapsychology. As with Simenon, the mature work is wary of politics and history and chooses to re-orientate itself around the private sphere and around an abstract and universalizing psychology.

In Hergé's case as in that of Simenon, we can say that these post-war revisions were a success, in the sense that they largely conditioned the reception of the two *œuvres*; and it would be wrong to see them uniquely as a simple effect of ideological masking or of political euphemisms in relation to the preceding period. On one hand, indeed, it must be noted that this process, with both authors, helped to strongly accentuate the internal coherence of their *œuvres* and that these *œuvres*, when conceived of in this way, are exciting to explore, a fact proved by the proliferation of critical readings, often with psychological or biographical overtones.[37] The exploratory dimension of their production during the thirties was therefore replaced by a balance and mastery that was doubtless important in the consecration that the two *œuvres* have experienced from the 1960s onwards. We might add that in freeing themselves from an overly marked historical or ideological field of interest, they also avoided dating too rapidly, and became, in their field, classics. We could summarize this as 'faire date sans être daté': marks a milestone, but is not dated.

On the other hand, it seems that Hergé's and Simenon's evolutions speak, in a singularly readable form, of a much more general destiny: the avatars of a particular conservative catholic way of thinking which was strong in between-the-wars Belgium. The passage from political engagement and ideological activism to a depoliticized and a-historical mode of thinking, founded on an abstract universalism with a psychological and spiritualist base was indeed a process undergone by a good number of intellectuals or Belgian authors of the catholic right: for example, Georges Poulet, Maurassian and in favour of a 'reactionary revolution' in the thirties, one of the most eminent critics of the 'conscientious criticism'; or even Henry Bauchau, active member of the catholic youth and wartime founder of 'Volontaires du Travail', whose post-war work, in the fields of psychoanalysis and the investigation of famous antique myths, is today considered as amongst the most significant in Francophone Belgium. What we are dealing with is therefore much more than a series of singular adventures, indeed it is a collective phenomenon which could profitably be explored. In their own particular way, which is to say a way both marginal and little elaborated, Hergé and Simenon give us a precious insight into this phenomenon.

Notes to Chapter 9

1. Pierre Assouline, *Simenon* (Paris: Julliard 1992) reissued in the Folio series (Paris: Gallimard, 1996); *Hergé* (Paris: Plon, 1996), also reissued in the Folio series (Paris: Gallimard, 1998). Let us not forget the two early works by Pol Vandromme, a well-known right-wing critic in Belgium.

2. With his solid line, Hergé codified a 'classical' aesthetic, in the strongest sense of the word, which became a reference point for the francophone cartoon strip.

3. On this topic see: Jean-Claude Jouret, *Tintin et le merchandising. Une gestion stratégique des droits dérivés* (Louvain-la-Neuve: Academia-Érasme, 1991).

4. The name of the federal entity responsible for culture and education in French-speaking Belgium changed its name a few years ago: it changed from 'Communauté française de

Belgique' to 'Communauté française de Wallonie-Bruxelles', which tells us much about the political divisions around this issue. Let us add that these problems are an intrinsic part of the Belgian State, which did not wish or was unable to organize itself on a French-style centralized model.

5. On Hergé's identification with Brussels culture (Marollian, Zwanze dialect etc.), see this relevant work: Daniel Justens et Alain Préaux, *Hergé, Keetje de Bruxelles* (Tournai: Casterman, 2004).

6. See: Michel Lemoine, *Liège couleur Simenon*, 3 vols. (Liège: CEFAL, 2002).

7. The Belgian school system at the time indeed structured teaching according to a social logic: classic humanities (Greek and Latin) led to higher university education and traditionally accepted the children of the well-to-do; professional and technical studies were only for future workers and artisans. The petite bourgeoisie of civil servants, employees and merchants received an education in what was called 'modern humanities', which put the emphasis on languages and scientific knowledge.

8. We might add that the 'simplicity' and 'readability' that are the defining features of the styles of Simenon and Hergé and which are today agreed to be one of their qualities, can also be read as the product of a change in direction away from their cultural baggage, towards a coherent aesthetic line. This stylistic option is the opposite of 'over-writing' and compensating practices (hypercorrect-ism, insistent use of 'beau style', excesses of ornamental rhetoric, etc.) are often encountered in the domain of para-literature.

9. See Jacques Lemaire, *Simenon, jeune journaliste. Un anarchiste 'conformiste'* (Brussels: Complexe, 2003).

10. See for example this description of the Luskas, father and son, in *Les Inconnus dans la maison* (Paris: Gallimard, 1940). See the re-edition of the novel by Jacques Dubois and Benoît Denis, in Bibliothèque de la Pléiade, vol. I (Paris: Gallimard, 2003), p. 1028.

11. We shall give the date of publication in the press, and not that of publication in album form.

12. These are the terms that Simenon was to use himself to describe his novel formula: we shall come back to them.

13. The most striking novel from this point of view, and perhaps one of Simenon's strongest, is *La Neige était sale* (Paris: Presses de la Cité, 1948), written immediately after he received news of his brother Christian's death, who served with the Foreign Legion in Indochina, after having seriously compromised his position with active, armed collaboration in Belgium (see the 'notice' of the novel, in Simenon, *Romans*, ed. by Jacques Dubois et Benoît Denis, II, pp. 1503–1519).

14. This is the 'Phototexte' collection, published by Jacques Haumont, with photos by Germaine Krull. A text was published in 1931, *La Folle d'Iteville*.

15. See Frédéric Soumois, *Dossier Tintin* (Brussels: Jacques Antoine, 1987).

16. This production, undertaken at a truly industrial rhythm, comprises around 190 novels, signed with 17 different pseudonyms and most often published in installments by Ferenczi, Tallandier, Fayard, Rouff or Prima.

17. On this ambition to move towards the status of a fully recognized novelist, see Simenon's long letter to André Gide of mid-January 1939: Georges Simenon — André Gide, *...Sans trop de pudeur. Correspondance 1938–1950*, ed. by Benoît Denis, Carnets (Paris: Omnibus, 1999), pp. 26–40. On the importance of the novel-chronicle and the genesis of *Pedigrée*, see: Benoît Denis, 'Simenon, le roman et l'Histoire', in Jean-Louis Dumortier (ed.), *Le Roman de Simenon. Pedigree: entre réalité et fiction* (Tournai: La Renaissance du Livre, 2003), pp. 87–112.

18. '[...] j'ai voulu vivre coûte que coûte *toutes les vies possibles*. [...] Avoir d'abord les hommes en soi (l'idéal serait de pouvoir dire tous les hommes), d'avoir vécu toutes leurs vies [...]. Georges Simenon — André Gide, *...Sans trop de pudeur*, pp. 32–33.

19. Here Hergé invents fictional countries for the first time: San Theodoros and Nuevo Rico.

20. This begins in *Tintin au pays des Soviets*, the 'Potemkin' villages are heavily alluded to; it is explicit in *L'Oreille cassée* where the plot is based on the fabrication of false arumbaya fetishes and the search for the original statue; it culminates in the first version of *Au Pays de l'or noir*, when Tintin meets his doppelganger, an Irgoun militant.

21. This statement applies less to the first adventures, in the *Petit Vingtième*, than it does in general: in these, Tintin is presented as an identifiable young catholic Belgian boy, a direct reflection of the supposed identity of his readers.

22. An instructive fact is that in the first Maigret series (1931 — 1933), the commissioner belongs to a mobile unit: based in Paris, his investigations are mostly in the provinces. Only in the post-war period will the commissioner carry out the main part of his work in the capital.

23. Simenon, *Peuples qui ont faim* [1934], in *Mes Apprentissages. Reportages 1931–1946*, edited and introduced by Francis Lacassin (Paris: Omnibus, 2001), p. 931.

24. Simenon, *Histoires du monde malade* [1935], in *Mes Apprentissages*, p. 550.

25. Marc Angenot, *La Parole pamphlétaire. Typologie des discours modernes* (Paris: Payot, 1982).

26. 'Et le gentleman glabre nous a expliqué que si c'était nécessaire de tuer froidement cent mille hommes, un million d'hommes pour le Progrès, il n'aurait pas une hésitation, ni lui, ni n'importe quel Yankee digne de ce nom'. Simenon, *Histoires du monde malade*, p. 550.

27. 'Vous êtes étranger... Vous ne pouvez pas comprendre... Chez vous, quelques milliers de morts ça compte... Chez nous, on peut en laisser mourir des millions... D'ailleurs, nous importons des machines à la place...' Simenon, *Peuples qui ont faim*, p. 904.

28. Georges Simenon, *L'Heure du nègre* [1932], in *Mes Apprentissages. Reportages 1931–1946*, ed. by Francis Lacassin (Paris: Omnibus, 2001), p. 394.

29. Simenon, 'En marge des méridiens' [1935], in *Mes Apprentissages*, p. 502.

30. Simenon, *Peuples qui ont faim*, p. 931.

31. Simenon, *Peuples qui ont faim*, p. 933.

32. The recurrent schema is illustrated in an ideal/typical fashion by *Le Coup de Lune* (Paris: Fayard, 1933), a novel inspired by Simenon's experience in Africa.

33. A first version, under the title *Je me souviens...*, was written in the first person, as a classic autobiographical tale; Simenon rewrote the text on Gide's advice, introducing a fictional substitute for himself, Roger Mamelin. This is why the term 'autobiographical novel' is ambiguous.

34. Simenon, 'L'âge du roman', in *Confluences* (*Problèmes du roman*), 1943; republished in Simenon, *Le Roman de l'Homme* (Lausanne: Éditions de l'Aire, 1980).

35. Simenon, 'L'âge du roman', p. 72.

36. A letter from Simenon to Gide (29 March 1948), in Simenon — Gide, *...Sans trop de pudeur*, p. 132.

37. Let us quote, at random, on Hergé: Jean-Marie Apostolidès, *Les métamorphoses de Tintin* (Paris: Seghers, 1984); Pierre-Yves Bourdil, *Hergé. Tintin au Tibet* (Brussels: Labor, 1985); Michel David, *Une psychanalyse amusante. Tintin à la lumière de Lacan* (Paris: Desclée De Brouwer/ Epi-La Méridienne, 1994); Serge Tisseron, *Tintin chez le psychanalyste* (Paris: Aubier, 1985). On Simenon, there is a similar profusion of studies: Salvatore Cesario, *Su Georges Simenon. Maigret, conversazionalismo, abduzione, proustismo, schizo-scrittura*, Semiosis Su , 3 (Napoli: Edizioni Scientifiche Italiane, 1996); Paul Mercier, *La Pulsion d'écrire*. *Approche psychologique de la création romanesque chez Georges Simenon* (Besançon: P.U. de Franche-Comté, 2003); Henri-Charles Tauxe, *Georges Simenon: De l'humain au vide: Essai de micropsychanalyse appliquée*, (Paris: Buchet-Chastel, 1983); Maurizio Testa, *Maigret et l'affaire Simenon* (Marseille: Éditions Via Valeriano, 2000).

A Road Story of the Belgian Avant-Garde

An Paenhuysen

The avant-garde was, Christopher Reed states, 'not at home.' It 'imagined itself away from home, marching toward the glory on the battlefield of culture.' The constructivist artist turned against the sentimental hysteria of the cult of the house, and for the surrealist the 'uncanny' was a key notion. Reed concludes, that 'home is a place you leave behind at the start of something significant'.[1] And without doubt, after the escape from home, the avant-garde artist chose to go straight ahead. The cult of the house was exchanged for a nomadic way of life. A steady place was being replaced by a new freedom. It was a position outside the ancestral home, of which the foundations and the building blocks had to be pulled down. An old world in which individuals felt connected through acknowledged norms, traditions and loyalties was left behind for a new adventure.

The following essay sets out to analyze the itinerary of the Belgian avant-garde artists after their departure from home in the interwar period. Specific journeys of the Belgian avant-garde abroad — the *Heimat* left behind — will be used as case-studies to show its encounter with modernity and the different answers formulated to cope with the new challenges. Exploring the road stories of the avant-garde presupposes that the movements and the settings of the avant-garde happenings are worth a closer look. The avant-garde can be considered as a social occurrence in which counterculture was formed. Therefore, in addition to manifestos, journals and art production, the lifestyle, the body language and also the settings used by the avant-garde are important to the understanding of its project. Where did the Belgian avant-garde turn to? Is it a shifting topography? Could travel destinations reflect a changing attitude of the avant-garde artists towards modernity? These are but a few of the questions that will be explored here.

Venice

The travel itinerary of the first Belgian avant-garde artist was impressive. The 'mythical ex-patriot' Jules Schmalzigaug traveled through Germany, The Netherlands, France and Italy.[2] The point of departure was Antwerp. In 1899, as a youngster, he was sent to Dessau, Germany, to receive treatment for his scoliosis which had been diagnosed at the age of sixteen. It was in this newly industrialized Germany of the turn of the century that Schmalzigaug's interests in the modern were evoked. His mentor Paul Riess pushed him in the direction of the applied

arts and Schmalzigaug moved to Karlsruhe where he specialized in modern, industrial design. In 1903 he returned to Belgium to continue his art education at the academy of Brussels. Some years later, in 1910, he decided to leave his home country again and to settle down in Paris where he took classes from Lucien Simon. In 1913 another move, this time to Italy, was undertaken. It was in Venice that Schmalzigaug became the 'only authentic futurist artist' of Belgium.[3]

Futurism had been launched in Italy in 1909. In his *Manifesto of Futurism* Filippo Tommaso Marinetti had forbidden to look at the past any longer. The futurist artist needed to burn the 'catacombs' of the libraries and to flood the 'graveyards' of the museums. 'Passeism', the orientation towards the past, made people 'blind, deaf and stupid' towards life. The dynamic art, which resulted out of these revolutionary futurist ideas, was received with indifference at that time in Belgium. After having been in Paris, Berlin, and London, the first futurist exhibition in Europe arrived in Brussels in 1912. On its way it had stirred up the entire art world, but no such reaction was noted in Belgium. The interest was poor and feelings didn't even run high at the scandalous and shocking performances of Marinetti and Umberto Boccioni. 'These events had no influence at all,' an art critic stated later, 'we still wonder why'.[4] A rather conservative tendency appeared to have characterized the Belgian art scene before the outbreak of the First World War. Also, more generally, modernity did not seem to have affected Belgium yet. A possible explanation for this calm can in my opinion be found in the lack of migration within Belgium. The flight from the country to the city was limited and people usually stayed in the same place they had been born and raised. The expanding population was not concentrated in huge cities and the capital of Brussels did not have the same dominance as Berlin, Paris, and London. The densest railroad network in the world connected the small cities in Belgium but modern transportation had in the end a conservative outcome. Coming home after work was guaranteed and moving to the city became unnecessary. In this way, no actual mobility or dislocation occurred and the tradition of living in the country could be preserved. If migration produced, as Anton Kaes states, 'destabilization, displacement, and disorientation with radical consequences for personal identity, social and cultural homogeneity',[5] then it is not surprising that modern sensibility had not yet infiltrated Belgium before the First World War.

Yet, Schmalzigaug's journey abroad was not that exceptional, even for a Belgian artist. A solid bourgeois education was often finalized with a stay abroad. It was more or less a tradition that art studies had to be concluded with a *'grand tour'*, that was mostly restricted to Italy, in particular to Rome — the most important city for classicist art. A special 'Prix de Rome' was awarded to further young talent in developing their drawing skills in the classic tradition.[6] Paris also became attractive as a *Capitale des Arts* in the fin-de-siècle period. The journey of Schmalzigaug definitely had features of a *'grand tour'*. Having no income, he relied on his parents to finance his journeys abroad. A respectful relationship was always maintained. Every two weeks Schmalzigaug had to write the obligatory letter home. In this way the contact with Antwerp was never broken. The home front pointed out Schmalzigaug's responsibilities, rebuked now and then the irregularity of his mail

or exerted pressure to which Schmalzigaug occasionally offered resistance: 'I am not crazy' — 'I am no longer a child'.[7]

Although Schmalzigaug started his journey as a kind of *grand tour*, it soon turned out to be something completely different. Abroad, he came in contact with the modern world, which made him break with tradition. In Germany, he discovered the 'new beauty' of modern industry. In Paris, he admired the Tour Eiffel as a symbol of progress. He visited the *Salon de l'Aéronautique* in 1911 and was fascinated by the airplanes, which appeared to him to be more interesting than any art exhibition ever could be.[8] In the streets of Paris, Schmalzigaug was exhilarated to see how the cityscape was changing due to increasing traffic. He told his parents in a letter that crossing a boulevard, taking a bus, or taking a train demanded gymnastic skills.[9] Schmazigaug's admiration for modern life reached a climax in Venice, where a Belgian visitor wondered why his fellow countryman was so fond of picturing the stirring street life, the trembling of the machines, and the irritating noises and nervous movements of the cars. With his 'rhythmic orchestrations' Schmalzigaug wanted to accomplish a new aim: creating a contemporary style, which would reconcile people with the new world.[10]

In order to reach his aim Schmalzigaug had to break with his masters and move on. 'We have to learn from our teachers,' he wrote to his brother, 'we don't have to follow them'.[11] In Dessau he was already afraid of losing his personality by being dependent on one school. After spending two years in Paris, the city was left behind in order to throw his ex-master Simon 'over board' in Italy. Schmalzigaug turned against the 'gerontocracy' and claimed absolute freedom of ideas.[12] In Venice, his enthusiasm and self-confidence culminated. 'I am drunk with ideas,' he wrote to the Belgian artist Richard Baseleer, 'and may my drunkenness continue.' He saw himself sailing the open sea, while Baseleer, standing on the shore, warned him against the dangers of drowning — 'So it may be. Who cares?' —, taking the helm, 'freed from all fetishism of museums, salons and reminiscences.' The connection between art and modern life, Schmalzigaug argued, had been lost because art opposed modern innovations such as cinema, photography, illustrated press and advertising: 'Why this anxiety and this constant worrying about saving the 'prestige' of Art (with a big A) [...] There is a new world in front of us and we should doubt ourselves? So what if I'm wrong?'[13]

Exile was in Schmalzigaug's opinion necessary to reach his goal. An unfamiliar environment stimulated a rebellious mentality while life at home was too easy and comfortable.[14] Abroad, Schmalzigaug developed an almost physical disgust of his home country. He tried to avoid Belgian tourists in Venice and 'quivered' when he encountered them.[15] Living in the right 'ambiance' was for him of utmost importance, and Venice offered this environment. Schmalzigaug had discussions with his friends in the famous Caffé Florian at the Piazza San Marco during the day, and at night he visited the café-concerts. The volatile atmosphere of these modern places were the inspiration for such futurist paintings as *Sensazione dinamica di danza (Interno di bar notturno)*. Schmalzigaug was now convinced, as he wrote to his parents in November 1913, that he would become a *'chef de file.'* 'We are in Venice the "young fools",' he boasted to his brother, 'who wear a red carnation

in their buttonhole, discuss enthusiastically, suspect the unknown of the modern expression, refuse present art and rebel against paternal protection. This is the milieu in which it is essential to work'.[16]

Berlin

The outbreak of the First World War, however, interfered with Schmalzigaug's optimistic ambitions. He hurried back to Belgium and fled to The Hague in the Netherlands together with his family. This exile was of a different kind than the previous one. This time his bourgeois family was with him. The war, moreover, did not provide any prospect of escape to other regions but forced isolation in this hinterland of Europe divided by war. Schmalzigaug began to suffer from 'mental neurasthenia'.[17] Exile, which once had freed him from his family, a bourgeois environment and a conservative Belgian art scene, now turned against him. He would, and could, no longer adapt to his old world. Moreover, the Great War had created a new world the likes of which he had not imagined. Schmalzigaug felt trapped. On 13 May 1917 he committed suicide.

In Belgium, however, the war created a generation of avant-garde artists. The *tabula rasa* of the war seemed to open up new possibilities and to shake the self-satisfied art world.[18] While the war was for Schmalzigaug a time of isolated exile, in Belgium it meant an encounter with the modern world. The 'turn to the city' happened in Schmalzigaug's hometown of Antwerp, which was occupied by the Germans in 1916. The experience of modern technological warfare significantly changed the perception of artists. 'Oh no, I will never forget this night so suddenly lightened, fantastic as a phantom of an unknown land,' the young poet Paul van Ostaijen wrote in 1914 during the first days of the war.[19] In 1916 he published his first expressionist inspired collection of poems entitled *Music-Hall*, in which the experience of the war and the adventure of the cabaret mingled. The war gave the impression that old authorities and values had disappeared. In Antwerp, the rebellion of a young generation of artists was especially roused by their struggle for the rights of the Flemish people. Political and artistic revolutions were for the 'humanitarian expressionist' indistinguishably connected. The fight against capitalism and the leading bourgeois elite was reduced to a fight for the Flemish people. It also gave the young generation the opportunity to react with their 'activism' against the 'passivism' of the older generation, which had decided to rest the Flemish case until the war was over and which refused to work together with the German occupiers to accomplish their claims. The young humanitarian expressionists incited brotherhood and community spirit. The artist was in the service of the community and felt united with the people — the Flemish people.

When the war was over in 1918, Van Ostaijen, who had become the key figure of the growing expressionist avant-garde in Antwerp, had to flee to Berlin. His exile was not voluntary but an attempt to escape a conviction for his 'activism' during the war. Still, the metropolis of Berlin must have been a promising destination for an avant-garde artist. It was the city where the expressionist movement was already flourishing. Van Ostaijen had read *Die Weissen Blätter* during the war and was well

informed about the Berliner art world. Berlin was 'an international meeting place of the first rank'.[20] It was a migrant city. In a few decades, Berlin population had exploded into the population of four million it had in the 1920s. Van Ostaijen not only experienced the transition from country to world capital, but also a migration from abroad. The German capital was above all a magnet for young artists and intellectuals. The 'Berliner Begegnungen' were numerous.[21] Berlin not only functioned as an 'Ostbahnhof' for migrating East-European artists, but the Italian futurists had also founded their *casa futurista* in the city. Even Dutch artists like Theo van Doesburg, Joris Ivens and Paul Citroen lived in Berlin. As a Belgian migrant, however, Van Ostaijen was quite alone.[22]

Van Ostaijen seemed to have integrated easily in the fancy art scene of Berlin. He visited the Sturm gallery, read the *Sturm* art magazine, bought poetry in the gallery and even went to meetings. His favourite bar was the legendary Café des Westens on Kurfürstendamm. He met Georg Grosz, Else Laske-Schüler, and Adolf Behne. His best friends in Berlin were Heinrich Campendonk, Fritz Stuckenberg, Georg Muche and Arnold Topp. A revolution wasn't only happening on the level of the Berlin art scene. When Van Ostaijen arrived at the end of October 1918, the political revolution was about to break out. In November, Berlin became a city of revolutionary movements, uprisings, strikes, barricades, Workers' and Soldiers' Councils and November manifestos. The Belgian artist, living in a room on Wilhelmstrasse, saw the mass demonstrations pass in front of his window. The Dadaists marched through the governmental neighborhood and the Spartakus uprising was crushed in these same streets. Van Ostaijen was literally confronted with the revolution which he had imagined in Belgium. He watched its rise and collapse.

In Berlin, Van Ostaijen dealt for the first time with the 'shock of modernity.' At the end of the 19th century, industrialization and urbanization had transformed the German city very rapidly into a metropolis. In contrast to Belgium, huge waves of migration to the capital had caused great tensions between rural and urban Germany. As nowhere else the *Weltmetropole* Berlin became a place of confrontation disturbed by modernity. Van Ostaijen's encounter with the city led to nervous breakdowns. The gap between utopia and his reality was too big. Not only on a political level were his dreams scattered, but also the artistic avant-garde world did not measure up to his expectations: 'There is no movement. Hardly ever does one meet two people who can stand each other.'[23] In the letters to his friends in Antwerp Van Ostaijen reached for the usual clichés about Germany to describe his aversion toward the city of Berlin, as if trying to get a grip on a world which he could not understand (or grasp). The German was a Prussian, with all negative associations connected to the word: stiff, rude, boring, militaristic and sterile.[24] In contrast to France, German culture lacked a '*joie de vivre*'.[25] Van Ostaijen's perception of Berlin, however, was far more a critique of the modern city and European culture as a whole. His trust in European culture — 'Our generation must perish in the most stupid way' — and the modern city — 'I have always believed that I need the big city. I don't need it. But that is a mere negative statement' — was gone.[26]

This anti-urban orientation also became clear in his poetry book titled *Bezette Stad (Occupied City)* written in 1920 during his stay in Berlin. Seemingly about

Antwerp during the First World War, the poems rather reflect a traumatic encounter with the modern city. The big city is, in this Dadaist poetry book, a landscape of disaster and decline. Advertisements, film, cabaret and jazz are interwoven in the text in a terrifying manner. Not only the city, but the whole of society is doomed. Some sentences refer to Van Ostaijen's letters to his Belgian friends. 'I've had it' was written in a hopeless mood in May 1920, 'let's go to work' was a reminder of the excitement of the first days in Berlin, followed, however, directly by: 'Everything is without meaning.' The word '*nihil*' dominates. Karl Liebknecht is mentioned in capital letters, but the revolution is over without having achieved anything: 'O our desire / for the destruction of all concepts / all hope / all craziness / the red flood doesn't increase / the red armies don't rise / and nothing gets broken / and nothing gets broken'.[27]

Yet one place could reconcile Van Ostaijen with Berlin. Alexanderplatz was situated in the eastern, more popular part of the city, far away from the governmental neighborhood where he lived, or the 'civilized' Kurfürstendamm where modern Berlin was flourishing.[28] It was in all probability in this neighbourhood that the poet, under the influence of cocaine, considered Berlin 'beautiful.' In September 1920 he wrote: 'I'm starting to think about Berlin as beautiful. Even very beautiful in its primitive brutality. Berlin is unsystematic. A mushroom has found fertile ground and extends rapidly in huge dimensions. Only this: a heap of houses, a *forêt vierge* of houses smashed next to each other, without direction, style or anything; the advantage of the barbarian, of the absolute lack of tradition. Not half-and-half, but totally barbarian'.[29]

It was this desire for a new start, for a pre-modern, uncomplicated life that drew Van Ostaijen to Dadaism. Through the denial of all grammatical rules and the deconstruction of words and concepts, an alternative was created for the civilized bourgeois society. 'I want to be naked and start', Van Ostaijen jotted down in 1920.[30] Still, Van Ostaijen longed to be 'home' again, that is, in the 'Latinate' civilization. In Berlin, he wrote in an autobiographical essay that he was becoming a melancholic 'who gazed towards the West with nostalgia'.[31] The roots of Western culture were not noticeable in the German city in which a cool, rational modernity, without memories, had taken over. The best cup of coffee, Van Ostaijen told himself, could be drunk after all in Café Hulstkamp at the Keyserlei in Antwerp.[32]

Paris

Was the 'Unheimlichkeit' of Van Ostaijen in Berlin not in the end *the* experience of the modern man — the feeling that, as Karl Marx wrote, 'all that is solid melts into air?'[33] The poet, while in Berlin, could only think about escaping: 'I don't give a damn if they put me for some months in a box or if I have to be a soldier. One thing: away from here. [...] Adjöh Berlin du Schöne Stadt!!!!!'[34] [adieu Berlin you beautiful city]. The estrangement was not to disappear after his return home in 1921. His Belgian comrades reproached him as a cynic.[35] The once cheerful poet must have spoken with hesitation.[36] He had, his brother noticed, 'some kind of trouble around the mouth, as when one has a speech impediment'.[37] Van Ostaijen's

poems and letters during his stay in Berlin showed how much he remained concerned with the events in his hometown, both in politics and in the arts. He had nevertheless lost control over the avant-garde in Antwerp and while his ideas about art changed, his friends did not follow his direction. The diverse short-lived expressionist movements which came into being in Antwerp after the war were still stuck in the 'O Mensch'-lyricism of Kurt Hiller and Franz Werfel. From a Berliner's point of view this art could only be out-dated. It was not only a late arrival, but, inevitably, the Flemish engagement of the artists in Antwerp which had restricted the movement to a local enterprise.

Van Ostaijen's return to Antwerp was initially supposed to be an intermediate stop on his way to Paris. 'Maybe I'll be in Montparnasse for Christmas,' he wrote to Stuckenberg before his departure.[38] In 1926, he still mentioned in a letter to Campendonk that 'if sweet God helps a little, we'll ride to Paris at the end of the year'.[39] When he died in 1928 of tuberculosis, he had, however, not made it to the City of Light. The geographical distance between Antwerp and Paris must not be underestimated, but mental distance most likely also played a role. In Berlin, Van Ostaijen had lost his belief in the avant-garde project, which was, in the 1920s, more than ever symbolized by Paris. Nevertheless, other Belgian artists traveled often to Paris and spent their vacations in the city. Brussels, instead of Antwerp, became the point of departure. Time abroad was no longer considered an exile, but had rather the character of travel. That was partly because the return home was always kept in sight, but also because Paris did not cause the same feeling of estrangement as Berlin. The French metropolis appeared to be different. While Siegfried Kracauer defined Berlin as 'a city in which one quickly forgets', Paris represented for him 'Europe's oasis'.[40] Modernity had infiltrated Paris in a more gradual and therefore more acceptable manner. The city had a modern 'tradition.' The boulevards and arcades were for Walter Benjamin the metaphors of this nineteenth-century, modern Paris.[41]

No Belgian avant-garde group was as fond of Paris as the *Sélection*-group. *Sélection* was a journal in which expressionist art — with 'French roots'[42] — was propagated, and at the same time a gallery in Brussels in which the avant-garde performances took place. A key figure of this group was Paul-Gustave van Hecke, who happened to adore the French capital. '*Soirées à Paris*' were enjoyed on a regular basis. The 'place to be' was *Le Boeuf sur le Toit*, a trendy jazz bar of Jean Cocteau's in the Rue Boissy d'Anglas. Van Hecke saw *Les Ballets Russes* on their tour through Paris and in *Théâtre La Cigale* he attended the latest show of Tristan Tzara.[43] But 'real' Paris was also not unfamiliar to him. Van Hecke knew his way through the 'backrooms', the studios and the small restaurants where the 'great' worked and lived.[44] Most of the time, however, he played 'Paris' in Belgium. The Parisian 'joie de vivre' was stirred up in different places — at home in the 'Avenue de Congo', in the gallery, in the fashion house of his wife Norine and in their summer residence in the Flemish country — and in many ways — through parties, dinners, music, art and *haute couture*. One of these Parisian adaptations was the fashion show — 'gala des choses en vogue' — organized to promote the fashions designed by Norine. A combination of *haute couture* and music — foxtrots and blues played by the Parisian

musicians Camille Doucet and Jean Wiener — was sufficient to draw similarities between them and the world of Coco Chanel, Ernest Hemingway's 'moveable feast', Josephine Baker's *Revue nègre*, and the 'Moulin Rouge'.

Yet the *Sélection*-group was not a mere epigone of the avant-garde happening in Paris. The city was used to represent the artists whom *Sélection* promoted as utterly modern. This group — Gustave de Smet was the most renowned — lived in the Flemish village of Latem. Rural country and modern metropolis were brought together in *Sélection*. Primitivism was the binding agent and Brussels was the connector between centre and periphery, where Latem and Paris were brought together and sold in one package as 'avant-garde.' The art of the Flemish 'primitive souls' who lived in Latem in close relationship with the local farmers, was associated with the *art nègre*, the black jazz and the *'virus noir'* in Paris. The new, modern man followed his instincts and was vital and passionate in contrast to the decadent and passive European. This connection between Paris and Latem was perfectly visualized in Van Hecke's house. In his bar, Paris — with its cocktails, its portraits of Parisian friends, jazz music — and Latem — the flags of the local shipping companies, the folklore, and the portraits of Flemish friends — were brought together.

Two worlds were joined in the bar of Paul-Gustave van Hecke in Brussels.

Another avant-garde movement, which brought Paris to Brussels, was the constructivist *7 Arts*-group. While the *Sélection*-group searched for an alternative modernity in primitivism, the *7 Arts*-movement decided that mechanization and industrialization had to be radicalized. The machine was at the centre of its aesthetics. The artists of *7 Arts* were fervent urban citizens who disapproved of countryside. The readers of their journal were being addressed as 'modern townsmen.' 'Recall,' the editors of *7 Arts* wrote enthusiastically, 'the first view of the city as the train approaches'.[45] In an essay entitled 'Villes et forces modernes' of 1924, Maurice Casteels described the light, pace, smell and sound of the metropolis. He admired the skid marks on the street, sniffed the perfume of petrol, enjoyed the symphony of sirens, tooting, whistling, and buzzing and loved to watch the electric billboards.[46] In an almost weekly column of *7 Arts*, titled 'Carnet d'un citadin', the aesthetics of diverse aspects of urban life were analyzed — street lighting, parks, monuments, avenues, signposts, gravestones, and even the typography of license plates were at the centre of attention.[47] Never was a specific city, i.e. Brussels, named. It seemed as if the writers of these essays on the metropolis did not need to go out on the street for inspiration, but only had to think about the paradigmatic place of modernity — Paris.

Paris was for *7 Arts* the source of inspiration but also the terminus of their avant-garde project. Their project relied on the purist aesthetics of the French journal *L'Esprit Nouveau,* edited by Amédée Ozenfant and Charles-Edouard Jeanneret, alias Le Corbusier. The *7 Arts*-movement shared the statement of the editors of *L'Esprit Nouveau* that it was impossible to be indifferent towards 'the intelligence incorporated by some machines, the proportions of their thorough calculations, meticulously shaped elements, the precision of their materials and the confidence of their movements'.[48] The *7 Arts*-artists' faith in the machine was however broken in 1925. The *Exposition Internationale des Arts Décoratifs*, organized in Paris, was the

event of the year. Participation and the international break-through had already been enthusiastically prepared by *7 Arts* in 1924. The 'modern spirit' had to be evoked at the exposition. *7 Arts*-artists Victor Servranckx, Marcel-Louis Baugniet and Stanislas Jasinski participated in the Belgian pavilion. But the exhibition was a disappointment. *7 Arts* was confronted with the new phenomenon of *art deco*. Abstract design was weakened by 'the half-heartedness, the pliability, the awful kindness or the bad, gilded taste' of mediocre artists. This 'new epidemic', diagnosed by *7 Arts* in Paris, was the kitsch, the modern wrapped in a popular, enjoyable, ordinary and easy throw-away product. Kitsch was the superficial product of imitation, manufactured and reproduced by the machine.[49] The specter of 'fashion' suddenly seemed to be more frightening to *7 Arts* than isolation.

After 1925, their relationship with Paris soured. Not only was the *7 Arts*-group discouraged, but even the *Sélection*-editors adapted a more protectionist attitude concerning their Flemish idyll. At the same time, a new movement came into existence in Brussels: surrealism. Again, of course, the inspiration came from Paris but still, Brussels Surrealism distanced itself from the French capital and actually cherished their position at the edge. Even in Brussels they did not frequent the modern centre of the city but limited their activities to the suburbs, where they lived. Most of their surrealist actions even took place inside the house, although conducted in an 'un-homely' manner. The Brussels surrealists used methods and strategies different from the ones used by Parisians in an attempt to make bourgeois capitalist society collapse. On an artistic level the *écriture automatique*, the analysis of dreams and unconsciousness of the Parisian group, were rejected by them. On a political level, the membership of Breton and his fellows in the French Communist Party was considered a huge mistake.[50] Anonymity and independence were the house rules of Brussels' surrealist group. Disguised as petit bourgeois, living in mediocre houses in dreary suburbs, they compared their roles to those of thieves, detectives or spies. The most common objects and banal, daily life situations were exploited for subversive action against bourgeois society. Subtle changes had to waver in deep-rooted certainties and convictions of the public and shake their usual routines, habits and interpretations.

With their critical distance towards Paris, the Brussels surrealists represented themselves as even more radical than the centre of the avant-garde. The provinces offered them 'free play.' Variations on the surrealist 'canon' could be created without being excommunicated by André Breton. Moreover, the marginal positioning created the illusion that they could occupy an independent place outside of modern happening — the ideal place for every cultural critic. While the Brussels surrealists maintained their avant-garde marginality, the Parisian group wrestled with problems of popularity and snobbishness. Yet two surrealists of the Brussels group moved to Paris in 1927; the painter René Magritte, the most renowned of the Belgian surrealists, and the poet and gallery-owner Camille Goemans. Dependent on their art to make a living — the other Brussels surrealists had day jobs aside from their avant-garde activities — Magritte and Goemans wanted to try out the advantages of the Parisian art market. Their relationship with the Parisian surrealists was not very cordial. 'To please them,' Goemans wrote to Paul Nougé,

'you have to become absorbed by them'.[51] *Distances*, the journal which Magritte and Goemans edited together with Nougé in 1928, refers most likely to this problematic relationship. The situation improved in 1929, but a fight between Magritte and Breton at the end of the year cooled it down. The upcoming economical crisis did nothing to further the circumstances of life in Paris and in 1930 Goemans and Magritte returned home. The homecoming of Magritte was described by fellow surrealist Louis Scutenaire: 'He supports the transformation of his weapons and his dogmas so badly that, in order to have free play, he returns [...] to Brussels, where he no longer moves'.[52]

Bruges

The mobility of the Belgian avant-garde was brought to a close in the 1930s. The economical and political crisis did not further the international avant-garde spirit. But there were exceptions. The surrealist movement still continued its subversive activities in Brussels, although its subtle, anonymous and therefore mostly invisible action could easily have been mistaken for a 'provincial sleep'.[53] In the Walloon provinces, a surrealist movement named 'Rupture' came into existence in 1934. Its journal *Mauvais Temps* with its symbolic title lasted only one issue. Yet there was still a different kind of avant-garde life possible. The 'innere Immigration' of the Antwerp Dadaist Paul Joostens was an alternative to exile abroad. For the outside world he complied, but in his 'inner' life he wanted to preserve his critical attitude towards society. While his studio in the 1920s was situated on the fifth floor with big windows and a view on the international port district, his home in the 1930s was wrapped in darkness with rags covering the window to block the view. The city was shut out. No sunlight, but only electric light was allowed to shine in this 'cavern.' Joostens created an artificial world, which he called his 'abbey.' His critique of the 'retour à l'ordre' in society and the 'retour à l'humain' in art was only confided to a journal. For Joostens, it was the only place where his thoughts could be expressed freely. It offered consolation and complicity, which could no longer be counted on in an avant-garde group.

'Time is the most abstract *Heimat* of man,' the émigré-writer W.G. Sebald noted.[54] While it became clear to Walter Benjamin in 1932 that he would soon have to undertake a long and perhaps lasting stay away from his city of birth, Berlin, he 'called to mind those images which, in exile, are most apt to waken homesickness: images of childhood.' Joostens, too, was in search for the security, which had formed his childhood. No 'adventure' was longed for anymore. Joostens did not look for reflections on his childhood in Antwerp — the city he had shut out. He remembered on the contrary the vacations spent in Bruges in the first decade of the twentieth century. Postcards, written to his parents in 1902, were added to his journal, mentioning the famous exhibition of the Flemish Primitives and the huge impression the paintings of Hans Memling had made on the young boy. Joostens even took Memling's paintings as an inspirational source for his art in the 1930s. Nevertheless, he didn't find comfort in his childhood memories. What fascinated him about the old city Bruges was its dark side — the 'autumn tide of the middle

ages.' 'Let's go back to the Dark, my brothers,' he wrote in 1934, 'let's go back to the gothic cathedrals, to the organ, to the dungeons of concrete, to the loneliness.'[55] The deep, threatening sounds of the organ, the dark of the gothic cathedrals and the grey of the modern concrete were being mixed. In collages, too, Joostens combined modern features with old elements of Bruges such as the 'Béguinage'. While for a lot of catholic intellectuals the Béguinage was an oasis of piousness and stillness in a 'disenchanted world' and the middle ages was a period of spirituality, solidarity and community, Joostens created a postmodern project avant-la-lettre, in which Bruges disclosed a splintered reality where the old certainties had disappeared, and where the great epics were played out.

Besides the search for times past in Bruges, Joostens also tried to find an 'imaginary homeland' in the movies, and he was luckier there.[56] The illusions on the white screen offered compensation for his experience of estrangement. Also, in the 1920s, Joostens had been addicted to the cinema and the city of Paris had been for him the symbol of this artificial world. His visit to the French capital in 1926 and the confrontation with reality of the everyday in the city had, however, disappointed him. After his return home, he restricted himself to the cinema. The Memling-inspired Madonna's in his paintings of the 1930s often had the faces of film stars. In his journal, Joostens described the blessed feeling which a visit to the cinema provided: 'Today I am totally happy. I'm back from L'Impératrice rouge with Marlène [Dietrich]. I have no terrestrial love. But I'm crazy with love for my three goddesses Greta [Garbo], Brigitte [Helm] and Marlène.' The cinema was 'his unique and big Church.' 'Watching the screen,' he wrote, 'is like living with the universe'.[57]

The imagined worlds of Bruges and of the cinema can be considered the last stops of the Belgian avant-garde in the interwar period. The outbreak of the Second World War caused a caesura. The travels of the Belgian avant-garde artists in the 1920s and 1930s had had a double outcome. The encounter with the modern world in Venice, Berlin and Paris created first of all an overwhelming feeling of freedom. But the freedom of exile could turn into a feeling of being trapped. It was no coincidence that both Schmalzigaug and Van Ostaijen suffered from suicidal thoughts and nervous breakdowns. It was the consequence of the fact that wherever the avant-garde artist dwelled, he was always on the road, marked by a site of departure which could never be turned into 'home', and a point of arrival which could never be reached: a new utopian world. After 1945 a neo-avant-garde came into existence, which also fostered the ideals of internationalism and revolution. The metropolis as a symbolic point of reference had however been rubbed out. In a globalizing world the relation between centre and periphery had been turned upside down. To the Belgian artists of the 'historical' avant-garde, the Second World War signified 'the final end of a city, of a time, of an idea'.[58]

Notes to Chapter 10

1. Christopher Reed, 'Introduction', in Not at Home. The Suppression of Domesticity in Modern Art and Architecture, ed. by Christopher Reed (London 1996), pp. 7–17.
2. Jean F. Buyck, 'Het geheugen van de avant-garde', Knack, 18 October 2000, p. 76.

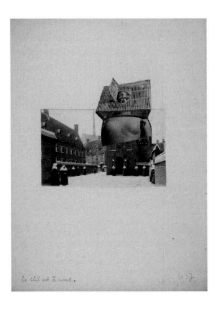

'Le ciel est à nous' by Paul Joostens in the series 'Le Royaume des choses inutiles'(end of the 1930s) shows the mannequin of the Parisian surrealist André Masson in the beguinage of Bruges. Who is more caged in its desire? Modern man, reaching toward heaven with skyscrapers as towers of Babel or the beguines wrapped in their all-covering habit?

3. Walter Gobbers, 'Literatuur en kunst in de greep van machine en snelheid: De impact van het Futurisme in België', *Spiegel der Letteren*, 30 (1988), 1–66 (p. 53).

4. See the article 'L'école belge contemporaine' by André de Ridder in *Cahiers de Belgique*, 4 (1931) (pp. 4–5, 177–91), cited in Robert Hoozee, 'De periode voor de Eerste Wereldoorlog', in *Moderne kunst in België 1900–1945* (Antwerp: Mercatorfonds, 1992), pp. 12–13.

5. Anton Kaes, 'Leaving Home: Film, Migration and the Urban Experience', *New German Critique*, Special Issue on Nazi Cinema, 74 (Spring / Summer 1998), p. 186.

6. See Denis Coekelberghs, *Les peintres belges à Rome de 1700 à 1830* (Brussels & Rome: Institut Historique Belge de Rome, 1976) and Christine Dupont, *Modèles italiens et traditions nationales: les artistes belges en Italie (1830–1914)* (Brussels & Rome: Institut Historique Belge de Rome, 2005).

7. Brussels, Archive of Contemporary Art in Belgium, Jules Schmalzigaug, 15.112, letter of Schmalzigaug to his parents (26 November 1913) and 15.111, letter of Schmalzigaug to his brother Walter (24 November 1913).

8. Brussels, Archives of Contemporary Art in Belgium, Jules Schmalzigaug, 50.210, letter of Schmalzigaug to his parents (20 December 1911).

9. Brussels, Archives of Contemporary Art in Belgium, Jules Schmalzigaug, 50.187, letter of Schmalzigaug to his parents (13 December 1910).

10. Brussels, Archives of Contemporary Art in Belgium, Jules Schmalzigaug, 15.113, letter of Schmalzigaug to his brother Walter (8 December 1913).

11. Brussels, Archives of Contemporary Art in Belgium, Jules Schmalzigaug, 15.111, letter to his brother Walter (24 November 1913).

12. Brussels, Archive of Contemporary Art in Belgium, Jules Schmalzigaug, 15.108, letter of Schmalzigaug to Richard Baseleer (3 November 1913).

13. Brussels, Archive of Contemporary Art in Belgium, Jules Schmalzigaug, letter of Schmalzigaug to Richard Baseleer (3 November 1913).

14. Brussels, Archive of Contemporary Art in Belgium, Jules Schmalzigaug, 50.182, letter of Schmalzigaug to his parents (20 November 1910).

15. Brussels, Archive of Contemporary Art in Belgium, Jules Schmalzigaug, 15.095, letter of Schmalzigaug to Walter (end of May 1913).

16. Letter of Schmalzigaug to Walter, end of May 1913, translated in Phil Mertens, *Jules Schmalzigaug: 1882–1917* (Antwerp: Galerij R. Van de Velde & Brussels: Internationaal Centrum voor Structuuanalyse en Constructivisme, 1985), p. 61.

17. Cited in Mertens, *Jules Schmalzigaug*, p. 67.

18. On the consequences of the First World War, Bernd Hüppauf writes: 'The experience of the dissolution of subjectivity and its traditional patterns of orientation and values, the transformation of modes of perception, and the destruction of vast areas of landscape and experienced time and space have become constitutive elements of the modern consciousness. Although the destructiveness of modernity did not originate in World War I, this war was clearly experienced as a gigantic *rite de passage* into the modern condition.' See 'Experiences of Modern Warfare and the Crisis of Representation', *New German Critique,* 59 (Spring/Summer 1993), p. 61.

19. Paul van Ostaijen, 'Ons dorpken (December 1914)', in Paul van Ostaijen, *Verzameld werk* (Amsterdam: Bakker, 1979), IV, p. 416.

20. Klaus Kändler a.o. ed.., *Berliner Begegnungen: Ausländische Künstler in Berlin, 1918 bis 1933: Aufsätze — Bilder — Dokumente* (Berlin: Dietz, 1987), p. 5.

21. Bärbel Schräder and Jürgen Schebera, *Kunstmetropole Berlin 1918–1933: Dokumente und Selbstzeugnisse* (Berlin & Weimar: Aufbau-Verlag, 1987) and Karl Schlögel, *Berlin: Ostbahnhof Europas: Russen und Deutschen in ihrem Jahrhundert* (Berlin: Siedler, 1998).

22. Clément Pansaers, also an expressionist artist at that time and involved with the German 'Kriegskolonie' in Belgium during the war, was in Berlin in November 1918 and returned in 1919 for a short visit. The abstract artists Jozef Peeters and Fernand Berckelaers visited the city in 1922 to promote their magazine *Het Overzicht*.

23. Letter of Paul van Ostaijen to Geo van Tichelen, [April 1919], in *Paul van Ostaijen. Een documentatie*, ed. by Gerrit Borgers (Amsterdam: Bakker, 1996) I, p. 218.

24. Letter of Paul van Ostaijen to Peter Baeyens, 20 August 1920, in *Paul van Ostaijen. Een documentatie*, I, pp. 349–50.

25. Letter of Paul van Ostaijen to Peter Baeyens, 22 May 1920, in *Paul van Ostaijen. Een documentatie*, I, p. 292.

26. Letter of Paul van Ostaijen to Fritz Stuckenberg, 25 May 1920, published in Van Ostaijen, *Eine Künstlerfreundschaft* (Oldenburg: Holzberg 1992), p. 90.

27. *Paul van Ostaijen. Een documentatie*, I, p. 326.

28. See the letter of Paul van Ostaijen to Fritz Stuckenberg, 10 September 1920, published in Van Ostaijen, *Eine Künstlerfreundschaft*, p. 106: 'This morning I was in the northern part and around Alexanderplatz. This always reconciles me with Berlin.'

29. Letter of Paul van Ostaijen to Peter Baeyens, 29 September 1920, in *Paul van Ostaijen. Een documentatie*, ed. by Gerrit Borgers, I, pp. 389–91.

30. See 'vers 6' by Van Ostaijen in his book *De feesten van angst en pijn* (Nijmegen: Vantilt, 2006).

31. Van Ostaijen, 'Zelfbiografie', in Van Ostaijen, *Verzameld werk*, IV, p. 11.

32. *Paul van Ostaijen. Een documentatie*, ed. by Gerrit Borgers, I, p. 440.

33. See Marshall Berman, *The experience of modernity: All that is solid melts into air* (New York: Verso, 1988), p. 15.

34. Letter of Paul van Ostaijen to Peter Baeyens, 22 May 1920, in *Paul van Ostaijen. Een documentatie*, ed. by Gerrit Borgers, I, pp. 349–50.

35. *Paul van Ostaijen. Een documentatie*, ed. by Gerrit Borgers, II, p. 441.

36. F. Francken, 'Paul van Ostayen voor en na den oorlog', *Vlaamsche Arbeid*, 23 (1928), 3–166 (p. 166).

37. P. van Ostaijen, 'Wies Moens en ik', in Paul van Ostaijen, *Verzameld werk. Proza. Besprekingen en beschouwingen* (Amsterdam: Bakker, 1979) IV, p. 359.

38. Letter of Paul van Ostaijen to Fritz Stuckenberg, 12 May 1921, published in Van Ostaijen., *Eine Künstlerfreundschaft*, p. 141.

39. Letter of Paul van Ostaijen to Heinrich Campendonk, 16 September 1926, in *Paul van Ostaijen. Een documentatie*, ed. by Gerrit Borgers, II, p. 715.

40. A. Phillips, *City of darkness, city of light: Emigré filmmakers in Parijs, 1929–1939* (Amsterdam: Amsterdam University Press, 2004), p. 26.

41. Walter Benjamin, 'Paris, the Capital of the Nineteenth Century (1935 en 1939)', in Benjamin, *The arcades project* (Cambridge-Massachusetts & London: The Belknap Press of Harvard University Press, 2004), pp. 3–26.

42. André de Ridder, 'Notes sur la nouvelle peinture française', *Sélection*, 1 March 1921, 8, no page.

43. Letter of E.L.T. Mesens to Tristan Tzara, 13 May 1924, published in *E.L.T. Mesens and Tristan Tzara, Dada Terminus,* ed. By Stéphane Massonet (Brussels: Devillez, 1997), p. 35.

44. Antwerp, Archief en Museum voor het Vlaamse Cultuurleven — Letterenhuis, Paul-Gustave van Hecke, H3832, letter of Van Hecke to Arthur Cornette, 22 September 1920.

45. *7 Arts*, 10 April 1924. More information on the journal in: Serge Goyens de Heusch, *7 Arts. Bruxelles 1922–1929: Un front de jeunesse pour la révolution artistique* (Brussels: Ministère de la culture française, 1976) and on *7 Arts*: Fernand Verhesen, '7 Arts et l'avant-garde poétique', in *Etudes de littérature française de Belgique offertes à Joseph Hanse pour son 75e anniversaire*, ed. by Michel Otten (Brussels: Jacques Antoine, 1978), pp. 335–47.

46. Maurice Casteels, 'Villes et forces modernes', *7 Arts*, 20 July 1924.

47. See for example: 'Carnet d'un citadin. Plaidoyer pour le badaudage', *7 Arts*, 18 October 1923, and 'Carnet d'un citadin. Le spectacle urbain', *7 Arts*, 4 December 1924.

48. Cited in Lieven de Cauter, 'De machine als paradigma', in *'Dat is architectuur.' Sleutelteksten uit de twintigste eeuw*, ed. by Hilde Heynen et al. (Rotterdam: 010, 2001), pp. 749–50.

49. See on kitsch and modernity: M. Calinescu, *Faces of modernity: Avant-garde, decadence, kitsch* (Bloomington — London: Indiana University Press, 1977), pp. 225–62.

50. As Nathalie Aubert's chapter *Twenty Years On — Distances: Belgian and French Surrealists and 'the' Revolution* shows, pp. 174–89.

51. Brussels, Archives et Musée de la Littérature, Marcel Mariën, FS47 54/51, letter of Camille Goemans to Paul Nougé, no date.

52. Louis Scutenaire, *Magritte* (Brussels: Éditions du Cercle d'Art, 1948), p. 7.

53. Paris, Bibliothèque Littéraire Jacques Doucet, BRT 1196 and 1192, letters of E.L.T. Mesens to André Breton, August 1936 and 21 April 1937.

54. Cited in M. van Kerkhoven, '*Trauerarbeit*. Een theaterbewerking van *De Emigrés* van W.G. Sebald' *Dietsche Warande en Belfort*, special issue 'W.G. Sebald: kaddisj voor een literair archeoloog', 1 (2005), 39–45 (pp. 40, 150).

55. Brussels, Archives et Musée de la Littérature, Paul Joostens, ML6166, 'Journal V', August — September 1934.

56. A. Kaes, 'Leaving Home: Film, Migration and the Urban Experience', *New German Critique*, Special Issue on Nazi Cinema, 74 (Spring / Summer 1998) 190.

57. Brussels, Archives et Musée de la Littérature, Paul Joostens, ML6166, 'Journal V', August — September 1934.

58. Paul Nougé, 'La Guerre', in Nougé, *Quelques bribes* (Brussels: Didier Devillez, 1995), p. 84.

CHAPTER 11

The Avant-Garde on the Reworking of Tradition

Virginie Devillez

Introduction

It is impossible to separate the question of the avant-garde between the wars from the study of the modernists' incessant oscillation between tradition and innovation. Many artists who were immersed in cubism, futurism, Dadaism or even constructivism, also spent time exploring a certain classicism that they had at first attacked, in the footsteps of Breton who had declared that 'creation comes through revolt.' Such infidelities were commonplace between the wars, to the point of being the dominant trend, especially given that the avant-garde was an exception, not only in the profession, but also in the production of artists seen as revolutionaries. This 'rappel' and/or 'retour à l'ordre' spread during the depression of the thirties: the deflation of the art market made the public wary of movements that had lost, in their eyes, all credibility in a destabilized society, each day increasingly menaced by dangers abroad. Hitler's rise to power, the Spanish civil war... divided the population and the art scene which took note of the way three powerful states, the USSR, Italy and Germany, managed to integrate artists into community life. Of course, in the thirties avant-gardes were not exclusively composed of sycophants but, in the following decade, one thought begins to dominate, sometimes espoused by the former protagonists of the very same avant-garde: the necessity of utilitarian art, the superiority of architecture over painting and sculpture, a return to the human, to peace-brokering, to realism... to an art that sees itself as the positive and reassuring reflection of its times, however troubled they may be. This trend continued until the end of the Second World War and illustrates the shift of power within the art scene around the fateful date of 10 May 1940. Indeed, the German occupation took place in a country where the art had already begun condemning its own degenerate art, where the 'retour à l'ordre' had often taken precedence over the 'rappel à l'ordre'.

'Rappel à l'ordre' and 'Retour à l'ordre'

The philosophy of the 'rappel à l'ordre' was decided upon in the aftermath of the Armistice, mainly by protagonists of the avant-garde keen to revitalize their aesthetic experiments in such a way that construction again be seen as honourable.

In 1919, the painters Roger Bissière and André Lhote used this term for the first time in their respective reviews of the Braque exhibition at Léonce Rosenberg's *Effort moderne* gallery.[1] Picasso's multiple forays into the realm of monumental painting, inspired by the sensuality of Derain's sculptures, equally recall this 'rappel à l'ordre'. Picasso revised his knowledge of tradition, and classicism tempered the cubist explosion. The 'rappel à l'ordre' thus poses the problem of tradition as a source of rejuvenation for modern art. However, in practice, it is sometimes difficult to distinguish this 'rappel à l'ordre' from the 'retour à l'ordre' which more specifically signifies a slow disappearance of avant-garde practices (this will never occur in the work of Lhote, Léger or even the Delaunays), in addition to the celebration of the 'values of classicism, of order, of a new spirit, in which we finally witness a return to realism'.[2] This 'retour à l'ordre' has its roots in the shock felt by a civilization confronted with its own dehumanization. The Great War was indeed the first modern conflict to have pushed violence to its extremes via new military technology. Millions of haggard men returned home, their broken bodies asking: what sense is there in disfiguring the human being in paintings? Does the artist have any right to play around with the body when men have suffered so much physically, recreating in the fiction of art the reality of the veteran?

Fairly strangely, it is impossible to dissociate this respect for the human figure and nature, as a reaction to the horrors of war, from the great ideological operations which produced this very butchery: the unreasoned elevation of the nation's interest above all others. The rethinking of national values is ever-present in the paintings of the Italian 'metaphysicals' grouped around the review *Valori Plastici* which openly defends the grand masters such as Raphael and Lorenzo Lotto. But, unlike Picasso, Severini's and De Chirico's paintings completely do away with their tempered modernism, that is to say futurist and cubist penchants for the former, and oniric references for the latter. From then on, their works served solely as pretexts for the rediscovery of the grand themes of Italian art since the Renaissance. Giorgio Morandi took this precept to its logical conclusion, 'unrepentantly' painting still-lives after traditional etudes at Bologna's Academy of Fine Arts.[3]

In the trend of 1919–1925 towards rethinking modernity, the New German Objectivity, tinged with Magic Realism, also illustrates just how difficult it is to separate the 'rappel à l'ordre' from a 'retour à l'ordre'. Even though artists such as Dix and Grosz were exiled by the nazi regime, their post-expressionist painting which took inspiration from traditional values and national sources has long been considered a 'pre-national socialist' way of painting. This amalgam is born out of a misunderstanding since, just like the art of the third Reich, they claimed for their own the 'great Grünewald' and the greats of the past, whom they honoured with detached subject matter, outside any contemporary reality. So, is this a 'rappel' or a 'retour à l'ordre'? In a nuanced manner, Jean Clair has managed to bring under proper scrutiny this false reputation that has long been applied to the New German Objectivism. The distinction is to be found in the relation with the outside world: the individual (women and children who have first names) against the collective (women and children who synthesize the spirit of a nation), real time (interior decoration that is datable, identifiable in social terms) against fantasy time (interior decoration that is anecdotal, verist), singularity (the misshapen hands of a peasant)

against idealization (general, indeterminate types)... It was by twisting the referents of the New Objectivity that the national-socialist state expressed its collective will, 'that differed from the will of its composite individuals'.[4]

The line of distinction, sometimes so thin, that separates the 'rappel à l'ordre' from the 'retour à l'ordre' might therefore be found in the political intentions which drive a work of art. This work then becomes a pretext, both in the nuances of representation (New Objectivity against national-socialist Art), and in the way in which the critic, or even the politician, uses art and makes of it the vehicle for his own ideology. In any case, this last element is essential for a proper understanding of the Belgian art scene.

The Belgian Avant-Gardes as Parenthesis?

Following the Armistice, the Belgian art scene was teeming with new reviews and groups of artists working under the sign of futurism, abstraction, expressionism or even Dadaism. This difference with respect to other countries is in large part explained by the slow awakening to movements of renewal developed abroad. The First World War made possible the encounter with the international avant-gardes. Many artists chose exile in Britain; a few remained either in Belgium, where Antwerp became a centre of activity under the influence of its fervent young population, or in Holland, where Dutch neutrality offered greater security. This period was extremely fruitful for Frits Van den Berghe and Gustave De Smet who adapted easily to the artistic life in Amsterdam, where they put on several exhibitions. During this period they definitively moved away from impressionism, in order to immerse themselves in a moderate cubism inspired by German expresssionism.[5] In Antwerp, the generation born around 1880–1890 lived in an activist environment which provoked a revolutionary climate stirred-up by the young ring-leader Paul Van Ostaijen. His writings and conferences defended the idea of experimentation at any cost, based on a symbiosis of all the avant-gardes. In the same period, Clément Pansaers equally played a key role as 'smuggler' of the Teutonic aesthetic, by publishing engravings by artists of the *Der Sturm* group in the review *Résurrection*, whilst putting down the bases for an *avant-la-lettre* dada group.

At the Armistice, after four years of meetings and exchanges, several important reference points were to develop in Belgium in a spirit both pacifist and revolutionary, inspired by the sweeping movements of international ideas that vibrated to the far-off echo created by Red October. Important reviews and groups of artists were born in Brussels and Antwerp: *L'Art libre*, *Le Geste* then *7 Arts* in the former, *Ruimte*, *Ça Ira*, *Sienjaal*, *Sélection* and *Het Overzicht* in the latter. This episode in the history of the Belgian avant-gardes was however to last only a short time, a fact which is often forgotten, since the majority of monographs dedicated to this initial wave of protagonists concentrate mainly on these few years, which of course were fundamental, although their role remained somewhat incidental. One example is Joostens, author of the dadaist text *Salopes*, who from 1925 on distanced himself from his disparate assemblage and collage compositions, and develops a gothic style, directly influenced by Memling and the Flemish primitives. For around

twenty years his work is dominated by representations of female and monumental nudes but also incorporates scenes from the religious and popular life of Flanders. In parallel with this new direction, Joostens will on the other hand never abandon the collages which gave him a critical, subversive and cynical take on his times. Indeed this 'safety valve' is the fundamental difference between Joostens and the futurist Prosper De Troyer, whose break with futurism was complete. From 1922, De Troyer evolves towards a monumental style that aimed intially to represent 'mothers and children', recalling now Severini, now the expressionism prohibited by the *Sélection* gallery. The Bible, as well as Flemish popular life and folklore, subsequently became some of his favourite subjects, with an omnipresent moralising tone. De Troyer did not try out any new directions and was to remain pigeon-holed as a folk enthusiast.

If the desire to make peace with realism and figuration was one of the fundamental aspects of this 'retour à l'ordre', the act of turning away from the easel in order to create a utilitarian art, which served the community, also reveals the evolution of the avant-garde which emphasizes its theoretical provocativeness more than its aesthetic choices. The whole evolution of the *7 arts* group is important in such a viewpoint. During the twenties, Marcel-Louis Baugniet made a career both as an abstract artist and as an interior designer, with a design style directly inspired by his paintings. But, at the beginning of the thirties, he could no longer see any regenerative interest in his pictures: 'painting and sculpture are *secondary* arts linked to architecture, and complement it by expression. As soon as they are dissociated from architecture, they become *decadent...*' Henceforth interior design and the creation of furniture became Baugniet's main activities, the logical conclusion of the adventure of the *7 arts* group, whose constructed abstraction paved the way for this return to architecture.[6] Victor Servranckx came to the same conclusion, practising mural art in the thirties. He even became one of the revivalists of tapestry by creating, in a medieval-inspired style, a piece recalling the *Battle of Two Knights* with, in the background, the armouries and stronghold of Ecaussines-Lalaing. Disowning his participation in the effervescent period of avant-gardes, he was to state in 1936 that

> les divers '-ismes' des dernières années jonchent le terrain, comme autant de peaux que délaisse la couleuvre de saison en saison. Un jour, ce seront autant de pièces d'alibi, lorsqu'il s'agira d'instruire le procès de la sombre aventure des mutations à travers lesquelles l'art de notre temps tenta d'atteindre sa destinée.[7]

Pierre-Louis Flouquet took the same path, leaving painting in order to dedicate himself to poetry (he founded the review *Journal des Poètes*), and to criticism in the review *Bâtir* which he directed and where he wrote numerous articles on architecture, which had become in his eyes the only full and complete art:

> Par BÂTIR, le public connaîtra ce qu'est l'art architectural que l'on nommait autrefois l'Art Maître, celui de tous les jours, celui des monuments comme de la petite habitation, celui qui contient la décoration et l'ameublement, la sculpture et la peinture, celui qui exige de la clarté, de l'ordre, de la fantaisie ordonnée, de la méthode en toutes.[8]

The adherents of *7 arts* always had a close relationship with architecture and the applied arts — they are amongst those responsible for Henry van de Velde's return to Belgium — , these elective affinities meaning they were naturally inclined to move away from the flat surface of paintings in order to re-conquer three-dimensional space. But did they really need to question the very essence of their profession as painters? Conversely, 1920s expressionism escaped this crisis of conscience that touched Futurism, Dadaism and Abstraction. One can find the reason in its foundations which, far from forming an aesthetic tendancy of cosmopolitan spirit, represented a pictural tradition directly under the sign of Flemish painting since Bruegel. Indeed, from the 1920s on, Flemish expressionism was accompanied by a 'réflexe nationaliste croissant'.[9] Thus, *Sélection*, the homonymous gallery and review that defended this movement under the leadership of Paul-Gustave Van Hecke, its creator, and André De Ridder, its theorist, adopted 'une attitude plus défensive face aux influences de l'étranger':

> L'indépendance et le caractère propre des expressionnistes flamands furent accentués et on parla du "génie du Nord". Le classicisme français fut condamné et rejeté en tant qu'art académique, l'influence de l'expressionnisme allemand elle aussi fut reniée'.[10]

This tendency to withdraw into oneself, towards nationalism, which is suggested as early as the 1920s, was to culminate during the 1930s, the process hastened by the stock market crash in 1929 but also by the resurgent idea of a strong, centralized State. The aesthetic crisis was to become political, art became ideologically attuned. However, at the heart of what would become an enormous undermining operation, Surrealism adopted a stance more distant than ever: born in 1924, and with clearly internationalist and subversive tendencies, it lived on during the following decade, despite the fall of its value on the art market, thus confirming its maverick status amongst the Belgian avant-gardes.

The 'Sacrificed' Generation

At the beginning of the thirties, the expressionist and surrealist movements suffered greatly from the failure of the larger galleries in terms of being represented in the art market, even if the *Palais des Beaux-Arts* in Brussels did soften the blow of this 'fallow period' by its multiple activities. This is also the era of inquests into the consequences of liquidation of *art vivant* and into a possible 'return' to figurative art.

On the 6th January 1932, *Le Rouge et le Noir* organized a debate around the theme 'Y a-t-il une crise de la peinture?'. Four days later, in the 20th January edition, the painter and critic Albert Dasnoy published an article entitled 'Faillite de l'art vivant?'. The review was in a state of alert, since the liquidation of several important collections of modern art was being prepared. On the first and second of February 1932 an auction sale of the works belonging to Walter Schwarzenberg — the former director of the *Centaure* gallery which privileged expressionist and surrealist works — was therefore arranged. Overall, the sale of the Schwarzenberg group's 360 pictures was more successful than had been envisaged, and 'la seule faillite à laquelle on assista fut celle des surréalistes': Max Ernsts went at 240 francs,

Mirós at 750 francs, Van den Berghs 'au-dessous du prix du cadre', etc.[11] The prestige of *art vivant* dropped a further level with the sale of the collections, libraries and furniture of the *Centaure* on 17, 19, 24 and 25 October 1932. The day of the sale, a Dufresne is sold for 1500 francs, a Derain for 5500, several Ernsts for 1700 and 1800, a Vlaminck for 4400, a Miró for 800...[12] The auctions serve to re-confirm the collapse of Surrealism: in order to avoid humiliating prices, some canvasses were not even presented to the public. At these auctions E.L.T. Mesens, with his friend Claude Spaak who was director of the Exhibitions Society of the *Palais des Beaux-Arts*, purchased a collection of 150 Magritte works for 5000 francs, whilst the Liège painter Auguste Mambour bought back for a modest sum his own works which he then destroyed.[13] Finally, P.-G. Van Hecke sold his collection in the *Galerie du Prisme* for next to nothing, on the 8th and 9th May 1933. This chain of negative events was accompanied by numerous commentaries and investigations in the art press: *Le Rouge et le Noir* published, starting on the 6th April 1932, responses to the theme 'L'art vivant et la crise'; *Les Beaux-Arts*[14] in turn launched an investigation hoping to answer the following question: 'Quelles sont les perspectives que vous entrevoyez quant à l'avenir en Belgique du mouvement esthétique avec lequel "Le Centaure" s'était identifié?'.

These investigations were made even more pertinent by the fact that a series of aesthetic movements and new '–isms' had appeared since the end of the twenties. Of course the avant-gardes had mellowed significantly but they had not yet been replaced by any other trend that could in turn have been theorized, supported by critics and, soon after, by the art martket. In 1930, art historian Georges Marlier, who had directed the *Sélection* and *Centaure* reviews, was full of praise for the exhibition *L'Art du Bas-Empire*, which the French art critic Waldemar George had organized at the Brummer gallery in Paris. For Marlier, roman art was an example to be followed as it really investigated faces in search of the smallest detail, like mirrors of the soul, not out of 'goût du réalisme' but 'comme le résultat d'une attitude spirituelle'. Prophetically, he declared that 'our' artists, after having taken their inspiration from 'les sculpteurs noirs des tropiques' would perhaps turn 'vers leur patrimoine authentique: l'art anti-classique, l'art humaniste, à la fois romantique et baroque de la Rome du Bas-Empire'.[15] This trend was confirmed in 1931 with the organization at the Giroux gallery of the *New Generation* exhibition that displayed works by Robert Buyle, Alice Frey, Maurits Schelck, Jean Timmermans, Suzanne Van Damme, Albert Van Dyck, Julien Van Vlasselaer, Sander Wijnants and Fernand Debonnaires, all young artists who had started on a path far-removed from expressionism's disfiguration and Surrealism's literary references.

The majority of these artists were born at the beginning of the century and tried to find their way at a time when the tone was decided by the leading lights of expressionism. Instead of the former 'batailles livrées joyeusement', writes the critic, there was now a 'silent' atmosphere, 'alourdie de bien des incertitudes' facing the creative artist left in his own company and prey to financial difficulties. Timidly yet surely, this generation appeared that he qualifies as post-expressionist. They had developed as artists 'en pleine crise économique et morale [and had to] combattre moins pour obtenir du public le respect de ses franchises esthétiques,

que pour défendre ses droits à l'existence'.[16] Without being able to 'définir ces artistes en bloc', Marlier notes that they had moved away from the 'mots d'ordre de l'expressionnisme doctrinaire' and that Surrealism did not tempt them. On the contrary, the recent exhibitions by Jean Timmermans, Zygmunt Dobrzycki, Albert van Dyck, Alice Frey and Mayou Iserentant displayed a 'répulsion' for all that was 'anormal', for vague impulses 'plus ou moins teintées de sadisme' of a Magritte or even of the German exponents of the New Objectivity. These artists in search of a placated human figure and of a reassuring intimacy had nothing in common with the realities, worrying and a-temporal respectively, of a Van de Woestyne or a Buisseret. Their reality conformed much more to art's interpretative commonplaces and was measured against a 'combinaison harmonieuse de formes, de couleurs et de valeurs', guarantor of a 'langage rigoureusement pictural'.[17]

In 1935, the art critic Paul Fierens, deeply troubled by the publication of *Profits et pertes de l'Art contemporain* de Waldemar George,[18] launched an investigation into the crisis in painting in an attempt to redress the balance and to reply 'aux généralisations hâtives et aux sophismes'[19] of the French critic. Several months later, during which time the *Beaux-Arts* review received dozens of replies,[20] it appeared that the majority of correspondents saw the period 'entre guerre et crise' as 'révolue et complète en soi'. The fashion for 'mots d'ordre' was completely dead, the time for polemics had passed and critics and artists alike were freer in their choices. The same year, le *Musée du Jeu de Paume* in Paris hosted an exhibition of Belgian art, the selection of which caused a stir in *art vivant* circles, who were astonished at the exclusion of artists like Van den Berghe or Floris Jespers in favour of Jean Timmermans, Marcel Stobbaerts, Suzanne Van Damme and Mayou Iserentant. In 1928, the same group had given the avant-garde in Paris, then marked by triumphant expressionism, more than its due. Eight years later, the 'other' exhibition also allowed several conclusions to be drawn. The exhibition of 1928 established 'la certitude qu'il existait une école d'art belge', that of 1935 presented 'tout bonnement des artistes pleins de foi et soucieux du bon métier'. 'C'est peut-être préférable' said Richard Dupierreux, and 'on ne peut rien espérer de mieux d'un peuple qui voue à la peinture et à la sculpture, en même temps qu'une profonde ferveur, une sincère conscience artisanale'.[21]

The creation of 'Les Compagnons de l'Art' in 1937 appears to have been a last-ditch attempt to defend *art vivant* in a toned-down pictorial form, even if led by the older generation, tempted with re-taking control in the face of surrounding apathy. This group was equally formed in reaction to the *Beaux-Arts*' administrative policy on official exhibitions which, in their eyes, was backwards looking. The 'Compagnons' counted amongst their members Hyppolite Daeye, Gustave De Smet, Floris and Oscar Jespers, Constant Permeke, Edgard Tytgat, Henri Puvrez, Frits Van den Berghe, Ramah, Léon Spilliaert... and a few younger men who were asked to join the movement: Albert Dasnoy, Paul Delvaux, Gustave Fontaine, Charles Leplae and René Magritte. In June 1938, they organized an exhibition at the *Palais des Beaux-Arts* in Brussels with the aim of presenting an essential part of contemporary artistic activity, together with the heritage of more senior artists who were also included (Ensor, Mellery, Minne, Evenepoel). The Compagnons' show followed in the tradition of events that had previously been organized by *L'Art Libre,*

Les XX, la Libre Esthétique... However, as the young critic Georges Marlier noted:

> ces associations furent fondées par des jeunes hommes animés, à l'aube de leur carrière, d'un idéal artistique tout neuf, qu'ils avaient l'ambition d'opposer à la routine de leurs aînés. Tandis que les Compagnons de l'Art redescendent dans l'arène pour défendre une forme d'art qu'ils ont eux-mêmes créée et propagée il y a un quart de siècle, une forme d'art qui est représentée depuis longtemps dans nos musées.[22]

Georges Marlier therefore wonders whether the art movement had been 'brusquement immobilisé vers 1930 pour repartir aujourd'hui après un long sommeil?'. Marlier sees this exhibition as a 'magnifique anthologie' of the Belgian art of the first third of the century, a salon for The 'plus de cinquante ans'. He also underlines that 'l'ardeur toute juvénile' of these painters 'chevronnés' did not go together with the works of the 'moins de trente ans' who 'paraissent affligés d'une sagesse et d'une prudence passablement inquiétantes...'.[23]

The 'Compagnons de l'Art' exhibition represents a testament to the avant-garde which, in 1938, was an anachronism in a society where the violence of the economic crisis had been associated with the excesses of modern art and where a new generation of painters had responded to a need for calm and for professional painting. The focus of the art scene in Belgium on the eve of the Second World War lay away from this melancholic attempt by the former colossi of *Sélection* and of *Centaure*. The art scene was driven instead by the 'post-expressionism' defined by Marlier. The *Orientations* group created just before the war is typical of this new trend. Composed of the painters Alice Frey, Marcel Stobbaerts, Marie Howet, Albert Van Dyck, Jozef Vinck, Jean Timmermans... and of the sculptors Robert Delnest, Georges Grard, Fernand Desbonnaires and Antoine Vriens, it was to become the link between these creative artists 'poursuivant leurs recherches et soutenant un effort continu'.[24] Indeed, they thought it useful to 'se réunir [...] en montrant leurs œuvres côte à côte [pour] faire en quelque façon le point d'un voyage sur une mer fort agitée'.[25] This 'voyage' brought about works marked by a common aim: the return to composition, to real-life feelings and to everyday humanity. When *Orientations* presented its second salon in December 1941, Marlier qualified its adherents as 'indiscutablement' the most 'marquants de leur génération, celle qui est née avec le siècle'.[26] In 1942, Paul Haesaerts dedicates an essay entitled *Retour à l'humain. Sur une tendance actuelle de l'Art belge. L'animisme*.[27] Animism is the art of the soul:

> exalter l'humain, l'amour de l'homme, ses besoins essentiels. Désigner par le portrait le mystère de l'individu; montrer dans l'enfant le renouveau perpétuel et singulier de la vie; parler de l'équilibre, de l'efficacité, de la sensualité des corps; chanter la méditation, la rêverie, le retour à soi-même; retrouver le charme, la douceur de vivre, le ravissement devant la nature; et si on aborde la grande composition, parler de récolte, de travail, de réjouissances comme en somme le firent Breughel ou Rubens, mais dans notre langage actuel et en s'inspirant de la vie présente et de son décor tels qu'ils sont ou pourraient être '[28]

If Georges Marlier has his doubts and only sees yet another '-ism', the formula subtly synthesizes this 'respect de la vie, sens du mystère, ferveur, poésie, conscience, ordre,

délicatesse, profondeur, subtilité, charme'[29] in which the artists were immersed. When the time for taking stock came around, the time of the renewal was never slow to follow, but, on the eve of war, the art world was best represented by a still life.

Conclusion

This 'still life' that characterized the art of the thirties was naturally prolonged during the German occupation of Belgium, in a way making the censorship work of the *Propaganda Abteilung* easier, being confronted as it was with an art scene ready-purged, almost self-censored. The awakening began during the war and later exploded as the Resistance took on a completely new significance with the arrival of the 'Jeune Peinture Belge' and of Abstraction: it is no longer simply a reflection of an aesthetic resistance launched in the spirit of rebellion by painters below thirty but also a rebellious, regenerative response from the very same artists who now called into question the animist atmosphere in which they had bathed since the start of their careers. These protagonists of the renewal of the Belgian avant-garde found themselves enrolled with relative ease in the 'Art Jeune' salons organized at the *Atelier* gallery by Georges Marlier and the *Le Soir* newspaper, both of whom were devoted to the German occupant's cause. The programme 'demande' that the new artist pay more attention 'à la réalité qui l'environne, [be] plus amoureusement dépendant de cette réalité, plus engagé dans la vie de tous, dont il s'agit d'exprimer en beauté les tourments et les espoirs.' This new artist would have to create an *oeuvre* that gave to the masses the 'sentiment' of recognizing in it 'sa propre vie [...] embellie et transfigurée.'[30]

The first edition of the competition, in 1941, honoured, amongst others, Louis Van Lint, Anne Bonnet, Gaston Bertrand and Willy Anthoons. For the time being, they still practised a reinvigorated animism in which Georges Marlier sees great things. At the same time, thanks to the work of Robert L. Delevoy and the Apollo gallery, a regenerative greenroom is created for the same young artists taking part in the Apport Salons. For the 1943 edition, Louis Van Lint showed at the *Apollo* an *Ecorché* whose violence provoked the wrath of Georges Marlier who regarded it as an 'œuvre ratée, dont les prétentions surréalistes sont, au surplus, d'un goût discutable.'[31] As soon as Brussels was liberated, on 30 September 1944, the *Apollo* gallery organized, far from the theoretical distortions of the New Order, an exhibition of the 'Jeune Peinture belge' which gave priority to painters under thirty-five, who had turned away from the interventionist control of 'Art Jeune'. Painting could once more dedicate itself to researching form and being 'gestes d'intention'.[32]

Notes to Chapter 11

1. Yves Michaud, *La Crise de l'Art contemporain* (Paris: PUF, 1997), p.81.
2. Michaud, *La Crise de l'art*, p.79.
3. Lionel Richard, *L'Art et la guerre: Les artistes confrontés à la Seconde Guerre mondiale* (Paris: Flammarion, 1995), p.36.

4. Jean Clair, 'Nouvelle objectivité et art national-socialiste: l'inversion des signes', in *L'Art face à la crise: L'art en Occident 1929–1939* (Saint-Étienne: Université de Saint-Étienne/Centre interdisciplinaire d'Études et de recherches sur l'expression contemporaine, 1980), pp. 43–61 (p. 53).

5. For further details, see the doctoral thesis by Nathalie Toussaint, 'Interconnexions des avant-gardes picturales entre la Belgique, l'Allemagne et les Pays-Bas de 1914 à 1924. Une exemplification' (unpublished doctoral thesis, Université Catholique de Louvain, 2000).

6. Extract from Marcel-Louis Baugniet, *Vers une Synthèse esthétique et sociale* (Brussels: Labor, 1986), quoted in *Marcel-Louis Baugniet: Dans le tourbillon des avant-gardes* (Tournai:La Renaissance du Livre-Dexia, 2001), p. 97.

7. Victor Servranckx, 'La peinture décorative', *Bulletin de l'Association des Artistes professionnels de Belgique*, June 1936, 1–6 (p. 2).

8. Pierre-Louis Flouquet, 'Bâtir?', *Bâtir*, 1 (December 1932), p. 1.

9. Inge Henneman, 'Le mouvement Sélection', in *L'Art moderne en Belgique* (Anvers: Fonds Mercator, 1992), pp. 148–85 (183–84).

10. Inge Henneman, 'Le mouvement Sélection', pp. 148–85 (183–84).

11. Lucien François, 'Une date pour l'art vivant', *Le Rouge et le Noir*, 10 February 1932, p. 3.

12. 'Résultats des ventes. Collection Galerie Le Centaure', *Les Beaux-Arts*, 21 October 1932, p. 6.

13. Jean Milo, *Vie et survie du 'Centaure'* (Brussels: Éditions nationales d'art, 1980), p. 67.

14. See the issues of 28 October (pp. 2, 4–5), 4 November (pp. 3–4) and 11 November 1932 (p. 4).

15. Georges Marlier, 'Ex Roma Lux. Une réhabilitation de l'art romain', *Les Beaux-Arts*, 28 November 1930, p. 4.

16. Georges Marlier, 'Les Arts. Post-Expressionnisme', *La Revue réactionnaire*, 7 (15 December 1933), p. 427.

17. Marlier, 'Les Arts. Post-Expressionnisme', p. 428.

18. Waldemar George, *Profits et pertes de l'Art contemporain* (Paris: Éditions de chroniques du jour, 1933).

19. Paul Fierens, 'Notre enquête sur la crise de la peinture. Pour conclure', *Les Beaux-Arts*, 23 August 1935, pp. 8–9.

20. The following wrote to the review: Roger Avermaete, Jean Cassou, Marc Chagall, Léon Degand, André De Ridder, Henri Focillon, Paul Haesaerts, Franz Hellens, Philippe Hosiasson, René Huyghe, Oscar Jespers, Henry Kahnweiler, André Lhote, Jean Lurçat, René Magritte, Georges Marlier, Jean Milo, Amédée Ozenfant, Léonce Rosenberg, Gino Severini, Edgard Tytgat, Waldemar George, etc. See *Paul Fierens: enquête sur la crise de la peinture*, ed. by Norbert Poulain (Gand: Interbellum V.Z.W., 1984), re-edition of an investigation published in *Les Beaux-Arts*, 157–71 (except 157, 160 and 166), (22 March–23 August 1935).

21. Richard Dupierreux, 'Un Bilan 1935', *L'Art belge*, 2 (28 February 1935), p. 13.

22. Georges Marlier, ' Une grande exposition: "Les Compagnons de l'Art"', *La Nation belge*, 23 June 1938 .

23. Georges Marlier, ' Une grande exposition...'.

24. R.D. [Richard Dupierreux], 'Les expositions d'art. Orientations', *Le Soir*, 15 March 1940, p. 2.

25. R.D. [Richard Dupierreux], 'Les expositions d'art. Orientations'.

26. Georges Marlier, 'Une exposition significative. Orientations de l'art contemporain en Belgique', 2 December 1941, p. 1.

27. Paul Haesaerts, *Retour à l'humain: Sur une tendance actuelle de l'Art belge: L'animisme* (Brussels/Paris: Éditions Apollo, 1943).

28. Haesaerts, *Retour à l'humain*, p. 83.

29. Haesaerts, *Retour à l'humain*, p. 77.

30. 'La remise des prix aux huit lauréats d'"Art Jeune 1941"', *Le Soir*, 30–31 January 1941, p. 2.

31. Georges Marlier, 'À propos d' "Apport 43"', *Le Soir*, 23 juin 1943, p. 3, quoted in Christine De Naeyer, 'La Situation de l'art et de l'artiste en Belgique sous l'occupation allemande (1940–1945)', (unpublished undergraduate dissertation, Université libre de Bruxelles, 1988, p. 150).

32. Michel Draguet, 'Aux origines de la Jeune Peinture belge. L'animisme et la guerre', in *La Jeune Peinture belge. 1945–1948*, Crédit Communal gallery, 25 September–22 November 1992 (Brussels: Crédit Communal, 1992), 13–39 (p.36).

CHAPTER 12

'Tranquil Independence':
National Identity and Musical Modernity
in Belgium between the Wars

Valérie Dufour

Dealing with music in a volume dedicated to modernity in Belgium opens two general possibilities: either choosing an isolated musical figure representative of the tendencies of art history associated with modernity (for example thinking about the musical surrealism of André Souris), or, on the other hand, attempting a more global approach to the significance of Belgian composers in terms of modernity. We have chosen the second option.

Collecting together a body of work that might allow us to summarize Belgian music between the wars is no easy affair. Rather than limiting the research to a list of names and of parallel tendencies, we have opted for an analysis of the contemporary discourse on Belgian music. By basing ourselves in musical criticism, this option allows us to define the appreciation of modern music as well as the point to which the artistic evolutions were conscious.

In France, the *Revue musicale*, edited in Paris by Henry Prunières, published every month an annex entitled 'Chroniques et notes de l'étranger', in which Belgian critics reported regularly on the most important Belgian creations and on the music scene in Belgium. The texts, when gathered together, put across the standpoint of Belgian music criticism when writing for a French readership, everything being underpinned by a discourse both informative and wishing to promote Belgian music. What's more, by looking at this body of texts we can reconcile two approaches: on one hand, distinguishing the characteristics of Belgian music which were highlighted by its contemporary critics, and, on the other, evaluating the pertinence as well as the durability, present or otherwise, of the concept of national identity in this precise context.

Between 1920 and 1940, *La Revue musicale* published ten articles dedicated to Belgian composers or more generally to Belgian music, and ninety-five smaller pieces summarizing the Belgian music scene, *i.e.* concerts of Belgian and foreign composers' work, held for the most part in Brussels. For the purposes of this investigation, we shall put the pieces dealing with the work of foreign composers in Belgium to one side in order to concentrate on that of Belgian composers. When put together with the articles already mentioned, they offer a substantial body of work that allows us to identify the salient points of the discourse on Belgian music.

National Identity and National School

In the summarizing articles on 'la musique belge' that we find in the *Revue musicale* at the beginning of the twenties, the majority of authors agree that a double musical tradition existed in the country, dating from the 19th century: one strand was Flemish and the other Walloon.[1]

The composer Peter Benoit (1834–1901) was celebrated as the father of Flemish music. Wishing to create a musical art that was typically Flemish, both close to the people and sensitive to the nationalist movement which was in full flow during the second half of the 19th century, he founded the country's first Dutch-speaking music school in Antwerpen, which became a Royal Conservatory in 1898. Benoit would also compose numerous choral works which were relatively simply written in order to be accessible to all. Criticism still remembers the numerous Flemish composers of the next generation who followed his footsteps: Jan Blockx, Gustave Huberti, Edgar Tinel and even Paul Gilson. With an untiring persuasive force, Peter Benoit incessantly showed his desire to be played and understood by all. In this vein, he re-worked the rhythms and melodic phrasing of popular Flemish music. His project can therefore be included in the context of 'national schools', an expression which in this period was most often applied to Russian, Czech or Scandinavian composers. The Belgian musicologist Charles Van den Borren summarizes the situation in these terms: 'À cet égard, il est curieux de constater que la situation est la même dans la plupart des pays — tels la Scandinavie, la Russie et la Bohême — où une musique nationale s'est constituée. Il semble qu'une fois passée la période héroïque, qui coïncide avec l'éclosion des écoles nationales, celles-ci soient fatalement vouées à la stérilité'.[2] Indeed, even though Benoit remained the icon *par excellence* for composers of the next generation, the Flemish school he established left no important bases from which musical modernity in Belgium could begin its trajectory.

In parallel to all this, the Walloon tradition was entirely developed in the shadow of Liège composer César Franck (1822–1890). He is both the most famous name in 19th century Belgian music and the great rejuvenating force in French music after 1870. During the twenties and thirties, the Belgian school was very widely dependent on the post-franckist aesthetic. 'Modern music' and the questioning that it implied after the First War had not touched composition teachers who, via the mechanical teaching of the conservatoires, still prohibited Wagnerian audaciousness. In Brussels, at the start of the century, the dominant model was still that of the *Schola Cantorum* of Vincent D'Indy, Franck's pupil who spread from Paris the idea of artistic progress based on moral elevation, the cult of pure music, the practice of a perfect art composed by using forms inherited from the classics, combined with the unquestioned ideal that art should necessarily be put in the service of expressing one's feelings. It was in this context that, until the beginning of the twenties, the young composers of the Walloon school from Guillaume Lekeu to Victor Vruels as well as Joseph Jongen, venerated César Franck as the maestro *par excellence*.

The insistence with which César Franck was exploited as the musicians' national icon is one of the strong points of the *Revue musicale*'s Belgian criticism. Indeed, the

desire to situate the master in the role of the young generation's unchallenged guide speaks volumes about the Belgian's concern not only to reclaim a major figure of the 19th century, but also, consequently, to establish a Belgian branch of the French school:

> Parler de l'influence de la symphonie franckiste en Belgique, c'est rappeler l'existence d'une branche belge de la jeune école française, ne se distinguant de l'autre que par le particulier mysticisme, la trouble et nostalgique rêverie, si émouvante pour qui sait la comprendre, qui sépare l'âme liégeoise de sa sœur française. Qu'il soit même permis de souligner que, à part Chausson (que de mystérieuses affinités rapprochaient si étrangement de son maître), la sensibilité particulière de Franck se retrouve davantage chez ses tenants belges que chez les Français, en vertu des inéluctables lois raciques.[3]

According to Paul Collaer, the composer Paul de Maleingrau (1887–1956) was one of the last Belgians to be a fervent advocate of César Franck: 'Cette humilité devant Franck est complète. Elle lui est dictée par son tempérament profondément religieux', states Collaer,[4] who also systematically attacks insensitivities to all sorts of renewals, or complacent studies of the past, which might resist modernist ideas.[5]

However, the progressive down-sizing of religious music's role in young composers' production brought with it a lessened interest in the author of *Béatitudes*. For the young generation, Franck began to belong to the past. As in the Flemish tradition, the nationalist interest left no fertile ground in its heritage to young artists of the modern era, haunted by the idea of revising values.

Heritage and Independence

At the dawn of the twenties, the new generation of composers in Belgium is characterized by this desire to move away from the great models of the 19th century, Peter Benoit and César Franck most of all, but also by the tendency to want to free themselves of any foreign influence and achieve what Henry Le Boeuf, a music critic who used the pseudonym of Henry Lesbroussart, had called 'L'indépendance tranquille'.[6] In this sense, even if freed from the icons of its past, the nationalist tendency lived on. What's more, Lesbroussart also notes that the concern with interacting with modern art's most innovative tendencies was only minimally present for young Belgian artists. 'Les artistes belges sont trop jaloux de leur personnalité pour en aliéner une parcelle en employant des formules étrangères à leur tempérament', Henry Le Boeuf went on to say.[7] It was the same for intellectuality, a fundamental feature of the musical avant-guards of the twenties, largely rejected in favour of a post-romantic lyricism which had a few minor additions taken from the impressionism of Debussy, Ravel or Duparc. The 'Synthétistes' group illustrate this situation perfectly. Founded in Brussels in 1925, the group united seven composers: René Bernier (1905–1984), Gaston Brenta (1902–1969), Théodore Dejoncker (1894–1964), Robert Otlet (1889–1948), Marcel Poot (1901–1988), Maurice Shoemaker (1890–1964), and Jules Strens (1893–1971). Conversely to the Group of Five in Russia or the Group of Six in France, their association had no common founding in aesthetic or ideological grounds; under the cover provided by the idea of 'synthesizing' contemporary tendencies in music,

they worked simply as a group which attempted to multiply the occasions they had to make themselves known. It was therefore a promotional tool — nothing more, nothing less. Thus, with the Synthetists too, each composer had his own 'tranquil independence' without having to be concerned with joining a contemporary movement or world view, i.e. without any real 'historical conscience.'

The salient fact distinguishing Belgian music between the wars was, in addition to the rejection of all intellectualism, this independence in relation to any existing ideology at a time when the term 'musique savante' appeared more and more frequently in critical works. Belgian musicians between the wars never found any great ideas to defend, objectives to follow or ideologies to support — whilst in France debates raged over, for example, the new aesthetics discussed in the *Nouvelle Revue Française* or exchanges with philosophers such as Jacques Maritain (1882–1973), with the right-wing or even the Catholic revival. In Belgium, composers found their calling first and foremost in the search for a satisfying proximity with their listeners or in attempting to express their feelings. Henry Lesbroussart attempted to explain this when he questioned why Debussy only had a weak influence in Belgium:

> Si le public belge a compris et aimé Debussy, il est curieux de constater que nos compositeurs ne semblent pas en subir l'influence. Pourquoi? [...] Parce que la plupart de nos compositeurs lisent peu. L'invention est pittoresque chez les flamands, harmonique chez les wallons; le folklore les sollicite volontiers. Mais pas la transposition en musique de la pensée écrite, surtout raffinée et subtile.[8]

In this way August Getteman presents Joseph Jongen, an important figure on the Belgian music scene of the twenties — both as a teacher and as a composer — as a Walloon artist 'dépourvu de toute préoccupation intellectuelle'; 'les spéculations cérébro-musicales', adds the critic, 'lui sont étrangères, comme étant dépourvues de cette spontanéité qui est, pour lui, une des conditions premières de toute expression musicale'.[9] Are we not forced to see, in this a provincial complex on the part of the critic who denounces the 'nivellement de la pensée' and the 'l'ignorance du mouvement actuel' in Albert Dupuis,[10] the 'absence de directions' in Paul de Maleingrau[11] and even the 'conservatism' of Léon Jongen (1884 — 1969)?[12] If we are to believe what this criticism tells us, it would seem that Belgian composers' aesthetics rest largely on the Romantic ideal of the all-powerfulness of the feelings, of the spiritual and emotional world. This viewpoint is also present in an imposing article written in two parts, dealing with another very important musical personality in Belgium at the time: Jean Absil (1893–1974). Joseph Dopp sees in him one of the main exponents of the music of today in terms of the 'parfaite pureté du style' and of the 'profondeur de l'émotion'.[13]

Belgian musical modernity was thus somewhat unwillingly inserted into the margin of the contemporary movement toward a growing complexity in music that could be observed in France with the polytonality aimed at by Milhaud, the tortuous harmonies and rhythms of Stravinsky, or in Germany with Schoenberg's atonality or Berg's expressionism. Belgian musicians were not tempted to explore the limits of the musical system in a context where the fear of seeing an overly refined music appear only accessible to an élite, is present and strong. In this vein, Henry Prunières, Editor in Chief of the *Revue musicale*, eulogized Peter Benoit in 1934:

> La T.S.F. s'efforce en vain jusqu'ici d'amener ce qu'on nomme le grand public à
> la musique savante. L'auditeur rebelle a tôt fait de tourner le bouton... Il ne s'agit
> pas de rabaisser le grand art au niveau des masses, il faudrait qu'en marge de lui
> se développât un grand art vraiment populaire, simple, expressif, direct, animé
> d'un puissant souffle, écrit par de vrais musiciens, connaissant leur métier,
> comme était Peter Benoit.[14]

In this way, on numerous occasions critics (even French ones) emphasized this
Belgian characteristic of being particularly 'close to the people', and lacking any
intellectualist pretensions. It is not going too far to hypothesize that the valorization
of this particular aspect of Belgian music since the 19th century led young musicians
to cultivate this quality of accessibility and of popularity, be it via the prism of a
collective unconscious.

If the concern with popular music comes more from the Flemish heritage, the
discourse on the Walloon heritage puts a special emphasis on the sentimental aspects
which link the aesthetics to the country and to the character of the people. Thus
in an article dealing with Guillaume Lekeu (1870–1937), an important Belgian
disciple of César Franck, the composer's music is put back into context via 'la
poésie mystérieuse des cités industrielles des pays du Nord' and the 'brumes de son
pays'.[15] In the same way, Auguste de Broeck's art (1865–1937) is presented to French
readers as

> un art franc, robuste, bien musclé, si j'ose dire, haut en couleur et riche de
> sève, un art qui est bien de notre pays, du pays de Breughel et de Rubens,
> de Courtens et de Claus, de celui de Charles De Coster, de Lemonnier et de
> Demolder.[16]

There is no way of counting the many allusions to a typically Brabantian *bonhomie*,
to a disdain for overly refined things, to a steady character... In this way the desire
to create a Belgian musical identity rests largely on the evocation of the specific
characteristics of the region. One has to wait until the very end of the period
between the wars before this position in the *Revue musicale* changes in any way.
In fact, in the February-March edition of 1940, the composer Jean Absil explains
that after the torments of 1914–18, the eyes of young Belgians were not completely
indifferent to modernity and had a degree of interest in the aesthetic movements
of different types which were unfolding at the four corners of Europe, but 'cette
influence se borna aux aspects extérieurs car le fond comme l'esprit leur restèrent
complètement étrangers'.[17] A proof of this tardy discovery of the most advanced
phenomena of modernity is that we must wait until 1940 to see the first appearance
of André Souris's (1899–1970) name in the *Revue musicale,* a composer who today
is considered one of the major figures of Surrealism and the only one to have tried
to transpose the movement into the domain of music. During the entire period
between the wars, the surrealist and hyper-modern attempts by Souris or E.L.T.
Mesens (1903–1971), one of Satie's most active disciples, are brazenly ignored in
the reports prepared for foreign readers. We must not hide the fact that there was a
'*Revue musicale* spirit', a reflection of good French intellectualism, which doubtless
imposed limits that were not to be transgressed.

Musical life and Modernity

When compared to the number of articles or chronicles dealing specifically with Belgian composers or 'Belgian music,' the sections relevant to Brussels's music scene, taking into account the works — created or performed in Brussels — of composers from many different countries, have a predominant role, with a clear tendency to grow from 1930 onwards. The upshot of this is that Belgian criticism's main aim when writing for French audiences was to underline Brussels's vitality as a hub of musical activity. Indeed, we have already seen that the idea of creating a national music with strong national characteristics was abandoned fairly quickly after 1918, even if some traces remained here and there of a less and less credible nationalism. Instead, the dream of making Brussels the biggest centre of musical activity outside Paris occupied many minds. The situation is ably summarized by Arthur Hoerée who wrote in 1931: 'A défaut de compositeurs de classe internationale, la Belgique peut s'enorgueillir d'institutions, d'interprètes, d'une *tradition musicale* de tout premier ordre qui lui assurent le rythme sonore d'une grande nation'.[18]

If we were to look for a sign of historical consciousness in the Belgian music scene in the twenties, we would have to turn towards the famous *Pro Arte* concerts organized by Paul Collaer. At the time, Collaer (1891–1989) was the only figure to be truly well informed about the trends of modern music and to try to spread them in Belgium. From before 1914, this music-loving chemistry teacher, who became a musician and musicologist, already understood the progress of Debussy-ism and was interested in Scriabine, Kodály, Bartók and Stravinski. He took on the leading role of the Brussels avant-guard movement. By creating the *Pro Arte* concerts in 1922, he made the capital an extremely active centre for the spread of contemporary music and also encouraged symphonic concert and popular concert groups to take an interset in the contemporary evolution of the art. Unfortunately, these exceptional concerts and this search for the best parts of the living art had only, it would seem, a very slight influence on Belgian composers, with a few exceptions such as Raymond Chevreuille (1901–1976), Albert Huybrechts (1899–1938) and André Souris (1899–1970), who took an inspiration from modernity during these concerts. Between twenty and thirty years of age, these young artists discovered at the *Pro Arte* concerts Stravinsky's chamber music, the whole young French school, from Satie to Poulenc passing through Milhaud, Roussel, Honegger in addition to names like Hindemith, Schoenberg, Berg, and without forgetting Bartok.

The pride of the Belgian critics was based in the fact that Brussels was just as familiar with the key works of modernity as Paris.[19] Auguste Getteman remarked:

> Le groupe Pro Arte, composé du Quatuor Pro Arte et de MM. Collaer et Prevost, se propose de présenter au public belge les chefs de file de la musique contemporaine afin de lui permettre de se rendre compte des diverses directions prises ces dernières années par la musique en Europe. Toutes les œuvres inscrites au programme sont des nouveautés pour Bruxelles. [...] La Musique des Guides, sous la direction d'Arthur Prevost, inscrivait à son programme des œuvres modernes aussi audacieuses que les *Symphonies pour instruments à vent*

de Stravinski qui avaient paru si étranges lorsqu'elles furent exécutées pour la première fois à Paris au concert Wiener en 1923.[20]

Despite the fact that Collaer was immersed in modernity, the Belgian avant-garde wasn't interested and in fact could not even conceive its existence. In his book *La musique moderne,* he wrote 'Par *musique moderne*, nous entendons la musique qui a été écrite après Debussy et Ravel en France; après Strauss, Reger et Mahler en Allemagne et en Autriche; après les *Cinq* et Scriabine en Russie; après le vérisme en Italie'.[21] Belgian composers would always have a running quarrel with this musicologist due to his mistrust of his country's contemporary music. Several musicians were particularly aggressive towards him: the weekly *7 Arts*, which first came out in Brussels in 1922 and counted the composer Georges Monier amongst its contributors, published an anonymous article in which one can read:

> [Collaer] parle de musique moderne en Belgique! Il dit sans s'émouvoir aucunement 'la musique belge n'existe pas'! Evidemment! Monsieur Collaer a découvert qu'il est plus facile d'être patriote désaxé en pleine vogue de patriotisme allié (vent N–S) et crie: 'Vive la France', certain de voir éclore le même cri sur les lèvres blêmes de quelques mondains efféminés, passant avec aisance du cocktail à la musique dernier bateau.[22]

The composers who thought themselves at the forefront of creativity in Belgium were apparently unable to make a departure from the vocal nationalism that we will find in the *Revue musicale*.

Of course musical creativity in Belgium has not left us any major figures able to compare with the aesthetic innovations of a Stravinsky or a Schoenberg, but is it not in this almost completely multilateral refusal of the intellectualist tradition of Western music that we must recognize its aplomb, even its audacity? In the case of André Souris as well, whose modern characteristics are today unanimously recognized, and for whom everything took place in a half-clandestine way, the idea of associating music and surrealism was one in the eye for *musique savante.* Dealing with the point of view of the critics of the time allows us to take the measure of their mentalities and levels of awareness in real time, and not with historical hindsight. The result is that the notions of school and of national identity remain. In the spirit of critics and composers, the notions of national culture, school and tradition are still very much at work in the 20th century and continue to dictate the way of teaching in conservatoires.

We are some way from wishing to demonstrate that musical modernity in Belgium was absent or that it took place strictly elsewhere (in the concerts). What is important here is to underline the fact that criticism was not really open to this evolution, privileging until 1940 a sort of national consciousness which was on one hand outdated, whilst on the other it cultivated a form of provincial complex in relation to its own artists.

If musical modernity in Belgium did not have any great success, we must also recall and renew the intrinsic value of the composers in question, remembering the figure of Joseph Jonken as a post-franckist figure who timidly attempted to break from the classical syntax, in addition to the modern efforts of the Synthetists whose dream of mingling together the salient characteristics of modernity generated only

pale imitations, as well as the great surrealist adventure, fascinating but sterile in terms of the future of music, and finally several widely popular composers such as Albert Huybrechts, Fernand Quinet and Raymond Chevreuille who were able to inspire a wave of modernity according to their own particular aesthetic views. The years between the wars were difficult ones for Belgian music. We must also remember that at the time there was no sufficiently powerful publishing firm, nor any recording company on a national scale. Belgian composers largely depended on foreign, generally French, commercial enterprises for the publication and the distribution of their works. The aim of a Belgian composer was simple: getting oneself played in Paris. An international stage for Belgian critics, the *Revue musicale* was the place of a valorization of the particular characteristics of Belgian music, and also that of a constant recollection of the efforts made on Brussels scenes to promote modern music and modern French music in particular. Between 1920 and 1940, Belgium witnessed a progressive erosion of the 19th century desire to create a national identity; this desire acted for a while as a parasite on composers' work and even delayed the growth of a modernity that from that time on became totally indifferent towards the concept of national identity.

Notes to Chapter 12

1. See, notably, Arthur Hoérée, 'L'école belge', *La Revue musicale*, 117–18 (July-August 1931), 89–96.

2. Charles Van den Borren, 'La musique belge moderne' in *L'Ecole moderne de musique française, la musique belge moderne, la musique de chambre en Allemagne: Trois causeries faites à Bruxelles par MM. Lesbroussart, Van den Borren et Systermans* (Brussels: Ed. L'Art Moderne, 1911), p. 22.

3. Ernest Closson, 'César Franck à l'étranger. Franck symphoniste', *La Revue musicale*, 2 (1 December 1922), p. 176.

4. Paul Collaer, 'Franck et les jeunes compositeurs belges', *La Revue musicale*, 2 (1December 1922), p. 177.

5. Paul Collaer, 'Paul de Maleingreau', *La Revue musicale*, 7 (1 May 1921), pp. 169–71.

6. Quoted by Auguste Getteman, 'Joseph Jongen', *La Revue musicale*, 9 (1July 1923), p. 239.

7. Henry Lesboursart [pseudonym of Henry Le Boeuf], 'Debussy en Belgique', *La Revue musicale*, 1 (1 November 1920), p. 206.

8. Henry Lesbroussart [pseud. of Henry Le Bœuf], 'Debussy en Belgique', *La Revue musicale*, 1 (1 November 1920), p. 205.

9. Auguste Getteman, 'Joseph Jongen', *La Revue musicale*, 9 (1 July 1923, p. 241.

10. Auguste Getteman, '*La Victoire* d'Albert Dupuis', *La Revue musicale*, 7 (1 May 1923), pp. 89–90.

11. Paul Collaer, 'Paul de Maleingreau', *La Revue musicale*, 7 (1 May 1921), p. 169.

12. Auguste Getteman, 'A Bruxelles: le groupe Pro Arte: *Thomas l'Agnelet*', *La Revue musicale*, 6 (1 April 1924), p. 85–86.

13. Joseph Dopp, ' Le style dans l'œuvre de Jean Absil' *La Revue musicale*, 176 (August-September 1937).

14. Henry Prunières, ' Peter Benoit', *La Revue musicale*, 149 (September-October 1934), p. 176.

15. Romuald Vandelle, 'Guillaume Lekeu', *La Revue musicale*, 4 (1 February 1921), 122–28.

16. Paul Bergmans, 'La Route d'Emeraude d'Auguste de Boeck à Gand', *La Revue musicale*, 6 (1 April 192), pp. 74–76.

17. Jean Absil, 'La Musique belge', *La Revue musicale*, February-March 1940, 66–70, (pp. 66–68).

18. Arthur Hoérée, 'L'école belge', *La Revue musicale*, 117–18 (July-August 1931), p. 96.

19. See the important article by Pierre Janlet, 'Le public de Bruxelles et les œuvres modernes', *La Revue musicale*, 9 (1 July 1921), p. 70–71.

20. Auguste Getteman, 'La musique à Bruxelles', *La Revue musicale*, p. 63–65.

21. Paul Collaer, *La musique moderne 1905–1955*, preface by Claude Rostand (Paris-Brussels: Elsevier, 1955), p. 2.
22. Unsigned, *7 Arts, Hebdomadaire d'information et de critique*, 28 December 1922, quoted in Robert Wangermée (ed.), *Paul Collaer, Correspondance avec des amis musiciens* (Sprimont: Mardaga, 1996), p. 22.

CHAPTER 13

Surrealism in Belgium between the Wars

Bibiane Fréché

> Il n'y a pas eu de surréalistes belges, pas plus qu'il n'y a des surréalistes chinois. Il y a eu des surréalistes en Belgique.[1]

Though Surrealism in Belgium now has an international reputation (having recently been the subject of a special issue of *Europe* in 2005), the movement was always somewhat hidden from view, and fell into oblivion soon after the Second World War. It was rediscovered in the late 1970s, thanks in part to the 'Surréalisme en Hainaut, 1932–1945' exhibition that toured La Louvière, Brussels, Paris and Marseilles from 1979 to 1980. Another impetus to the movement's rediscovery was Marcel Mariën 1979 *L'activité surréaliste en Belgique, 1924–1950*. Finally, the hundred-and-fiftieth anniversary of Belgium and *Europalia 80 Belgique* were followed, in terms of literary history, by Marc Quaghebeur's seminal *Alphabet des lettres belges* (1982), which gave a prominent place to the 'irréguliers', among them the surrealists.

These events functioned as catalysts for further research. There followed a number of important works,[2] predominantly critical monographs and new editions of surrealist writings, published by Editions Labor and, from 1993 onwards, by Didier Devillez. Several studies took a more sociological approach to the movement,[3] speculating, notably, about the reasons behind the movement's oblivion and its eventual rediscovery: Belgian Surrealism's lack of critical attention comes primarily from the notions of effacement and clandestine activity that characterise the movement, and which will be our focus here. The *Communauté française de Belgique*, coming into being as a result of the country's federalisation, also helps bring Surrealism (back) into focus, seeing it as a product of its local cultural context, in need of emphasising in order to buttress *communauté*'s own emerging status.

Sociological analysis draws attention to the specificities of Belgian Surrealism. If the movement is international in scope, it nonetheless appears differently in each of its literary and artistic fields. Thus the Surrealism that emerges in Belgium has certain traits that differentiate it from Surrealism in France. This is because the movement takes place in literary, artistic and political contexts that are unique to it. After having elucidated these contexts this chapter will analyse the earliest examples of *bruxellois* Surrealism, and assess what makes them different from what was happening in France. We will then move on to an examination of Franco-Belgian

joint productions, before discussing the *hennuyer* surrealist group and its connections with the *Bruxellois*. This chapter's primary focus is on the period between the wars; what comes after is examined elsewhere in this book.[4]

The Political and Literary Context

The First World War affected attitudes to the dominant values that had held sway until then. *L'Art libre* (1919–1923), founded by Paul Colin, appeared as the epigone of the pacifism of Romain Rolland, who, with Henri Barbusse and Paul Vaillant-Couturier, had founded the review *Clarté* in the same year. *L'Art libre* received contributions from, among others, the modernists Pierre and Victor Bourgeois, the *anversois* associated with *Lumière*, Roger Avermaete, Bob Claessens and Paul Neuhuys, and two future surrealists, Paul Colinet and René Magritte. These figures constitute a foretaste of the different currents that will define the literary field of the 1920s.

The monthly *Lumière* (1919–1923) was founded by Roger Avermaete in Antwerp in the wake of *Clarté*. Another monthly, *Ça ira!* (1920–1923), arose from opposition to *Lumière*, and this magazine became a focal point for figures such as Bob Claessens, Paul Neuhuys and Clément Pansaers. The latter, heavily influenced by Dadaist nihilism, produced a special number of *Ça ira!* on Dada, entitled *DADA. SA NAISSANCE, SA VIE, SA MORT*. In the journal's orbit came the musician E.L.T. Mesens and the painter René Magritte, who published two dada-inspired reviews, *Œsophage* (1925) and *Marie* (1926), before joining forces with the *bruxellois* surrealists. When *Ça ira!* finished, several of its leading personnel joined Pierre and Victor Bourgeois' *7 Arts* group.

From the start of the 1920s, the Bourgeois brothers became the centre of the most influential group, taking an interest in the most modernistic artistic tendencies, relaunching the 'Section d'Art' of the *Parti ouvrier belge* (POB) and setting up a number of links between different areas of interest and activity. With the help of Georges Monier, Karel Maes and Pierre-Louis Flouquet, the Bourgeois brothers edited the weekly *7 Arts* between 1922 and 1929, supporting constructivist, modern, social and functional ideas — in short, practical art. The group became involved in various areas: in the political, cultural and cinematographic domains with the Belgique-Russie group, especially active in cinematography and which co-ordinated cultural contacts with Russia; in the literary domain with the *Le Journal des poètes* (1931 onwards) under the aegis of Pierre-Louis Flouquet and Pierre Bourgeois; in the architectural domain, in which Victor Bourgeois — whose ideas were inspired by Le Corbusier and were later disseminated in *Bâtir* (1932–1934) — played an important role; and generally in the artistic domain by acting as a touchstone for modernism.

The other influential review of the period was *Le Disque vert* (1922–1957), a literary monthly founded by Franz Hellens. Open to collaborations with the French, this review published Henri Michaux, Norge and the future surrealist Camille Goemans. *Le Disque Vert* was more traditional, and only moderately open to avant-garde impulses. It published several key issues: one on Freudian theory (1925) and another entitled *Le cas Lautréamont* (1925).

Intellectuals attracted by the revolutionary message of Bolshevism and by the extreme left of the POB clustered around several small groups, such as Joseph Jacquemotte's *L'Exploité* or the *Groupe communiste de Belgique* and its periodical *L'ouvrier communiste*, edited by the painter War Van Overstraeten. Among the first members of the *Groupe communiste de Belgique*, a dissident faction of the POB led by Van Overstraeten, we find the future surrealist Paul Nougé. Just as these different currents came together in 1921 to create the *Parti communiste de Belgique* after the Third International, Nougé distanced himself from militant communism, as is shown in Nathalie Aubert's chapter. He nonetheless became involved with the *Secours rouge international*'s humanitarian activities up to 1927, with the likes of Pierre Bourgeois, Camille Goemans and Charles Plisnier.

The intellectuals who claimed to pursue communist ideals defended proletarian literature, taking their lead from the Third Internationale, an option supported in France by Henri Barbusse and Henri Poulaille. Augustin Habaru made this the cornerstone of his literary column in the daily paper, *Le Drapeau rouge*. Francis André, Albert Ayguesparse and Pierre Hubermont gradually moved towards this position; in 1929 they signed up to the *Manifeste de l'équipe belge des écrivains prolétariens de langue française*. Constant Malva, with the support of Henri Poulaille, launched the 'Cahiers bleus' series published by Valois in 1931 with its first text, 'Un ouvrier qui s'ennuie'. As in his later works, it takes as a subject the life and working conditions of miners.

The configuration of the literary scene in the 1920s, with each group on the Left occupying a clear-cut position, allowed the Belgian surrealists little room for manoeuvre. This goes some way towards explaining the aesthetic choices they made and the specific traits which differentiate them from the French surrealists. If the latter emerged in opposition to Dadaism (whose role in Paris was to prepare the way for them), the Belgian surrealists defined themselves through a rivalry with the literary-political left, in which they needed to define their own place.

'Correspondance'

The emergence of the surrealists happens in two phases. In November 1924 René Magritte and E.L.T. Mesens, along with Camille Goemans and Marcel Lecomte, planned a Dadaist-inspired paper, *Période*. Mesens announced its imminence in one of his tracts, which Paul Nougé parodied in a second tract. There ensued a rift between the groups. Mesens and Magritte pursued the project and it eventually appeared in March 1925 as the periodical *Œsophage*.

Meanwhile, Goemans and Lecomte joined Nougé to form the first core group of Belgian surrealists. On the 22nd of November 1924 they launched the first in a series of twenty-two tracts which became the series *Correspondance*. These deserve specific attention, since they lay the groundwork for *Bruxellois* surrealism's interventions in the literary scene. Put together and signed alternately by each of the three members of the group, these tracts appeared in twenty-two issues, published in different colours, 'à raison d'un par décade'[5] until 20 June 1925. In editions of a hundred, each was sent free to people chosen from among 'les personnalités les plus actives du monde littéraire d'alors'[6], and changing from one issue to the next.

'Bleu 1', signed by Paul Nougé, appeared a few days after the issue of *7 Arts* which opened the 1924–1925 season, and a week before the appearance of *La révolution surréaliste* in France. The poet, who became the principal theorist of *Bruxellois* Surrealism situated his movement in relation to the various groupings in the literary field. 'Réponse à une enquête sur le modernisme' began by referring to a survey organised by the editors of *7 Arts*. Nougé immediately distanced himself from the Bourgeois brothers' group: 'Regarder jouer aux échecs, à la balle, aux sept arts nous amuse quelque peu, mais l'avènement d'un art nouveau ne nous préoccupe guère.' In the tract he took a few answers to the survey, and turned them around. Thus: 'L'art a démobilisé. Que faire? VIVRE' became 'L'art est démobilisé, il s'agit de vivre./ Plutôt la vie, dit la voix d'en face'. The second part of this statement referred to André Breton's work, in relation to which the Brussels group were to position themselves more clearly in further tracts. Finally, the last lines of the poem 'Rassurez-vous, elles volent, libres encore' refer to a volume by Goemans, published by *Disque vert* editions, the review that the author abandoned to join *Correspondance*. Franz Hellens's review was more explicitly attacked in another tract, dated 10 July 1925 and entitled 'Eloge de Lautréamont' in reference to a *Disque vert* special number *Le cas Lautréamont*, which had recently appeared. Right from the start, therefore, the *Correspondance* set out their agenda by announcing their differences from *Disque vert*, from *7 Arts*, and from French Surrealism.

The French surrealists were singled out in later tracts, and there were many differences between the Brussels group and Breton's. The Belgians sought to distinguish themselves from the Parisians (both from the surrealists and from the influential *Nouvelle Revue Française*). They made this clear in the tract entitled 'Pour garder les distances' (*Orange 19*), symbolically dedicated to Breton, to Pierre Morhange (militant communist and poet connected to the *Philosophies* group) and to the editor of *NRF*, Jean Paulhan. If radicalism and revolt characterised both Belgian and French Surrealism, this permanent 'état de guerre' (*Correspondance, Orange 19*) was sustained in different ways in Paris and Brussels. These differences were connected with the following four spheres: relations with the literary establishment, writing, politics and art.

The differences are evident from the very start. Where the *Bruxellois* worked by distributing unclassifiable literary creations in a semi-private manner, André Breton published, one week after the first tract of *Correspondance*, the first number *La révolution surréaliste*. Breton set himself up immediately as the chief of a movement which he called 'Surréalisme'. Though he claimed to sweep away all that came before, Breton nonetheless respected the rules of the literary game, and clearly hoped to emerge as a major writer on those terms. The Nougé-Goemans-Lecomte trio had little respect for the codes and practices of the literary scene, and infiltrated it with something that was not exactly a literary review. Moreover, the *Bruxellois* refused the label 'surréaliste' and did not behave as a hierarchical group. Though they did eventually accept the denomination 'surréalistes', this was only 'pour les commodités de la conversation',[7] and with this proviso, reiterated even in 1945 by Nougé: 'Exégètes, pour y voir clair, rayez le mot surréalisme'. Opting to remain an underground group, the *Bruxellois* sought to avoid recognition, and rejected literary

careerism, following Nougé who 'redout[e] cette sorte de ciment implacable qui fait les monuments et les tombeaux éternels'[8]. For them, writing was above all a *re*-writing, and a secondary activity — Nougé, for instance, was a biochemist. French surrealists by contrast saw themselves as professional writers, making literary production their main activity. Their rejection of the personality cult was what brought Nougé to tell Breton in 1929 that 'J'aimerais assez, que ceux d'entre nous dont le nom commence à marquer un peu, *l'effacent...*'. Closer to home, Lecomte would pay dearly for his literary ambitions: finding him too careerist, Nougé and Goemans excluded him from the trio, publishing a visiting card dated 21 July 1925 with the simple announcement: '*Correspondance* prend congé de Marcel Lecomte'.

There were other differences between the *Bruxellois* and the French surrealists. In France for instance, any writer wanting to join the exclusive surrealist group had to practice automatic writing. Nougé, as theorist of the group, announced right from the first tract of *Correspondance* his misgivings about this attitude to language: 'On conquiert le mot, il vous domine'. The French sought freedom in the unconscious, Nougé preferred to seek it in linguistic experimentation, subverting language. In any case, the psychoanalytic field had already been claimed by *Le Disque vert* with its special issue on Freud. *Correspondance* had to take another approach. A scientist by training, Nougé thought of language as an object of experimentation. This theoretical perspective translated into word play, such as his 'équations poétiques', and into the rewriting, re-composition and re-arrangement of existing texts. This second procedure was already in evidence in *Correspondance* when Goemans pastiched Gide's *Les Faux-monnayeurs* or Marcel Arland's *Terre étrangère*. This will be a frequently-used formula: the 'détournement' of publicity slogans, set phrases or the rewriting of examples from an old grammar book belonging to Marthe Nougé, written by Clarisse Juranville. Probably inspired by Lautréamont's rewriting of classic authors, this type of experimentation functioned as a 'miroir déformant',[9] playing off the original text and its new, subverted form. This was a solution for authors wanting to act subversively both inside and against the literary system.

The verb 'agir' was of capital importance for the *Bruxellois*. As Nougé put it in his re-casting of Descartes: 'J'agis donc je suis'[10]. For Nougé and his group, art was simply 'une volonté délibérée d'agir sur le monde',[11] as he put it in a 1929 lecture in Charleroi. Indeed, according to him, writing and music were 'objets bouleversants', capable of provoking revolutionary thoughts. It is thus by means of writing — as social and political action — that the Bruxellois surrealists attacked the bourgeois order. But they never used the style or language of what might be called 'littérature prolétarienne'. Their approach was always to experiment with and subvert the literary codes already in place. They also refused to try and reconcile militant action and artistic and literary experimentation like Breton. In September 1925, *Correspondance* agreed to sign the condemnation of the French war in Morocco, 'La révolution d'abord et toujours!', along with *Clarté* and *Philosophies*. Nonetheless Goemans and Nougé felt the need to clarifiy their position with regard to political action. In a tract dated 28 Septembre 1925 and entitled 'A l'occasion d'un manifeste', they wrote:

> Il n'est aucune démarche extérieure à son objet dont la stérilité ne s'avère dès l'abord. Après tant d'expériences misérables, quel doute garderait ici sa place? L'on s'effraie si l'on trouve encore des esprits pour fonder sur de semblables tentatives. [...] Nous nous opposons à ce que l'on situe [notre] activité sur le plan politique qui n'est pas le nôtre.

Unlike the French surrealists who were drawn towards the Third Internationale after having discovered writing, Nougé et Goemans had been previously associated with communism and had learned their lesson. Henceforth it is only by literary action that their revolutionary activities would proceed.

Artistic Experimentation

One final feature distinguishes the Belgians from Breton's group. It needs to be put in its historical context before it can be discussed. While he was involved in his Dadaist experiments with Mesens, Magritte met Marcel Lecomte in 1922. Lecomte introduced him to Goemans in late 1924 and then Nougé in 1925.[12] In November 1924, Mesens, Magritte, Goemans and Lecomte decided to found the review *Période*. After they left to start *Correspondance* with Nougé, Goemans and Lecomte were joined in 1925 by the musicians André Souris and Paul Hooreman. By becoming involved with *Correspondance*, these two gave up any prospect of career advancement. They created two musical tracts intended as expressions of artistic solidarity and responses to the literary tracts of Nougé, Goemans and Lecomte. 'Musique I — Le tombeau de Socrate' appeared in July 1925, its title an echo of 'Blanc 7 — Délire de Socrate' by Nougé. This tract grappled with the music of Erik Satie, who had died on 1 July 1925. Under the aegis of *Correspondance*, Hooreman and Souris effectively wrote a musical score opposed to the formalism of Satie, who had also composed a *Socrate* and who had deeply influenced the Dadaist Mesens in the early 1920s. *Correspondance* also sustained links, albeit ephemeral, with the cinema, through the 'Cabinet Maldoror' *ciné-club* led by Geert Van Bruaene. This came to nothing.

Strengthened by the arrival of the two musicians, *Correspondance* was joined in 1926 by Magritte and Mesens, who had abandoned music. The union was sealed by two symbolic publications: a sober visiting card dated 10 September 1926, announcing '*Correspondance* prend congé de *Correspondance*'; and, in early 1927, *Adieu à Marie*, a collaboration between Nougé, Goemans, Souris, Mesens and Magritte. On 11 October 1926, the group made its first public appearance, disrupting the performance of Géo Norge's *Tam-Tam* at the Casino of Saint-Josse in Brussels. They explained and justified themselves in the tract 'Défiez-vous', prepared five days earlier. A little later, Cocteau's *Les mariés de la Tour Eiffel* met the same fate.

In 1927, Louis Scutenaire joined the group, with Magritte, Lecomte, Nougé, Souris, Goemans, Mesens and Gaston Dehoy, on the monthly review *Distances* in 1928. This review, which had only three issues, has a symbolic title, evoking both the distance between the Belgian surrealists and their literary or artistic experiments, and the distance between them and their Parisian counterparts. Goemans and Magritte nonetheless went to Paris, the former to set up an art gallery, the latter to

meet other artists — indeed, the review was edited from Goemans's Paris home. Marc Eemans published a poem and a drawing in the first number of *Distances*, but he soon moved away from the group towards a much more traditional art. Mesens would later condemn Eemans's artistic processes, along with those of the art critic René Baert, in the second number of *Documents 34* (1934).

In May 1928, P.-G. Van Hecke, art dealer and director of the Brussels art gallery *L'Epoque*, set up a review which he opened up to avant-gardists from Belgium and beyond, publishing a special number in June 1929 entitled 'Le surréalisme en 1929'. Here we find many Parisian representatives, along with Paul Nougé et E.L.T. Mesens. Earlier, Van Hecke and Walter Schwarzenberg, director of the Brussels gallery *Le Centaure*, had signed a deal giving financial independence to Magritte. Thanks to this deal, Magritte could afford to go to Paris, and he benefited from two shows in Brussels, the first in the *Centaure* gallery from 23 April to 3 May 1927, and the second at *L'Epoque* in January 1928. Neither was greeted favourably by the press, which was more open to modernism or to more traditional art.

In 1930, after the Wall Street crash and the economic crisis that followed, *Le Centaure* went bankrupt. Without a contract, Magritte returned to Brussels, followed quickly by Goemans who, for his part, was accused by the other surrealists of luring Magritte into the Parisian trap, and who then began to drift away from the group. Despite financial difficulties, E.L.T. Mesens and Ewold van Tonderen showed sixteen Magritte paintings in the *Salle Giso* in the *Palais des Beaux-arts* in Brussels, for which Nougé wrote the catalogue. Nougé took the opportunity to return to his literary and artistic theories: art is an 'attentat à la sûreté publique', which 'enferme de quoi modifier à jamais le sens de la justice, de l'amour, le sens, l'allure et la tension d'une existence humaine'.[13] It is through experimentation and not through political action that the artist can change bourgeois society, because 'certaines peintures atteignent en virulence, et par des voies qui leur sont propres, les plus ardentes provocations à la révolte'.[14] Nougé also reaffirmed his rejection of proletarian literature, to which he prefers the subversion of familiar objects in order to make them extraordinary and unnerving.

The catalogue came after a number of works in which Nougé explained the artistic work of the Brussels surrealists. He took up from the important Charleroi lecture of 1929, in which he had discussed the music of André Souris, played on the same evening, and in which Nougé explained his experimental theory of 'objets bouleversants', equally applicable to visual and musical arts as to writing. The closeness between different artistic disciplines was not just evidenced in theoretical texts, but in a background of collaborative endeavour. Thus in 1928, a catalogue of aphorisms by Nougé and illustrations by Magritte appeared from the coat designer Samuel. There is also the rewriting and recasting of examples from Clarisse Juranville's grammar manual 'La conjugaison enseignée par la pratique', which became *Quelques écrits et quelques dessins* (1927), by Nougé and Magritte and with music by André Souris (1928). There were five tracts of poetry and images with the single title *Le sens propre*, published in Paris in 1929 par Goemans and Magritte, and the titles of Magritte's paintings, attributed to the *Bruxellois* surrealist group as a collective. These are just a few examples.

All the specificities that define *Correspondance* can be found in this collaborative spirit between writers and artists. The Bruxellois surrrealists, who symbolically chose for themselves the name 'La société du mystère', carried out their activities in a clandestine way in relation to the establishment. Their goal was to revolutionise bourgeois society by experimenting on, and subverting, linguistic and artistic conventions, leaving political action to the militants. Unlike the French surrealists (Breton for instance considered music 'profondément confusionnelle'[15] and unusable to surrealist ends), the *Bruxellois* brought off genuinely collaborative activities. They were thus able to take their place alongside the French surrealists, allowing the French to focus on the literary, and concentrating for their own part on the artistic dimension (this being, thanks to Magritte, largely pictorial). It is more than possible that Goemans and Magritte also served, while they lived in Paris, as intermediaries between the two groups.

The 1930s: A Turning Point

The French surrealists' recognition of their Belgian counterparts as official interlocutors is evidenced in a number of collaborative actions. Despite this, the Belgians retained their initial theoretical presuppositions. They also differed from other avant-garde groups in Belgium which, by and large, returned towards a kind of conservatism and order by the 1930s.[16] André Souris felt the consequences of this after agreeing to direct the Brussels Symphony Orchestra for a mass in memory of Henry Le Bœuf, cofounder of the *Palais des Beaux-arts*, on 26 January 1936. As soon as the event was announced, the tract *Le domestique zélé* sanctioned the expulsion of Souris from the group, on the grounds that he had broken the rules of secrecy.

In 1929, Belgian surrealists were among the recipients of a questionnaire sent by Breton on the subject of shared projects, at a time of crisis for surrealism in Paris. It is in this context that Nougé re-emphasised the distance between Paris and Brussels with his comment, quoted earlier, about Breton's prominence in the group. Despite this categorical statement, Nougé, Magritte and Mesens were invited to contribute to the last number of *La révolution surréaliste* in 1929, while *Variétés* published several French writers in its special number 'Le surréalisme en 1929'.

The 'affaire Aragon' in January 1932 gave the Belgians another chance to define themselves as distinct from the French. While Aragon was moving away from the surrealist group to follow official Marxist cultural initiatives, he composed the poem 'Front rouge', in which he called on people to defend the Soviet Union and to promote its political ideals. When the poem appeared in *Littérature de la révolution mondiale*, Aragon was accused of 'excitation de militaires à la désobéissance' et 'provocation au meurtre dans un but de propagande anarchiste'.[17] The surrealists immediately came to their former companion's defence and published 'L'affaire Aragon' protesting against the interpretation of a poem for legal ends. The Brussels surrealists did not share this view, which according to them was based on a bourgeois belief in literature as harbouring intrinsic value. In 'La poésie transfigurée' (30 January 1932), Magritte, Mesens, Nougé and Souris drew attention

to the text's specific social implications, implications which a bourgeois reading tries to do away with:

> Mot pour mot, il n'y a plus de mot qui tienne. Le poème prend corps dans la vie sociale. Le poème invite désormais les défenseurs de l'ordre établi à user envers le poète de tous les moyens de répression réservés aux auteurs de tentatives subversives.

Despite these differences, the *Bruxellois* remain, in Breton's view, a fully-fledged surrealist group, which even functioned as a forum for publishing. The two groups continued their regular collaborations. In 1933 éditions Nicolas Flamel, run by E.L.T. Mesens, published a collection in honour of the parricide Violette Nozières, brought down by public opinion. In May that year, several *Bruxellois* collaborated on number 5 and 6 of *Le Surréalisme au Service de la Révolution*. The following year, the first international exhibition of Surrealism took place at the *Palais des Beaux-arts* in Brussels, under the auspices of the French review *Minotaure*. André Breton came to Brussels for the opening and gave a lecture entitled 'Qu'est-ce que le surréalisme?', in which he drew attention to the relationship of collaboration and distance between the French and Belgian groups, and assimilating the latter into an international movement:

> L'activité de nos camarades surréalistes en Belgique n'a pas cessé d'être parallèle à la nôtre, liée étroitement à la nôtre et je suis heureux de me trouver ce soir parmi eux. Magritte, Mesens, Nougé, Scutenaire, Souris sont de ceux dont, en particulier, la volonté révolutionnaire (indépendamment de toute considération d'entente totale avec nous sur un autre plan) a été pour nous à Paris une raison constante de penser que l'entreprise surréaliste peut, par delà l'espace et le temps, contribuer à réunir efficacement ceux qui ne désespèrent pas de la transformation du monde et la veulent aussi radicale que possible.[18]

Surrealism in Hainaut

During this period, economic crisis was ravaging the province of Hainaut, with mines and old industries closing down. Unemployment rates were rising as salaries lost value. In June 1932, violent strikes broke out across the province among different professions. The province was on the brink of insurrection, and police action was violently repressive.

Achille Chavée, André Lorent, Albert Ludé and Marcel Parfondry, young intellectuals of the extreme left were marked by these events. They founded on 29 March 1934 the *Rupture* group in Haine-Saint-Paul (La Louvière). The essentially ethical and political goals of the movement were 'forger une conscience révolutionnaire [et de] contribuer à l'élaboration d'une morale prolétarienne'.[19] To be admitted to the group, one had to be a member of a socialist, anarchist or communist organisation. 'Membres coloniaux', or sympathisers, were also allowed. To remain closer to its revolutionary goals, the group admitted the miner and proletarian writer Constant Malva to its ranks. René Lefebvre and Marcel Parfondry, who joined later, were also proletarian in origins. A few members came from the *petite bourgeoisie*, while the lawyer Chavée was from a more traditional

bourgeois background.[20] Following Chavée's example, *Rupture*, for all its political objectives, was open to literature:

> Le surréalisme a été pour moi une véritable libération, liée à l'aspect social et insurrectionnel des grèves de 1932. La synthèse s'est établie d'elle-même entre la poésie et mes convictions politiques.[21]

But it was Fernand Dumont who most influenced the activities of *Rupture* in a more literary and cultural direction. This young lawyer, fellow student of Chavée's at the *Athénée* of Mons and then at the *Université libre de Bruxelles*, was a fervent admirer of Breton. At the start of the 1930s he became associated, through Max Servais, with the *bruxellois* surrealists, but left the group's orbit soon after the Aragon affair, on which issue he sided with Breton. His own elitist conception of aesthetics was in complete opposition to the proletarian ethic of Lorent. First, a 'membre colonial'; Dumont gained influence in the *Rupture* group after a meeting on 9 March 1935, during which the issue of the relationship between the group and its sympathisers was discussed. Four days later, in a letter to Chavée, he began to lead *Rupture*'s activities in a more literary direction, asserting the need for the group to have its own review, and naming them 'le groupe surréaliste du Hainaut'. He then proposed opening the rank of 'membres coloniaux' to Magritte, Mesens, Scutenaire, Nougé and Servais, as well as Breton and Paul Eluard.

The 13 April 1935 saw the first meeting with a Brussels surrealist, Mesens, whose links with Dumont date from the latter's involvement in Nougé's group. The issue is political engagement, and this is where the first cracks began to appear: Chavée insisted that *Rupture* needed to stay in touch with workers and with the political left; Dumont, following Mesens, declared that Surrealism was more important than any political position.

This literary/political split marks the one and only issue of *Mauvais temps* (1935), whose title had been suggested by Lorent. In the preface, which cites quotations from Marx and Lenin as epigraphs, *Rupture* (Chavée, Parfondry, Jean Dieu, Dumont, Marcel Havrenne, Lefebvre, Lorent, Ludé, Malva) asserts its adherence to the social and political realities of the day, and to the *Front littéraire de gauche* (FLG). The *La Louvière* group sees itself as more radical in terms of proletarian revolution and 'irrémédiablement hostile à toute collaboration intellectuelle avec les chrétiens', to which the FLG had opened its doors. It also emphasises its support for Surrealism's principles, but asserts that the review's literary texts were composed without any literary preoccupations, as examples of proletarian literature. If the literary dimension seemed to take second place, *Mauvais temps* remains a hybrid document, polarised between political and proletarian objectives on the one hand and surrealist preoccupations on the other. Sent by Dumont to Breton, it received the Master's approval, and marks the emergence of a second centre of surrealism in Belgium:

> Il me serait bien difficile de ne pas être parfaitement d'accord avec tous vos amis. Une revue comme *Mauvais temps* répond vraiment, dans tous les domaines, à mon plus grand désir.[22]

Mauvais temps also published two pieces by Brussels surrealists: a collage by Servais and Magritte's *Le viol*.

The collaboration between *Hennuyers* and *Bruxellois* deepened with the joint authorship of a tract entitled 'Le couteau dans la plaie' in the third number of *Bulletin international du surréalisme*[23] (20 August 1935, published by Mesens's Nicolas Flamel editions). The so-called 'Groupe surréaliste en Belgique' condemned the Franco-Soviet pact and reaffirmed the worldwide reach of the proletarian revolution. Collective action continued during the international Surrealism exhibition in *La Louvière* from the 13th to the 27th of October 1935. On the day of the opening, the *Bruxellois* Mesens and Irène Hamoir (Jean Scutenaire's lover) gave speeches. The evening ended with Souris's 'Quelques airs de Clarisse Juranville'.

The *entente* between the two Belgian surrealist groups seemed cordial enough, despite their differences. In fact, they differed greatly in their relationship with literature too, since the *Bruxellois* rejected automatism, to which the *Hennuyers* group, who also subscribed fully to Breton's personality cult, adhered. Nougé's group explicitly distinguished between literary production and political action, while Chavée's group saw ethical-political and literary goals as inseparable. Moreover, the *Bruxellois* experimented in various different arts, whereas the *Hennuyers* group focussed on literature. In this respect, it needs to be remembered that the *Hainaut* group did not encounter, in their province, the same competitive challenges from other artistic practices that the Bruxellois encountered in the capital. These characteristic differences are clearly visible in an *Art poétique* written by Chavée after the Second World War (1948). We may see on the one hand a desire for political action and on the other a faith in language and in the unconscious:

> **Ecrit sur un drapeau qui brûle**
> le collage des contrastes
> le colloque des contraires
> union confusion fusion **action**
> l'oiselet dans le vent
> le **désir dans le rêve** la neige de l'intégrité
> le **désespoir** qui brise sa rapière
> L'invisible se proportionne
> aux dialectes de nos **rêves**
> J'en parle pour nous **être utile**
> pour **mesurer notre puissance**[24]

In 1936, Chavée decided to join the republicans and fight in the Spanish civil war, leaving the running of *Rupture* to Dumont, who immediately moved the group to his home town of Mons. Dumont tried to resolve the group's divisions by proposing to alternate political and literary texts in the second issue of *Mauvais Temps*. But the projects came to nothing. In 1937, Chavée returned from Spain wounded. Henceforth won over to Stalinist principles, he left the POB to join the communist party. Internal disagreements then took over, between the group's Trotskyites, Ludé, Lorent and Havrenne, and its Stalinists. In 1938, when Breton sent them a questionnaire on the Trostkyist *Fédération internationale de l'art révolutionnaire indépendant* (FIARI), the *Rupture* group replied evasively, unable to agree on a common position. Then Mesens atttacked Chavée's political choices, and took *Rupture* itself on, which, because of its Stalinist association, no longer deserved to be called surrealist. In reply, Dumont, along with the photographer

Marcel Lefrancq and the painter Louis Van de Spiegele, denounced the inactivity of the *Bruxellois*.

On the 1st of July 1939, Chavée and Dumont founded the 'Groupe surréaliste en Hainaut' in Mons, with a far more literary-artistic focus. Whereas *Rupture* was mainly composed of left-wing intellectuals and writers, the new group counted painters such as Van de Spiegele, Pol Bury, Armand Simon, the photographer Lefrancq, along with Malva and Lucien André. This new grouping had barely begun when war started.

The new turn of events changed eveything: in 1941, Breton went to America while Mesens moved to England; in 1939, Nougé was called up as a reservist in the French army. Raoul Ubac, a Belgian photographer who had been living in France, contributing to surrealist activities since the beginning of the thirties, returned to Belgium. With Magritte, Ubac produced two editions of *L'Invention collective*, en 1940. The new *Hennuyer* group played a prominent role in this. Breton, who found the first number not *engagé* enough, agreed to contribute to the second. There was no third issue once the Germans invaded Belgium. After the Liberation, new groupings emerged, notably with the arrival of Christian Dotremont. But during the war, surrealism seemed to have gone quiet. Chavée went to ground, Dumont was arrested and died in a concentration camp. The Brussels surrealists continued to work in a clandestine way, in a literary sphere increasingly seeking a return to order and old certainties. Marginalised partly by their own principles of secrecy and anonymity, and partly by their opposition to the dominant literary scene, the Brussels surrealists were to remain sidelined for many years before their rediscovery. It is no accident that the *Hennuyer* group — the ones who trusted and believed in literature — were first to be restored to a place in literary history. The Brussels group preferred, as Nougé put it, 'se retire[r] avec modestie en effaçant leur signature'[25].

Notes to Chapter 13

1. E.L.T. Mesens, in *Transformation*, 10 (1979), p. 14.
2. See, among others, Achille and Christine Bechet, *Surréalismes wallons* (Brussels: Labor, 1987), Marc Quaghebeur *Les lettres belges entre absence et magie* (Brussels: Labor, 1990), Olivier Smolders *Paul Nougé: Ecriture et caractère à l'école de la ruse* (Brussels: Labor,1995) and Anna Soncini Fratta (ed.) *Paul Nougé: pourquoi pas un centenaire?* (Bologne: CLUEB, 1997).
3. See especially Serge Alarcia, *Approche sociologique et politique des mouvements littéraires d'avant-garde: Etude des groupes 'rupture' et 'front littéraire de gauche'* (Brussels: Université Libre de Bruxelles, Graduate dissertation, unpublished, 1986) and Paul Aron, 'Essai d'analyse institutionnelle d'un mouvement littéraire périphérique: l'exemple du surréalisme bruxellois entre les deux guerres' in *L'Identité culturelle dans les littératures de langue française* (Paris-Pécs: A. Vigle, 1990), pp. 151–162. Paul Aron, (ed.) *Surréalismes de Belgique, Textyles,* 8 (1991). Paul Aron, 'Le surréalisme hors frontières' in *Belgique Wallonie-Bruxelles. Une littérature francophone. Actes du Huitième colloque international francophone du Canton de Payrac et du Pays de Quercy* (Paris: Association des écrivains de langue française, in 'Mondes francophones', 'Colloques de l'ADELF' series, n° 8, 1999), pp. 455–464.
4. The aim of this article is specifically to present a chronological overview of Belgian surrealism and its various alliances and divisions.
5. André Souris, 'Entretiens sur le Surréalisme' (1968), cited in O. Smolders, op.cit., p. 95.
6. Ibid.

7. Nougé's words reported by Marcel Mariën in M. Mariën, *L'activité surréaliste en Belgique 1924–1950* (Brussels: Lebeer Hossmann, 1979), p. 129.

8. Nougé, Paul, *René Magritte ou les images défendues*. Quoted by Dominique Combe in 'La rhétorique de Paul Nougé', *Europe* 1995, p. 52.

9. See Annamaria Lasserra, 'Les miroirs déformants: métaphore et métamorphose dans la poétique de Paul Nougé', in A. Soncini Fratta, op.cit., pp. 107–124.

10. Paul Nougé 'La solution de continuité', in *Histoire de ne pas rire* (Lausanne: l'Age de l'Homme, 1980), p. 110.

11. Paul Nougé, *La conférence de Charleroi* (Brussels: Le Miroir infidèle, 1946).

12. René Magritte, *Ecrits complets* edited and annotated by André Blavier (Paris: Flammarion, 1979), p.367.

13. Article reproduced in Marcel Mariën, op.cit., p. 205–206.

14. Ibid; p.207.

15. Quoted in Robert Wangermée, 'Les surréalistes bruxellois et la musique', in Jean Weisgerber (ed.) *Les avant-gardes littéraires en Belgique. Au confluent des arts et des langues (1880–1950)* (Brussels: Labor, 1991), p. 345.

16. See Virginie Devillez, 'L'avant-garde sur le métier de la tradition', in Weisgarber, op. cit.

17. Serge Alarcia, op. cit., p.57.

18. André Breton, *Qu'est-ce que le Surréalisme?* in *Œuvres complètes* (Paris: Gallimard, 1992), Vol.II, p.225.

19. Serge Alarcia, op. cit., p.21.

20. The surrealists from the Brussels group mainly came from the bourgeoisie. Their social origin allowed them to adopt a position of withdrawal, non-profit seeking, in the literary field.

21. Cited in Jean Puissant, 'Un groupe surréaliste en Hainaut' (in *Surréalisme en Hainaut 1932–1945* (Kruishoutem: Imprimerie EMKA, 1979), p. 30.

22. Letter from Breton to Chavée, 1 November 1935 (cited in S.Alarcia, op.cit., p.221).

23. This international bulletin changed its place of publication for each new issue. The first one was published in Prague, the second in Tenerife, the third in Brussels and the last one in London.

24. My emphasis.

25. [Paul Nougé] Clarisse Juranville, Quelques écrits et quelques dessins (Brussels: Henriquez, 1927).

CHAPTER 14

Twenty years on — *Distances*: Belgian and French Surrealists and 'the' Revolution

Nathalie Aubert

In his book entitled *Toward the Poetics of surrealism*,[1] John Herbert Matthews tells of an anecdote which sums up the ambivalence of the relationship between Belgian and French surrealists quite well. In October 1967, a year after André Breton's death, the second issue of the French surrealist magazine *L'archibras* carried a prominent notice informing all who held letters written by the French surrealist poet that he had expressed in his will the wish that none of his letters be published until 50 years after his death. Without any delay, a small pamphlet entitled *André Breton, 5 lettres*, was published in Holland, under no publisher's name. These letters had been written by Breton, to a number of Belgian surrealists: one letter to Camille Goemans, one to Marcel Mariën, one to René Magritte, and two to Paul Nougé. The pamphlet bore the publication date MMXVI (2016), and printing was supposed to have been completed on 28 September of that year, the exact date of the fiftieth anniversary of Breton's death.[2] Beyond the anecdote, there was a demonstration of independence towards Breton, a last sign of irreverence in a long, rich, yet stormy relationship between the Brussels group[3] and Breton. This chapter proposes to examine the relationship between Paris and Brussels from the particular angle of the attitude they adopted towards their political commitment. Examining the conditions surrounding the complete reversal in the attitude of both groups towards the communist parties in both countries, from 1927 to 1947, will allow us to make a number of points emerge with regards to their conception of 'the' revolution as avant-garde movements.

'La Révolution d'abord et toujours!'

The relationship between Brussels and Paris started with the famous pamphlet *La Révolution d'abord et toujours!* published in 1925, in the journal *Correspondance* created by Nougé and Goemans in Brussels. It showed for the first time the signatures of Belgian surrealists Nougé and Goemans alongside those of their French counterparts. Historically, it is worth underlining how important this document is since it is the first time that intellectuals expressed themselves in favour

of the proletarian revolution. This was the first time that a section of the young, intellectual bourgeoisie moved towards the defence of a social class whose interests were contrary to those of their own. In this pamphlet, Nougé was responsible[4] for the addition of one sentence:

> Il importe de ne voir dans notre démarche que la confiance absolue que nous faisons à tel sentiment qui nous est commun, et proprement au sentiment de la révolte, sur quoi se fondent les seules choses valables[5].

Although Nougé and Goemans did sign the tract, the addition of this paragraph, the only one to mention the word 'revolt' instead of 'revolution' shows a reluctance, especially on Nougé's part, to directly associate surrealism with the ideologically charged word 'revolution'. The context surrounding the publication of this tract was that of the war in Morocco, seen by the surrealists and the communists as a characteristically colonial war whereby a colonized people seeking its freedom was being repressed. *La Révolution d'abord et toujours!* was an answer to the communist Henri Barbusse's *Appel aux Travailleurs intellectuels* and the call, by the initially pacifist journal *Clarté*[6] to condemn the war in the French colony. It was also an answer to the Academicians and 'official men of letters'[7] who, in a text entitled *Les intellectuels aux côtés de la patrie* had defended the intervention. Nougé could not but condemn the infamous oppression of the Moroccan people, but it immediately became obvious that he was wary of any concrete *rapprochement* with the political strategy of the Communist Party. Indeed, no sooner had *La Révolution encore et toujours!* been published in *Correspondance*,[8] than both Nougé and Goemans wrote another pamphlet, published in the same journal (28 September 1925) contesting some aspects of the previous one. In this second text, entitled *A l'occasion d'un manifeste,* Nougé expressed again his doubts concerning the use of the word 'revolution' by the French surrealists:

> L'aimable légèreté de certains esprits, le peu de soin qu'ils apportent à marquer les différences, cette hâte à se délester, à se dépouiller par la grâce de quelques formules dont les maigres vertus les enchantent, — voilà qui nous incline à sourire, incapables que nous sommes de nous étonner plus longtemps. L'emprise des mots est si vigoureuse qu'il semble que l'on renonce vite à s'en défendre, à en tirer parti. Et l'on peut regretter que le mot REVOLUTION suffise à brouiller tant de têtes que l'on imaginait moins faciles[9].

In this text, Nougé agreed to link his own activity 'de la manière la plus étroite au développement d'une révolution sociale' adding that hesitation would be 'mortelle qui différerait une adhésion sans réticence aux groupes mêmes qui tâchent à préparer cette révolution'. He was not convinced however that the best way to achieve this was to follow 'la creuse idéologie des tenants de la deuxième internationale'. Nougé, who had been, in 1919, one of the founding members of the Belgian section of the Third Internationale, had a first hand approach to the strategy and practice of the Communist Party. This explains why he can speak of 'la décomposition profonde des partis communistes occidentaux' in 1925, which was, at the time, unusually perceptive. On the contrary, Breton had a purely intellectual experience of Marxism informed by his readings of Trotsky's *Lénine* first, then of Marx and Engels via Hegel. Mostly, and this is how Nougé concluded his text, he insisted on

the incompatibility of the surrealist activity and the activity of those political parties that were acting towards a social revolution:

> L'on ne peut le méconnaître, notre activité ne se ramène pas à l'activité des partis qui travaillent à la révolution sociale. Nous nous opposons à ce que l'on situe cette activité sur le plan politique qui n'est pas le nôtre. L'on voit bien la manœuvre, tout ce que nos démarches auraient à souffrir, et quelle confusion nouvelle elles ne manqueraient pas d'entraîner, ainsi maquillées.
> Nous nous refusons de nous reconnaître dans ces miroirs faussés que l'on nous tend de toutes parts.[10]

Nougé refused to any political party, revolutionary or otherwise, the right to interfere with his domain, that of poetry. In fact, Breton himself agreed with that, and his political texts are always eager to underline the need to preserve the freedom of the artist. However, the question for him was more philosophical than pragmatic, as in Nougé's case. He needed to decide whether Surrealism wanted to opt for a metaphysical attitude or a dialectical one. These two options were mutually exclusive as Pierre Naville pointed out in *La Révolution et les intellectuels* (1926):[11] was the movement capable of moving away from a theoretical speculation on the data of internal experience and of a certain experience of external objects and events in order to embrace the progress of the mind according to its consciousness of itself? These two options, the metaphysical and the dialectical ones were mutually exclusive, as Naville demonstrated convincingly. According to him, the French surrealists were facing a dilemma. They needed to decide whether the liberation of the mind they were asking for was anterior to the abolition of the bourgeois conditions of material life (therefore, independent of these particular historical circumstances) or, on the contrary, dependent on the abolition of the bourgeois conditions of material life. Breton was adamant he did not want his movement to be purely 'a revolution of the mind', but equally, he did not intend to compromise the individualistic nature of the kind of liberation he was aiming at. Like Nougé in fact, he knew that the sphere of action that was his, as a poet, was different in nature to the sort of action that was required by political commitment. Equally, as Naville pointed out, he was aware of the fact that individualism as a revolutionary force was powerless.[12] Even if the surrealist group practised collective activity, this activity would be void by the limited impact of what largely remained confined in the artistic realm. Naville insisted on the dangers of a purely romantic alliance of the intellectuals with the proletariat and wondered what would be the modalities of such an alliance:

> Il [Breton] ne dit pas, et c'est la seule chose qui importe, jusqu'où peut aller cette collaboration, et par quels moyens; et en fin de compte de quelle nature est cette collaboration? Les 'Intellectuels', on nous rebat les oreilles, en France, avec ces mots, ce prestige.[13] De quoi s'agit-il? Quelle partie jouent les poètes, penseurs, artistes? Jusqu'où vont-ils encore tromper la classe ouvrière, la classe révolutionnaire, le seul authentique ferment de renouveau dans le monde? [...] Un mouvement comme le surréalisme, aussi purement cérébral et dont l'expérience des choses est nettement romantique, est-il dans les faits susceptible d'aller vers la révolution, c'est-à-dire où elle se crée, où elle se vit? Le goût de la révolution doit être adapté à la mesure de la nécessité révolutionnaire,

sinon il demeure un mouvement lyrique, toujours cet accent de révolte capable d'atteindre la bourgeoisie dans son intellectualisme omnipotent, mais non de toucher la naissante intelligence révolutionnaire du prolétariat.[14]

'The Naville crisis'[15] was instrumental in determining Breton's decision to join the French Communist Party, and, despite Nougé's warning, a number of French surrealists, among them, in addition to Breton, Eluard, Aragon, Peret, Unik, rallied the communist party in 1927, regularly writing in the journal *Clarté*, where the Communist Party counted by then a lot of sympathisers. At the time, Artaud and Vitrac decided to leave the movement for reasons similar to those exposed by Nougé. Showing their independence from Paris, the Brussels group did not leave the movement in protest, but decided to remain unattached to the Belgian Communist Party. It has to be said that there were significant historical differences between the French and Belgian communist parties at the time, which partly explain the divergence in choice. As Paul Aron points out,[16] before 1932, the Belgian Communist Party was nearly non existent (gathering only 2% of the votes) due to the hegemony of the P.O.B. (Belgian Labour Party). More importantly, the latter had a well-defined cultural line, linking 'toutes les avant-gardes possibles, qu'elles soient politique, architecturale, picturale, poétique ou autres'.[17] As Aron states, on the Communist side, the only individuals who counted were Nougé's old friends from the time he belonged to the War van Overstraeten group and they were more inclined towards proletarian literature:

> Chez Paul Nougé, la période de l'engagement communiste précède la période de l'engagement littéraire. C'est une différence sensible avec le parcours de Breton, qui est déjà un écrivain reconnu au moment de son engagement politique. Nougé est un homme qui a vécu la marginalité politique et qui met à profit cette expérience pour intervenir dans le champ littéraire. Le projet d'une liaison entre les avant-gardes comme position politique du surréalisme lui semble intenable en Belgique du fait de l'hégémonie du P.O.B et de la position 'prolétarienne' affichée par les communistes. D'où cette idée d'une séparation des domaines et l'exigence d'être révolutionnaire dans le domaine artistique pour être plus efficace.[18]

So, there were contacts with the Communist Party, but they were rare and insignificant. As to their reaction when Breton, Aragon, Péret, Eluard and Unik joined the Communist Party, it was one of dismay:

> Vous avez cru devoir adhérer au Parti communiste. Personne n'a compris le sens véritable de cette démarche. L'on tente de vous réduire.[19]

After this episode, and explicitly enough, the journal published by the now more substantial group in Brussels[20] was entitled *Distances* and developed independently, calling itself surrealist 'pour les commodités de la conversation' according to Nougé's expression. In Paris, the fact that Breton and his friends joined the Communist Party has been commented upon as 'an odd choice'[21] after 'Breton's fierce intractability with regard to the autonomy of surrealism'.[22] The question of the autonomy of art is at the heart of the very definition of what Breton's fight for Surrealism has come to embody in order to keep the integrity of the artist's freedom. However, at the beginning of Surrealism, and like Dadaism before it, Breton's movement did not

consider itself as yet another *stylistic* avant-garde intent on criticizing schools that preceded it. Indeed, as Jochen Schulte-Sasse remarks,[23] 'the experience of alienation in modern societies; the disqualifying effect of the instrumentalization of reason; and the domination of social interaction by exchange value' in bourgeois–capitalist society are the trade marks of *all* avant-garde movements since the 19th century. They tended to concentrate on stylistic creativity as a necessary reaction to these socio-historical developments.[24] The radicalism of the attack addressed first by the Dadaist movement, then by Surrealism in the early 1920s, is linked to the fact that they contested the very existence of an autonomous realm for art because, as Herbert Marcuse points out in *The affirmative character of culture* the autonomy of art had from the beginning a very ambivalent character: 'Individual works may have criticized negative aspects of society, but the anticipation of social harmony as psychic harmony, which is part of the aesthetic enjoyment for the individual, risks degenerating into a mere cerebral compensation for society's shortcomings, and thus of affirming precisely what is criticized by the content of the works'.[25] In other words, Marcuse maintains that even the most critical work inevitably exhibits a dialectical unity of affirmation and negation by virtue of its institutionalised separation from social praxis. Naville had pointed out himself that the efficiency of the surrealist attack against the bourgeois society was disputable because the surrealists themselves produced, whether they used the expression or not, *works of art*, that is to say 'des créations autonomes de l'esprit'. Indeed, the very possibility to move on from Dadaist negativism and rejection of art was what motivated Breton to initiate Surrealism as a movement in the first place. When the French poet said, as early as 1920:[26] 'On sait maintenant que la poésie doit mener quelque part', he was moving away — consciously or not — from Dada's nihilism. For Tzara's movement, the abandonment of an autonomous sphere for art was the cornerstone of its activities. Surrealism, under Breton's leadership, became an attempt to integrate its activities in life, rather that solely in the art realm, as had all the 19th century avant-garde movements before it.

Like the Dadaists before them, the surrealists realized that the ambiguous status of art in bourgeois society provided the key to understanding the contradiction between negation and affirmation implicit in the autonomous mode in which art functioned. With this realization came a raised awareness of the social ineffectiveness of their own medium and a true desire, especially on Breton's part in the early years of the movement to fight that inherent weakness. It is precisely the lack of art's social impact that the surrealists wanted to move away from, with a specific aim to reintegrate art into the praxis of life. The glorification of spontaneity and of the erotic, as well as a promulgation of collective works, were some of the responses envisaged by the French surrealists in order to avoid the danger of the retreat to the problems of the isolated subject. This first phase of the surrealist movement in France was clearly established as a way to negate the determinations essential to autonomous art, leading to a disjunction of art and the praxis of life. Progressively (from the creation of the review *La Révolution surréaliste*) the French surrealists sought on the contrary to integrate their activity into the praxis of life, seeking social effectiveness for their own medium, leading to ever more radical confrontations with bourgeois society. This explains the early call for a 'revolution'.

It is in this particular context that one must examine the progressive move of some of the French surrealists in the 1920s towards political action. Joining the Communist Party was for Breton a strategic move towards what seemed a possible 'way out' of the solipsism of the art's sphere. However, the basis of this association with the Communist Party was intellectually flawed. In his *Discours au congrès des écrivains* in June 1935, Breton famously combined Marx and Rimbaud:

> 'Transformer le monde', a dit Marx; 'changer la vie' a dit Rimbaud: ces deux mots d'ordre pour nous n'en font qu'un[27].

This alliance, in Marxist terms, was of course impossible as there was a dialectical question of anteriority of goals, already clearly defined by Pierre Naville in 1926:

> La question se pose donc nettement: les surréalistes croient-ils à une libération de l'esprit antérieure à l'abolition des conditions bourgeoises de la vie matérielle, ou estiment-ils qu'un esprit révolutionnaire ne peut se créer que grâce à la révolution accomplie[28]?

Sartre was keen, twenty years on, to scornfully point out about Breton's statement:

> 'Cela suffirait à dénoncer l'intellectuel bourgeois'. And, using the same argument as Naville twenty years before:

> Car il s'agit de savoir quel changement précède l'autre. [...] Pour le militant marxiste il ne fait pas de doute que la transformation sociale peut seule permettre des modifications radicales du sentiment de la pensée.[29]

To be fair to Breton however, one must say that by the time the *Congrès international des écrivains pour la défense de la culture* had taken place, in June 1935 in Paris, his links with the Communist Party had become so problematic that his leaving the Party was inevitable. Breton had grown only too aware of the fact that these two dimensions were, at least for the Communist Party, completely irreconcilable. The relationship between surrealist and political activity was seen by Breton in the 1920s as a means to avoid the divide between art and life, a means to avoid a discrepancy between the world of the mind a priori and the world of facts. If poetry was to 'lead somewhere', it meant that content only possessed value to the extent that it promised to lead 'somewhere', preferably to action. However, the story of his relationship with the Communist Party was one of constant unease[30] and repeated misunderstandings on both parts.[31] The texts that Breton wrote between 1925 and 1935 insist persistently on the fact that he considers the revolution the communists advocate as 'un programme minimum':[32]

> Nous n'avons l'impertinence d'opposer aucun programme au programme communiste. Tel quel, il est le seul qui nous paraisse s'inspirer valablement des circonstances, avoir une fois pour toutes réglé son objet sur la chance totale qu'il a de l'atteindre, présenter dans son développement théorique comme dans son exécution tous les caractères de la fatalité. Au-delà, nous ne trouvons qu'empirisme et rêverie. Et cependant il est en nous des lacunes que tout l'espoir que nous mettons dans le triomphe du communisme ne comble pas.[33]

If in this text, Breton was able to clearly mention the historical context ('il est le seul qui nous paraisse s'inspirer valablement des circonstances'), for him, true

revolution could not be conceived in pure material terms. This remained a constant preoccupation for him, and one that progressively led him to move away from trying to anchor Surrealism firmly in historical circumstances in order to look beyond, in another form of temporality, that of the myth.

Breton and his friends *were*, however much they had tried to disguise it, 'professional' artists; there was therefore no theoretical possibility to dismiss the autonomy of art, their freedom as they saw it depended on its very existence. This was a major difference with the Belgians from the Brussels group since a lot of them had jobs all their lives (Nougé was a biochemist, Scutenaire a civil servant at the Home Office..). Breton's contradictions were inherent to his status as a professional artist: he could only therefore adopt the same stance as other avant-garde movements that had preceded Surrealism (except Dadaism) and confine his activity within the limits of a critique of the bourgeois society he despised. He could criticize this society, but at the same time, he was depending on it. There was no other emancipation than the freedom to write his books, his revolution could only be a *revolution of the mind*.

Rupture inaugurale

Twenty years on from the important two years going from the moment *La Révolution encore et toujours!* was published and the time when, two years later, Breton, Aragon, Eluard and Unik joined the French Communist Party, another series of events produced for the same protagonists a complete reversal of situation rich in consequences for the survival of the surrealist movement in Post Second World War Europe. When Breton came back from his exile in the United States, the surrealist group was reconstituted, excluding a number of surrealists who, during the war, having created in Paris the group *La Main à Plume*[34] had tried to keep Surrealism alive and, towards the end of the war, had become close to the Communist Party. As Noël Arnaud, one of the group's founding members said afterwards:

> It was humanly impossible for us to consider our comrades in the resistance organizations who were members of the Communist Party as enemies.[35]

However Breton, who, as we have said, had left the Communist Party in 1935, had gone into exile during the war (1941–1946), and become hostile to any alliance with the Communist Party, as he suspected a Stalinist influence on people's minds. In June 1947, Breton and his group published a pamphlet entitled *Rupture inaugurale* which marked the definitive rejection of all forms of collaboration with the Communist Party. Breton accused the Communist Party of using the same methods as those of the bourgeoisie:

> Le PC, en adoptant les méthodes et les armes de la bourgeoisie — pour les besoins mal conçus d'un combat qui dès lors se disqualifie pour mener à une conclusion positive — commet une erreur fatale et irrémédiable, une erreur qui non seulement compromet davantage chaque jour les conquêtes partielles du prolétariat et repousse indéfiniment l'heure de sa victoire décisive, mais montre une fois de plus la complicité flagrante du Parti Communiste avec ceux qu'il appelait hier ses ennemis.[36]

Breton was referring to recent developments of French current affairs since the Communists had joined the government in November 1946 hence taking part in the democratic game. In fact, at the time *Rupture inaugurale* was published, in June, the Communists had just been expelled from the Ramadier government (5 May 1947) under the pretext that they had abstained during a vote at the Assembly on the government's social policy. *Rupture inaugurale* was published a few days before the opening of the surrealist international exhibition that was held at the Maeght Gallery in Paris, at the beginning of July. This exhibition confirmed, without any ambiguity for the viewer, that Breton's taste for the hermetic was stronger than ever. The text that opened the catalogue of the exhibition was entitled *Devant le rideau*. In this text, Breton attacked first a journalist who, in the communist daily newspaper *L'Humanité* had said that dreams had become a 'useless luxury'[37] when, according to the founder of Surrealism, socialism itself 'avait pris naissance dans le rêve éveillé' (*OC*, III. 745). The poet's argument was aiming at showing that 'un passé presque immémorial' linked Surrealism to the 'mystère des ténèbres [...] unique conduit par quoi l'homme communique avec l'obscur' quoting Thomas de Quincey. Breton went on establishing a link between the thinkers of the 'pensée poétique d'anticipation sociale', citing Hugo, Nerval and Fourier alongside thinkers of esotericism such as Martinès, Saint-Martin, Fabre d'Olivet, l'Abbé Constant (*OC*, III. 747) concluding: 'Il apparaît probable et l'avenir ne tardera sans doute pas à démontrer que cette conception influence de façon plus ou moins directe les grands poètes de la seconde moitié du 19es (Lautréamont, Rimbaud, Jarry).' In this text, Breton rejected both Sartre, the existentialists[38] and the Brussels group, in particular, Magritte and his 'Surréalisme en plein soleil'. For him, the Belgian painter (and Nougé defending his painting) had made a mistake when he decided 'de ne plus laisser passer dans [ses] œuvres que ce qui était charme, plaisir, soleil, objets de désir', excluding all that could be 'tristesse, ennui, objets menaçants'. Breton's irony sent Magritte's new manner back to an 'art de circonstance' aiming at 'se mettre en règle avec les résolutions du Comité des écrivains de Léningrad (1946) prescrivant l'optimisme à tous crins' (*OC*, III. 744).

For his part, the author of *Arcane 17* was aiming at throwing a bridge between past and future via the creation of a new mythical thought: 'un mythe part [des œuvres qu'il a mentionnées plus haut] qu'il ne dépend que de nous de [...] définir et de coordonner'[39] (*OC*, III. 749). The reason why Breton was particularly ironical with what he called '*l'ancien* [my emphasis] groupe surréaliste de Bruxelles' (*OC*, III. 744), was that some of the most prominent surrealists of the Belgian capital had established renewed links with the Communist Party at the end of the war. Even if the reasons were rather limited in time,[40] this complete reversal was significant of two conceptions of Surrealism that had become completely antagonistic. In October 1946, in the preface of the catalogue of Magritte's exhibition at the Dietrich Gallery (30 November–11 December), Nougé defended the painter's 'Surréalisme en plein soleil', attacking Breton directly:

> Ici l'on peut prévoir une question du lecteur: à quoi bon cette redite d'observations élémentaires? Je ne crois pas inutile pareille répétition si j'envisage l'étrange floraison de cet automne. Sous prétexte d'un retour à l'on

ne sait quelle 'tradition', quelle 'réalité humaine', l'on perçoit soudain un appel aux plus fumeuses doctrines ésotériques pseudo-orientales, aux plus dérisoires pratiques de la magie formelle. Sous prétexte d'on ne sait quelle 'liberté', quelle 'justice' l'on entend des spécialistes de la culture, des chevaliers de l'intelligence, s'en prendre aux seules armes mentales capables de leur assurer une réelle liberté. Les mêmes prétextes inclinent vers les vieux utopistes d'étranges révolutionnaires qui trouvent opportun d'attaquer pour l'instant la stratégie de *cette URSS à qui ils doivent la liberté de délirer à leur guise.*[41]

One can see that it was very difficult at the time, at least for those who had not left the war scene, not to feel indebted to the USSR. Directly referring to Breton's interview with Jean Duché in *Le littéraire* (5 and 12 October 1946) where the French poet denounced any train of thought that might lead to believe that 'la fin justifie les moyens', Nougé, on the contrary deliberately emphasized this notion in the text on Magritte. Evoking 'la méthode "expérimentale"' rather than speaking of Surrealism, the Belgian poet said:

> Et il est bien vrai que l'un des caractères essentiels de cette méthode peut s'exprimer par le vieux principe: la fin justifie les moyens. Ce principe a été, ces temps derniers, battu en brèche. L'on a même pris soin de nous informer qu'il nous vient des jésuites.[42] Mais sa vertu éclate dans toutes les œuvres efficaces. Et l'on veuille bien remarquer que son abandon entraînerait le retour des pires impératifs esthétiques avec, au premier plan, les soucis relevant du style et de la forme.

In fact, Nougé's irony was justified in so far as Breton was taking the debate out of its historical context:

> Ce précepte, j'en suis immédiatement tombé d'accord avec Camus à New York, est en effet celui auquel les derniers intellectuels libres doivent opposer aujourd'hui le refus le plus catégorique et le plus actif. C'est dans ce refus sans réserve que me paraît résider aujourd'hui la véritable affirmation efficace de la liberté. Une campagne ardente, à laquelle je me persuade que les ressources de persuasion afflueraient, doit à tout prix et d'urgence être entreprise pour régler son compte à ce vieux précepte jésuite dont le moindre tort est d'être antidialectique par excellence et dont on a eu la stupeur de voir se réclamer Trotsky lui-même, dans *Leur morale et la nôtre.*[43]

As Marguerite Bonnet remarks, *Leur morale et la nôtre* was written in 1938, at the time of the third 'great' Moscow trials. The accused were Boukharine and Rakovski. Trotsky's pamphlet was an attack against all the intellectuals, writers and politicians who, knowing that the Moscow trials were pure machinations, used them as pretexts to criticize bolchevism, drawing parallels between Stalin and Trotsky. Going back on the principle, attributed to the Jesuits of 'la fin justifie les moyens', Trotsky was saying at the time that the Jesuits were teaching that 'un moyen peut-être indifferent par lui-même, mais que la justification ou la condamnation d'un moyen donné est commandée par la fin'. Thus, according to them, it is the ends that must be judged. However, Trotsky's argument was that 'la morale est fonction de la lutte des classes' and the measures that must be taken against the oppressors must be appreciated according to the historical object of the fight. Lies and violence are condemnable in themselves, but all revolutions create them; it will only be in

a society devoid of any social antagonisms that they could be rejected. Marguerite Bonnet wonders why Breton's argument remains simplistic. It seems to me that Breton's productions during his exile, from his *Ode à Charles Fourier* (written in 1945 but published on his return, in 1947) onwards, indicate that his interest has evolved towards a non-historical time. Surrealism's mythical dimension had been clearly stated by him as soon as 1935, when, in his preface to *Position politique du Surréalisme* he had stated his long term preoccupation ('depuis dix ans'[44]) to 'concilier le Surréalisme comme *mode de création d'un mythe collectif* avec le mouvement beaucoup plus général de libération de l'homme'.[45] He had addressed the question of action, but leaving it open: 'le problème de *l'action*, de l'action immédiate à mener, demeure entier'.[46] Ten years on, with his interest in occultism growing, he was trying to find, in the *Ode à Charles Fourier* and in *Arcane 17* a new compromise between real and imaginary worlds, a utopia.[47] Just as 'utopia' is characterised by its lack of defined spatial and temporal boundaries, Breton was trying to take Surrealism towards a new dimension, in a new quest towards a finality without end. In the same interview Nougé was referring to, Breton clearly insisted on the same idea:

> Je reste acquis au désir de voir se constituer un tel mythe dont les éléments épars existent bel et bien et ne demandent qu'à être rassemblés.[48]

It is obvious that Breton's *Devant le Rideau* is a panegyric of the obscure which he opposes to both Magritte's 'plein soleil' and a fallacious faith (in his view) in 'soviet science' (*OC,* III. 745). Quoting extensively Thomas de Quincey:

> Parmi toutes les facultés qui, chez l'homme, ont à souffrir aujourd'hui de la vie trop intense des instincts sociaux, il n'en est pas une qui souffre davantage que la faculté de rêver. On aurait tort de n'y voir qu'un détail sans importance. La machinerie du rêve plantée dans notre cerveau a sa raison d'être. Cette faculté, qui possède des accointances avec le mystère des ténèbres est comme l'unique conduit par quoi l'homme communique avec l'obscur. (*OC,* III. 745)

He reminds the reader that Surrealism has always been an opening, a window to look upon something to which surrealist ideals lend importance, such as the marvellous. It was Pierre Mabille, who, in a book entitled *Le merveilleux*, expressed the need to go beyond limits imposed by our structure, the need to attain greater beauty and greater pleasure moving away from traditional aesthetic, towards 'le merveilleux' defined as mystery indefinitely reborn. According to Breton therefore, deliberately choosing charm and objects that are *pleasing* destroys the very idea of mystery on which the movement has evolved, since the *Second Manifesto*.

At the time of the publication of *Rupture inaugurale* and *Devant le rideau*, Surrealism, and Breton in particular, were under attack. Sartre, first of all, who had grown during the last years of the war, and since the creation of his influential journal, *Les Temps modernes*, to be an important figure of the literary scene, attacked the surrealists in *Qu'est-ce que la littérature?* Eager to impose his vision of the intellectual as *écrivain engagé*, Sartre dismissed the value of poetry, describing the surrealists as young bourgeois fascinated by 'un absolu situé en dehors de l'histoire, une fiction poétique'. Tristan Tzara, the founder of the Dada movement, later a surrealist, attacked Breton on a personal level in his lecture *Le Surréalisme et l'après-guerre*,[49]

contesting his legitimacy as someone who had been in exile when others decided to stay on and face the harsh realities of the war. In addition to these attacks, the situation was also complicated by the fact that a second generation of young surrealists had emerged from the war, some of them belonging to the group of *La Main à plume* who, as they had emphatically said in the first issue of their review, had decided to stay on:

> Nous nous refuserons toujours à fuir la poésie pour la réalité, mais nous nous refuserons toujours aussi à fuir la réalité pour la poésie. Et c'est pourquoi nous sommes aujourd'hui amenés à répondre à la grande question de Baudelaire: 'Faut-il partir? Rester? Si tu peux rester, reste...'
> — Nous savons qu'on ne peut jamais fuir que dans l'espace, et nous ne sommes pas encore assez vieux pour pouvoir décemment jouer à 'sauve-mouton'.
> — Nous restons.[50]

As we said at the beginning, they had developed links with the Communist Party and for a time, on both sides of the border, it seemed possible to maintain a common activity. However in France, under Laurent Casanova's leadership (he was responsible for the intellectuals) the Party defined in June 1947 the cultural policy it intended to follow: aligned with the Zhdanov doctrine in the USSR, it favoured a 'socialist realism' incompatible with all Surrealism stood for. In Belgium on the contrary, for reasons similar to those described in the 1920s, the cultural line of the Belgian Communist Party was more open, and there was room for manoeuvre. This is the reason why, out of these historical circumstances, the young Belgian poet Christian Dotremont, who had actively participated to the *La Main à plume* group in Paris during the war was able to take some form of leadership in the rebellion against Breton in 1947. He became very active on both sides of the border trying to create a group dynamic that was going to lead first to his joining the Communist Party (Nougé joined at the same time, in September 1947, the others had joined in 1945, apart from Scutenaire and Havrenne, unable to do so for professional reasons) and then, to the creation in 1947 of the 'Surréalisme Révolutionnaire' movement.

At the time of *Rupture inaugurale* and *Devant le rideau*, Dotremont wrote two texts which were a direct response to Breton's position. The first one, a parody, was entitled *En plein rideau*, where, ironically re-writing Breton's text, Dotremont clearly indicated that the French poet's obscure references to esotericism were totally inappropriate at a time when action was needed.

The second one, which acted as a manifesto, was entitled *La cause était entendue* and was published at the time of the opening of the surrealist exhibition of July. From the start, this pamphlet reaffirmed 'l'absolue détermination du Surréalisme par le matérialisme dialectique'. There was no ambiguity there, Dotremont spoke in the name of Surrealism[51] and placed it under the auspices of dialectical materialism. In addition, he was calling for Surrealism to participate 'par les moyens qui lui sont propres ou par les moyens propres à chaque surréaliste, à la lutte du prolétariat pour son affranchissement'. Referring directly to Breton's proposal for the constitution of a new myth, projecting Surrealism out of the historical realm, Dotremont emphatically called for a historical participation, a commitment of Surrealism here

and now. To Breton who defended in his text the rich possibilities of esotericism, he opposed science, asking for an 'investigation de l'irrationnel' conceived as inseparable from the 'connaissance du monde'.

Before the publication of this tract, there had been a number of meetings in Brussels (organised by Dotremont since April) which aimed at defining 'dans quelle perspective, sur quels objets [those who participated in these meetings][52] [envisaged] une expérience surréaliste en Belgique?' and at determining if the participants at these meetings envisaged 'une manifestation du groupe sur le plan extérieur et si oui, dans quelles formes'.[53] After a number of rather animated discussions which provoked a schism between Dotremont and the 'historic' Brussels group (Magritte and Nougé among them), a new movement, the 'Surréalisme révolutionnaire' was created on 17 May 1947.[54] The new group thus constituted had a manifesto, written by Dotremont and Seeger (member of the Belgian Communist Party) entitled *Pas de quartiers dans la révolution!* (adopted on 7 June 1947) and whose title was a reference to the 1925 tract *La Révolution encore et toujours!* If Dotremont was clearly targeting Breton in his criticism, he was also critical of Magritte's 'Surréalisme en plein soleil'.[55]

If it was a Belgian initiative, the group itself was certainly not exclusively composed of Belgian surrealists; there were French members, and members from other countries (Czechoslovakia, Denmark).[56] The underlying references to all these texts were Breton's texts, old and new.[57] But the manifesto of the 'Surréalisme révolutionnaire' urged the avant-garde to play its role in the political realm without ambiguity. However, the pamphlet sent Surrealism back to the heart of its own contradictions, articulating its argumentation around two stages: first/then ('d'abord'/'ensuite'). First of all poetry was to render its means available to all, and then was supposed to 'aider à l'unification des valeurs motrices, poétiques [...] par la totale résolution du désir et de la nécessité'. How was this resolution going to happen? Could one really believe in 1947 that poetry had such a power to change the world? This was another utopia, born out of the desire, for the second generation of surrealists (Noël Arnaud, in France, had the same demands) to change the world. As we have seen before, Sartre, writing in 1947, had this fundamental flaw in mind in his *Situation de l'écrivain en 1947*.[58] The very possibility for poetry to participate in social change was all the more limited than, at the time of the Zhdanov doctrine, the communist party was only interested in literature for propaganda purposes. This movement was thus bound to find an elusive efficiency in terms of action which was demonstrated by its short life: officially, it lasted around 2 years, but it was in fact over by 1948. In front of the Communist Party of the time, not matter what the revolutionary surrealists tried to say about their supposed 'grande efficacité dans le domaine de la sensibilité, de la psychologie, de la connaissance', their contribution to revolutionary action was in fact extremely limited.

'Mort à jamais? Qui peut le dire?' Subversion and Revolution

It was not completely over though. After the failure of the 'Surréalisme révolutionnaire', Dotremont embarked on another avant-garde adventure with the

international movement *Cobra*, born out of it and still based on the determination to link experimental art and political action.

If I mention *Cobra* at this stage, it is first because it represented an unprecedented attempt, undertaken by a Belgian,[59] Christian Dotremont, to move the heart of experimental art away from Paris, not exactly to Brussels, but to three Northern capitals: Copenhagen, Brussels and Amsterdam linked with a 'lien *souple*'.[60] What's interesting here is that it was not, like in Antoine Wiertz's famous claim 'Paris Province' and 'Bruxelles capitale' an identity claim, reflection of a time when the young nation was looking for its own cultural legitimacy at home; rather, going beyond this duality between centre and periphery, Dotremont wanted to explore, in Post-War Europe, the possibility of a *diasporic* identity through art. In his brief manifesto, jotted on a piece of paper in a Parisian café, Dotremont called for 'artistes de n'importe quel pays' to unite in order to work together. 'Travailler ensemble' was the simplified aim of this new movement that has been called, rightly in my view, the last avant-garde of the 20th century.

It certainly was the last avant-garde if by *avant-garde* is understood what Surrealism contributed in no small measure to associate with it, that is to say a movement intent on linking art and politics, art and 'revolution' as defined by Marx. However, in the context of the Cold War, and with the tensions emerging from the Korean war, Dotremont soon realized that it was impossible to go on pursuing the sort of experimental art he favoured with the demands of the Communist Party. In France, the Marxist attraction had fortified the Hegelian roots of Surrealism with its demanding dialectics and participated in the maturating and enriching of the movement. In the end though, as Sartre clearly understood, it was the links between history and poetry that were at stake. Is poetry a medium fit for History? In Belgium, Nougé came up with an original solution, abandoning 'revolution' for 'subversion', and in the end, moving away from 'Surrealism' altogether. In France, Breton moved away from real engagement with history, hoping to establish Surrealism as a *myth*, operating in a kind of time capsule encompassing the past, projecting into an unforeseen future, but leaving out the 'here and now'. In both cases, Cobra or Surrealism, it is interesting to notice that abandoning the ambition of making poetry an efficient tool in the sphere of action, coincided with the effective end of the movements. It was, at the heart of Cold War Europe, the end of the hope for poetry to change the world, or to participate in the general sphere of action. In the end, the poet was sent back to the autonomous sphere created by his own medium; in the end, 'the' revolution for the poet, could only be a revolution of words, a 'revolution of the mind'.

Notes to Chapter 14

1. John Herbert Matthews, *Toward the Poetics of Surrealism* (Syracuse: Syracuse University Press, 1976), note 7, p. 103.
2. All the recipients of these five letters belonged to the surrealist group in Brussels; a significant detail since Belgium, although a small country, had the particularity of hosting two surrealist groups: one based in Brussels, the capital, and one based in Mons, in the province of Hainaut. The latter was founded in 1938 by Fernand Dumont, and looked to Surrealism in France far

more than did the surrealists in the Belgian capital. Speaking of Achille Chavée, of the Mons group, Marcel Mariën, in *L'activité surréaliste en Belgique* (Bruxelles: Lebeer-Hossmann, 1979) said: 'Et Chavée n'existait que par Breton', p. 11.

3. I propose in this chapter to concentrate solely on the relationship between the Paris and Brussels groups. The 'Surréalisme en Hainaut', created in 1939 by the members of the group *Rupture* (gathered around Achille Chavée in the little industrial town of La Louvière) has different characteristics to that of the Belgian capital. The leaders were younger (Achille Chavée and Fernand Dumont were both born in 1906), and the socio-political configuration of the region was very different. As Paul Aron says (in *Les Surréalistes belges*, EUROPE, 912, April 2005, p. 46): 'Le Hainaut est en Belgique la seule région où, dans l'entre-deux-guerres, le Parti communiste est bien implanté. C'est aussi un univers où le P.O.B [Parti Ouvrier Belge] est quasiment hégémonique.[...] Dans les années trente, le P.O.B apparaît comme une institution quelque peu encroûtée, pesante.' Their group was concerned with avant-garde innovations as well as a strong desire to get involved politically in a social change. The relationship with Paris, as Chavée's letters to Breton show, is more in line with the French surrealist leader's ideas of the time (including on the question of automatic writing). Paul Aron goes as far as speaking of 'inféodation' [infeudation] of this movement towards Paris.

4. According to Marcel Mariën in his interview with Christian Bussy, *Anthologie du Surréalisme en Belgique* (Paris: Gallimard, 1972), p. 25.

5. Marcel Mariën, *L'activité surréaliste en Belgique 1924–1950* (Brussels: Lebeer Hossmann, 1979), p. 91.

6. The journal collaborated with the Surrealists but soon repudiated them in favour of closer ties with the French Communist Party.

7. Maurice Nadeau, *The History of Surrealism* (London: Jonathan Cape, 2000), p. 117.

8. The tract was then reproduced in *Philosophies*, in *La Révolution Surréaliste*, 5, (15 Octobre 1925) and in *Clarté*, 77, (15 Octobre 1925).

9. Marcel Mariën, op. cit., p. 92.

10. Ibid.

11. Pierre Naville, *La Révolution et les intellectuels* (Paris: Gallimard, 1975).

12. 'Les scandales moraux suscités par les surréalistes ne supposent par forcément un bouleversement des valeurs intellectuelles et sociales; la bourgeoisie ne les craint pas. Elle les absorbe facilement. Même les violentes attaques des surréalistes contre le patriotisme ont pris l'allure d'un scandale moral. Ces sortes de scandales n'empêchent pas de conserver la tête de la hiérarchie intellectuelle dans une république bourgeoise'. Op. cit., p. 88.

13. As Paul Aron says, in his interview with Pierre Vilar and Jean-Baptiste Para, *Originalités du surréalisme belge* in *Les Surréalistes belges,* EUROPE, op. cit., p. 40.

14. Pierre Naville, op. cit., p. 86–87.

15. This is Maurice Nadeau's expression in his *History of Surrealism* (London: Jonathan Cape, 1968).

16. Paul Aron, op. cit., p. 44.

17. Ibid.

18. Ibid.

19. Letter quoted in Maurice Nadeau, *Histoire du Surréalisme* (Paris: Le Seuil, 1964), p. 105.

20. Magritte and Scutenaire both joined in 1927.

21. Maurice Nadeau, op. cit., p. 135

22. Ibid.

23. In his foreword to Peter Bürger's *Theory of the Avant-Garde* (Minneapolis: Manchester University Press, 1984), p. IX.

24. For these very reasons, Schulte-Sasse notes that a critical consciousness provoked by the degeneration of language as it was used in the market place 'must have already existed in the late eighteenth century' (p. VIII) since the tensions created by the bourgeois capitalist society did not start with the second half of the nineteenth century..

25. *Theory of the Avant-garde,* op. cit., p. XI.

26. In *Les Pas Perdus*, André Breton *Œuvres Complètes* (Paris: Gallimard, 1988), Vol.I, p. 233.

27. André Breton, *Œuvres Complètes,* op. cit., Vol. II, p. 459.

28. Pierre Naville, op. cit., p. 85.

29. Jean-Paul Sartre, 'Situation de l'écrivain en 1947' in *Qu'est-ce que la littérature?* (Paris: Gallimard, [1948] 1987), p. 188.

30. And of many break ups, Aragon and Eluard were the most spectacular ones.

31. Breton's relationship with the *Association des écrivains et artistes révolutionnaires* (A.E.A.R) is, in that respect, enlightening.

32. André Breton, *Légitime défense* in *Œuvres Complètes*, op. cit., Vol. II, p. 283.

33. Ibid.

34. Which, in the true surrealist tradition had welcome artists from a number of countries, including the Belgians Raoul Ubac and the young Christian Dotremont.

35. Jean-Clarence Lambert, *Cobra* (London: Sotheby Publications, 1983), p. 19.

36. Ibid. p. 20

37. André Breton, *Œuvres Complètes*, op. cit., Vol. III, p. 745.

38. In Belgium as well, Louis Scutenaire had written a small piece for the surrealist exhibition held at the Galerie des Editions La Boétie in Brussels (15 December 1945–15 January 1946) saying: 'L'existentialisme se traîne péniblement vers la rivière connaissance que le surréalisme a franchie d'un bond il y a plus de 20 ans après que Dada l'eut mise à sec.' (see Marcel Marïen, op. cit., p. 363)

39. In *Prolégomènes à un troisième manifeste du surréalisme ou non*, written in 1942, the last sentence expressed the same idea.

40. In an interview with Luc Barthels, Georgette Magritte answered (*De Vlaamse Gids*, Mars 1974, p. 24, quoted by André Blavier in *René Magritte, écrits complets* (Paris: Flammarion, 1979), p. 239: '— Son adhésion au Parti Communiste a-t-elle à voir avec ses lectures philosophiques? — Oh non, c'était après la guerre, alors qu'il existait une mentalité commune de reconnaissance envers les Russes. Quelques-uns de ses amis furent également membres, mais après peu de temps cela ne l'intéressa plus.'

41. Text mentioned in Marcel Marïen, op. cit., p. 395–96.

42. André Breton, in *Entretiens, Œuvres complètes,* op. cit., Vol. III, p. 596.

43. Ibid.

44. André Breton, *Œuvres Complètes*, op. cit., Vol. II, p. 414.

45. Ibid.

46. Ibid. p. 415.

47. He sees in Fourier 'le grand poète de la vie harmonienne'. André Breton, *Œuvres complètes,* op. cit., Vol. III, p. 1246.

48. Interview with Jean Duché, op. cit., p. 599.

49. Conference pronounced at the Sorbonne on 11th April 1947.

50. *Etat de présence* was the manifesto of the *Main à Plume* group; written by Jean-François Chabrun, it was published in the fist issue of the group's journal *Géographie nocturne* on 9th September 1941. See Michel Fauré, *Histoire du Surréalisme sous l'occupation* (Paris: La Table Ronde, 1982), p. 73.

51. It must be noted, however, that neither Nougé nor Magritte agreed with him. They were highly suspicious of his intent.

52. They were: Christian Dotremont, René Magritte, Arents, Marcel Broodhaerts, Paul Bourgoignie, Denis, Jean Seeger. Not all surrealists, and Nougé was absent.

53. Francoise Lalande, *Christian Dotremont: l'inventeur de Cobra* (Paris: Stock, 1998), p. 92

54. At 8pm, in the back room of a Brussels café, *La Diligence*.

55. This is partly due to the fact that he had momentarily been expelled from the group because of his relationship with Cocteau, a rather controversial figure for the surrealists, and even more so after the war.

56. They were soon to form the backbone of the *Cobra* movement.

57. It is reminiscent of the letter sent in 1929 by Breton to 73 potential 'allies' of the surrealist movement (among them, the Belgians Goemans, Nougé, Mesens, Magritte) asking them to pronounce themselves on collective action. This is when Nougé famously replied 'J'aimerais assez que ceux d'entre nous dont le nom commence à marquer un peu *l'effacent*'. Cf André Breton, *Alentours III* in *Œuvres Complètes*, op. cit., Vol.I, p. 966.

58. Jean-Paul Sartre, op. cit., p. 188.

59. The other Belgian was the poet Joseph Noiret; the others were painters: three from Holland Constant, Corneille and Appel, one from Denmark, Jorn.

60. *La cause était entendue*, manifesto of the creation of the Cobra movement thus entitled because it refered ironically to *La cause est entendue*, the founding tract of the French section of 'Le Surréalisme révolutionnaire' whose excessive theorization they were trying to move away from.

CHAPTER 15

The Splendours of Hatred:
Louis Scutenaire between
Surrealism and Situationism

Andrew Hussey

In his long and mainly anonymous literary career, the Belgian poet and art critic Louis Scutenaire was distinguished by his fidelity to negative principles of subversion in both art and politics. These were principles which he had defined early on in his career, as far back as the 1920s, when he first encountered Surrealism and Surrealists in Brussels and Paris, and to which he remained firmly wedded in all circumstances until his death in 1987. 'Je ne suis ni poète, ni surréaliste, ni belge' was a formula which Scutenaire often invoked when asked by hapless editors of anthologies to contribute to various collections of poetry which might be gathered together under any one of theses rubrics. Scutenaire was, of course, all three of these identities, although not necessarily at the same time or in a manner which permits the cultural historian or literary critic easy classification.[1]

The difficulties of writing on Scutenaire are compounded by the fact that despite his high prestige during his lifetime — he was an intimate of Magritte and highly regarded by René Char amongst others — Scutenaire's critical legacy is slight. He is noted as a key contributor to the Belgian variant of Surrealism in Christian Bussy's classic *Anthologie du surréalisme en Belgique* but there is no real analysis of his work in this volume.[2] In the same way, Scutenaire is cited frequently in histories of Surrealism and its offshoot movements but the only real critical writing on his work is limited to a handful of short articles in journals and histories or catalogues of his era.[3]

The focus of this chapter is on Scutenaire's contributions to *Les Lèvres nues*, a para-Surrealist journal founded by Belgian *avant-gardistes* who had broken away from the influence of the Parisian Surrealists in the post-war period. *Les Lèvres nues* was founded in 1954 by Marcel Mariën, Paul Nougé and Scutenaire. The aim was to set up a journal which would continue the pre-war revolutionary tradition of Surrealism as a social movement as well as a creative method — the rationale, interestingly, was that the Parisians had become too interested in Occultism rather than politics. The ultimate aim was to provide a direct link back to the early days and hopes of Breton's *Premier manifeste*, *La Révolution surrréaliste* and *Le Surréalisme au service de la revolution*.[4]

The reason for focussing on Scutenaire's contribution to *Les Lèvres nues* is that this journal was not only read in the 1950s Paris by Gil Wolman and Guy Debord but that it was also to provide a platform for their earliest experiments and ideas. During the period when Wolman and Debord read and contributed to *Les Lèvres nues* they described themselves, under the influence of Isidore Isou, as *Lettristes*, and then, having broken violently away from Isou, established themselves as International Letterists in the journal *Potlatch* before becoming International Situationists. In other words it was during this crucial period, running roughly from 1951 to 1957, that Wolman and Debord made the journey from Lettrism to Situationism. This journey has already been fairly well documented in most of the critical or biographical texts which are mainly concerned with Letterism or Situationism.

What has been specifically overlooked in histories of the period, and which this article seeks to rectify, is the link between Surrealism in its Belgian form as represented in *Les Lèvres nues*, and Parisian 'Situationism'.[5] There were, to be sure, other influences on the core Situationists at this time, including the work of Ralph Rumney and Enrico Baj and the Italian school of 'pre-Situationists' such as Piero Simondo. But the Belgian influence was both the closest to home and the most strident. More specifically, 'Situationism', I will propose, was partly shaped in dialogue and reaction with the poetic techniques of Louis Scutenaire. In this sense, I want to suggest, Scutenaire provides a bridge from the pre-War avant-garde to the burgeoning ideologues of the post-War avant-garde.

Notwithstanding, in his iconoclastic fury, Scutenaire defiantly opposes all attempts at organisation or codification. That fundamental contradiction, or series of contradictions, is in a sense our real starting-point: in other words, how do we begin to attribute a fixed status to Scutenaire as a poet, a thinker, a figure? How then should we read Scutenaire?

Indeed, should we read him at all?

With the exception of the work contained in *Inscriptions*, Scutenaire published nearly all of his poems in journals or anthologies. This was not only a fairly commonplace practice amongst *avant-gardistes* of his generation but also part of a wider strategy which aimed at a deliberately fragmented *oeuvre* shaped by the inconsistencies of disgust, desire or any other mood, as much as by any overriding pursuit of recognition. This rather banal explanation of his *modus operandi* is the first and most practical reason why it is so difficult to classify Scutenaire, or even to think of him as a 'poet'.

Nonetheless, by the time of his death, he had produced a substantial body of work — six collection of poems and so-called 'fragments' which have been assembled in over a dozen works — which, when considered as a totality, is distinguished by recurring themes, patterns and techniques. Scutenaire had begun his writing career in 1926; he sent a selection of early poems to Paul Nougé, who was then active in Surrealist circles in both Brussels and Paris. Through Nougé was introduced to Camille Goemans, René Magritte, E. L. T. Mesens and others who went on to form the nucleus of Belgian Surrealist activity.

One of the most commonly held misperceptions around this group is that Belgian Surrealism was exceptional in that it was indifferent to Dada (this is the famous

argument made by Christian Bussy in his *Anthologie du Surréalisme en Belgique*). This was, however, certainly not the case with Scutenaire who, even at this early stage in his career, was working on aphoristic shards of poetry which owed a great deal to the lightning-strike black wit of the Dadaists. Another influence here was the work of the Spaniard Ramón Gomez de la Serna, whose *Greguerías* — short, sharp and extremely poetic aphorisms of Jarry-esque absurdity — had been translated and brought into France by Valéry Larbaud in the early 1920s.[6] Scutenaire was then a frequent visitor to Paris and, in the circle of Breton, René Char, Paul Eluard, Duchamp, he quickly became acquainted with the poetic theories of inversion and subversion as expounded in Lautréamont and other proto-Surrealist heroes.

In 1940, in the wake of the German advance, Scutenaire and his wife left Brussels for Paris, with the aim of reaching Bordeaux. During the brief period of exile from Belgium which was to follow, Scutenaire found himself once again in the company of Magritte and made the fresh acquaintance of Jean Paulhan and André Gide. Scuentaire returned to Brussels in 1941, where he remained for the rest of his career.

Scutenaire's most prolific period began in the 1950s, with his collaboration with the journals *La Carte d'après nature* (founded in Brussels by Magritte), *Les Temps mêlés*, *Rhétorique*, *Le Vocatif* and *Phantomas*, as well as *Les Lèvres nues*. All of these journals were distinguished by an iconoclastic energy and, had in common with many of the resurgent post-war Surrealist groups outside of France, an almost desperate urge to return to the chiliastic severity of pre-war Parisian Surrealism.[7]

Scutenaire's own poetry was designed from the outset to be as barbed and direct as possible, distinguishing itself amongst other Surrealist poems of the early period of the 1920s by the direct and visible nature of the anger and hatred which fuelled it. Above all, Scutenaire conceived of his writing as a form of assault on the stable organisation of everyday life. As he wrote, 'j'écris pour des raisons qui poussent les autres à dévaliser un bureau de poste, abattre le gendarme ou son maître, détruire un ordre social. Parce que me gêne quelque chose: un dégoût ou un désir.'[8] To this extent, Scutenaire was not strictly speaking 'Surrealist' — that is to say an adventurer in the uncharted realms of the unconscious — but rather a precise and articulate craftsman in language whose striking images were all the more arresting, or even shocking, because of their clear relation to everyday reality. In this approach he clearly mirrored Magritte, his friend and contemporary, who stood apart somewhat from the orthodoxies of Parisian Surrealism in his pursuit of an *onirique* realism grounded in painterly technique as much as the 'vision' so prized by the Parisians.

Les Lèvres nues was founded in precisely this spirit. The first number of April 1954 contained texts from Brecht — then a pariah amongst the Parisian Surrealists for his espousal of a variety of Stalinism — and, most notably, Lenin, whose standing was then also low in Parisian Surrealist circles. Most significantly, Lenin's text , quoting from Hegel, laid out not the abstract principles of revolutionary art but advocated its direct application in the most concrete manner. '[...] la logique dialectique nous enseigne qu'il n y a pas de vérité abstraite, que la vérite est toujours concrète'.[9] This was a deliberate insult and provocation to the Parisian Surrealists who, under the

guiding hand of Breton were then retreating, as the Belgians saw it, into occultism and mysticism.

Scutenaire made his first contribution to *Les Lèvres nues* in the second issue. This took the form of a series of apparently unconnected aphorisms of varying length, under the rubric of 'Un serpent coupé en deux qui se mord la queue', and all characterised by a mordant and uncompromising wit. Most importantly, each of the aphorisms is one way or another predicated upon a negative principle which is either made immediately explicit or not too deeply encoded in text. These are a few examples:

> L'ésoterisme est l'héroïne des intellectuels.
> Vous dormez pour un patron.
> Le réel n'a pas de contraire.
> 'Vous aimez mieux mon trou que ma fente, vous!', disait, dans le métro, une dame à un monsieur.
> 'Vous êtes une impératrice, une impératrice qui aurait des accointances avec les dieux', disait un autre monsieur à une autre dame, dans l'autobus.
> Je crois qu'il ne faut jamais employer le jargon de ses ennemis. Par exemple, sous l'occupation l'allemande, il convenait de dire la gendarmerie de campagne, l'arme du ciel, l'armée allemande, la police, pour ne point, comme on le faisait couramment, user des vocables de l'adversaire dans sa langue. Il faut à tout prix se différencier, éviter le point de contact, l'éviter jusqu'à l'absurde, jusqu'à l'enfantillage.[10]

What brings these apparently disparate, even random fragments together is an acute sense of the absurd, here distilled into the dead-ends or non-sequiturs which most often account for the comic effect, and the controlled play of oppositions which give shape and form to the texts.

It is this second technique, an unashamedly Hegelian play of dialectical images, which forms the overall motif of the complete text, revealing both Scutenaire's politics and his philosophy to be inextricably linked. The affiliation with Hegel is indicated in the opening gambit of the text: 'Hegel, palais de lumière et de miroir, sans fenêtre et sans porte.'[11]

Most importantly, the 'palace of light and mirrors' is not simply an emblem or poetic image but something which allows Scutenaire to undermine the very images he creates. More to the point, rather than, as the Surrealists did, citing the Hegelian dialectic on poetry and language as a pathway towards greater lucidity, Scutenaire is attracted by the specifically opaque aspects of Hegel's reflections on poetry and language.

The Surrealists' Hegel, as has been well documented, was essentially political had its ancestor in Marx's reading of the dialectic; as Georges Bataille pointed out, this was the case even when the Surrealists applied the dialectic to the 'mystical' models of alchemy and or pre-Socratic philosophy. For Scutenaire, however, what was most interesting about Hegel was his analysis of the different categories of language which preceded philosophical speculation and which was, in this sense, at the origins of all poetic feeling. This description was indeed codified into a theory in one of his later contributions to *Les Lèvres nues*:

> Je suis révolutionnaire bien plus contre le monde inacceptable qui me tient que
> pour le monde souhaitable qui va le remplacer. Je ne sens et ne pense pas que
> l'on puisse avec quelque sérieux, être révolutionnaire d'une autre façon. Car le
> monde inacceptable nous le connaissons autant qu'il est possible de connaître,
> à chaque seconde l'éprouvant par tous nos moyens de perception et l'ayant fait,
> nous aussi, quelque peu, ce monde. L'autre, nous pouvons seulement nous le
> figurer, puisqu'il est à faire, qu'il est prévision presque pure et qu'il se passera
> de l'exemple et qu'il niera les précédents en de larges mesures.
>
> Etant comme je suis, l'étant avec raison, je ne veux pas comprendre qu'aussi
> longtemps que le monde révoltant n'est pas jeté bas, un homme qui était
> révolutionnaire cesse de l'être, sauf pour des motifs vénaux ou de faiblesse.[12]

The 'revolutionary' statement of intent finds its fullest expression in Scutenaire's third and final contribution, which is again a series of aphorisms, this time accompanied by three poems and Jane Graverol's sketch called 'Les Splendeurs de la haine'. There is no significant development of Scutenaire's thought in this collection, which covers the by now familiar themes of revolt, disgust for work, the supreme pleasures of idleness and sensuality, hatred of religion, especially Catholicism, the intelligence of Sade and Rimbaud and the irrelevance of death. Above all, Scutenaire celebrates the 'beauty of the negative' as a sole and absolute value in poetry and life. This is here reduced to the simple and effective formula, 'Mais démolissez d'abord! Démolissez d'abord![13]

The theoretical core of Scutenaire's poetry, as this brief account demonstrates, is centred on a conception of poetry as the deliberate abuse of words and meaning and therefore an active living paradox. As such, the relation between the writer and the reader is not one of complicity but rather of confrontation. The reader of Scutenaire is often amused, entertained, or puzzled or even irritated and insulted; but always the relationship is one of perpetual attack on the part of the author, and a variety of destabilised moods on the part of the reader.

These literary tactics, more notably, are the consequence of an overarching ideological strategy, or series of strategies, which are more closely linked to politics — the real politics of class struggle and violent revolution — than any metaphysical sophistry around the textual games which have come to pass as 'the poetry of the negative' in recent years.

The model for this activity was, rather unsurprisingly, Mallarmé. Like the Situationists, Scutenaire prized Mallarmé for his capacity to draw language into the vortex; to write anti-poetry. Most importantly, Scutenaire valued the Mallarméan propensity to conceive of poetry as a kind of terrorist act which annihilated all meaning in favour of experience.[14] This version of Mallarmé was precisely what inspired the Letterists and the Situationist to read him and explains Guy Debord's otherwise puzzling reference in *Panégyrique* to 'modern poetry' as the source of the modern revolutionary spirit. This indeed is how Debord describes the origins of the Situationist International:

> Après tout, c'était la poésie moderne, depuis cent ans, qui nous avait menés là.
> Nous étions quelques-uns à penser qu'il fallait exécuter son programme dans la
> réalité; et en tout cas ne rien faire d'autre. On s'est parfois étonné, à vrai dire
> depuis une date extrêmement récente, en découvrant l'atmosphère de haine

et de malédiction qui m'a constamment environné et, autant que possible, dissimulé. Certains pensent que c'est à cause de la grave responsabilité que l'on ma souvent attribué dans les origines, ou même dans le commandement, de la révolte de mai 1968. Je crois plutôt que ce qui, chez moi, a déplu d'une manière très durable, c'est ce que j'ai fait en 1952. Une reine de France en colère rappelait un jour au plus séditieux de ses sujets: 'Il y a de la révolte à s'imaginer que l'on puisse révolter'.[15]

Debord goes on further in the same volume to quote from Scutenaire directly. In a passage in which he simultaneously denounces the language of the 'spectacular society' against which the Situationists waged such a ferocious war, and identifies himself with the stateless, nomadic community of Gypsies, Debord writes:

Les Gitans jugent avec raison que l'on n'a jamais à dire la vérité ailleurs que dans sa langue; dans celle de l'ennemi, le mensonge doit régner. [16]

This statement, it has been argued elsewhere, although it was published late on in Debord's career, is one of the key guiding principles of Situationist tactics and strategy — and, in particular one which explains the deliberately obscure and mysterious rationale for a variety of Situationist activities, from the Situationist-inspired 'scandale de Strasbourg' in 1966 to the auto-dissolution of the group in 1972. It is also, however, a direct echo of a maxim first formulated by Scutenaire in *Les Lèvres nues* in 1954:

Je crois qu'il faut ne jamais employer le jargon de ses ennemis. Par exemple, sous l'occupation allemande, il convenait de dire la gendarmerie, l'arme du ciel, l'armée allemande, la police, pour ne point, comme on le faisait couramment, user des vocables de l'adversaire dans sa langue. Il faut à tout prix se différencier, éviter le point de contact, l'éviter jusqu'à l'absurde, jusqu'à l'enfantillage.[17]

It would be a false conclusion to state simply that Scutenaire's themes and techniques had anything more than an indirect influence on the members of the Letterist International who read and contributed to *Les Lèvres nues* (by the time of issue 12 in 1958, these included Michèle Bernstein, Mohamed Dahou and Enrico Baj). It would be similarly false to argue for a non-existent continuity between Surrealism and Situationism in terms that elide the evident discord between the two modes of expression.

At the same time, it is a simple fact that much of Scutenaire's vocabulary and style, with origins in the thinking and method of Surrealism, finds it echo in the texts produced by the Situationists in *Potlatch* — the journal which they developed during this period — and the texts which the Situationists published in *Les Lèvres nues*. Above all, the Situationists were preoccupied during these formative years with developing what they termed 'literary communism' — a form of discourse which contained revolutionary potential in its power to both subvert and ruin all other forms of discourse. Examples of this activity included the famous cover for the semi-autobiographical collage *Mémoires* by Debord, which was bound in sandpaper so as to destroy any other books which were placed alongside it in a bookcase, pointless 'dérives' across Paris in search of 'Paris without Spectacle', Wolman's film *L'Anticoncept*, or the graffito 'Ne Travaillez Jamais' which was scrawled by Debord on a wall of the rue de Seine in 1953, and which was meant to signal the

demarcation line between the Right Bank as a capitalist work-camp and the Left Bank as a utopian playground.[18]

There is, however, no indication in any of the writings upon his work that Scutenaire might have contributed to any avant-garde movement beyond his early flirtation with Surrealism. The one real exception to this is a brief but illuminating book-length study, by the Belgian ex-situationist Raoul Vaneigem, in the 1991 series of *Poètes d'aujourd'hui* in Seghers. In this work Vaneigem makes the interesting and intriguing claim that although Scutenaire belonged to the Surrealist generation, and was indeed a participant in its history, he was in many ways a dissident Surrealist whose writing was constantly predicated against Surrealist orthodoxy, whether it came from Brussels or Paris. Vaneigem is sympathetic to Scutenaire as a fellow Belgian and, despite Scutenaire's protestations, clearly identifies him as such. This identity is, however, not an ethnic nationalism but rather a sensibility which is forged in a Francophone environment which lies at the margins of French-speaking culture.

Vaneigem's other, largely un-stated interest in Scutenaire is that Vaneigem was himself briefly a member of the Situationist International in the period 1966 to 1969, and was indeed the author of one of the group's best known and most influential texts, *Le Traité de Savoir-Vivre à l'usage des jeunes generations*. It has even been argued that Vaneigem was the only true rival to the Situationists' key theoretician and leader Guy Debord, whose central work of theory, *La société du spectacle*, was published at the same time as Vaneigem's book in 1967. Most intriguing of all is the fact that Vaneigem describes Scutenaire as a poet and sets out to analyse him as such.[19] Scutenaire himself was uncomfortable with this notion and, for this reason, few critics been able to read him as a 'poet' without guarding against the ambiguities of this word.

The singular importance of Scutenaire's writings is, however, not only that they found an echo in Situationist critical theory, but also that they function as emblematic modes of thinking; in other words, Scutenaire, as poet and strategist, thus becomes, alongside Lautréamont, Arthur Cravan, Jorge Manrique and others, a figure whose work makes a direct contribution to Situationist activity —whether in the form of riots, 'psychogeographical *dérives*' or indeed, poetry.

The 'poetic' activities of the Lettrists, as described above, were not merely random pranks; they were assigned a greater historical meaning. This much was formulated in 1954, in one of the earliest editions of *Potlatch* in an article signed by all the then members of the Lettrist International but most probably composed by Debord. This article traced the Lettrist International's itinerary from the experimental poetry phase led by Isidore Isou in the late 1950s to the wider ambitions of the proto-Situationist group led by Debord in the mid-1940s. Most importantly, the article laid out a programme for all future activity of the group as a consistently negative series of manoeuvres which aimed at disturbing the present realities in the name of a future society; for the Lettrists this had a clear and obvious historical significance:

> Nous avons toujours avoué qu'une certaine pratique de l'architecture, par exemple, ou de l'agitation sociale, ne représentait pour nous que des moyens d'approche d'une forme à construire. Seule, une hostilité de mauvaise foi

conduit une part de l'opinion à nous confondre avec une phase de l'expression poétique — ou de sa négation — qui nous importe aussi peu, et autant, que toute autre forme historique qu'a pu prendre l'écriture.[20]

These two movements, Lettrism/Situationism and Surrealism, are usually seen as mutually antagonistic (this claim is usually made by adherents to Surrealism or Situationism). But the fact of the matter is that during the period when *Les Lèvres nues* was at its height, the various Paris-based avant-gardes were not only in a state of flux but also in a permanent state of disagreement with each other. This meant that at the very least they were also in perpetual dialogue and debate with each other. The proof of this is that the vocabulary used by the Belgian Surrealists in *Les Lèvres nues* is, at certain moments, entirely interchangeable with the Parisian Situationists; the parallel use of terms such as 'étrange spectacle' (here derived from its usage in Lautréamont)[21] and a whole system of references, from Rimbaud to the Marquis de Sade, and the use in visual terms of the Situationist technique of 'détournement', indicate not only a commonality of tone but also of purpose.

More crucially, Scutenaire isolated non-meaning or the reversal of meaning in the logic of contradiction as the source and origin of true conceptual thinking in language; poetry, to this extent, both reflects and distorts thought as a necessary critique of its existence beyond any system of rational thought. Poetry is also in this way truly revolutionary, as the distillation of purely negative forces into a dialectical weapon. This is why and how, although Scutenaire frequently disdained the term 'poet' or 'Surrealist', or worse still 'Surrealist poet', he did not shy away from describing himself as a revolutionary: most significantly, the term 'revolution' and 'revolutionary' is defined in an entirely negative sense — in other words as a position of ironic detachment and constant critique.

It follows from this that Scutenaire, as proponent and theoretician of the purely negative value of poetry, is thus one of the 'missing links', as it were, between Surrealism and Situationism. Most importantly, however, the dialogue between Wolman, Debord and Scutenaire reveals Scutenaire less as an ancestor of Situationism — there are many of those already — but in fact, in a typically occluded fashion, as an active participant in the development of the Situationist critique. And he does so just as the Situationist adventure begins, most dazzlingly, in its earliest, most protean form.

Notes to Chapter 15

1. Most of Scutenaire 's important maxims, including this one, are gathered in Louis Scutenaire, *Mes Inscriptions* (Paris, Gallimard, 1945), republished in *Mes Inscriptions* (Paris: Allia, 1982).
2. Christian Bussy, *Anthologie du Surréalisme en Belgique* (Paris: Gallimard, 1972), p.172–73.
3. For an overview of current critical perspectives on Belgian Surrealism see Pierre Vilar, 'Introduction' to *Europe*, 'Les Surréalistes belges', no. 912, April 2005.
4. For an account of this formation of the group around *Les Lèvres nues*, see Andrew Hussey, *The Game of War* (London, Cape, 2001), p.90. The influence of the Belgian surrealists on the Situationists is most strikingly absent in Vincent Kaufman's otherwise quite comprehensive (if long-winded) *Guy Debord, La Révolution au service de la poésie* (Paris: Fayard, 2001).
5. The term 'Situationism' was of course never used by Situationists who, in the wake of the

foundation of the *Internationale Situationniste* in 1957, argued that there could never be a codified philosophy of Situationist activity but only Situationists who performed such activities. See, for example, *Internationale Situationniste*, 1, 1957, p. 57.

6. See *Ramón y las vanguardias* (Madrid: Esapas-Calpe, 1978), also Victor García de la Concha, 'Ramón y la vanguardia' in Francisco Rico (ed.) *Historia y crítica de la literature española*, vol III (Barcelona: Crítica, 1984).

7. For an interesting account of this period see Jules-François Dupuis (the pseudonym of Raoul Vaneigem), *Histoire Désinvolte du Surréalisme* (Paris: Vermont, 1977), pp. 67–69. The Belgian surrealists Magritte and Mesens are also cited in this volume as exemplary figures in their anti-Christian revolt. Op. cit., p. 55.

8. *Mes Inscriptions*, op. cit., p. 123.

9. *Les Lèvres nues*, 1, April 1954, pp. 3–4.

10. Ibid., 2, pp. 15–19.

11. Ibid., p. 15.

12. Ibid., 5, p. 29.

13. Ibid., 10–12, p. 87.

14. For a lucid account of this version of Mallarmé's 'terrorist' poetics see Laurent Nunez, *Les Écrivains contre l'écriture* (Paris: éditions José Corti, 2006). Vincent Kaufman also provides some useful readings of the relation between Debord and Mallarmé in *Guy Debord*, op.cit., pp. 10, 14, 35, 131–35.

15. Guy Debord, *Panégyrique* (Paris: Gallimard, 1989), p.15.

16. Ibid., p.14.

17. *Les Lèvres nues*, 1, op. cit., p.15.

18. A fairly comprehensive account of Situationist and Lettrist activity at this time is given in Simon Sadler, *The Situationist City* (Cambridge: MIT, 1999), pp. 45–55. See also Andrew Hussey 'Abolish Everything!', *London Review of Books*, 2, (September 1999), pp. 29–34.

19. Raoul Vaneigem, *Louis Scutenaire*, 'Poètes d'aujourd'hui' (Paris: Seghers, 1991).

20. *Potlatch* (reprinted in Paris: Allia, 1994), p.47.

21. *Les Lèvres nues*, op. cit; 10–12, p. 53. The same phrase is a recurring motif in *Potlatch* during the same period (see op. cit;, Hussey, *Game of War*, pp. 110–15).

BIBLIOGRAPHY

ADY, ENDRE, *Neighbours of the Night*, Eng. trans by Judith Sollosy (Budapest: Corvina, 1994)

AJAME, PIERRE, *Hergé* (Paris: Gallimard, 1991)

ALECHINSKY, PIERRE, *Des deux mains* (Paris: Mercure de France, 2004)

APOSTOLIDES, JEAN-MARIE, *Les métamorphoses de Tintin* (Paris: Seghers, 1984)

ARON, JACQUES, *La Cambre et l'architecture* (Liège: Mardaga, 1982)

ARON, PAUL, *Les Ecrivains belges et le socialisme (1880–1913): l'expérience de l'art social, d'Edmond Picard à Émile Verhaeren* (Brussels: Labor, 1985)

——ed., *Charles Plisnier: entre l'Evangile et la Révolution* (Brussels: Labor, 1988)

——'Essai d'analyse institutionnelle d'un mouvement littéraire périphérique: l'exemple du surréalisme bruxellois entre les deux guerres' in *L'Identité culturelle dans les littératures de langue française* (Paris-Pécs: A. Vigle, 1990)

——*La Belgique artistique et littéraire: une anthologie de langue française 1848–1914* (Brussels: Editions Complexe, 1997)

ASSOULINE, PIERRE, *Simenon* (1992; Paris: Gallimard, 1996)

——*Hergé* (1996; Paris: Gallimard, 1998)

AUBERT, NATHALIE, 'Les logogrammes de Christian Dotremont', *French Studies*, 1, (2006) 49–62, vol. LX

——, FRAITURE, PIERRE-PHILIPPE, and McGUINNESS, PATRICK, eds, *La Belgique entre deux siècles: laboratoire de la modernité (1880–1914)* (Oxford: Peter Lang, 2007)

AUGE, MARC, 'La Librairie du XXᵉ Siècle', in *Non-Lieux: introduction à une anthropologie de la surmodernité* (Paris: Seuil, 1992)

BAUGNIET, MARCEL-LOUIS, *Vers une Synthèse esthétique et sociale* (Brussels: Labor, 1986)

BECHET, ACHILLE and CHRISTINE, *Surréalismes wallons* (Brussels: Labor, 1987)

BENJAMIN, WALTER, *The Arcades Project* (Cambridge-Massachusetts & London: The Belknap Press of Harvard University Press, 2004)

BENVENISTE, EMILE; KRISTEVA, JULIA; MILNER, JEAN-CLAUDE and RUWET, NICOLAS, *Langue, discours, société: pour Émile Benveniste* (Paris: Seuil, 1975)

CeBeDeM, *Music in Belgium* (Brussels: CeBeDeM, 1964)

BERG, CHRISTIAN, *Jean de Boschère ou le mouvement de l'attente* (Brussels: Palais des Académies, 1978)

——and HALEN, PIERRE, eds., *Littératures belges de langue française: histoire et perspectives (1830–2000)* (Brussels: Le Cri Édition, 2000)

BERMAN, MARSHALL, *The Experience of Modernity: All that is Solid Melts into Air* (New York: Verso, 1988)

BERTRAND, JEAN-PIERRE; BIRON, MICHEL; DENIS, BENOIT and GRUTMAN, RANIER, eds., *Histoire de la littérature belge (1830–2000)* (Paris: Fayard, 2003)

BEYEN, ROLAND, *Michel de Ghelderode ou la hantise du masque: essai de biographie critique* (Brussels: Académie Royale de Langue et de Littérature Françaises, 1980)

BOURDIEU, PIERRE, *Les Règles de l'art: genèse et structure du champ littéraire* (Paris: Éditions du Seuil, 1992)

BRECHT, BERTOLT, *Gesammelte Gedichte*, 4 vols. (Frankfurt am Main: Suhrkamp, 1978)

BRETON, ANDRE, *Œuvres Complètes* (Paris: Gallimard, 1988)

BROGNIEZ, LAURENCE, 'La transposition d'art en Belgique: le "Massacre des Innocents" vu par Maurice Maeterlinck et Eugène Demolder' in *Écrire la peinture entre Xviiie et Xixe siècles*, ed. by Pascale Auraix-Jonchière (Clermont-Ferrand: Presses Universitaires Blaise Pascal, 2003)

BURGER, PETER, *Theory of the Avant-Garde* (Minneapolis: Manchester University Press, 1984)

BUSSY, CHRISTIAN, *Anthologie du Surréalisme en Belgique* (Paris: Gallimard, 1972)

CALINESCU, M., *Faces of Modernity: Avant-garde, Decadence, Kitsch* (Bloomington — London: Indiana University Press, 1977)

CLIFFORD, JAMES, *The Predicament of Culture: Twentieth-Century Ethnography, Literature and Art* (Cambridge, Mass. & London: Harvard University Press, 1988)

COEKELBERGHS, DENIS, *Les peintres belges à Rome de 1700 à 1830* (Brussels and Rome: Institut Historique Belge de Rome, 1976)

COLLAER, PAUL, *La musique moderne 1905–1955* (Paris-Brussels: Elsevier, 1955)

——*Paul Collaer: Correspondance avec des amis musiciens*, ed. by Robert Wangermée (Sprimont: Mardaga, 1996)

COOKE, PETER, *Gustave Moreau et les arts jumeaux: peinture et littérature au dix-neuvième siècle* (Berne: Peter Lang, 2003)

CROMMELYNCK, FERNAND, *Le Cocu magnifique* (Brussels: Labor, 1987)

CURTUIS, ERNST ROBERT, *Europäischer Literatur und lateinisches Mittelalter* (Bern and Munich: Francke, 1973)

DE GHELDERODE, MICHEL, *Pantagleize* (Brussels: Labor, 1998)

DE HEUSCH, LUC, *Le Roi ivre ou l'origine de l'État* (Paris: Gallimard, 1972)

DE KEYSER, EUGENIE, *Pas perdus dans Bruxelles: photographies du début du siècle: Germaine Van Parys* (Brussels: Monique Adam, 1979)

DEBRAY, REGIS, *Sur le pont d'Avignon* (Paris: Flammarion, 2005)

DELCOURT, CHRISTIAN; DUBOIS, JACQUES; GOTHOT-MERSCH, CLAUDINE; KLINKENBERG, JEAN-MARIE; and RACELLE-LATIN, DANIELE, *Lire Simenon: réalité/ficiton/écriture* (Brussels: Fernand Nathan — Labor, 1980)

DELSEMME, PAUL, *Teodor de Wyzewa et le cosmopolitisme littéraire en France à l'époque du symbolisme* (Brussels: Presses universitaires de Bruxelles, 1967)

DENIS, BENOIT and KLINKENBERG, JEAN-MARIE, *La Littérature belge: précis d'histoire sociale* (Brussels: Labor, 'Espace Nord', 2005)

DESSONS, GERARD, ed., *Penser la voix* (Poitiers: La Licorne, 1997)

DUPONT, CHRISTINE, *Modèles italiens et traditions nationales: les artistes belges en Italie (1830–1914)* (Brussels and Rome: Institut Historique Belge de Rome, 2005)

ENSOR, JAMES, *Mes Écrits ou les suffisances matamoresques* (Brussels: Labor, 'Espace Nord', 1999)

FABRE, JEAN, *Enquête sur un enquêteur, Maigret: un essai de sociocritique* (Montpellier: Editions du Ceres, 1981)

FAURE, MICHEL, *Histoire du Surréalisme sous l'occupation* (Paris: La Table Ronde, 1982)

FRAITURE, PIERRE-PHILIPPE, *Le Congo belge et son récit francophone à la veille des indépendances: sous l'empire du royaume*, collection 'Critiques Littéraires' (Paris: L'Harmattan, 2003).

——*La Mesure de l'autre: Afrique subsaharienne et prose ethnographique de Belgique et de France (1918–1940)*, 'Bibliothèque de Littérature Générale et Comparée' (Paris: Honoré Champion, 2007)

GAMBONI, DARIO, *Le Plume et le Pinceau: Odilon Redon et la littérature* (Paris: Les Éditions de Minuit, 1989)

GODDIN, PHILIPPE, ed., *Hergé, chronologie d'une oeuvre* (Brussels: Editions de Moulinsart, 5 volumes published since 2000)

GORCEIX, PAUL, ed., *L'Identité de la Belgique et de la Suisse francophones* (Paris: Champion, 1997)

GOYENS DE HEUSCH, SERGE, *7 Arts. Bruxelles 1922–1929: un front de jeunesse pour la révolution artistique* (Brussels: Ministère de la culture française, 1976)

GUILLERM, JEAN-PIERRE, *Les Peintures invisibles: l'héritage pictural et les textes en France et en Angleterre, 1870–1914* (Lille: Presses universitaires de Lille, 1982)

HAESAERTS, PAUL, *Retour à l'humain: sur une tendance actuelle de l'Art belge: l'animisme* (Brussels and Paris: Éditions Apollo, 1943)

HAUSER, OTTO, *Die Belgische Lyrik von 1880–1900: Eine Studie und Übersetzungen* (Großenhain: Baumert & Ronge, 1902)

HEINICH, NATHALIE, *Le Triple Jeu de l'art contemporain* (Paris: Les Éditions de Minuit, 1998)

HERGE, *l'Intégrale Hergé*, 13 volumes (Brussels: Rombaldi, 1984–1985)

HEYM, GEORG, *Dichtungen und Schriften*, ed. by Karl Ludwig Schneider, 3 vols. (Hamburg & München: Ellermann, 1964)

HOBSBAWM, ERIC J., *Age of Extremes: The Short Twentieth Century 1914–1991* (London: Abacus, 1995)

HURET, JULE, *Enquête sur l'évolution littéraire* (1891; Paris: José Corti, 1999)

JANKELEVITCH, VLADIMIR, *Debussy et le mystère de l'instant* (Paris: Plon, 1976)

——*La Musique et l'Ineffable* (Paris: Le Seuil, 1983)

JOURET, JEAN-CLAUDE, *Tintin et le merchandising: Une gestion stratégique des droits dérivés* (Louvain-la-Neuve: Academia-Érasme, 1991)

JURANVILLE, CLARISSE, *Quelques écrits et quelques dessins* (Brussels: Henriquez, 1927)

JUSTENS, DANIEL and PREAUX, ALAIN, *Hergé: Keetje de Bruxelles* (Tournai: Casterman, 2004)

KANDLER, KLAUS, *Berliner Begegnungen: Ausländische Künstler in Berlin, 1918 bis 1933: Aufsätze — Bilder — Dokumente* (Berlin: Dietz, 1987)

KAYSER, WOLFGANG, *Das Groteske in Malerei und Dichtung* (Hamburg: Rowohlt, 1960)

KLINKENBERG, JEAN-MARIE, *Petites Mythologies belges* (Brussels: Éditions Labor/Éditions Espace de libertés, 2003)

KRACAUER, SIEGFRIED, *From Caligari to Hitler: A psychological History of the German Film* (Princeton: Princeton University Press, 1947)

LALANDE, FRANCOISE, *Christian Dotremont: l'inventeur de Cobra* (Paris: Stock, 1998)

LAMBERT, JEAN-CLARENCE, *Cobra* (London: Sotheby Publications, 1983)

LEMAIRE, JACQUES, *Simenon, jeune journaliste: un anarchiste 'conformiste'* (Brussels: Complexe, 2003)

LEMOINE, MICHEL, *Liège couleur Simenon*, 3 vols. (Liège: Cefal, 2002)

——and PIRON, MAURICE, *L'Univers de Simenon* (Paris: Presses de la Cité, 1983)

——and SWINGS, CHRISTINE, eds., *Simenon: l'homme, l'univers, la création* (Brussels: Complexe, 1993)

LEMONNIER, CAMILLE, *Nos Flamands* (Brussels: De Somer, 1869)

——*Gustave Courbet et son œuvre* (Paris: Lemerre, 1878)

——*L'École belge de peinture 1830–1905* (1906; Brussels: Labor, 1991)

LEVAUX, THIERRY, ed., *Dictionnaire des compositeurs de Belgique du Moyen Âge à nos jours* (Ohain-Lasne: Art in Belgium, 2005)

LEYMARIE, MICHEL; MOLLIER, JEAN-YVES and PLUET-DESPATIN, eds., *La Belle Époque des revues 1880–1914* (Paris: Éditions de l'Imec, 2002)

LIEBRECHTS, CHARLES and MASUI, THEODORE, eds., *Guide de la section de l'État Indépendant du Congo à l'exposition de Bruxelles-Tervueren en 1897* (Brussels: Imprimerie Veuve Monnom, 1897)

MAETERLINCK, MAURICE, *L'Ornement des noces spirituelles de Ruysbroeck* (Brussels: Lacomblez, 1891)

——*Théâtre II* (Brussels: Lacomblez, 1902)

MAGRITTE, RENE, *Écrits complets*, ed. by André Blavier (Paris: Flammarion, 1979)

MARAN, RENE, *Batouala: Véritable roman nègre* (Paris: Albin Michel, 1921)

MARIEN, MARCEL, *L'activité surréaliste en Belgique 1924–1950* (Brussels: Lebeer Hossmann, 1979)

MASSONNET, STEPHANE, ed., *E.L.T. Mesens and Tristan Tzara: Dada Terminus* (Brussels: Devillez, 1997)

MATHET, MARIE-THERESE, ed., *L'Incompréhensible: littérature, réel, visuel* (Paris: L'Harmattan, 2003)

——*Littérature et brutalité* (Paris: L'Harmattan, 2006)

MATTHEWS, JOHN HERBERT, *Toward the Poetics of Surrealism* (Syracuse: Syracuse University Press, 1976)

MCGUINNESS, PATRICK, *Maurice Maeterlinck and the Making of Modern Theatre* (Oxford: Oxford University Press, 2000)

——*Symbolism, Decadence and the fin-de-siècle: French and European Perspectives* (Exeter: University of Exeter Press, 2000)

MERLEAU-PONTY, MAURICE, *Le Visible et l'Invisible* suivi de *notes de travail*, ed. by Claude Lefort (Paris, Gallimard, 1979)

MEYERHOLD, VSEVOLOD, *Ecrits sur le théâtre* (Lausanne: La Cité / L'Age d'homme, 1973)

MICHAUD, GUY, *Message poétique du Symbolisme* (Paris: Nizet, 1947)

MICHAUD, YVES, *La Crise de l'Art contemporain* (Paris: Puf, 1997)

MILO, JEAN, *Vie et survie du 'Centaure'* (Brussels: Éditions nationales d'art, 1980)

MORTON STANLEY, HENRY, *The Congo and the Founding of its Free State: A Story of Work and Exploration*, 2 vols. (London: Sampson, Low, Marston, Searle & Rivington; New York: Harper & Brothers, 1885)

NADEAU, MAURICE, *The History of Surrealism* (London: Jonathan Cape, 2000)

NARCEJAC, THOMAS, *Le cas Simenon* (Paris: Presses de la Cité, 1950)

NAVILLE, PIERRE, *La Révolution et les intellectuels* (Paris: Gallimard, 1975)

NOUGE, PAUL, *La conférence de Charleroi* (Brussels: Le Miroir infidèle, 1946)

——*Quelques bribes* (Brussels: Didier Devillez, 2002)

OTTEN, MICHEL, ed., *Etudes de littérature française de Belgique offertes à Joseph Hanse pour son 75e anniversaire* (Brussels: Jacques Antoine, 1978)

PAQUE, JEANNINE, *Le Symbolisme belge* (Brussels: Labor, 1989)

PEETERS, BENOIT, *Le monde d'Hergé* (Tournai: Casterman, 1983)

PERIER, GASTON-DENYS, *Le Rôle de la littérature coloniale* (Brussels: Imprimerie Gaston Bonnet, 1913)

——*Petite Histoire des lettres coloniales de Belgique* (Brussels: Office de Publicité, 1942)

PHILLIPPS, A., *City of Darkness, City of Light: Emigré filmmakers in Paris, 1929–1939* (Amsterdam: Amsterdam University Press, 2004)

PINTUS, KURT, *Menschheitsdämmerung* (Hamburg: Rowohlt, 1959)

PIRET, PIERRE, *Fernand Crommelynck: une dramaturgie de l'inauthentique* (Brussels: Labor, 1999)

POE, EDGAR ALLAN, *The Complete Works of Edgar Allan Poe*, ed. by James A. Harrison, 17 vols (New York: Ams Press, 1965)

POTVIN, CHARLES, *Nos premiers siècles littéraires, Choix de conférences données à l'hôtel de ville de Bruxelles dans les années 1865–1868* (Brussels: Lacroix, Verboeckhoven et cie, 1870)

POUND, EZRA, *Instigations* (New York: Boni and Liveright, 1920)

——*The Cantos* (New York: New Directions, 1972)

PROUST, MARCEL, *Du côté de chez Swann* in *Œuvres complètes* (Paris: Gallimard, 1987)

QUAGHEBEUR, MARC, *Les lettres belges entre absence et magie* (Brussels: Labor, 1990)

——*Balises pour l'histoire des Lettres belges de langue française* (Brussels: Labor, 1998)

——ed., *Présence/Absence de Maeterlinck* (Brussels: Labor, 2002)

——and VAN BALBERGHE, EMILE et al., *Papier blanc, encre noire: cent ans de culture francophone en Afrique centrale (Zaïre, Rwanda et Burundi)*, 2 vols (Brussels: Labor, 1992)

RAY, JEAN, *Contes du whisky* (Verviers: Gérard, 1965)

RICHARD, LIONEL, *L'Art et la guerre: les artistes confrontés à la Seconde Guerre mondiale* (Paris: Flammarion, 1995)

RODENBACH, GEORGES, *L'Elite* (Paris: Fasquelle, 1899)

——*Le Rouet des Brumes* (Paris: Flammarion, 1929)

ROEGIERS, PATRICK, *Le Mal du pays: autobiographie de la Belgique* (Paris: Le Seuil, 2003)

RYKNER, ARNAUD, *Pans: liberté de l'œuvre et résistance du texte* (Paris: Corti, 2004)

SARLET, CLAUDETTE, *Les Écrivains d'art en Belgique, 1860–1914* (Brussels: Labor, 1992)

SARRAUTE, NATHALIE, *L'Usage de la parole* (Paris: Gallimard, 1980)

SARTRE, JEAN-PAUL, *Qu'est-ce que la littérature?* (1948; Paris: Gallimard, 1987)

SCHLOGEL, KARL, *Berlin: Ostbahnhof Europas: Russen und Deutschen in ihrem Jahrhundert* (Berlin: Siedler, 1998)

SCHOPENHAUER, ARTHUR, *Le Monde comme volonté et comme représentation*, Fr. trans. by A. Burdeau (Paris: Presses Universitaires de France, 1966)

SCHRADER, BARBEL and SCHEBERA, JURGEN, *Kunstmetropole Berlin 1918–1933: Dokumente und Selbstzeugnisse* (Berlin and Weimar: Aufbau-Verlag, 1987)

SCHWEINFURTZ, GEORG, *Im Herzen von Afrika: Reisen und Entdeckungen im zentralen Äquatorial-Afrika während der Jahre 1868–1871: Ein Beitrag zur Entdeckungsgeschichte von Afrika* (Leipzig: F.A. Brockhaus, 1874)

SCUTENAIRE, LOUIS, *Magritte* (Brussels: Éditions du Cercle d'Art, 1948)

SEGALEN, VICTOR, *Essai sur l'exotism:, une esthétique du divers* (Paris: Fata Morgana, 1978)

SENGOR, LEOPOLD-SEDAR, *Anthologie de la nouvelle poésie nègre et malgache de langue française* (Paris: Puf, 1948)

SERRES, MICHEL, *Hergé mon ami* (Brussels: Editions de Moulinsart, 2000)

SIMENON, GEORGES, *Tout Simenon*, 27 volumes [1–25: Romans et nouvelles; 26–27: Écrits autobiographiques], (Paris: Omnibus, 1988–1993)

——*Mes apprentissages: Reportages 1931–1946*, ed. by Francis Lacassin (Paris: Omnibus, 2001)

——*Romans*, 2 vols., ed. by Jacques Dubois and Benoit Denis (Paris: Gallimard, 2003)

SMOLDERS, OLIVIER, *Paul Nougé: écriture et caractère à l'école de la ruse* (Brussels: Labor, 1995)

SONCICI FRATTA, ANNA, ed., *Paul Nougé: pourquoi pas un centenaire?* (Bologna: Clueb, 1997)

SOUMOIS, FREDERIC, *Dossier Tintin* (Brussels: Jacques Antoine, 1987)

TAINE, HIPPOLYTE, *Philosophie de l'art dans les Pays-Bas: leçons professées à l'école des Beaux-Arts, Paris* (Paris: Germer Baillière, 1869)

TODOROV, TZVETAN, *Introduction à la littérature fantastique* (Paris: Seuil, 1970)

TOLLER, ERNST, *Gesammelte Werke*, 5 vols. (München: Hanser, 1978)

VAN LOO, ANNE, ed., *Akarova: spectacle et avant-garde 1920–1950: entertainment and the avant-garde* (Brussels: Archives d'architecture moderne, 1988)

VAN OSTAIJEN, PAUL, *Eine Künstlerfreundschaft* (Oldenburg: Holzberg, 1992)

——*Paul van Ostaijen. Een documentatie*, ed. by Gerrit Borgers (Amsterdam: Bakker, 1996)

VANDENBREEDEN, JOS and VANLAETHEM, FRANCE, *Art deco et modernisme en Belgique: architecture de l'Entre-deux-guerres*, photographs by Christine Bastin & Jacques Evrard (Brussels: Editions Racine, 1996)

VANDROMME, PAUL, *Le monde de Tintin* (1959; Paris: La Table ronde, 1994)

——*Georges Simenon* (1962; Lausanne: L'age d'Homme, 2000)

VERHAEREN, EMILE, *Les Villes tentaculaires* (Paris: Gallimard, 2006)

WALDEMAR, GEORGE, *Profits et pertes de l'Art contemporain* (Paris: Éditions de chroniques du jour, 1933)

WANGERMEE, ROBERT, ed., *Paul Collaer: Correspondance avec des amis musiciens* (Sprimont: Mardaga, 1996)

WAUTERS, ALPHONSE-JULES, *L'Etat indépendent du Congo* (Brussels: Librairie Falk Fils, 1899)

——*Histoire politique du Congo belge* (Brussels: Pierre Van Fleteren, 1911)

WEISGERBER, JEAN, ed., *Les avant-gardes littéraires en Belgique: Au confluent des arts et des langues (1880–1950)* (Brussels: Labor, 1991)

WIELAND, CHRISTOPH MARTIN, *Sämtliche Werke*, 39 vols. (Hamburg: Hamburger Stiftung zur Förderung von Wissenschaft und Kultur, 1984)

INDEX